COASTAL CALIFORNIA

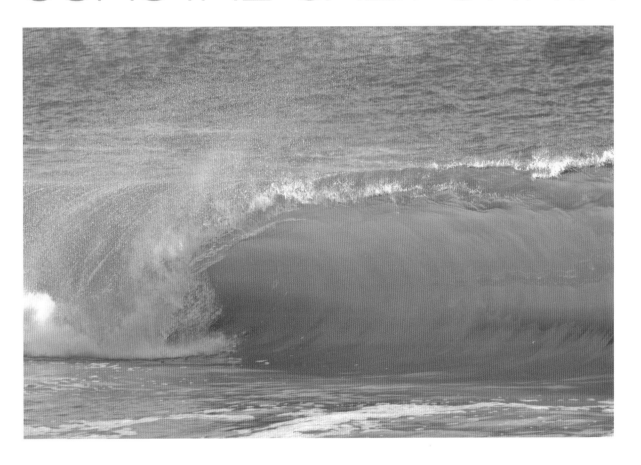

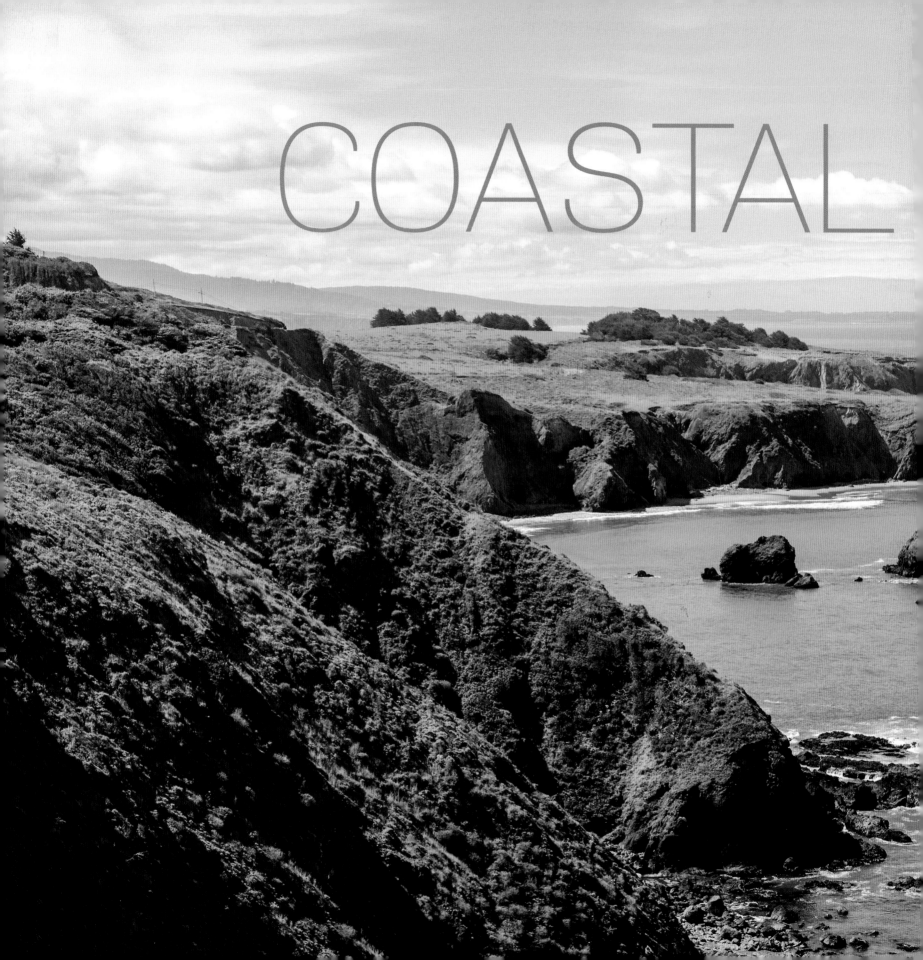

COASTAL

CALIFORNIA

The Pacific Coast Highway and Beyond

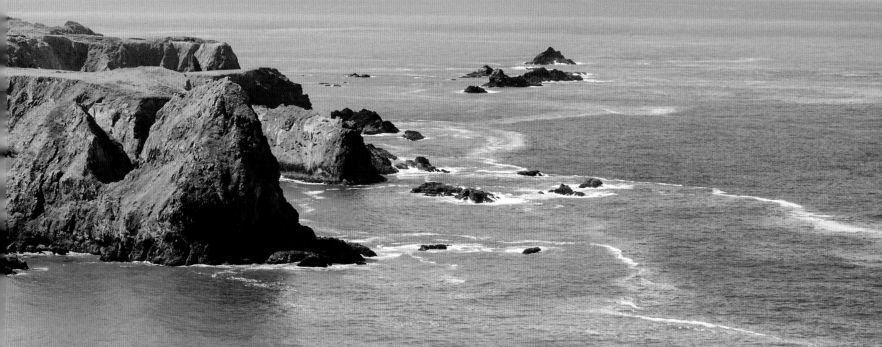

JAKE RAJS

Foreword by
GOVERNOR EDMUND G. BROWN JR.

RIZZOLI
NEW YORK

CONTENTS

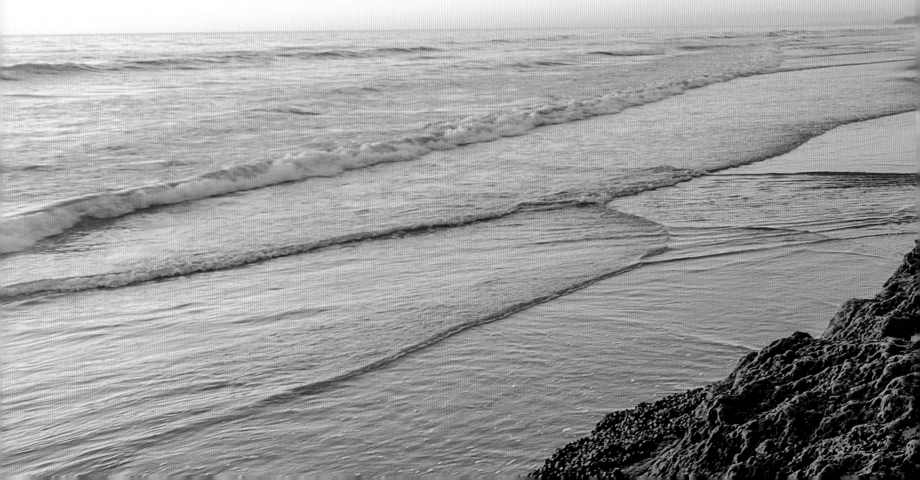

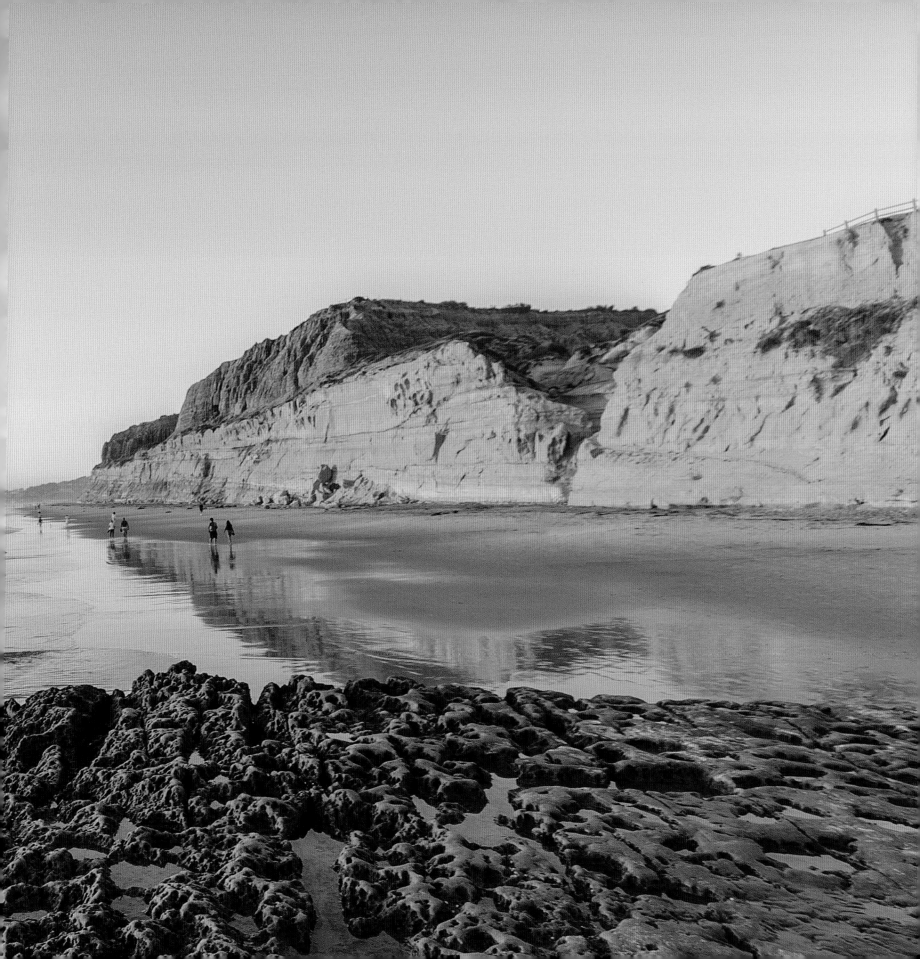

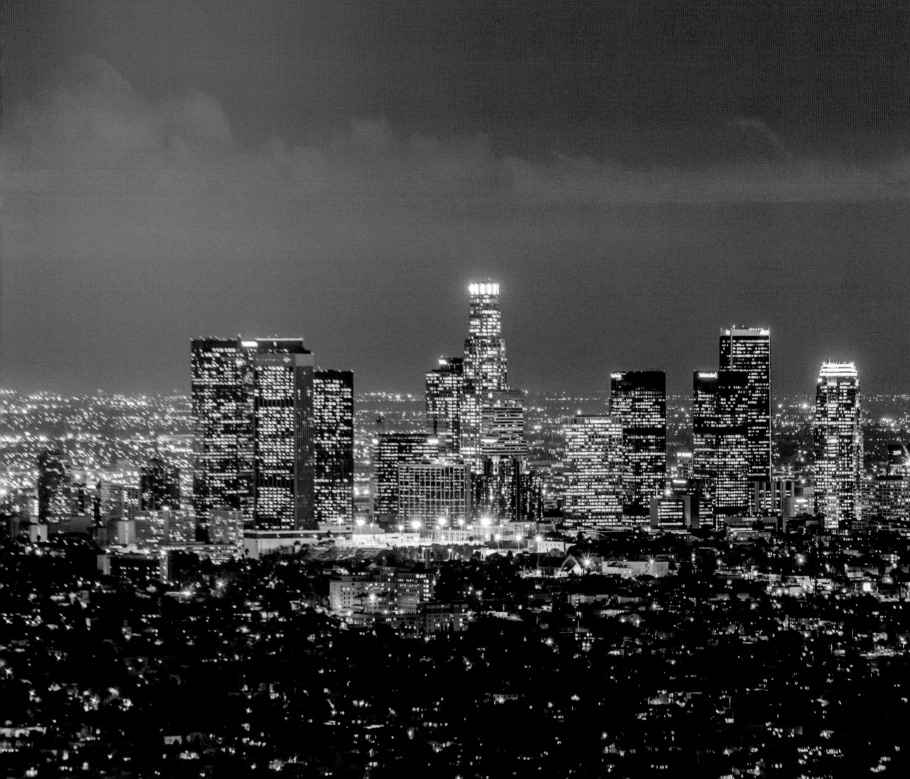

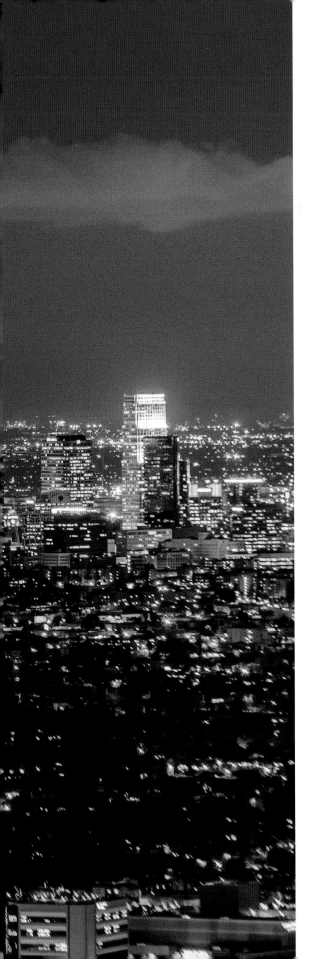

FOREWORD

The California coast is a natural treasure whose breathtaking scenery has inspired generations of artists, authors, dreamers, and sightseers. It has provided the setting for some of the state's most iconic successes in science and industry, from our multi-billion-dollar maritime trade and fisheries to the laboratories and institutes that have shed so much light on the age-old mysteries of the sea. Californians' love of the coast has also played an important role in making our state a world leader in the movement to protect oceans and other natural resources.

Perhaps less obvious than the aesthetic, commercial, and environmental value of our coast is the sheer audacity of our coastal highway, known variously in different parts of the state as the Coast Highway, Highway One, or the Pacific Coast Highway. For one thing, the route has no historical precedent. In many of its stretches the unaltered landscape was too rugged for oxcarts, horses, or even people on foot to navigate. Farther inland, US Highway 101, the more sensible but less exhilarating way to get up and down the coast, largely follows the path of the Spanish Camino Real, which in turn followed trade routes used by the native people of California for thousands of years. When native people went long distances along the coastline, they went by canoe.

Before the highway, one could say there were several separate California coasts with limited overland connections to each other and the outside world. Some parts were so isolated that they appeared stuck in a different time. There was no single vision for the road before it was built. Unlike the Transcontinental Railroad, the Interstate Highway System, the Golden Gate Bridge, or so many other legendary transportation projects in our history, no one dreamed up the Coast Highway as a single route and then set about building it.

◈ Los Angeles

Rather, the impetus to grade, pave, and bridge along the coastline was local and idiosyncratic. One of the most spectacular stretches of the highway, from Carmel to San Simeon, for instance, began with a Monterey doctor's chagrin at the time it took him to reach victims of an 1894 shipwreck. The state government didn't even designate the highway as a single route with a single number until 1964.

The poet Sam Walter Foss famously wrote, speaking of California, "Bring me men to match my mountains." On the vertiginous bridges and hairpin curves of our Coast Highway, we can see what Foss was talking about: a convergence of human audacity and natural grandeur.

Through the splendid images in this book, I invite you to enjoy the vibrant contrasts and awe-inspiring landscapes that express and define the Golden State of California.

GOVERNOR EDMUND G. BROWN JR.

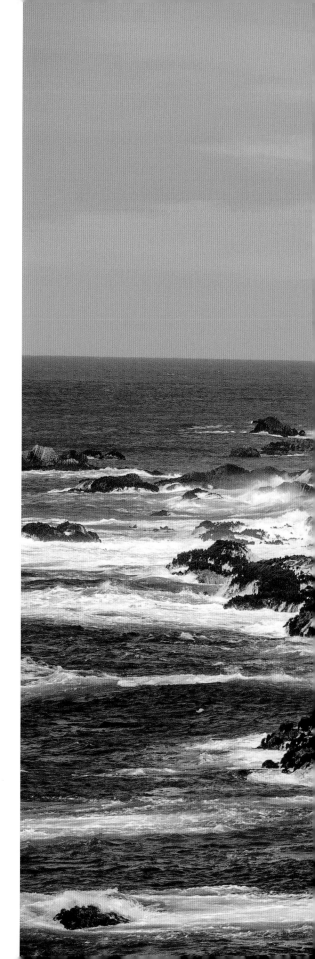

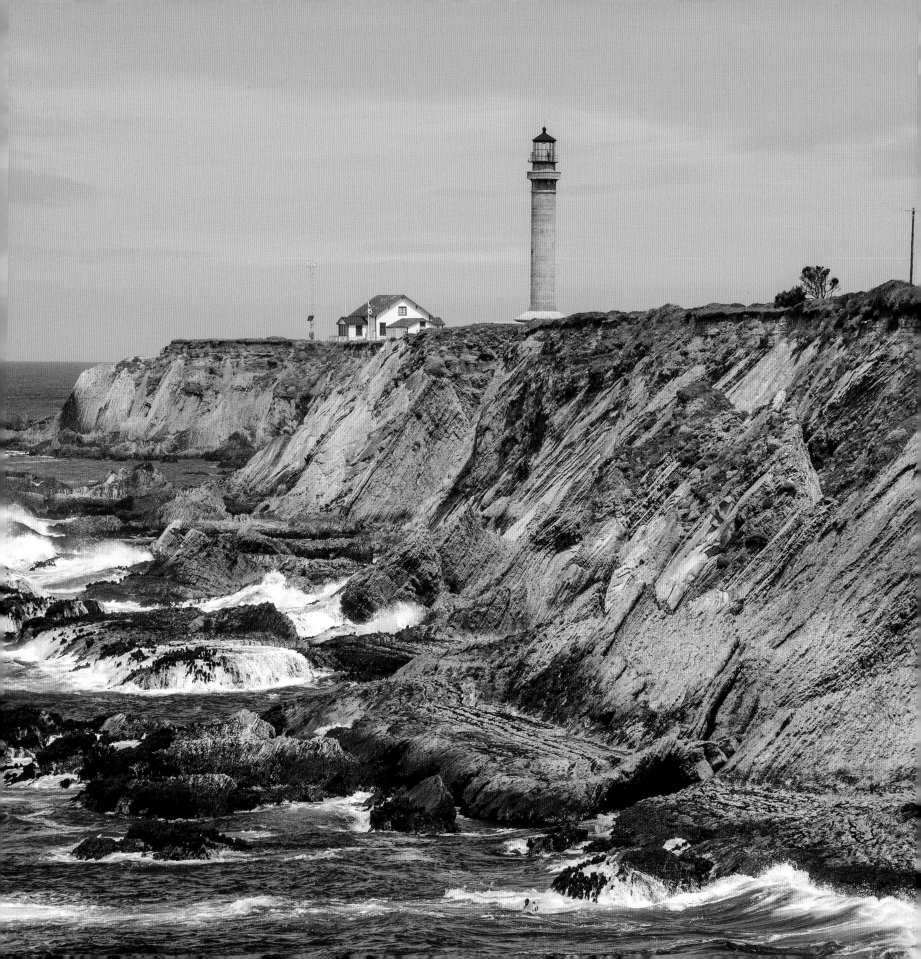

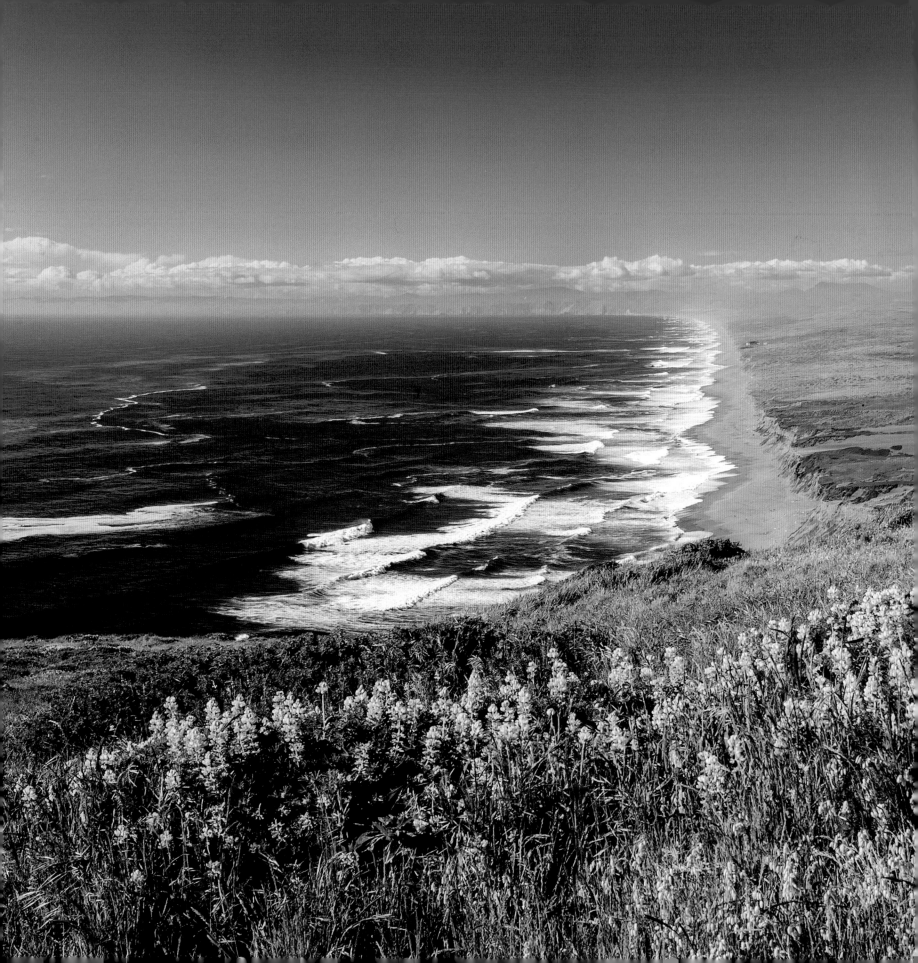

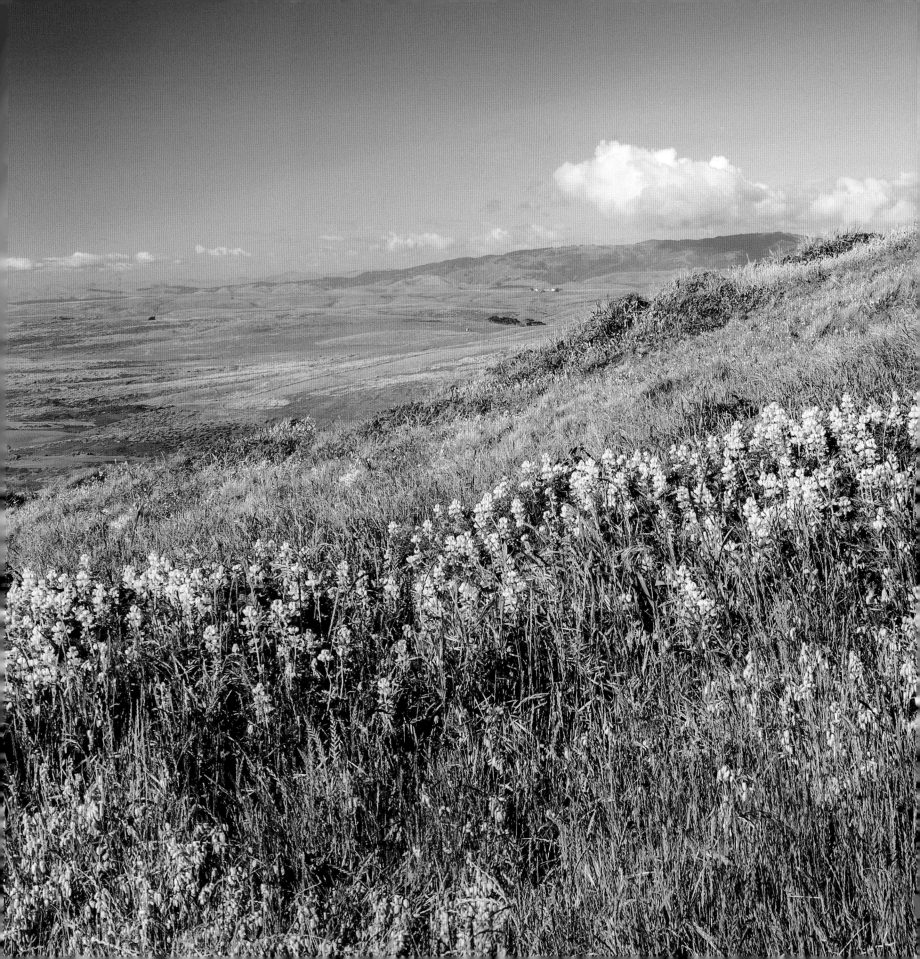

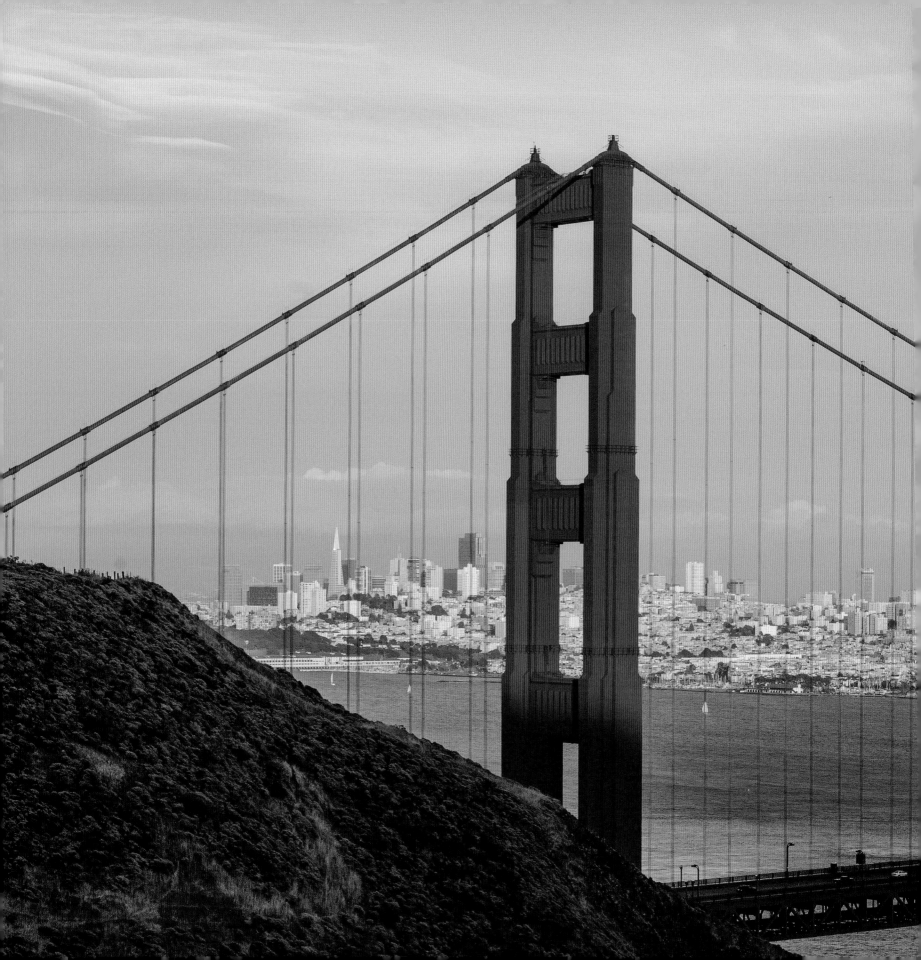

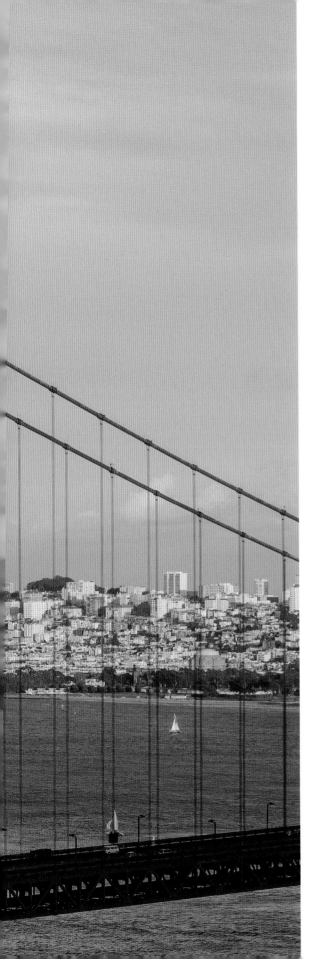

INTRODUCTION

The first time I visited California was in the 1970s. I hitchhiked across America along Route 66 to get to the Pacific Ocean. When I arrived, I dove into the water and experienced an unforgettable sunset in Santa Monica. It was a journey of self-discovery, and California held the promise of a new beginning. My spirit was captured by the state's pure beauty and vibrancy, and I became enamored with it. I've been drawn back again and again. What attracts me is the state's incredible diversity. It's as if California is its own country, encapsulating a unique variety of people, landscapes, towns, and cultures. Watching California change over the decades reminds me that what happens first in California happens later in the rest of the world.

There are so many wonderful sites you can see on one trip to California: iconic American landmarks such as the Golden Gate Bridge and Santa Monica Pier, towering trees of redwood forests, quaint fishing villages with crowded harbors full of boats, lighthouses peeking through the fog, national seashores with shorebirds hovering over sandy beaches and seals lounging on rocks, hiking trails where John Muir once walked, crashing waves backlit by orange sunsets, surfing communities still bearing traces of their hippie past, Spanish historic buildings and contemporary architecture by the world's greatest architects, palm trees swaying in the nearly nonstop sunshine and listening to the ocean's music—the list goes on and on. Is there any place more artistically inspiring?

California's breathtaking coastline stretches for more than 800 miles from Oregon to the Mexican border. It is the most dramatic and awe-inspiring coastline in the United States. There's something moving about the majestic power of the Pacific Ocean, the way the ocean shapes the landscape and lifestyle of California. The North Coast, from Crescent City to Sonoma, is known for its

◈ Golden Gate Bridge, San Francisco

13

rugged wilderness, towering redwoods, historic towns, and heavy fog. The Bay Area, from Sonoma to Santa Cruz, features both the charming vineyards and tiny communities of the wine country and the steep hills and stately Victorian houses of San Francisco. The Central Coast, from Santa Cruz to Ventura, is a photographer's dream: the Pacific Coast Highway winds through Steinbeck country, past the stunning natural beauty of Point Lobos and the crashing seas of Big Sur, and through the Mediterranean-like city of Santa Barbara. The Southern Coast, from Ventura to San Diego, has a more cosmopolitan vibe: in addition to the rush of Los Angeles, there are dozens of small coastal towns filled with Art Deco architecture painted in beachy colors, locals enjoying the spectacular Southern California weather, and surfers riding the waves.

As I drove along this spectacular coastline capturing photographs for this book, I always had you, the reader, in mind. I wanted to give you a sense of being in the photographs, to make you feel as if you were traveling with me, seeing firsthand the beautiful scenery, bustling cities, and everything else this state has to offer. I sincerely hope that I have accomplished that goal—and that this book inspires you to take a journey of your own, to experience the same sense of discovery that I had as I traveled coastal California.

JAKE RAJS

 El Matador State Beach, Malibu ⬦ San Clemente Pier, Oceanside

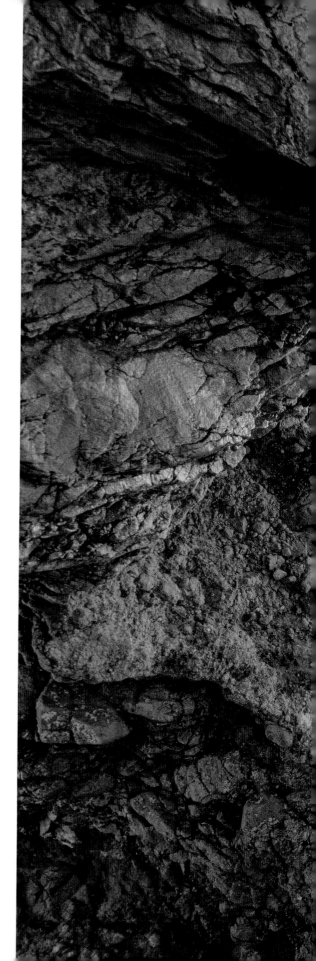

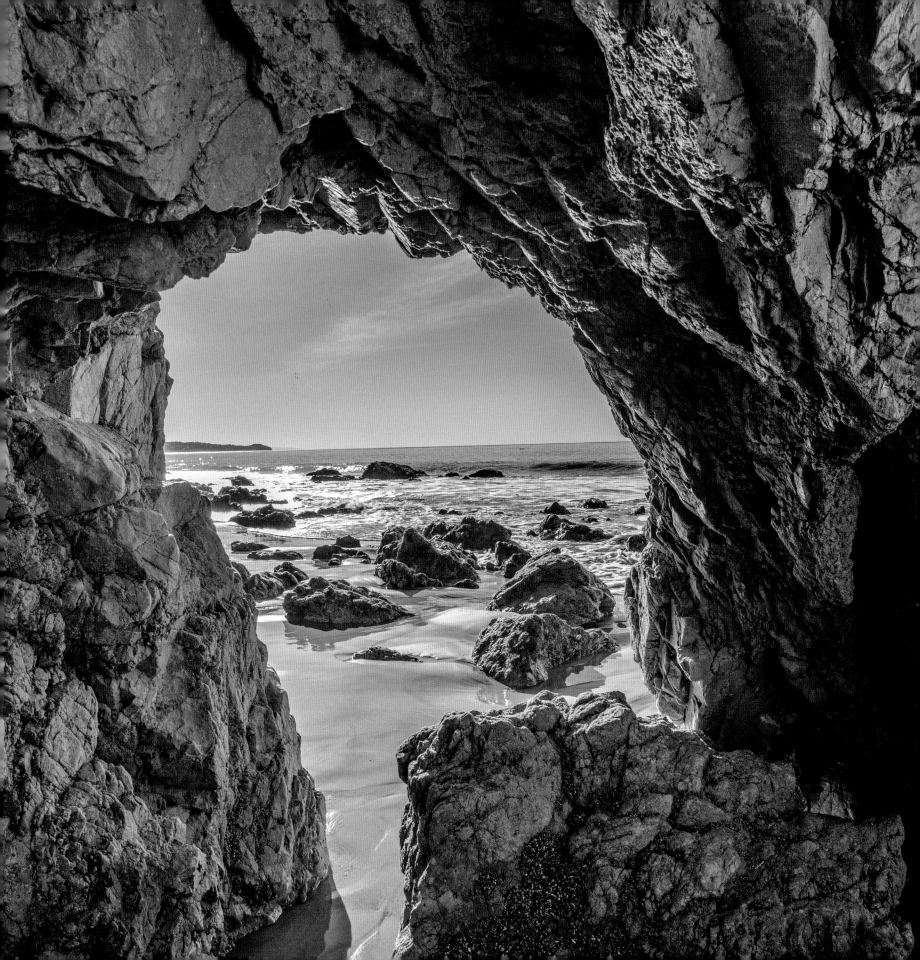

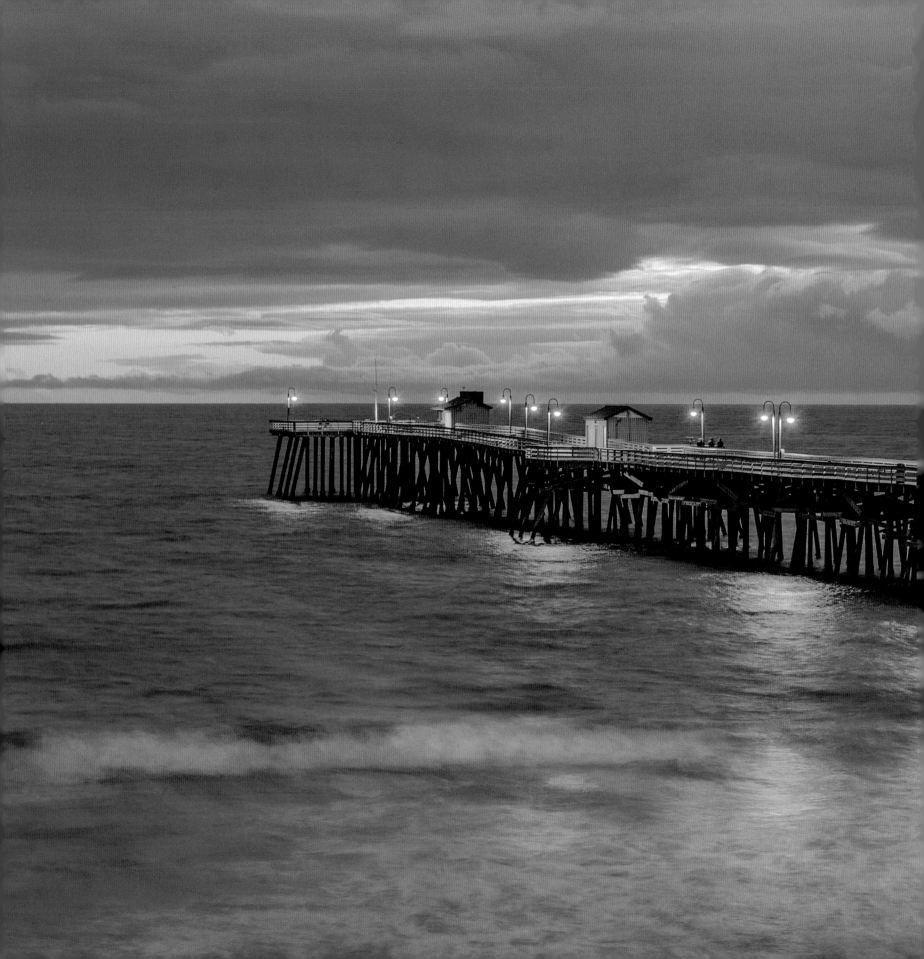

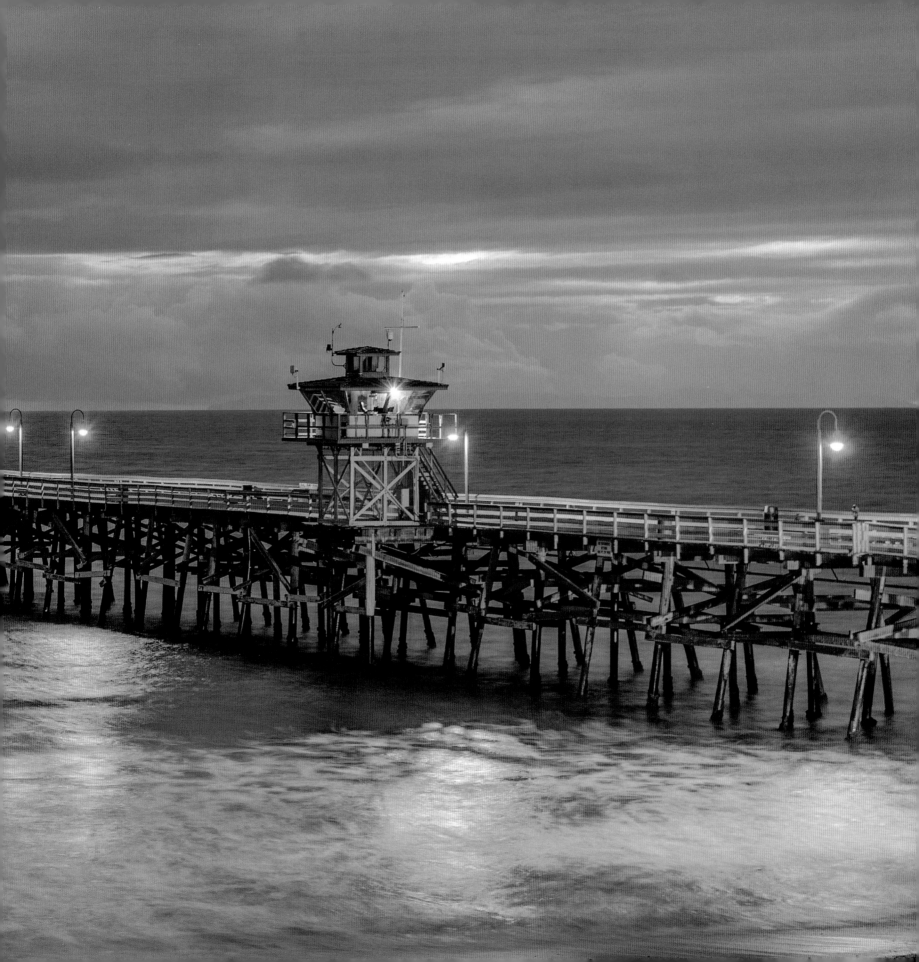

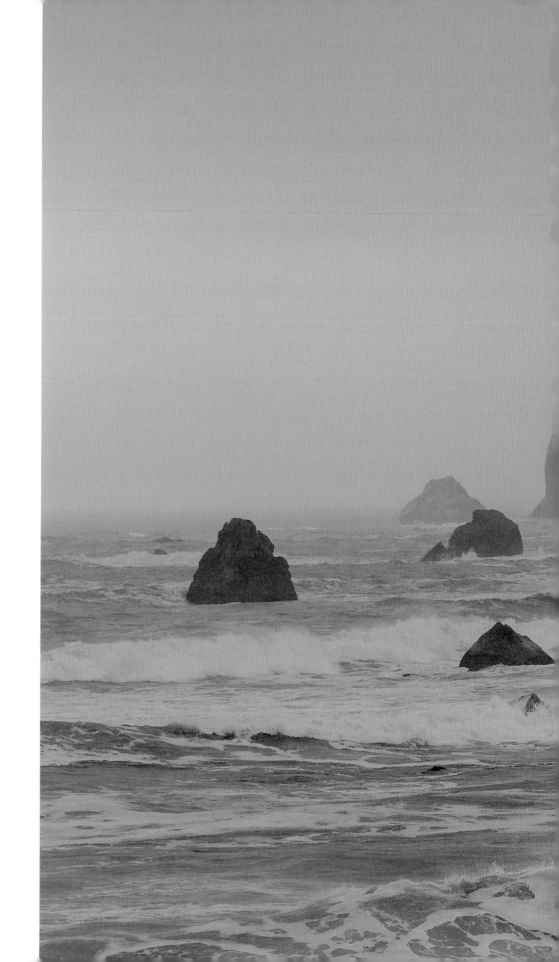

◆ Coastline, between Crescent City and Klamath

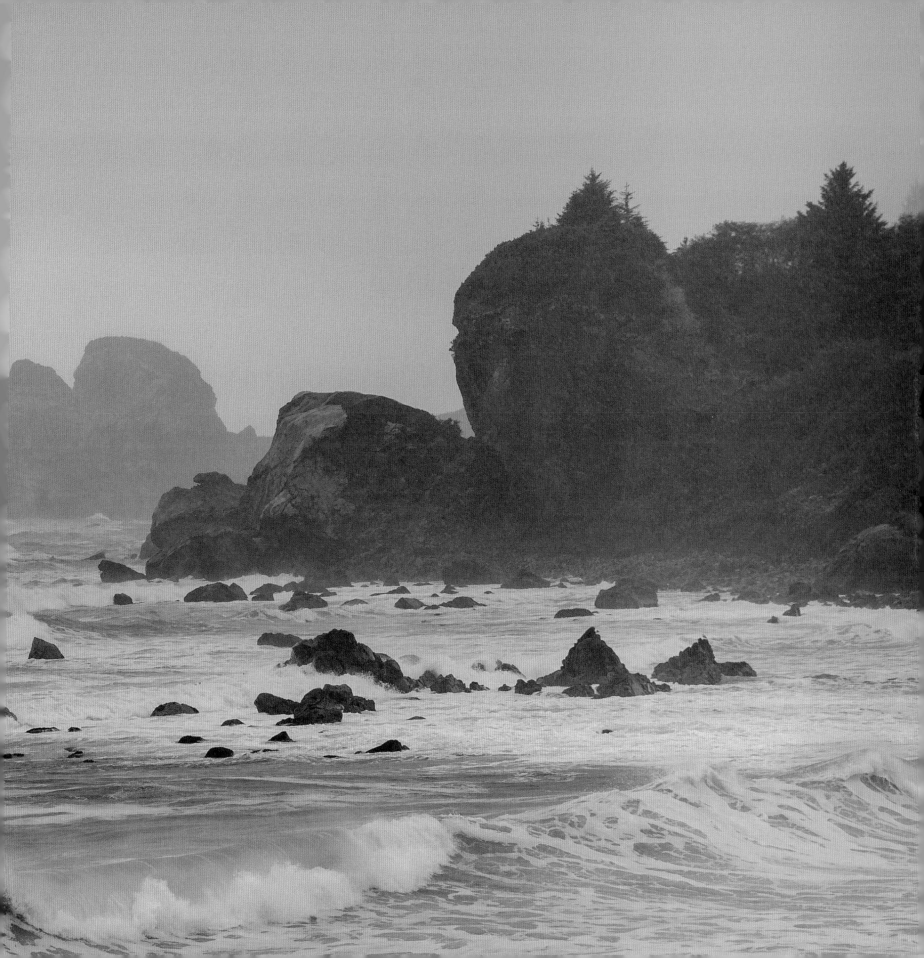

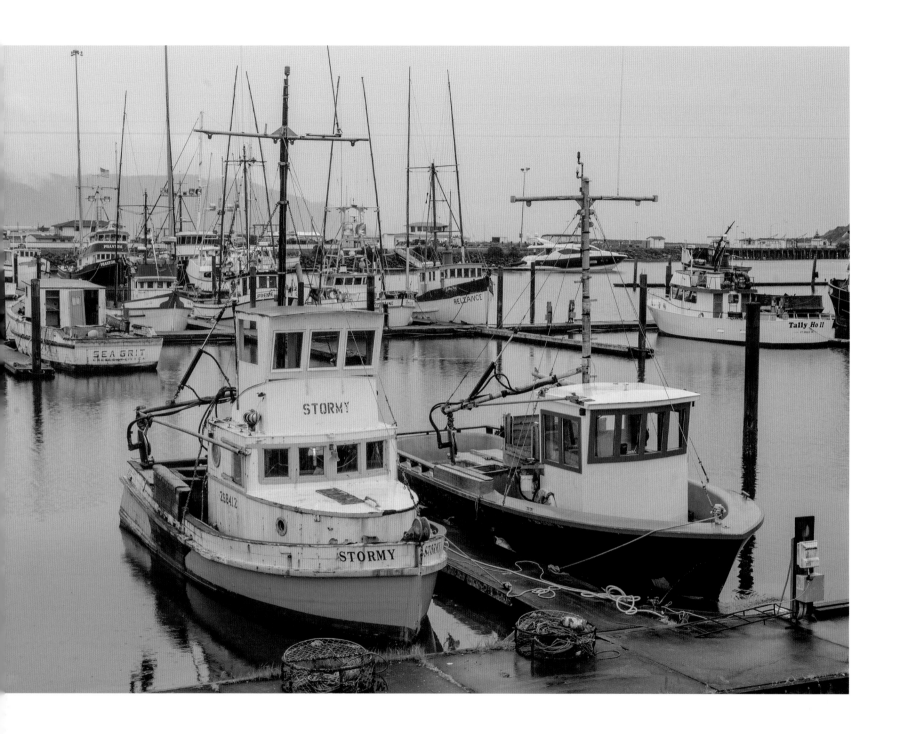

◈ Fishing boats in harbor, Crescent City ◈ Lighthouse, Crescent City ◈ Coastline, Crescent City

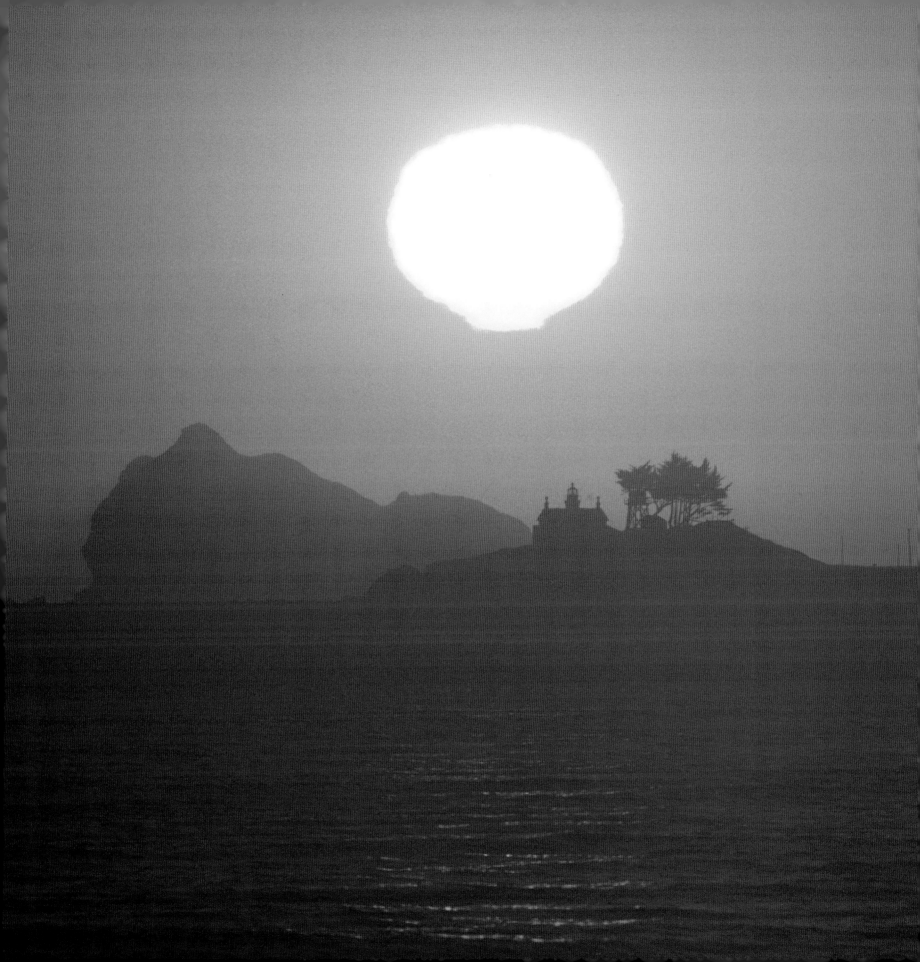

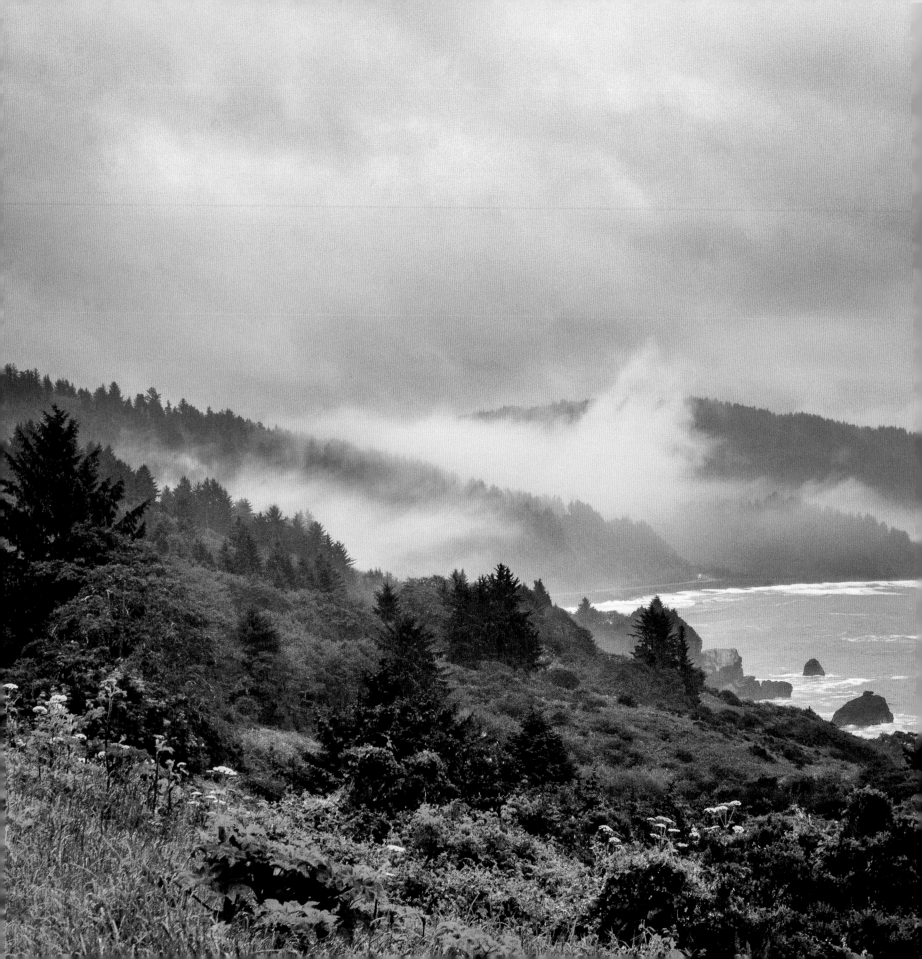

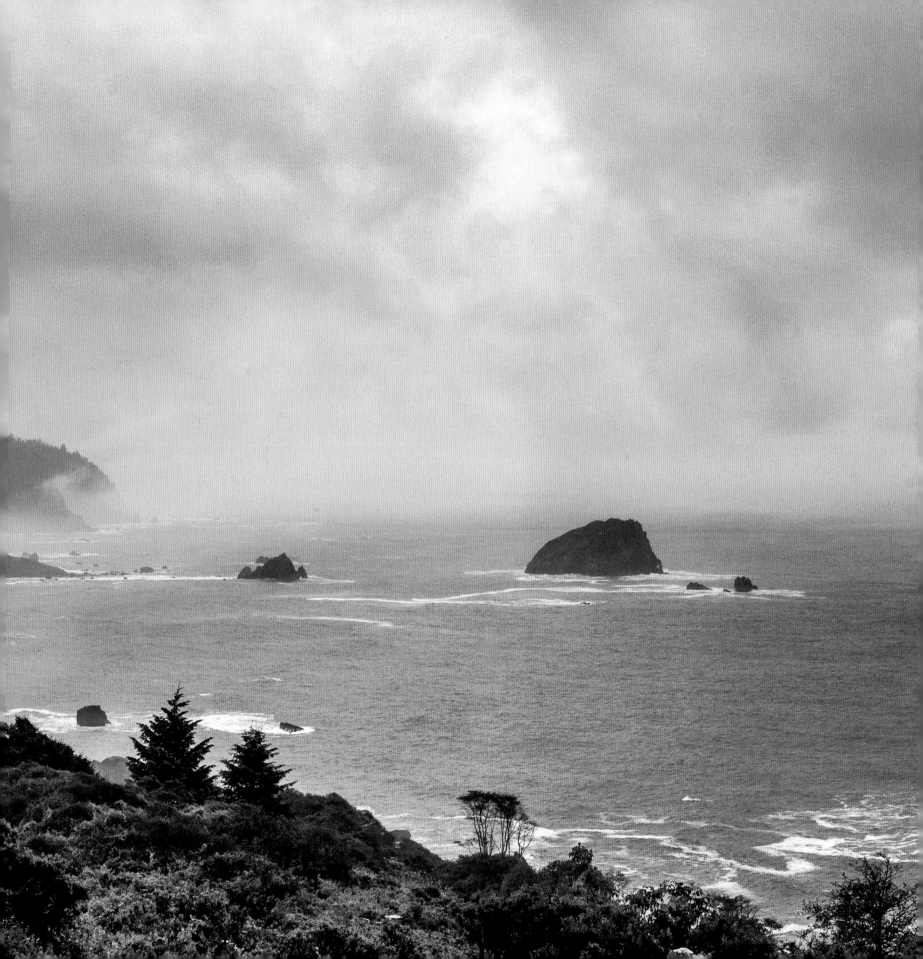

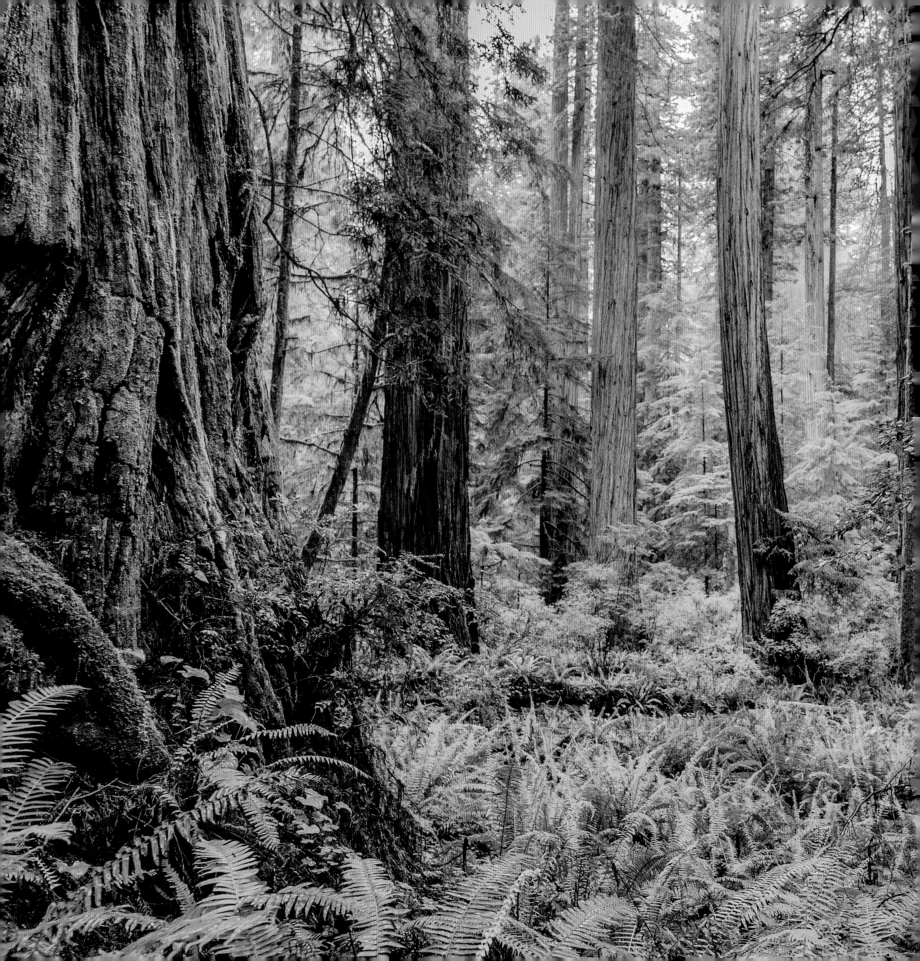

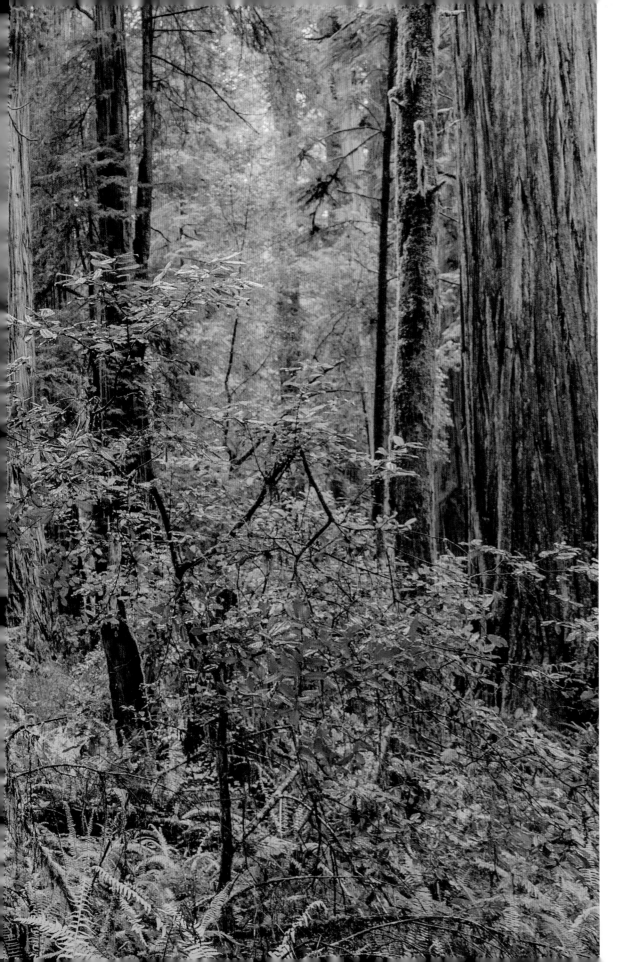

◈ ⬇ Jedediah Smith Redwoods
State Park, Crescent City

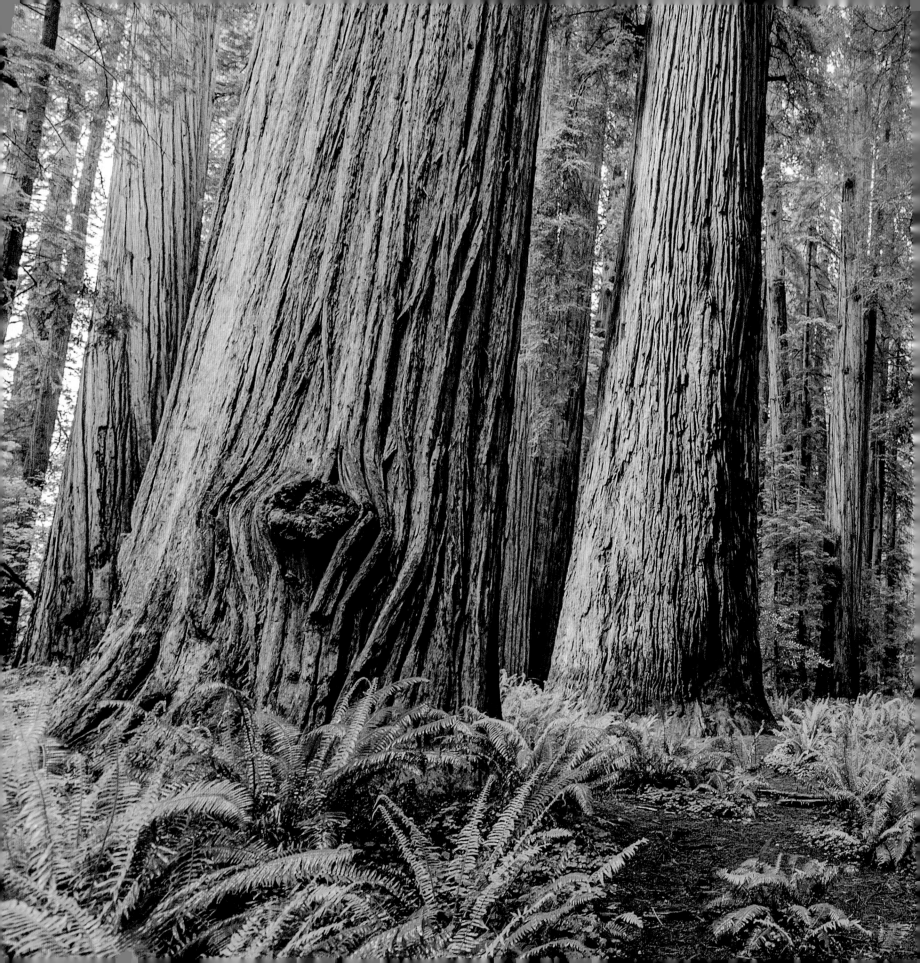

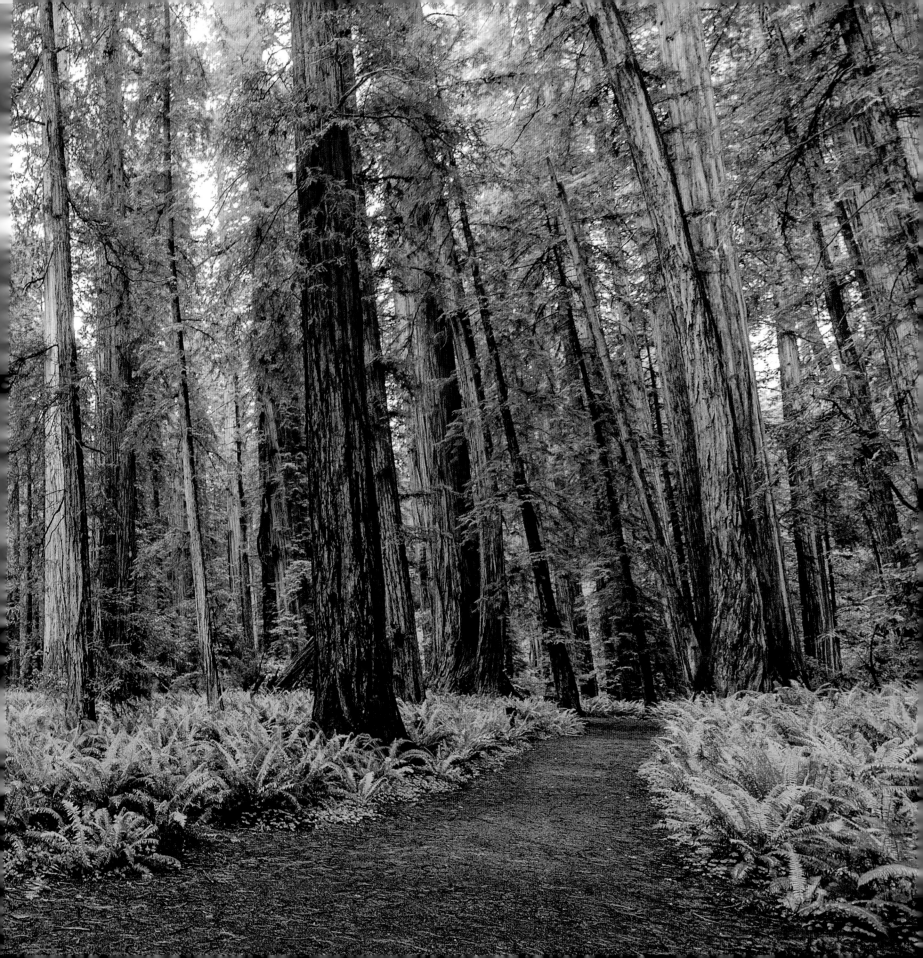

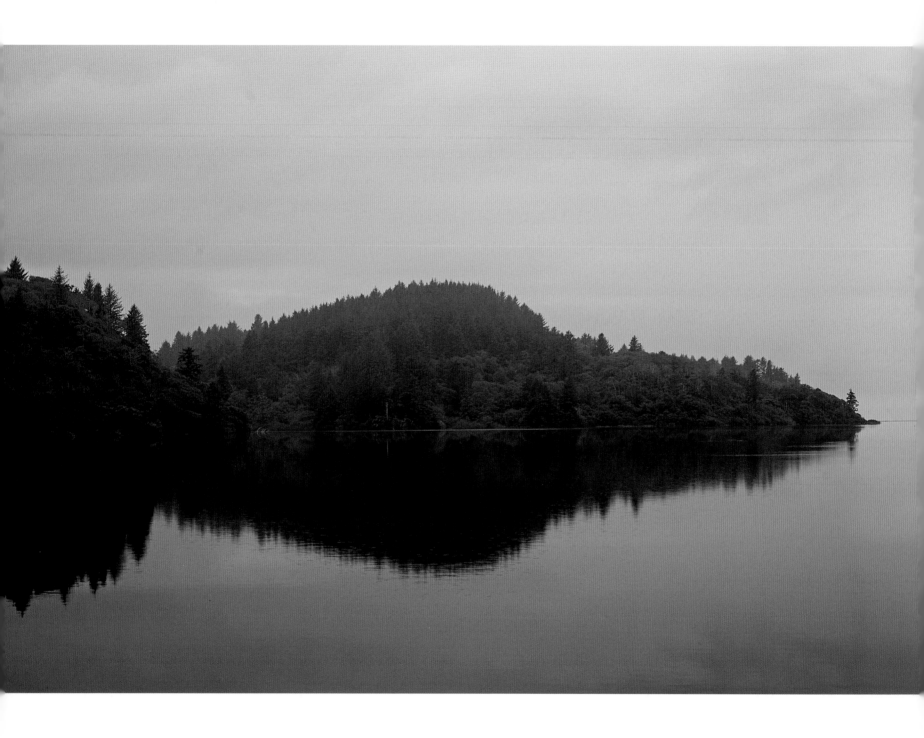

◈ Humboldt Lagoons State Park, Humboldt County

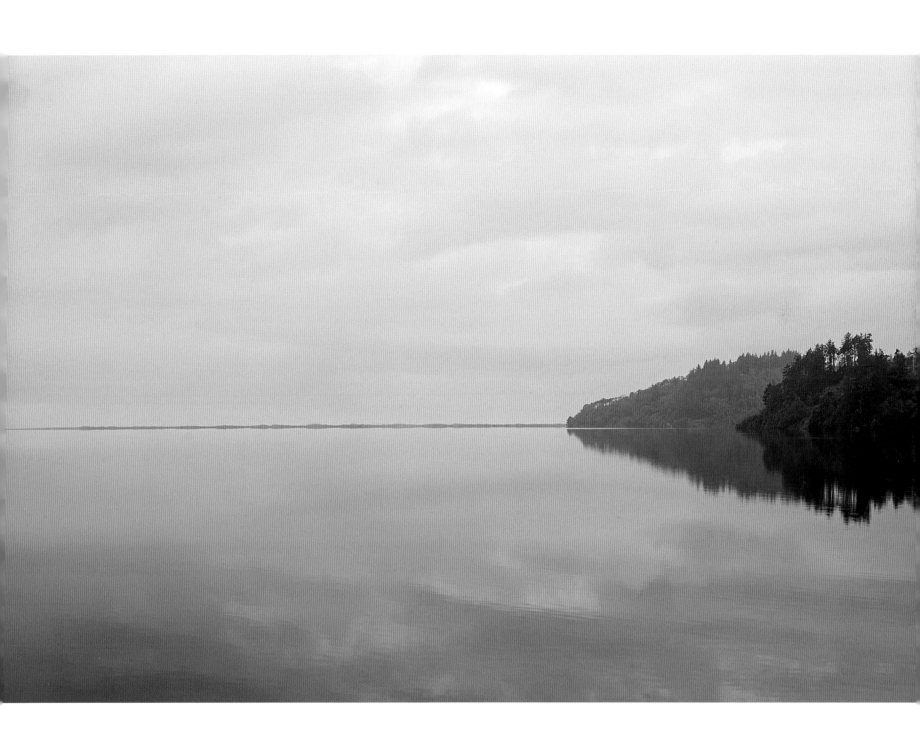

◈ Grazing sheep, Cape Mendocino (left); abandoned barn, Mendocino (right)

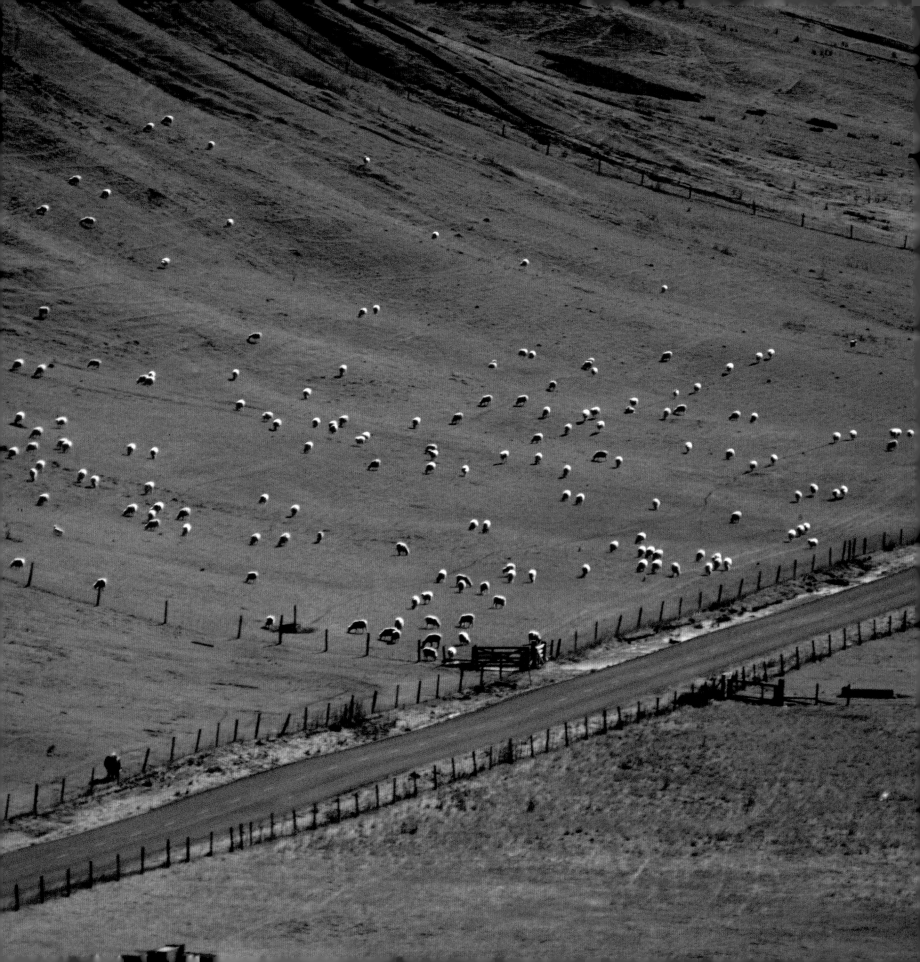

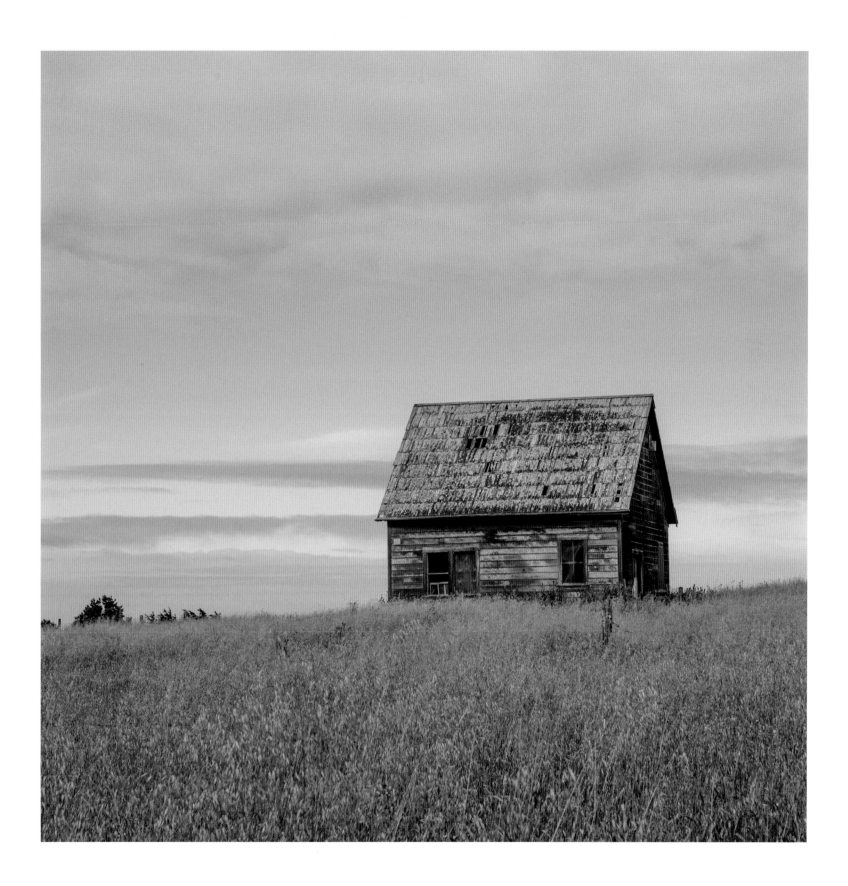

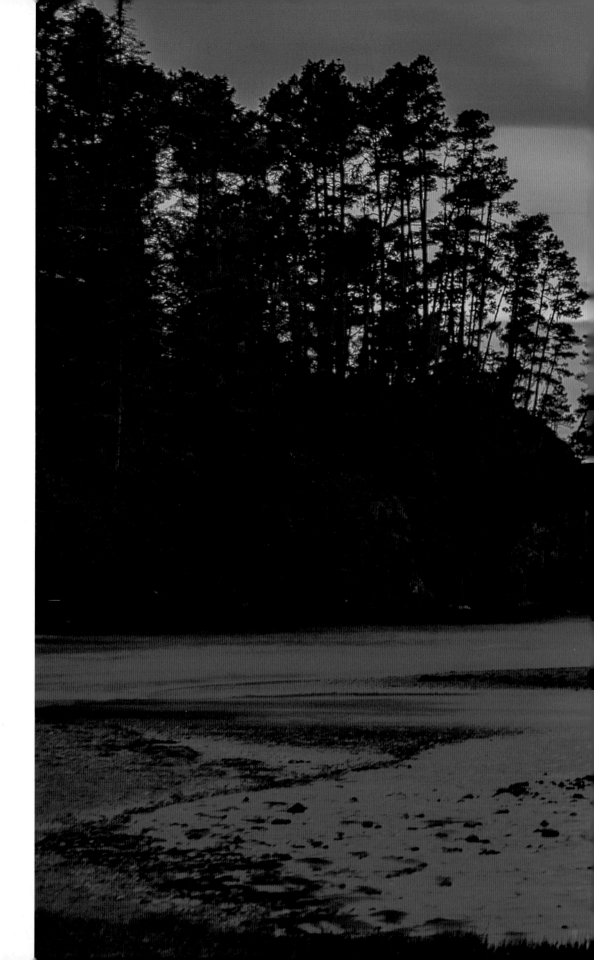

➔ Russian Gulch State Park, Mendocino

⬇ Coastline, Mendocino

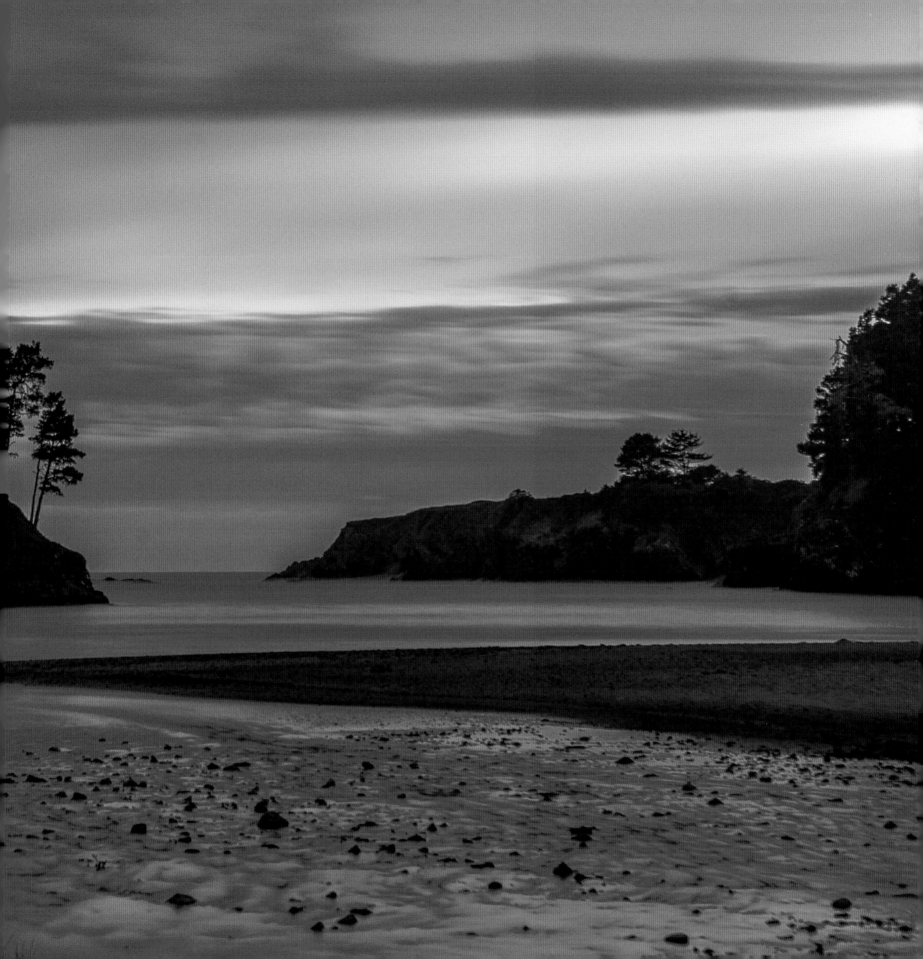

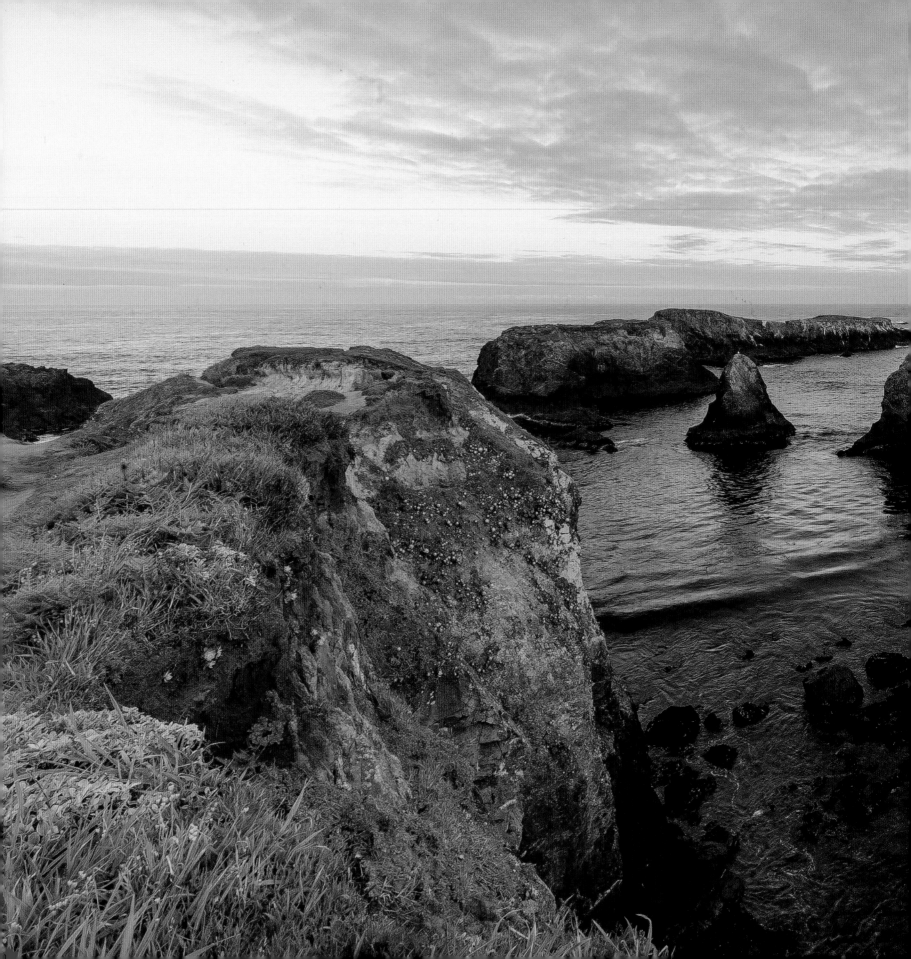

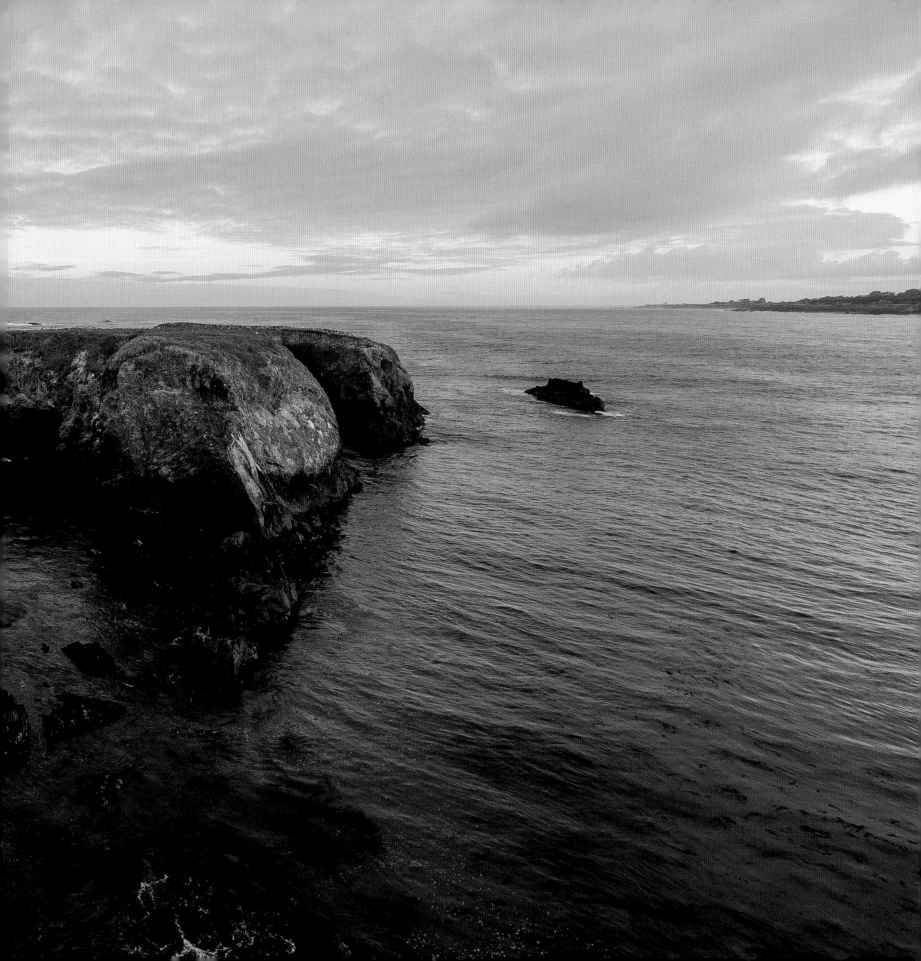

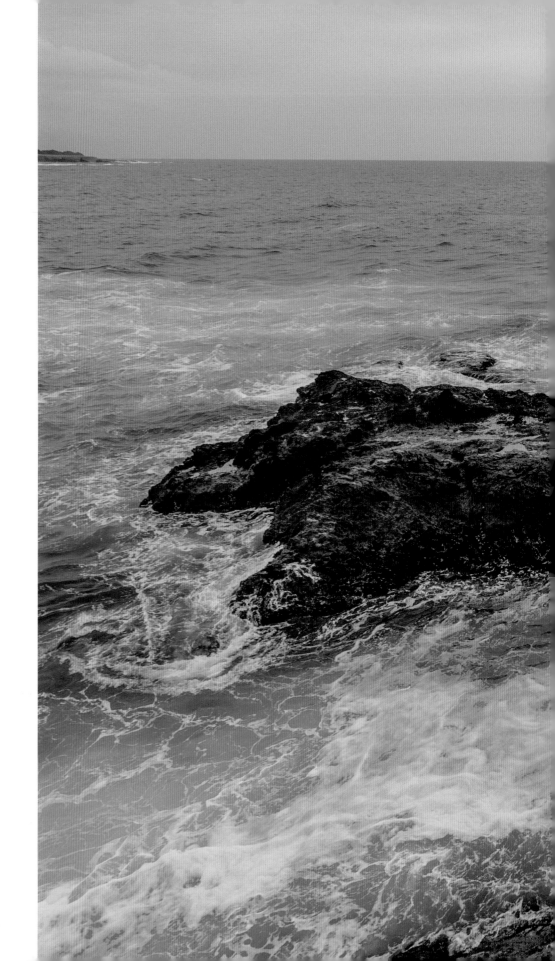

Mendocino Headlands State Park, Mendocino

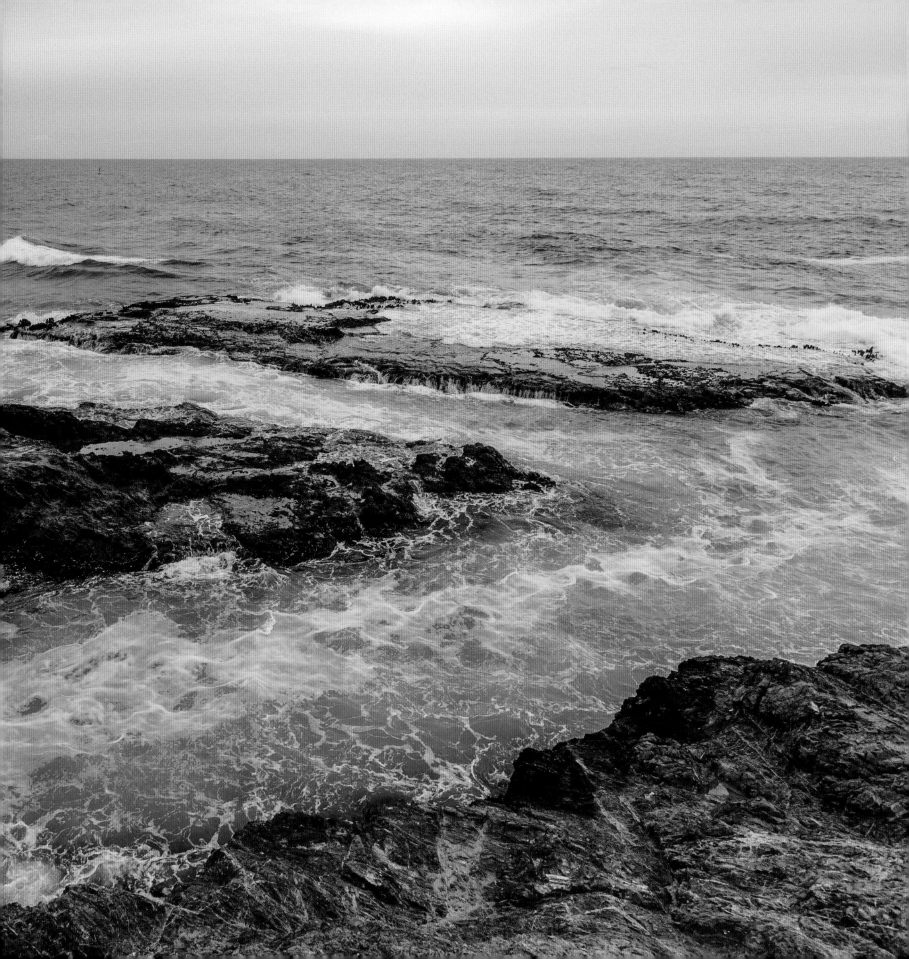

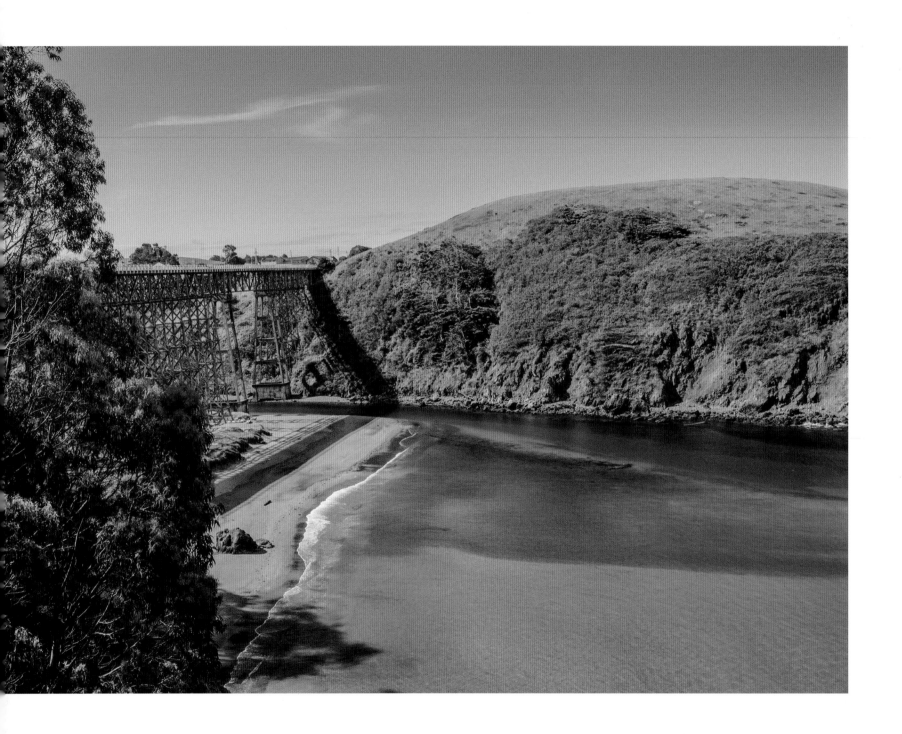

◈ Albion

◈ Mendocino

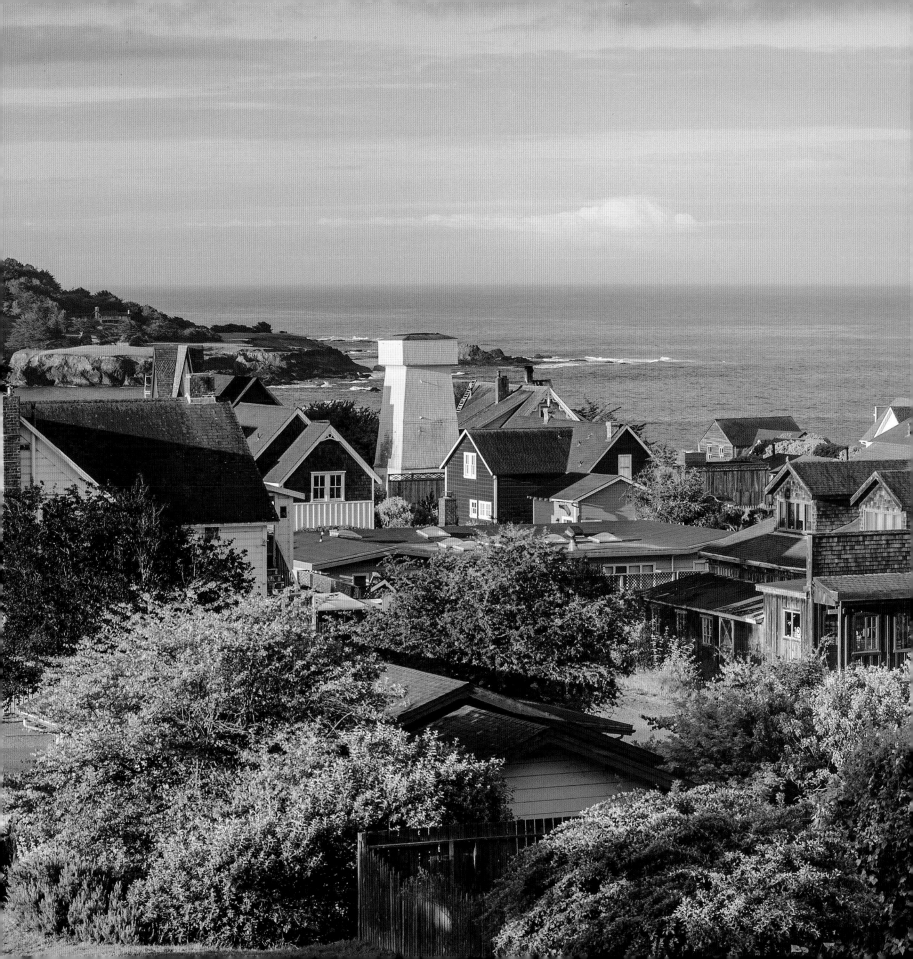

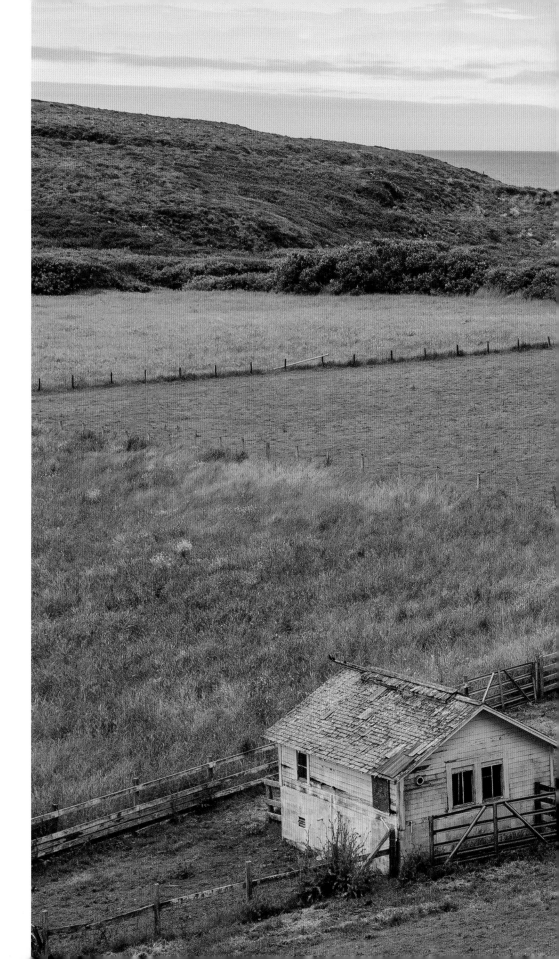

◈ Barn along State Route 1 near Elk

◈ Point Arena

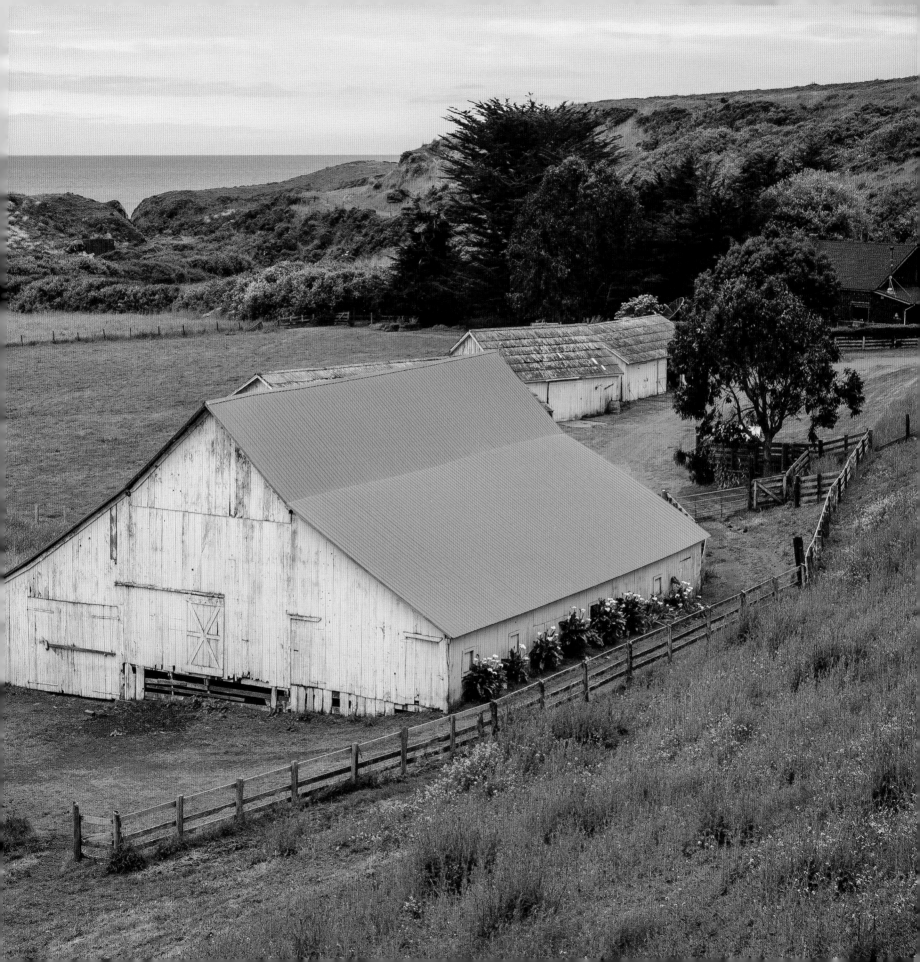

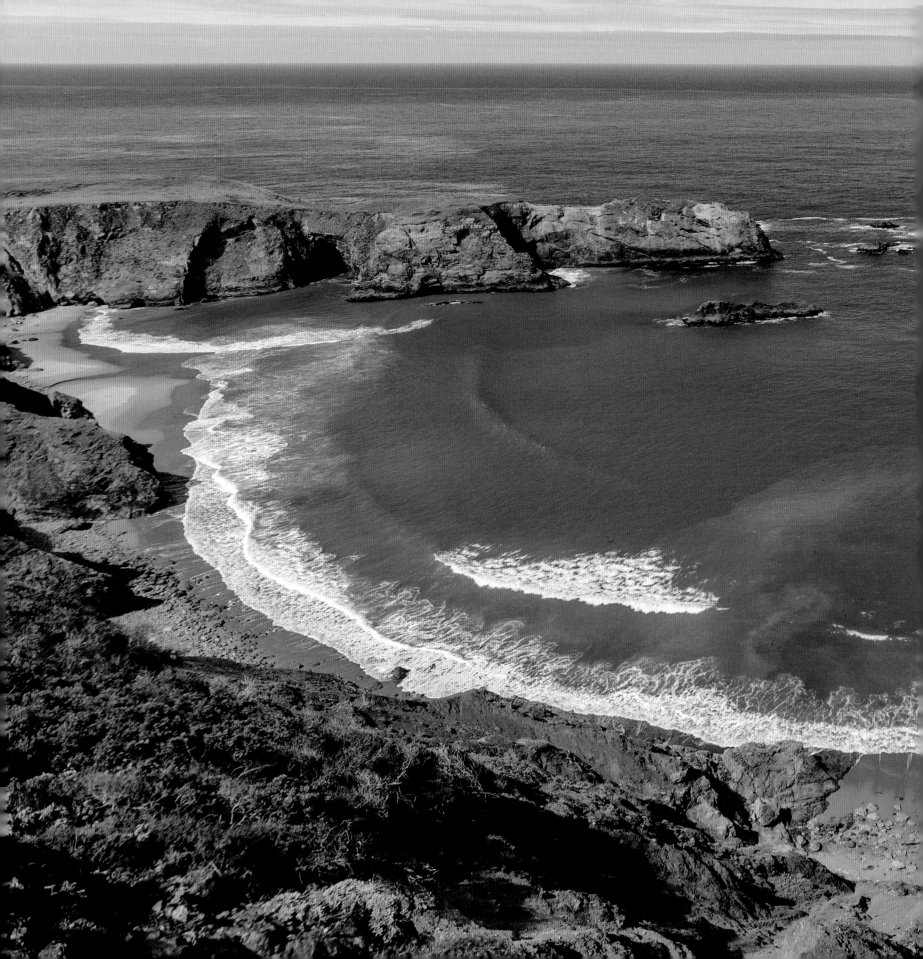

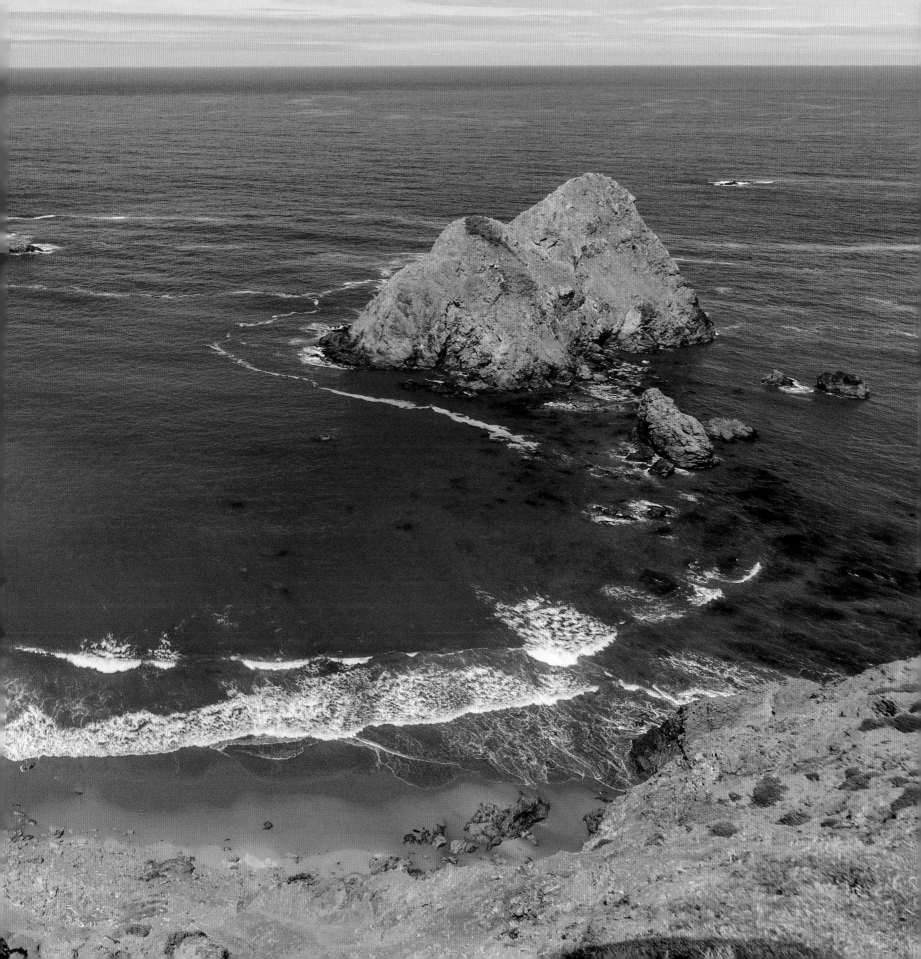

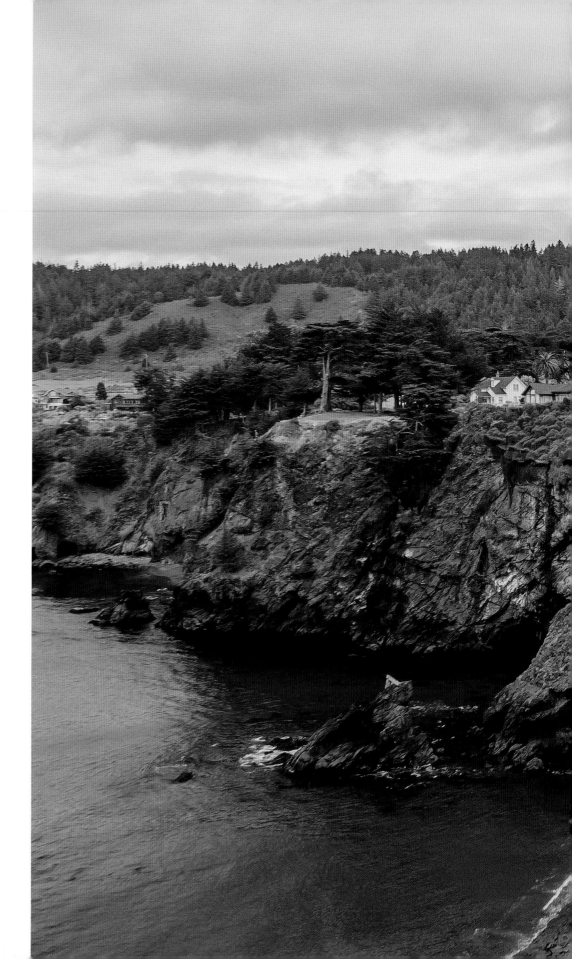

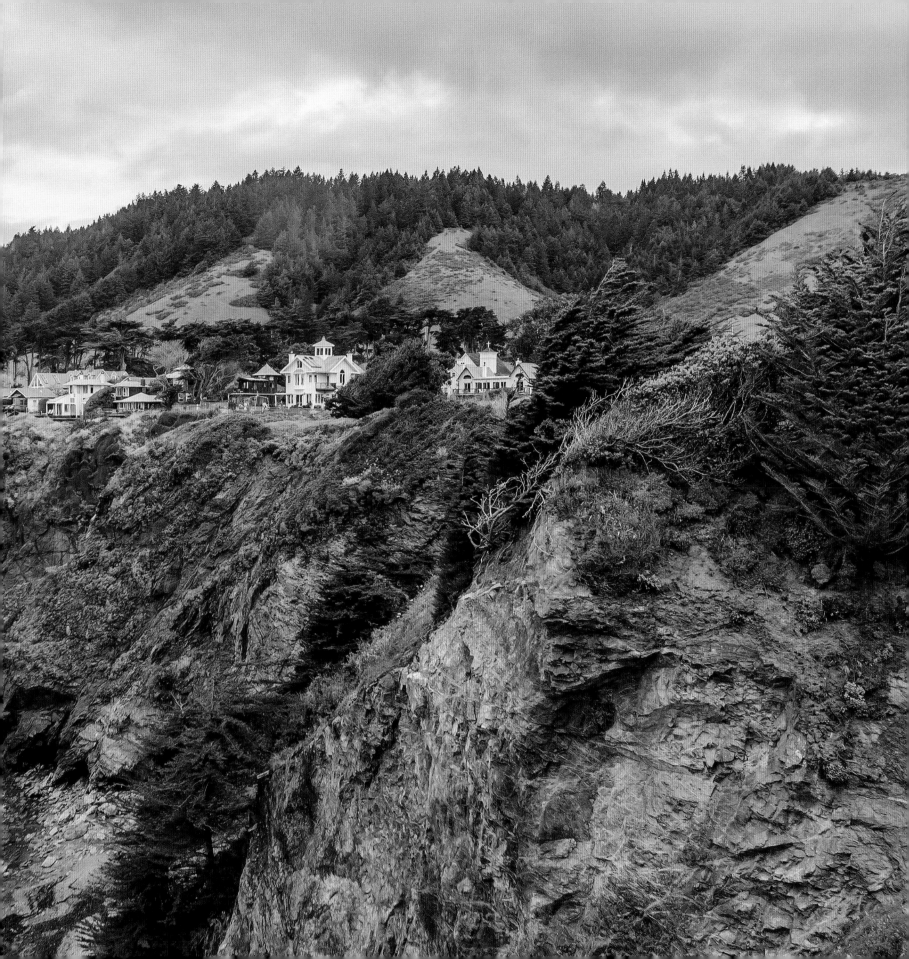

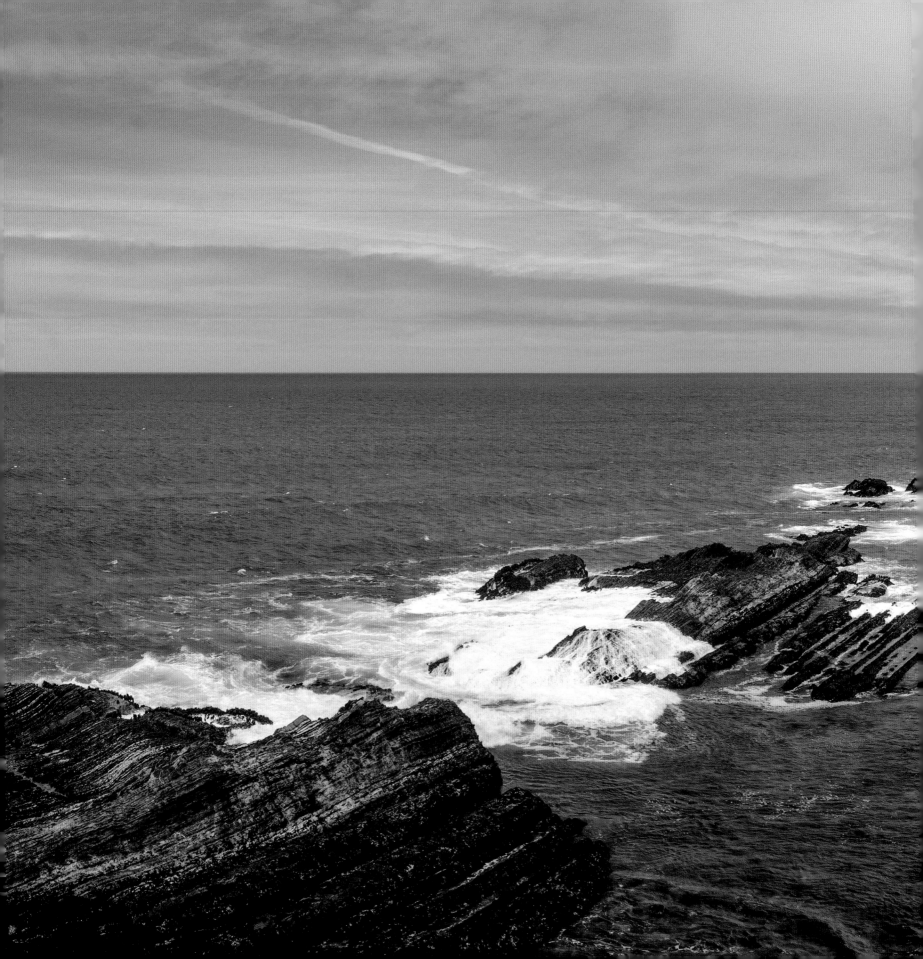

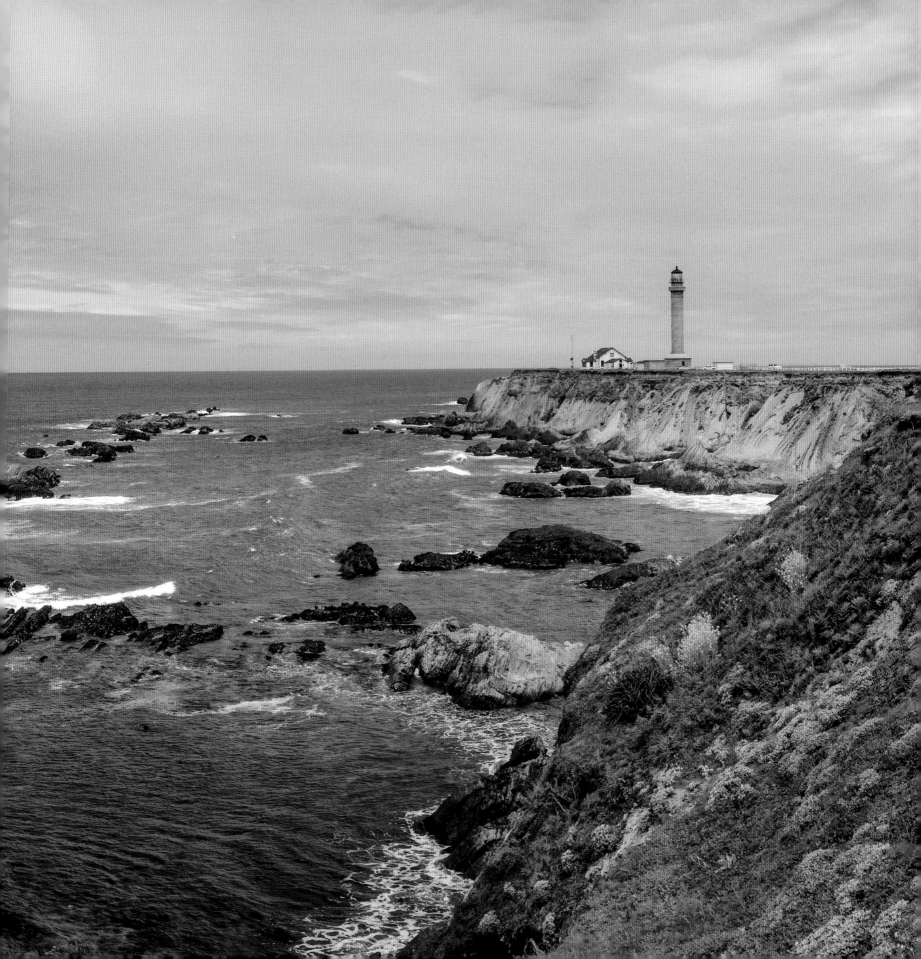

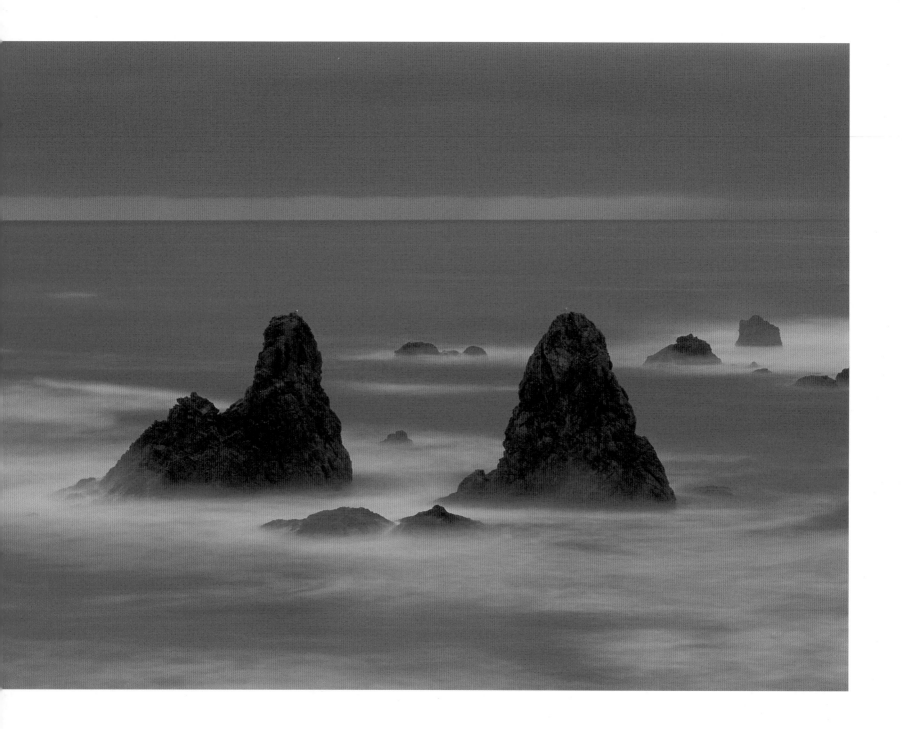

⬦ Coastline, Sea Ranch ⬦ Fort Ross State Historic Park, Jenner ⬦ Fort Ross Vineyard, Jenner

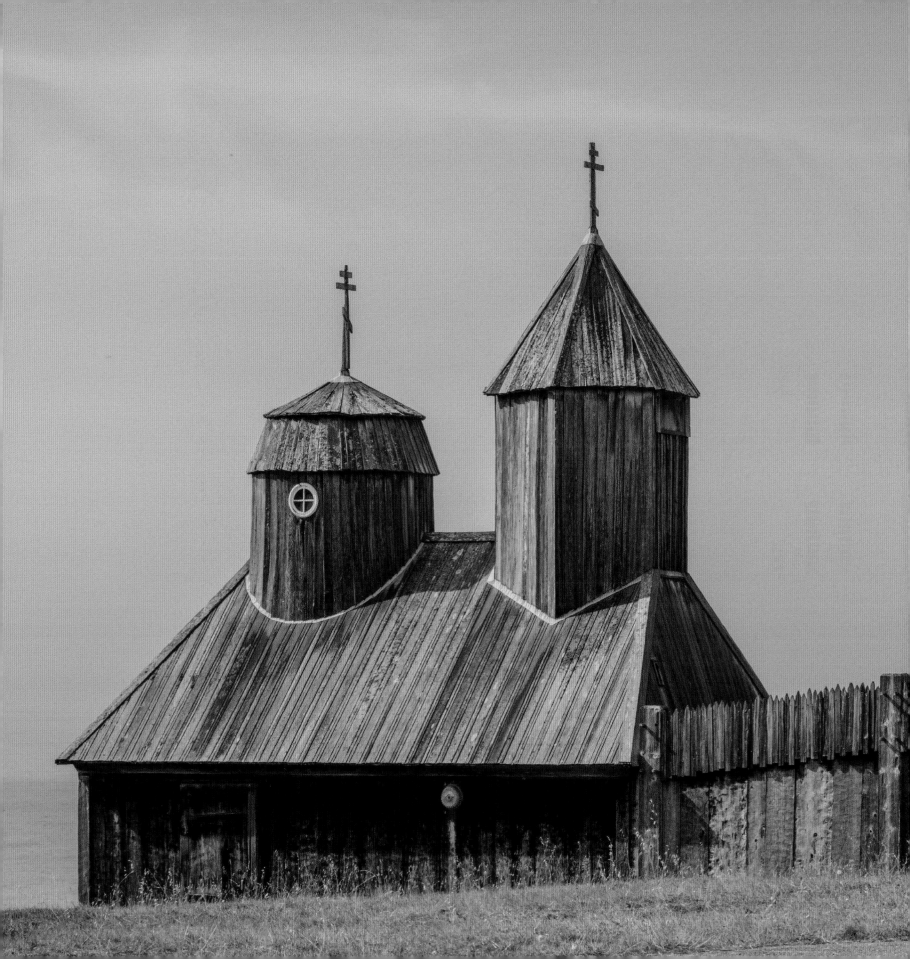

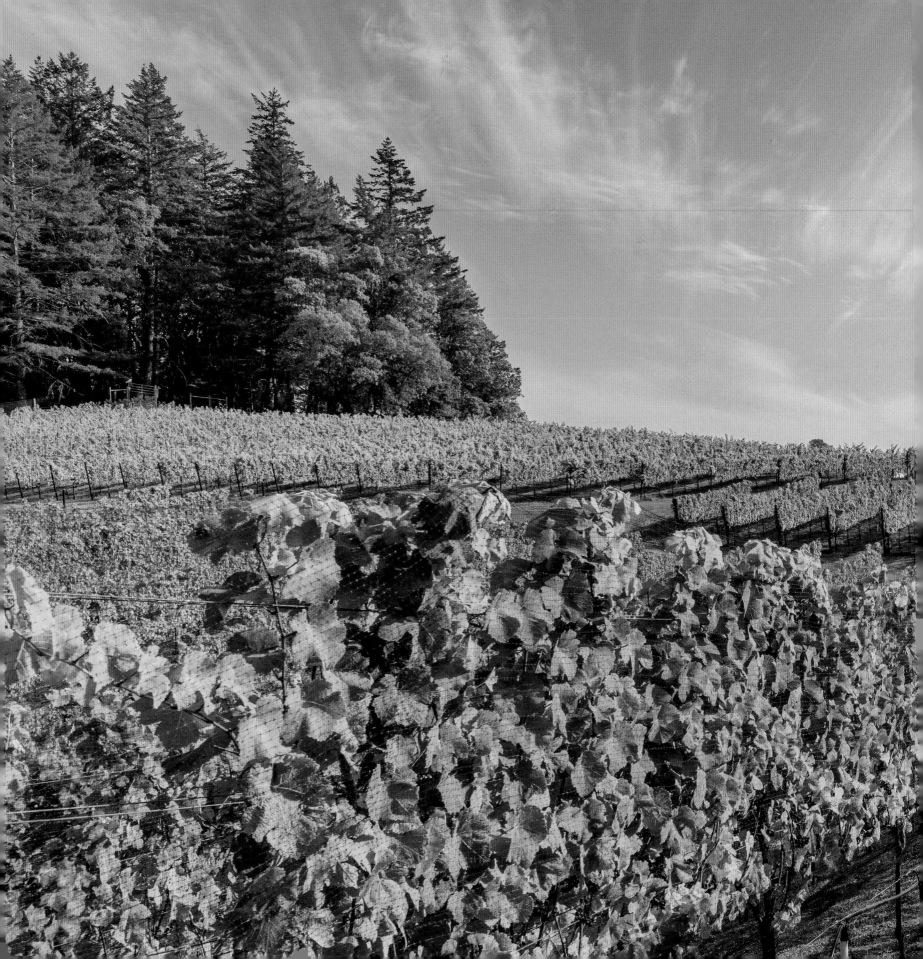

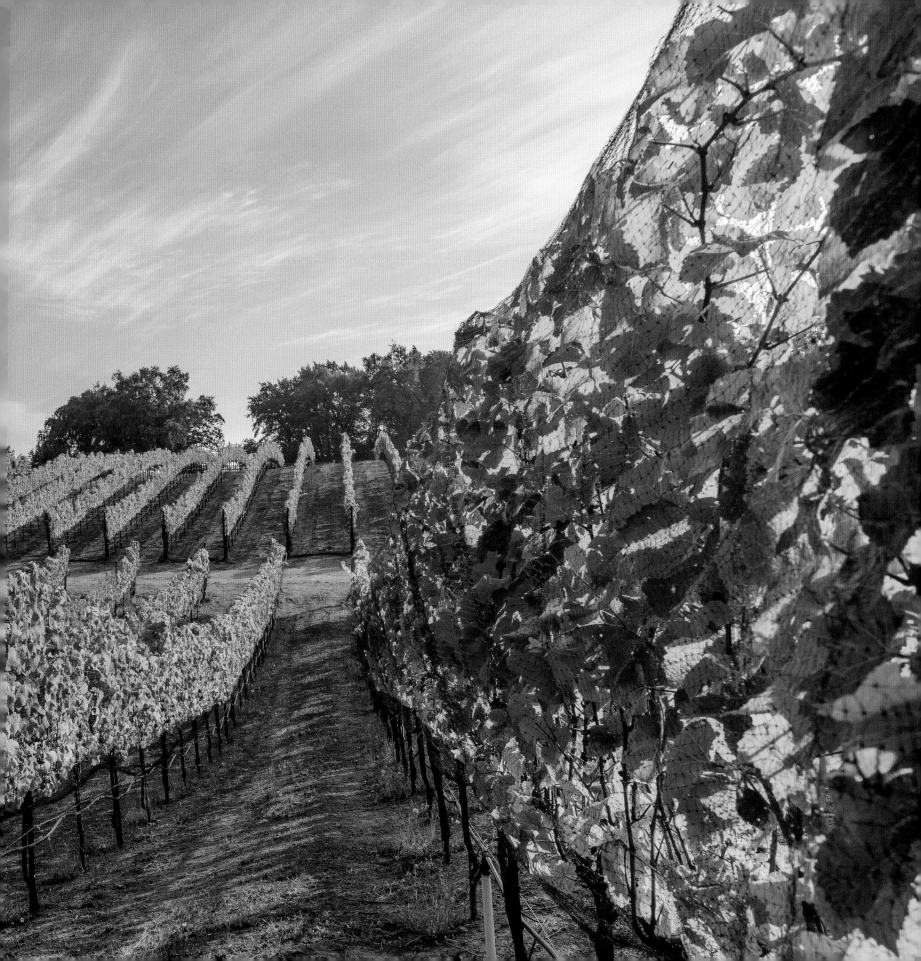

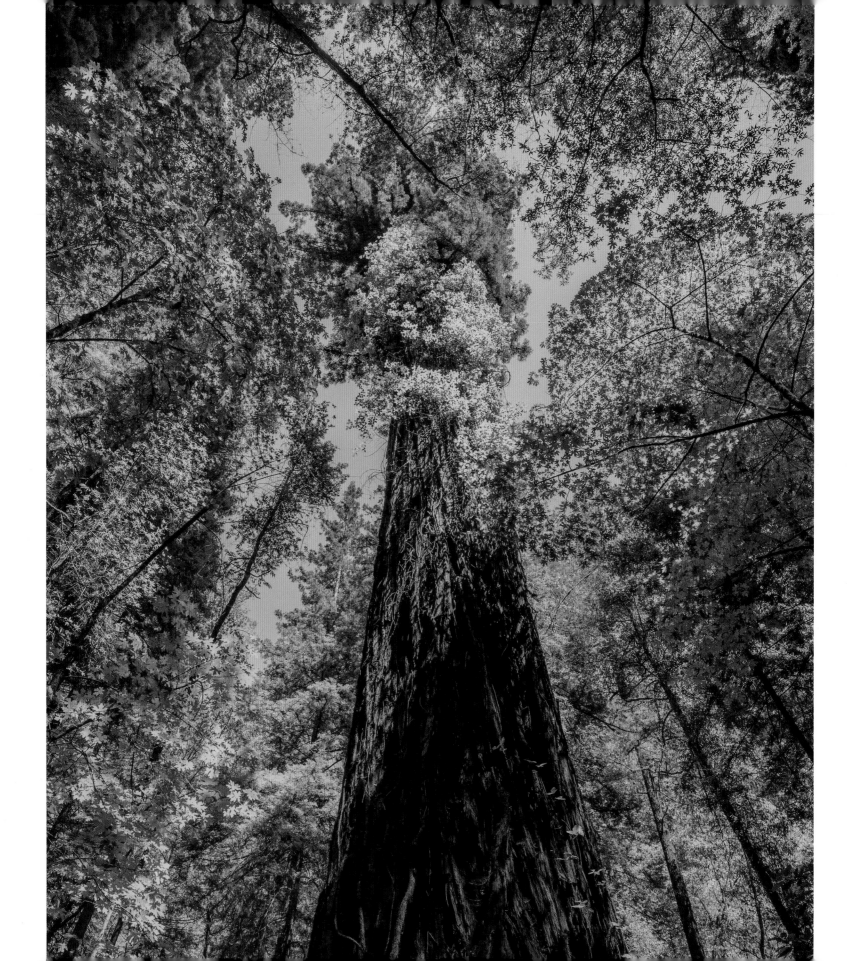

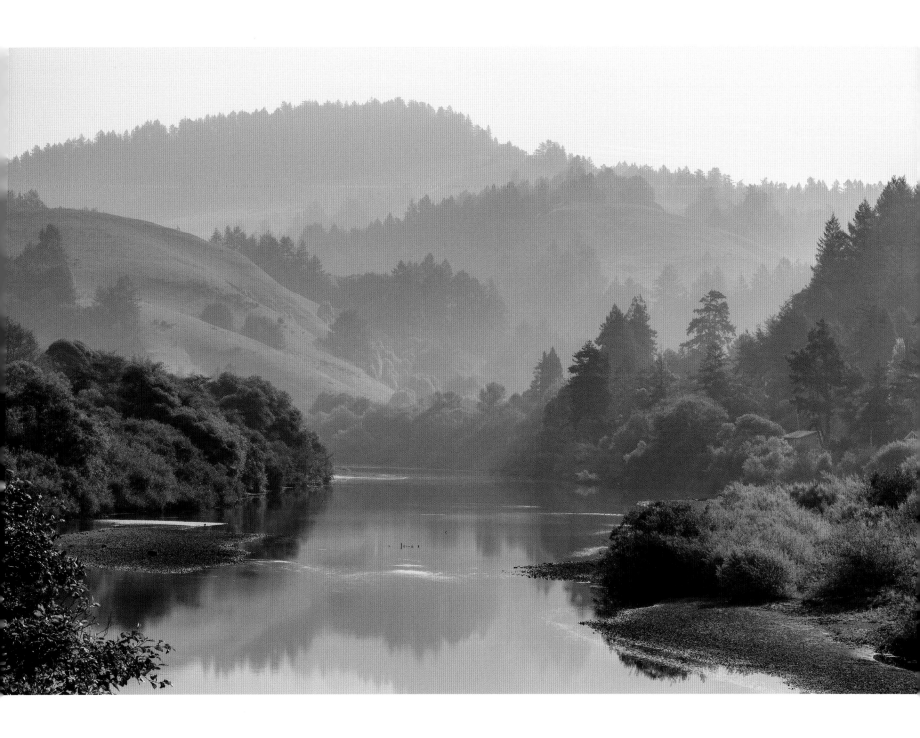

◆ Armstrong Redwoods State Natural Reserve, Sonoma County ◆ Russian River, Jenner ◆ Country road, Jenner

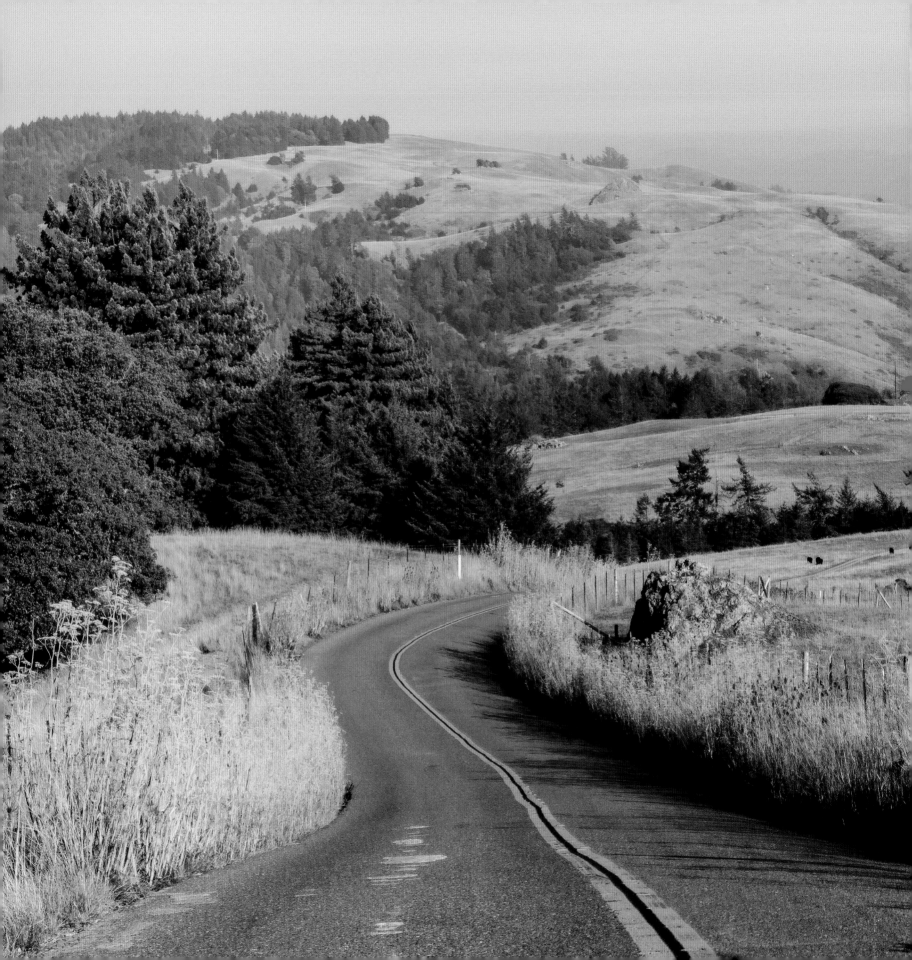

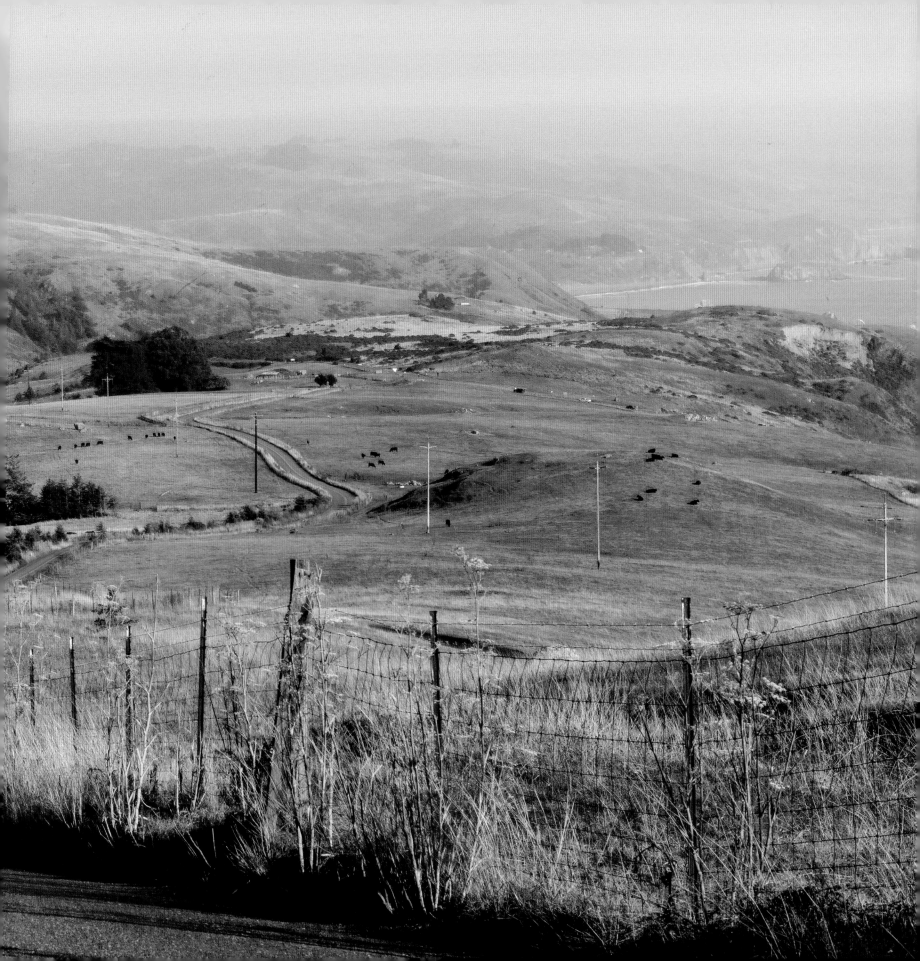

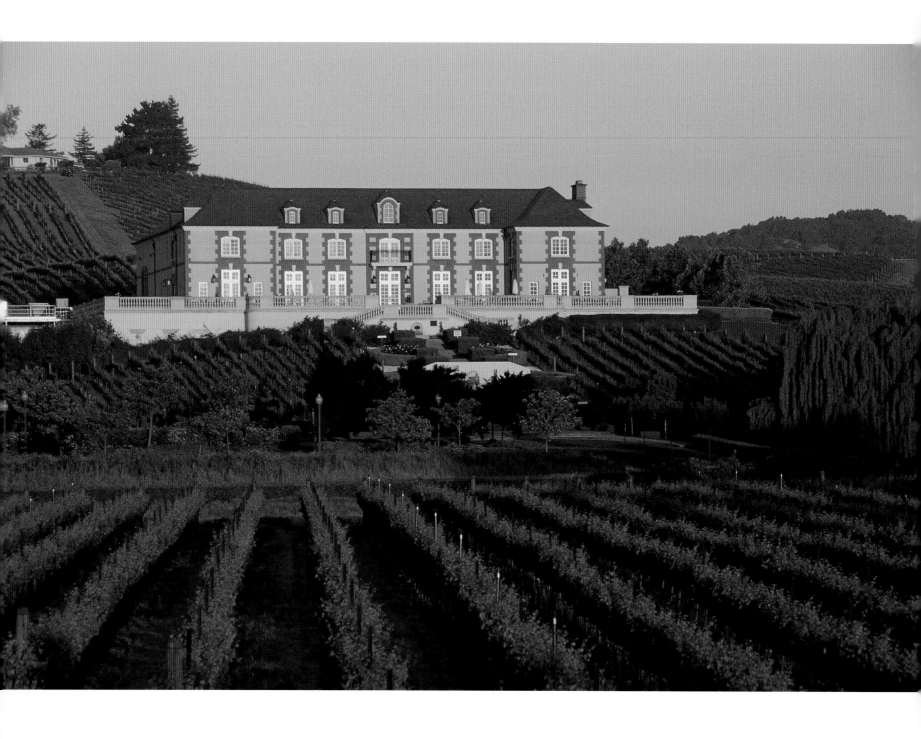

⬧⬆ ⬧⬇ Winery and vineyards, Napa

⬧➡ Jack London State Historic Park, Glen Ellen

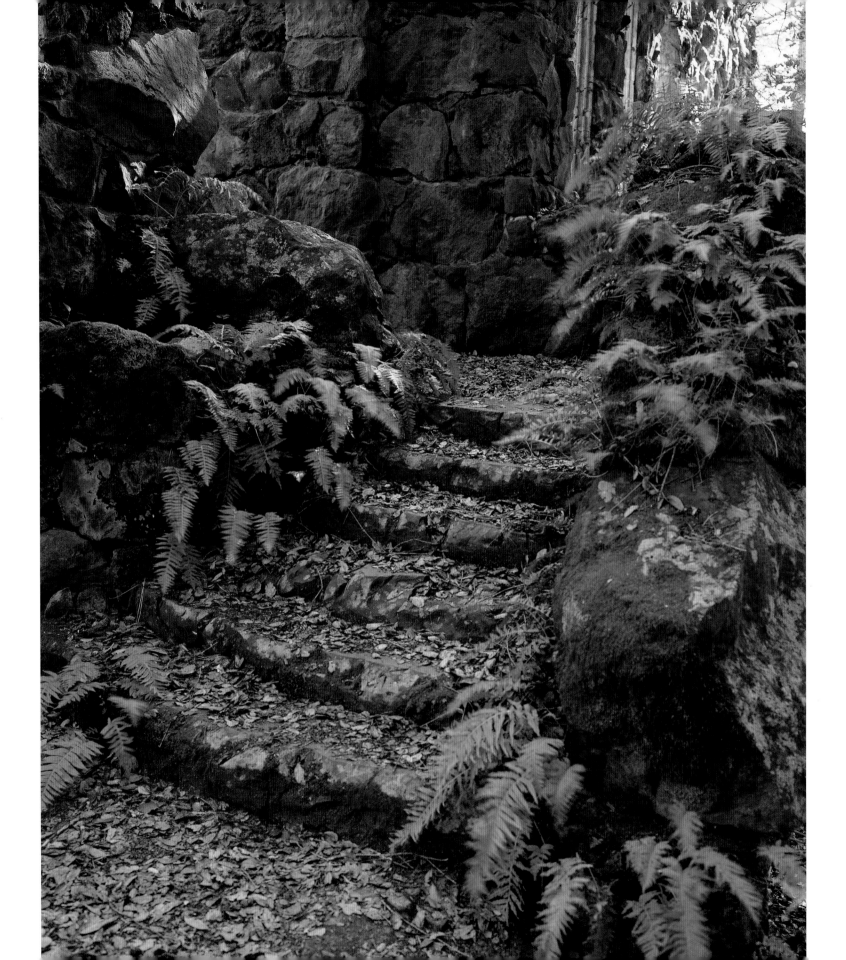

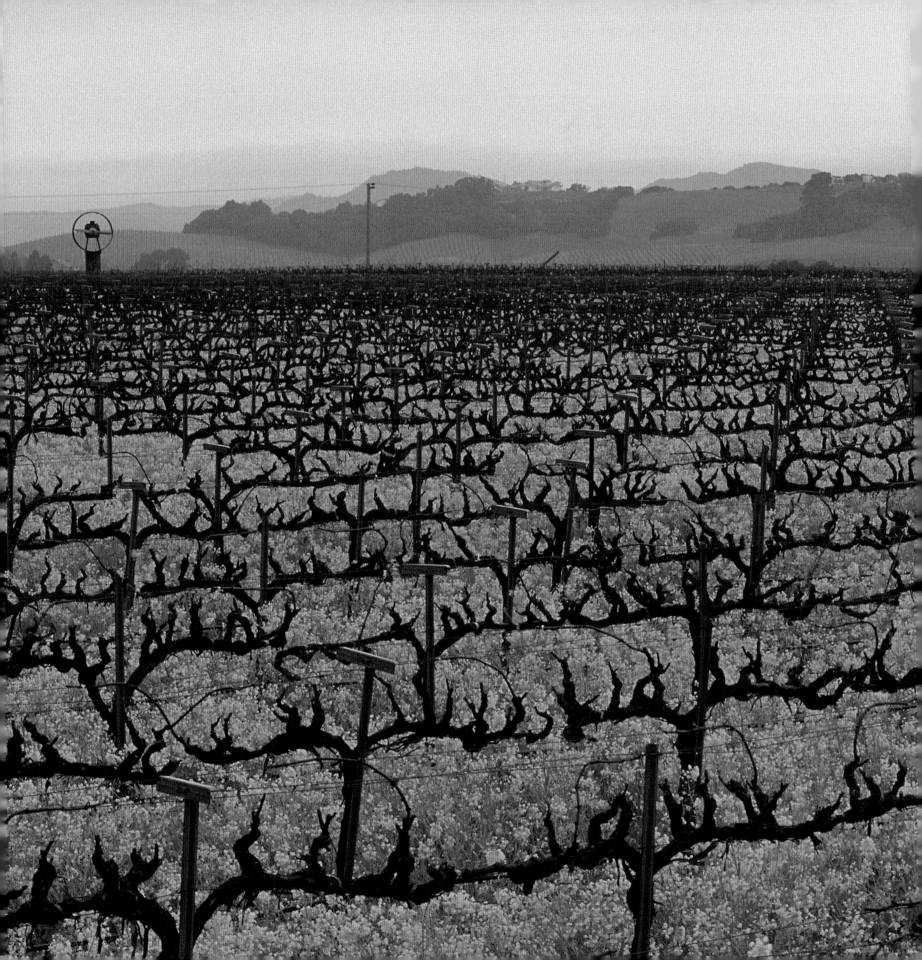

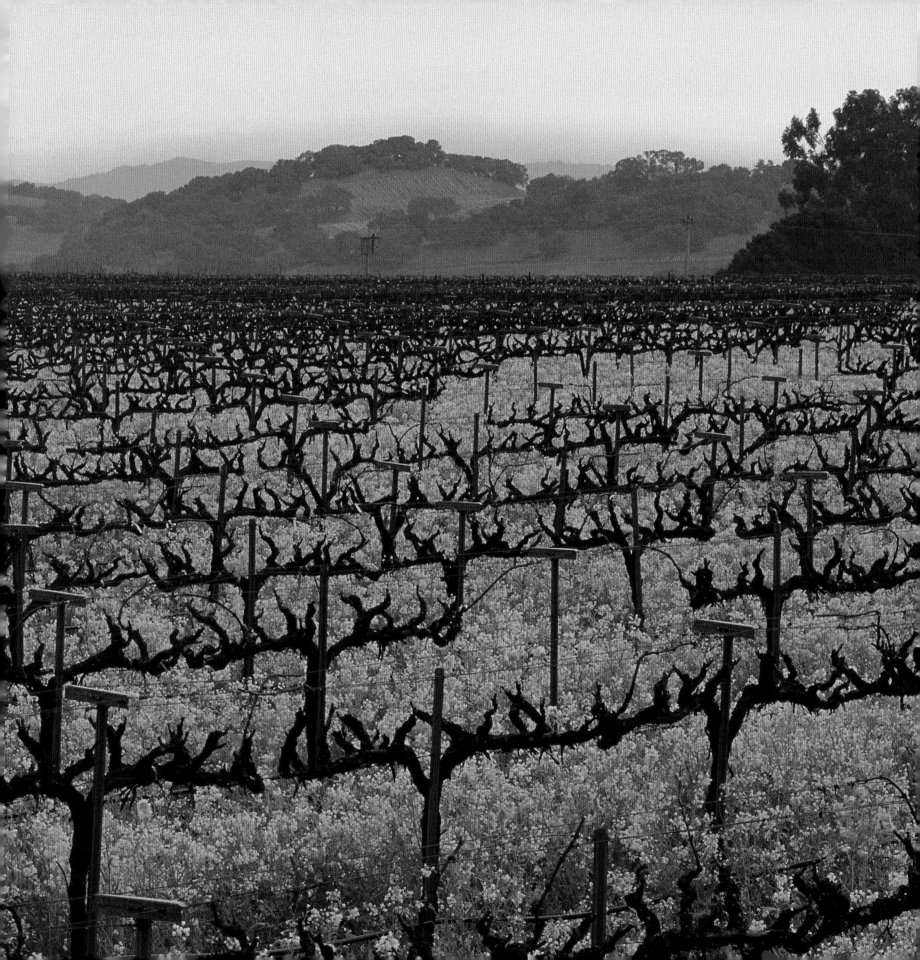

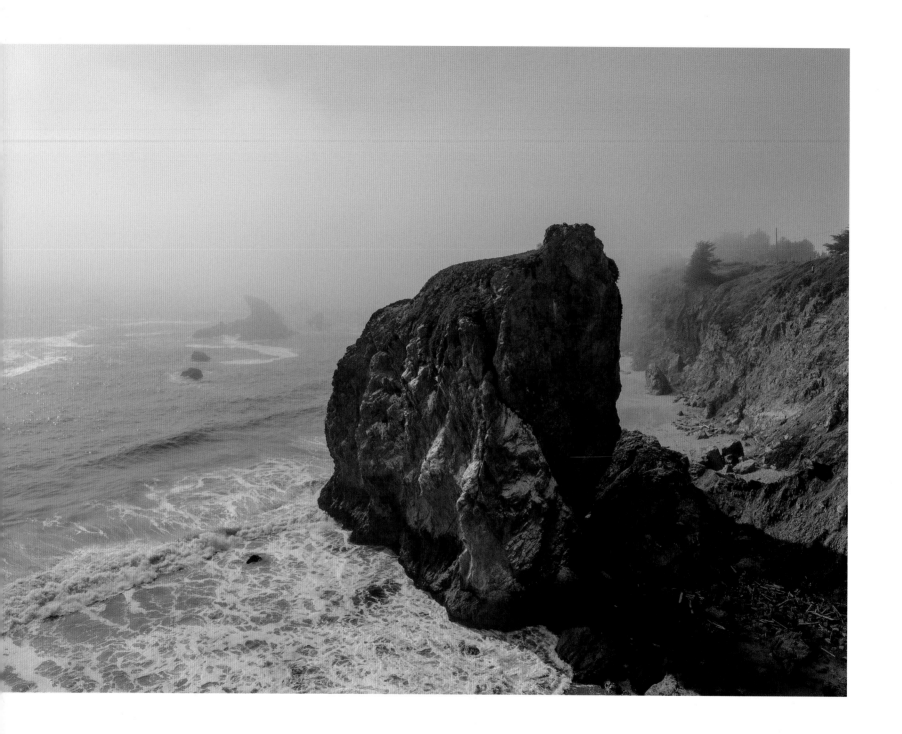

◈ Sonoma Coast State Park, Jenner

◈➔ ◈⬇ Goat Rock Beach, Sonoma Coast State Park, Jenner

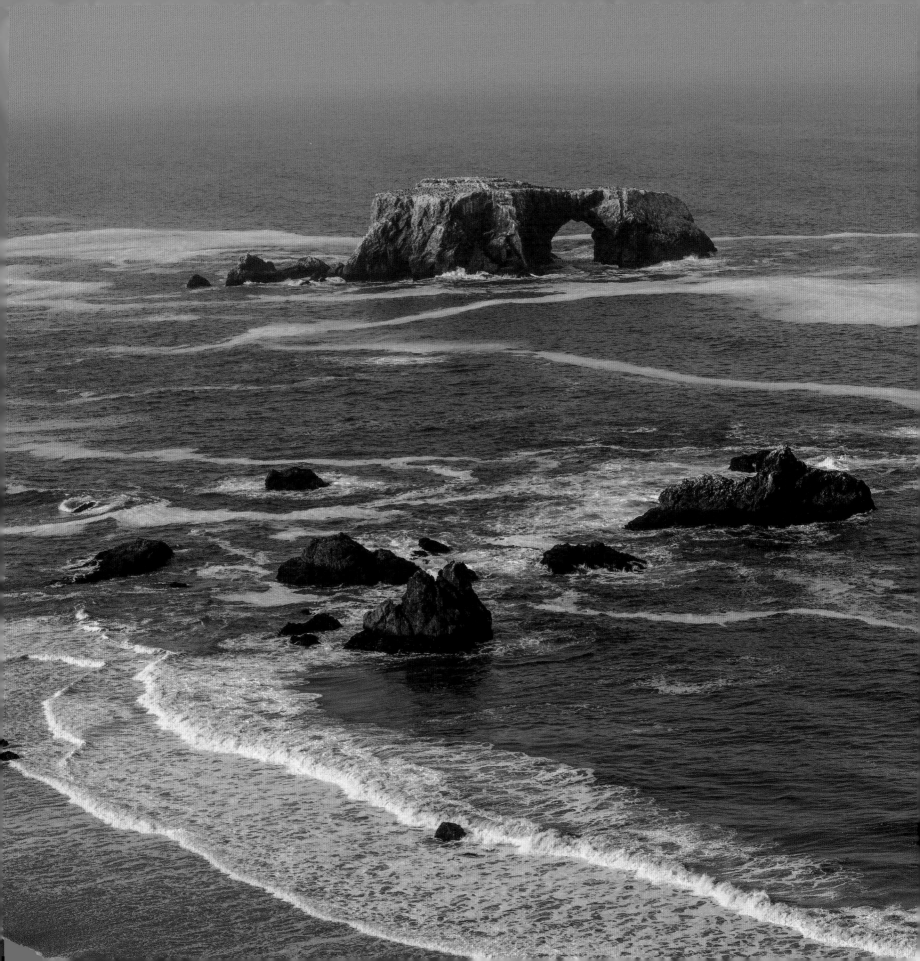

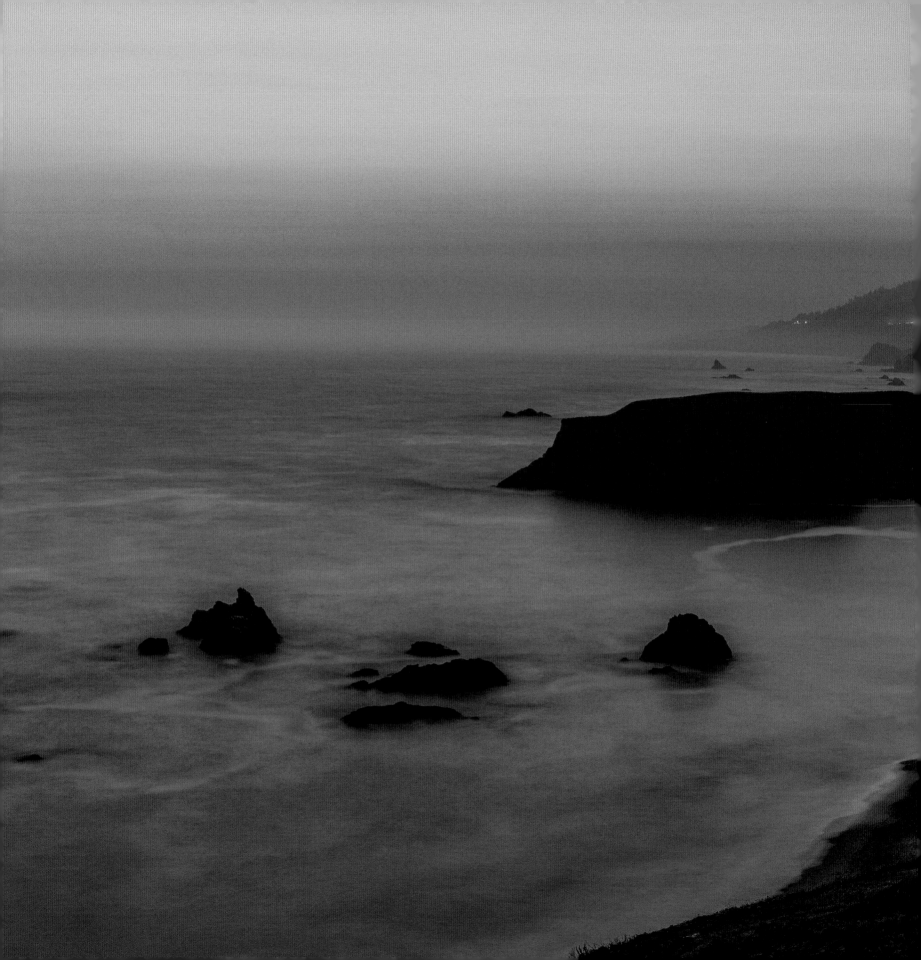

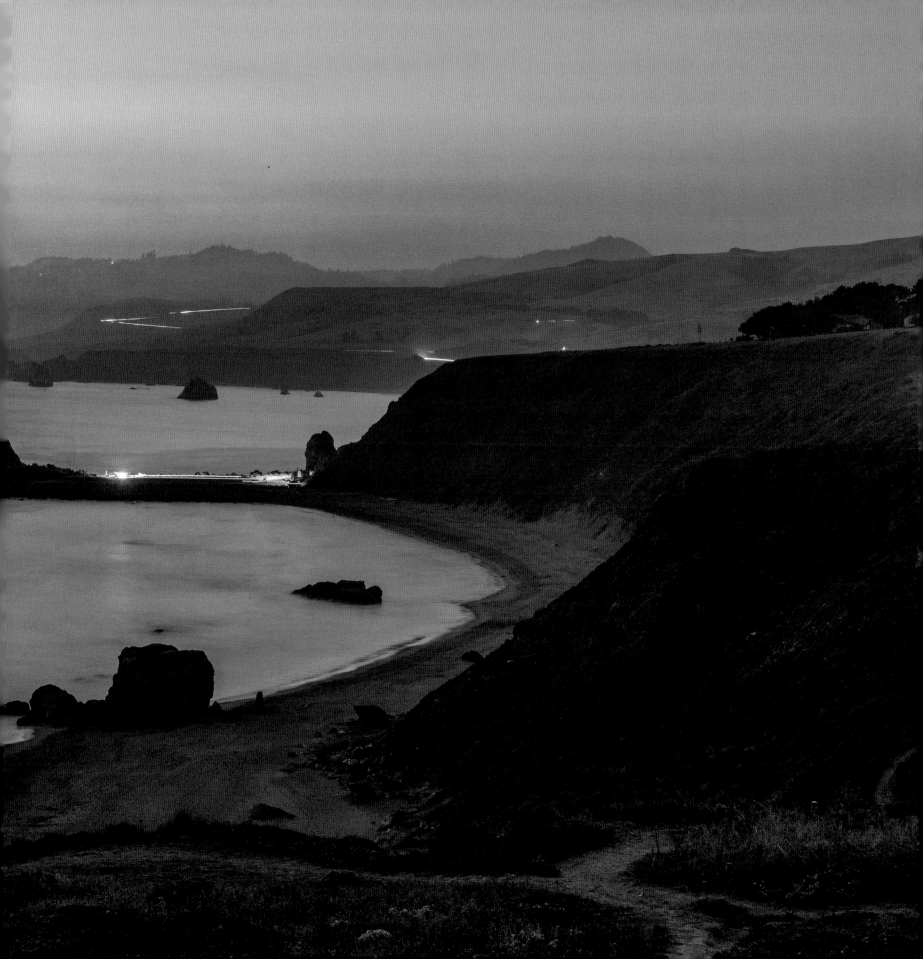

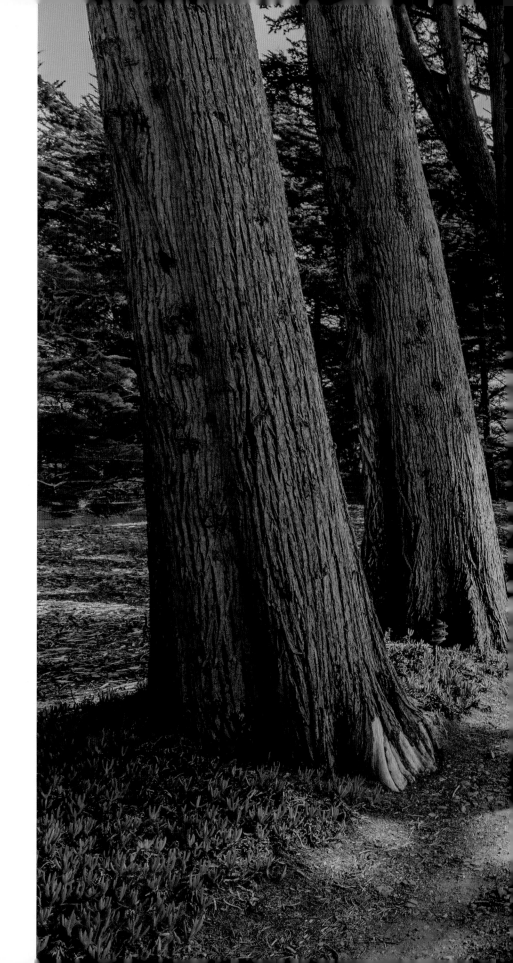

Audubon Canyon Ranch, Tomales Bay

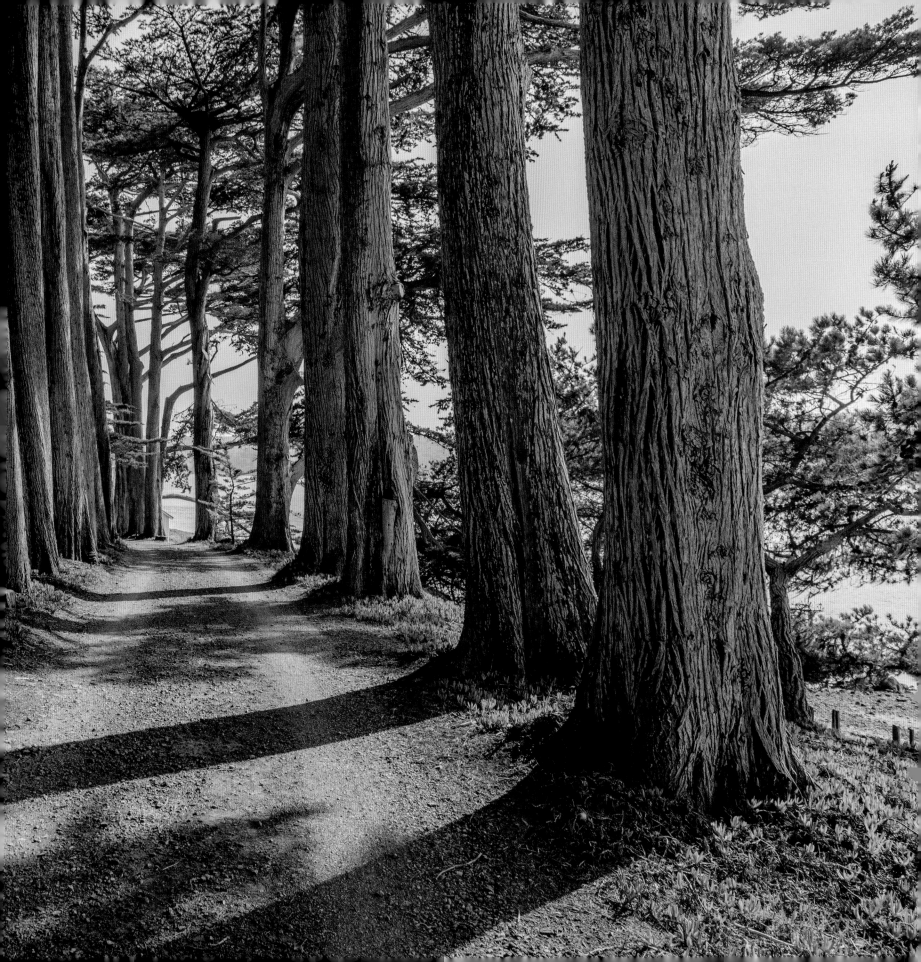

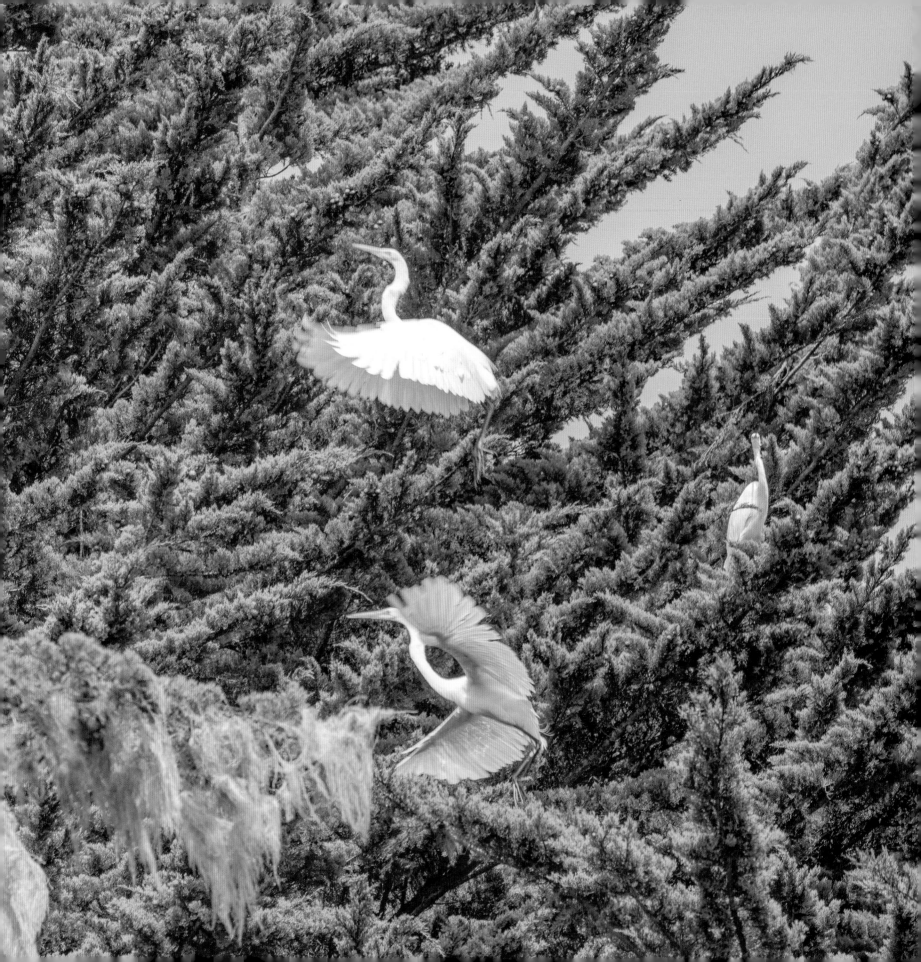

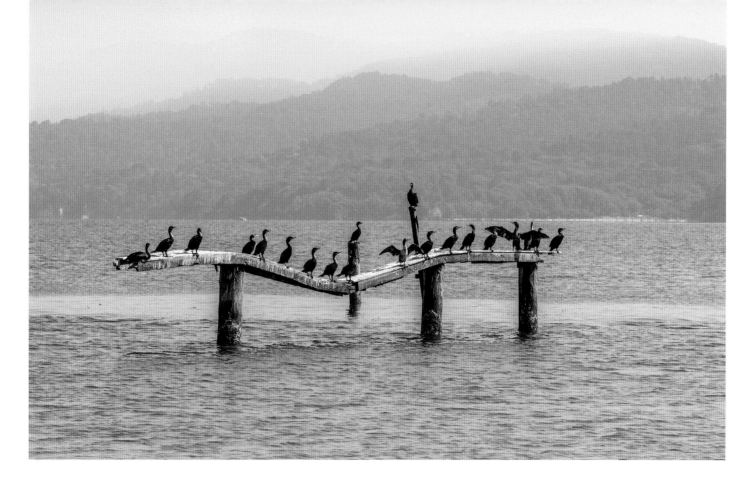

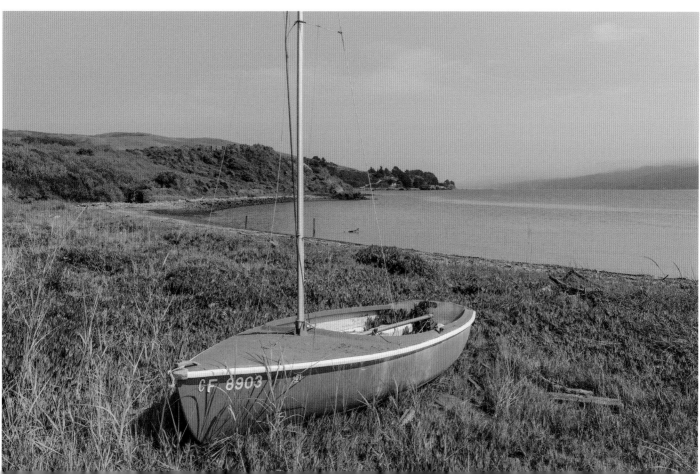

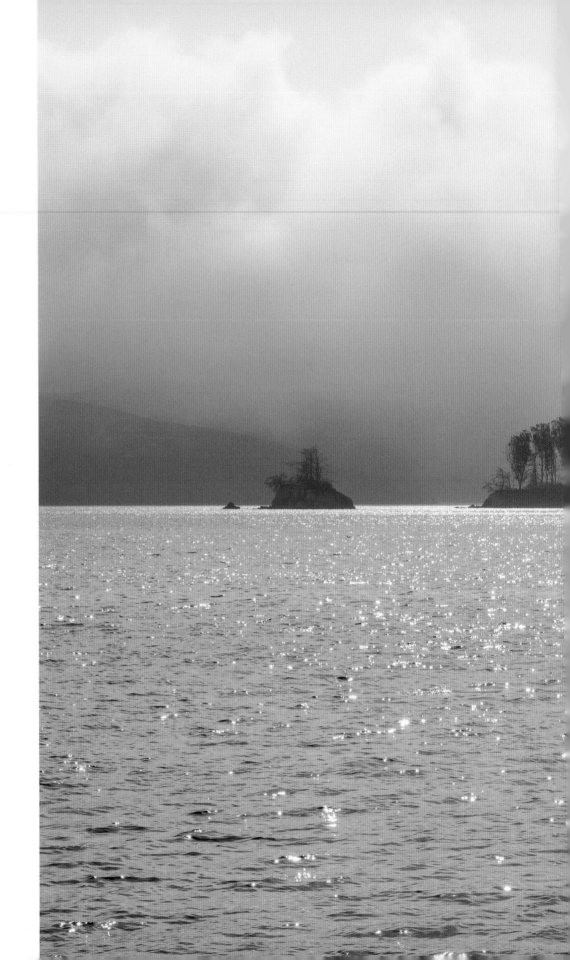

◈ Nick's Cove, Tomales Bay

◈ Point Reyes National Seashore, Marin County

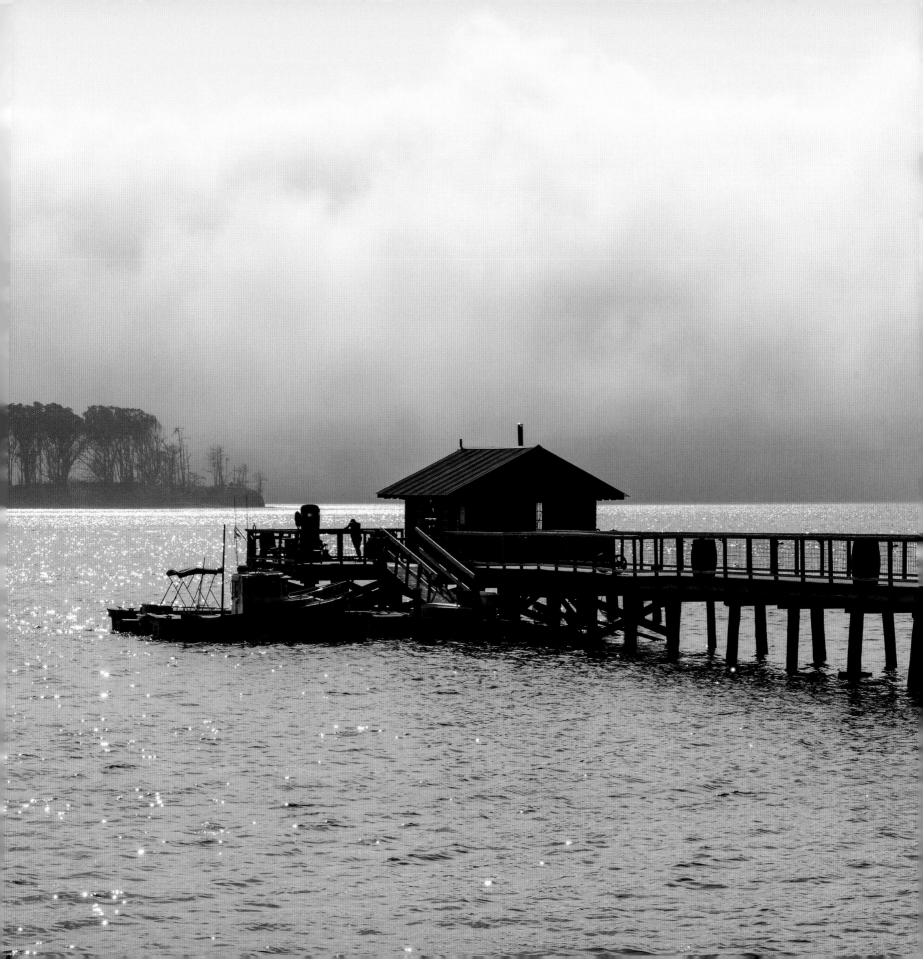

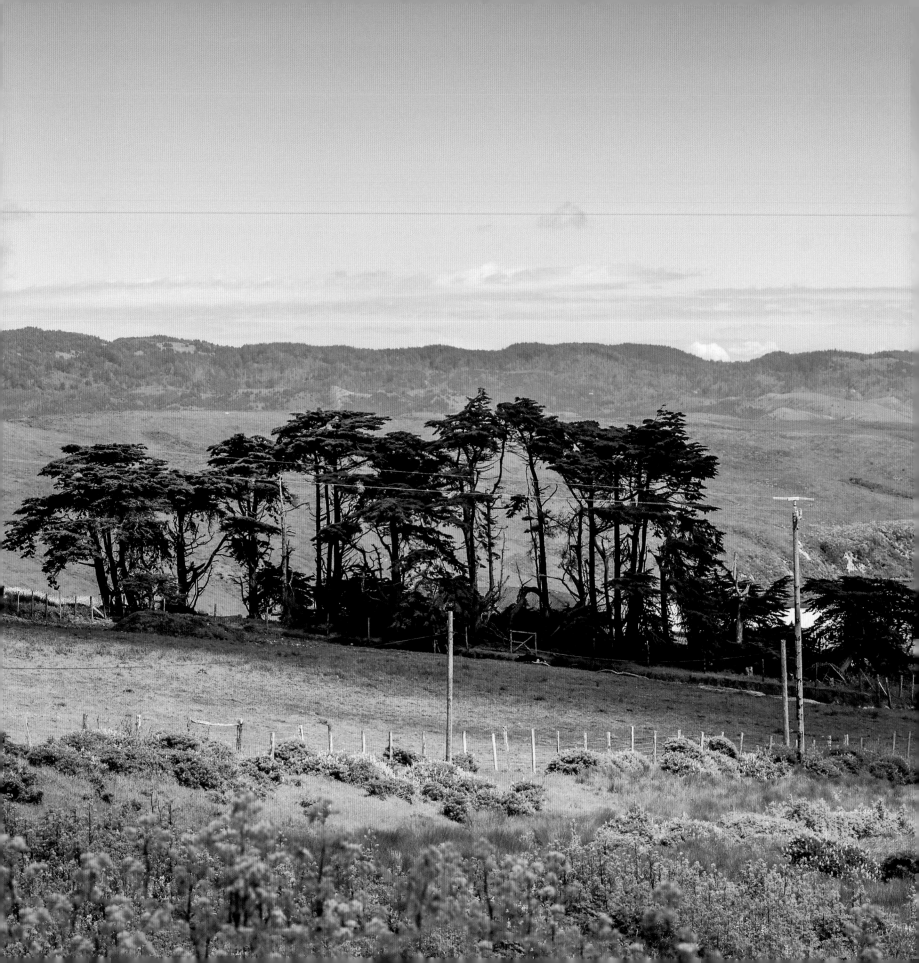

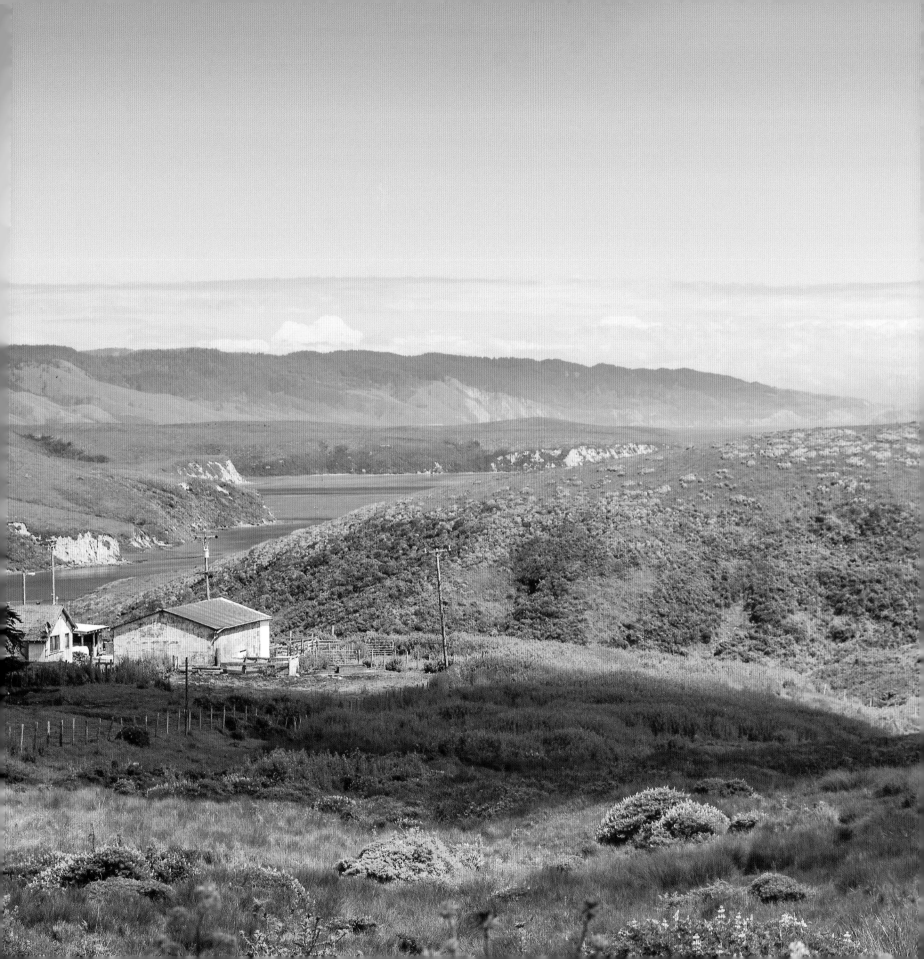

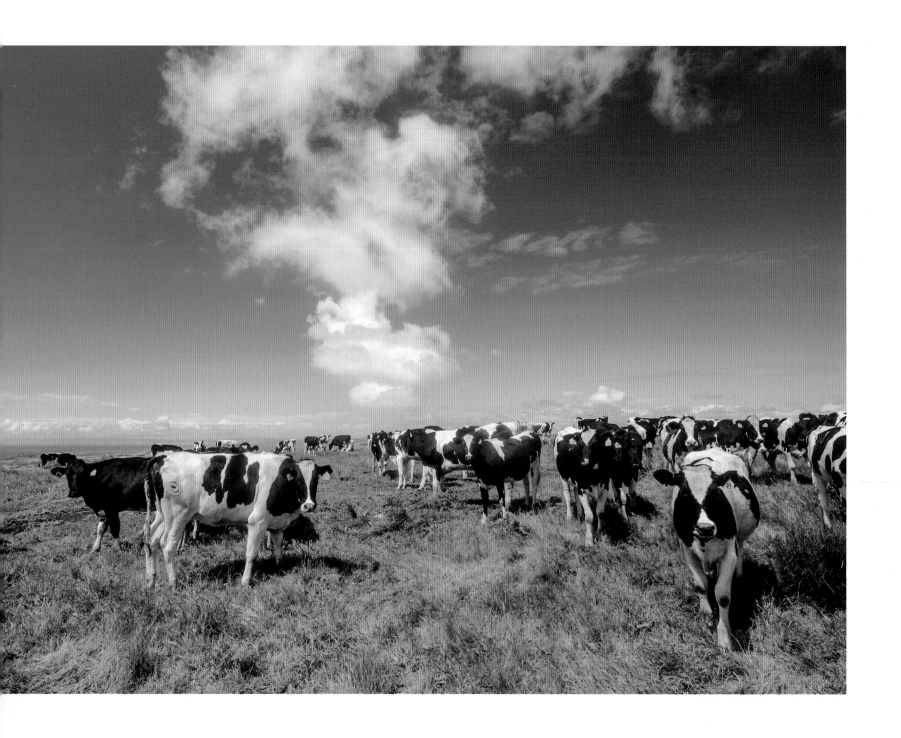

◈◈ ◈ Point Reyes National Seashore, Marin County

◈ Mount Tamalpais State Park, Mill Valley

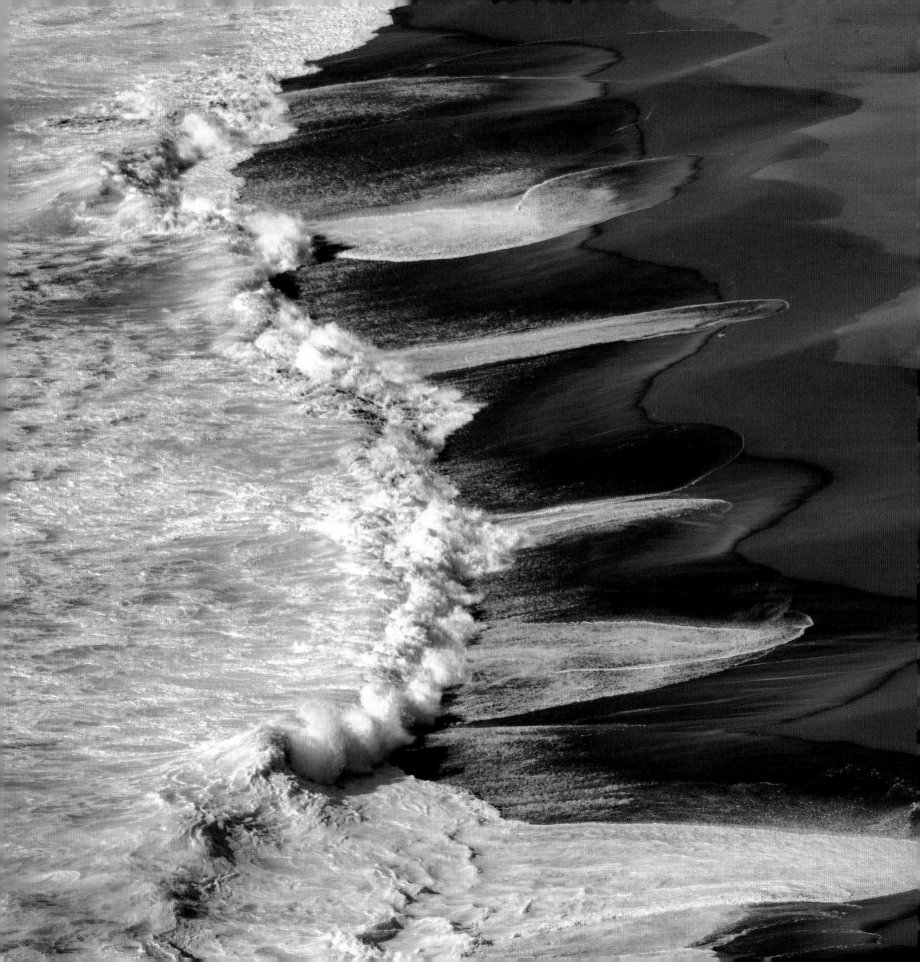

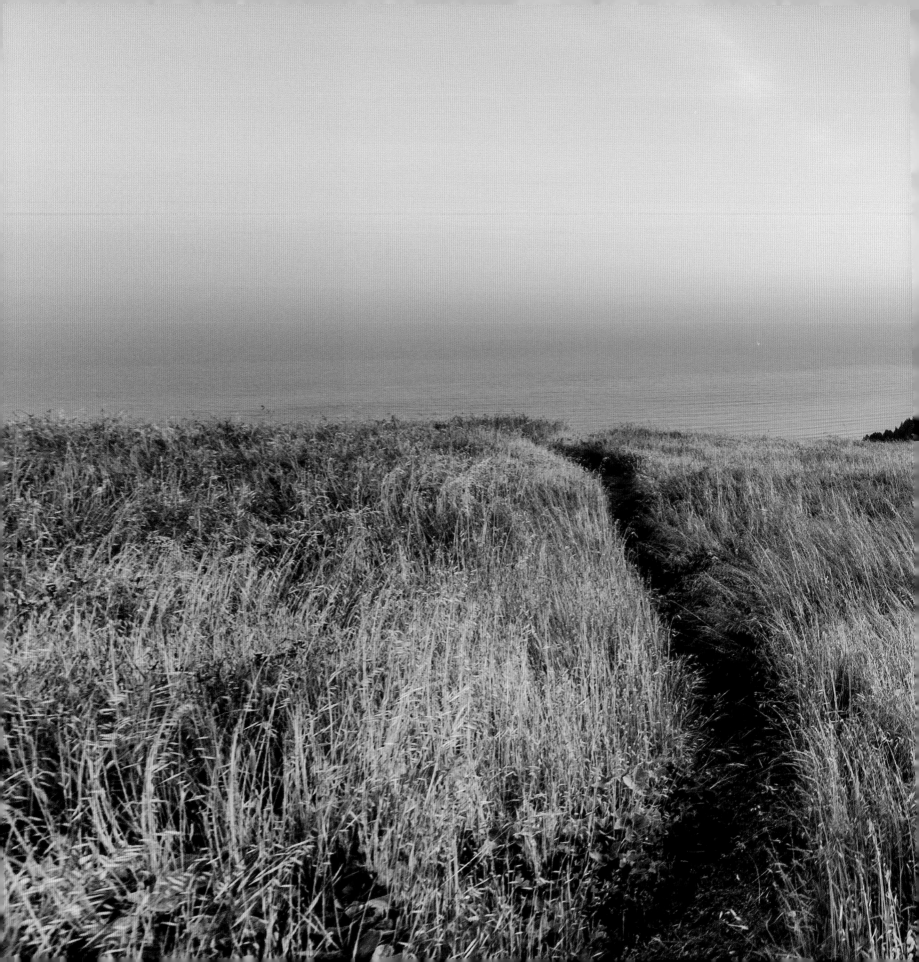

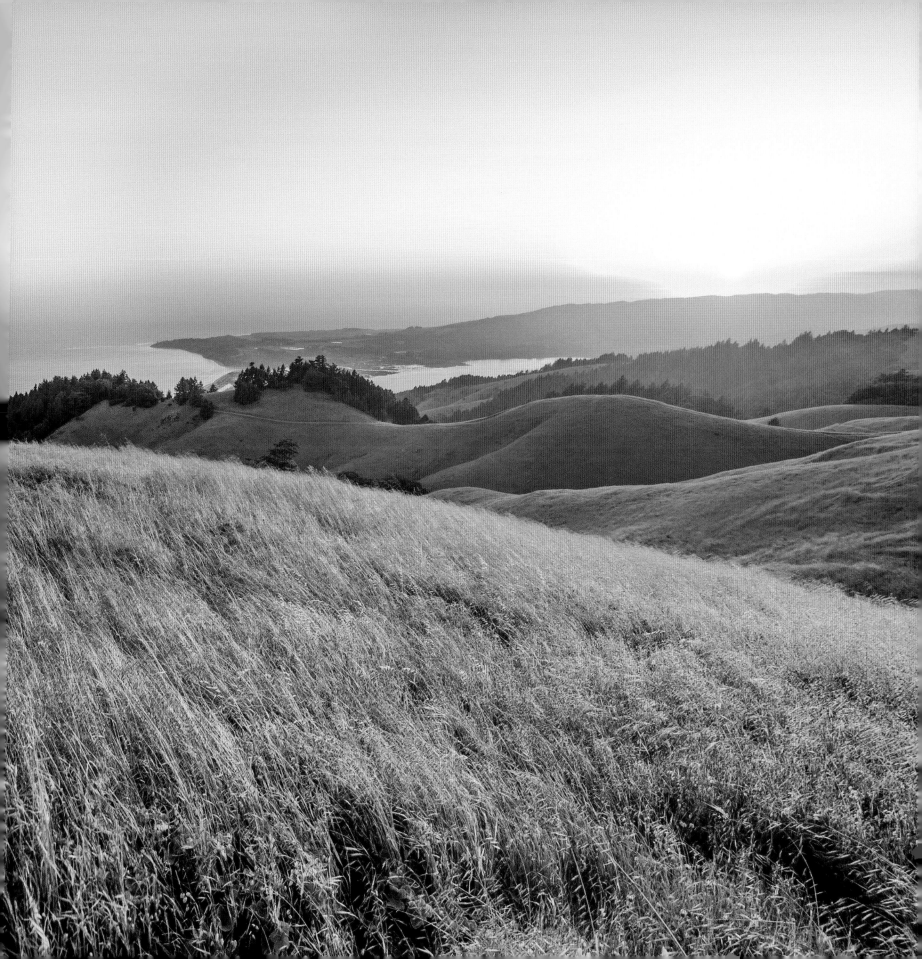

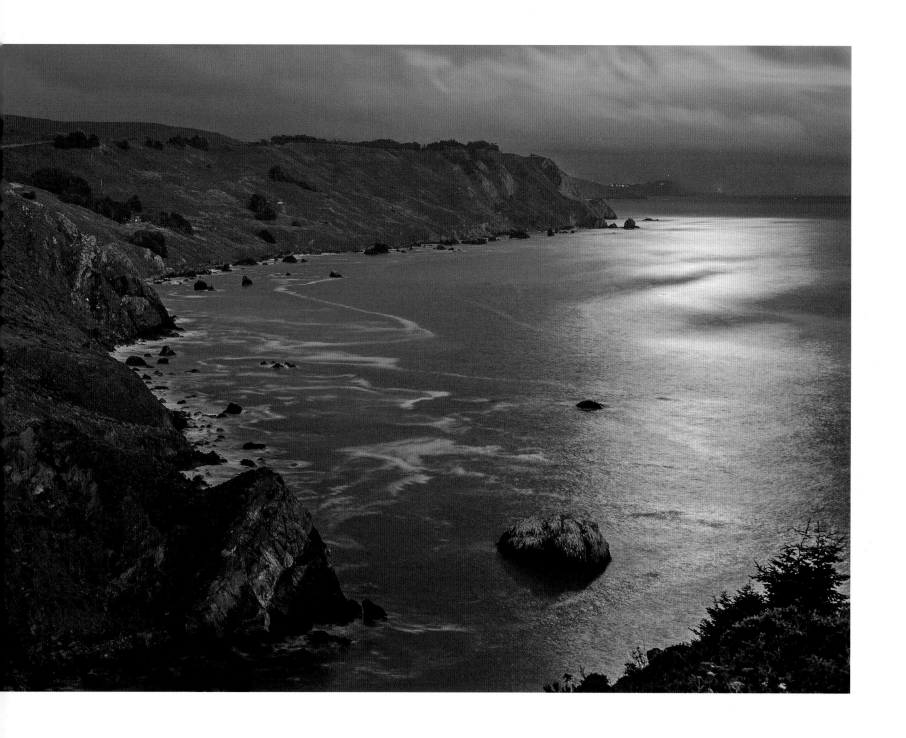

◈ Mount Tamalpais State Park, Mill Valley

◈ Muir Woods National Monument, Marin County

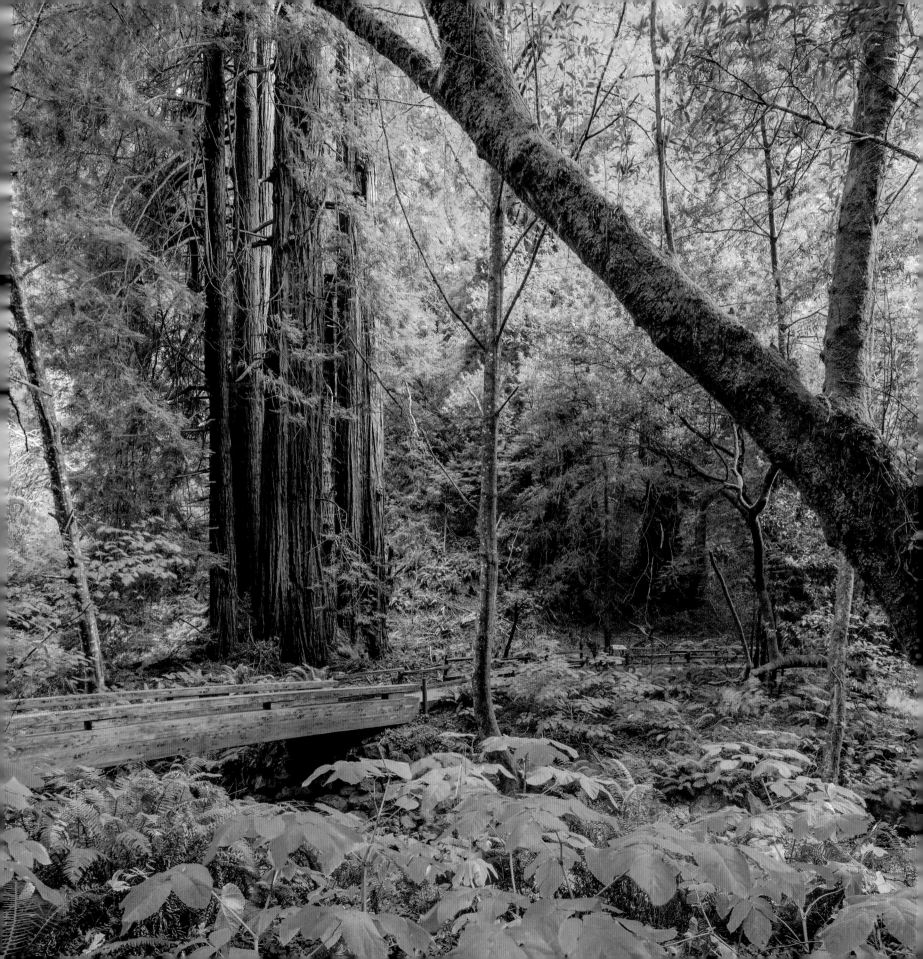

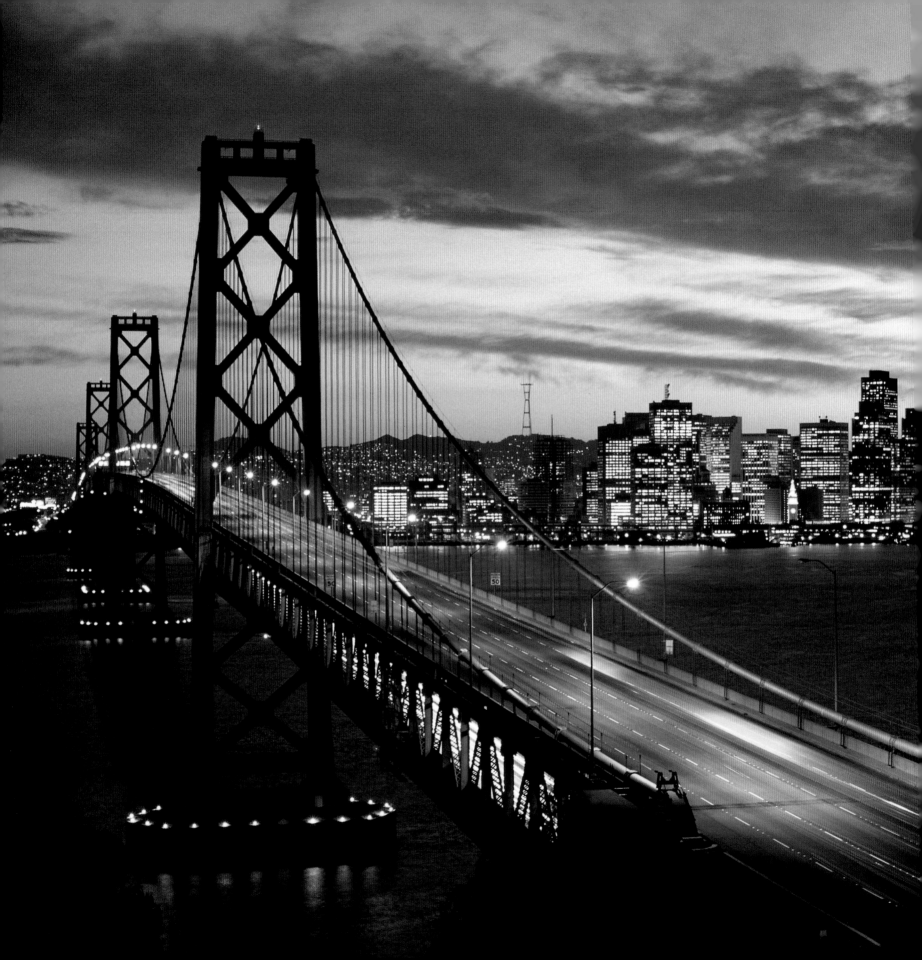

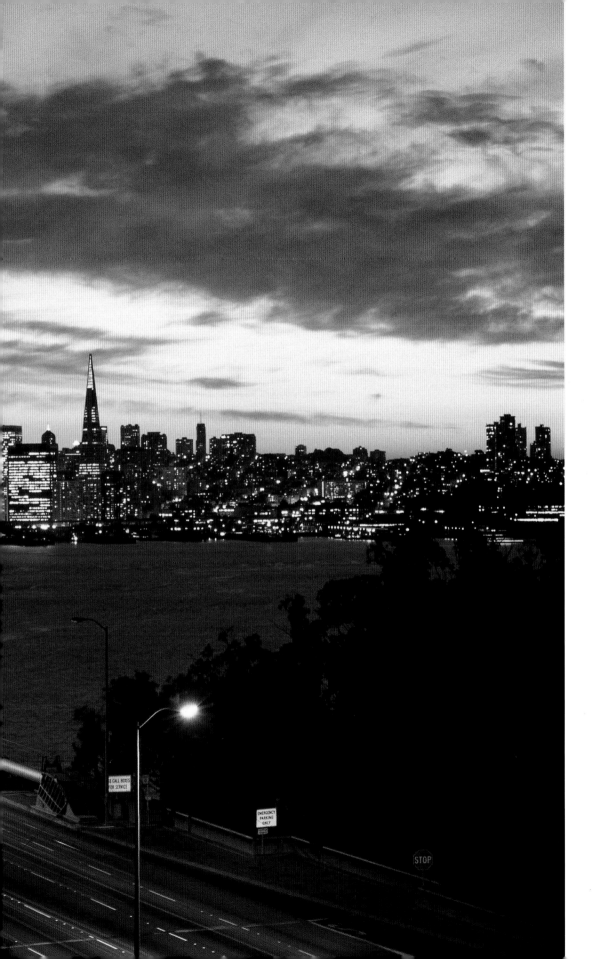

◈ Oakland Bay Bridge, San Francisco

◈ Tiburon (left); Sausalito (right)

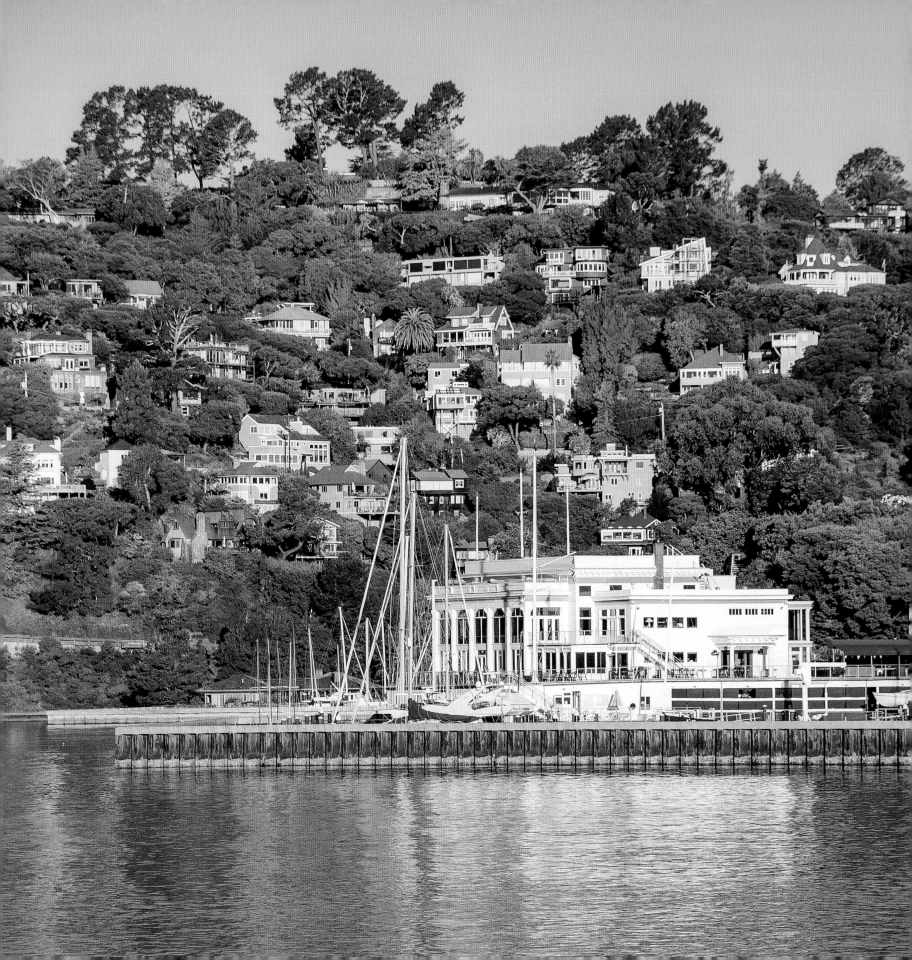

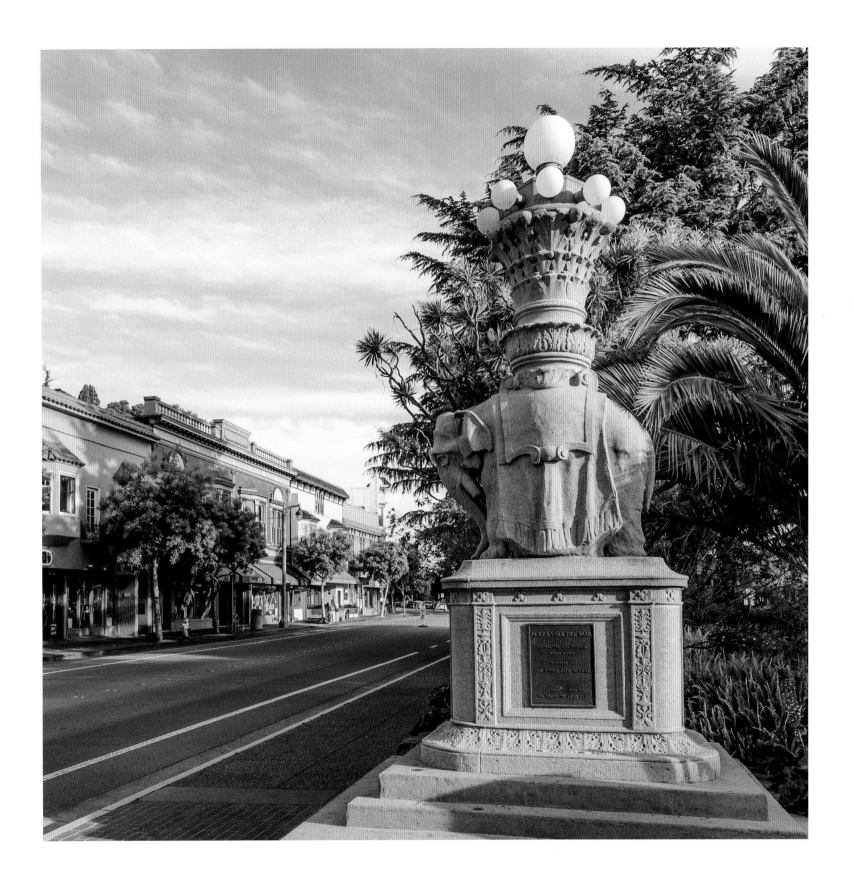

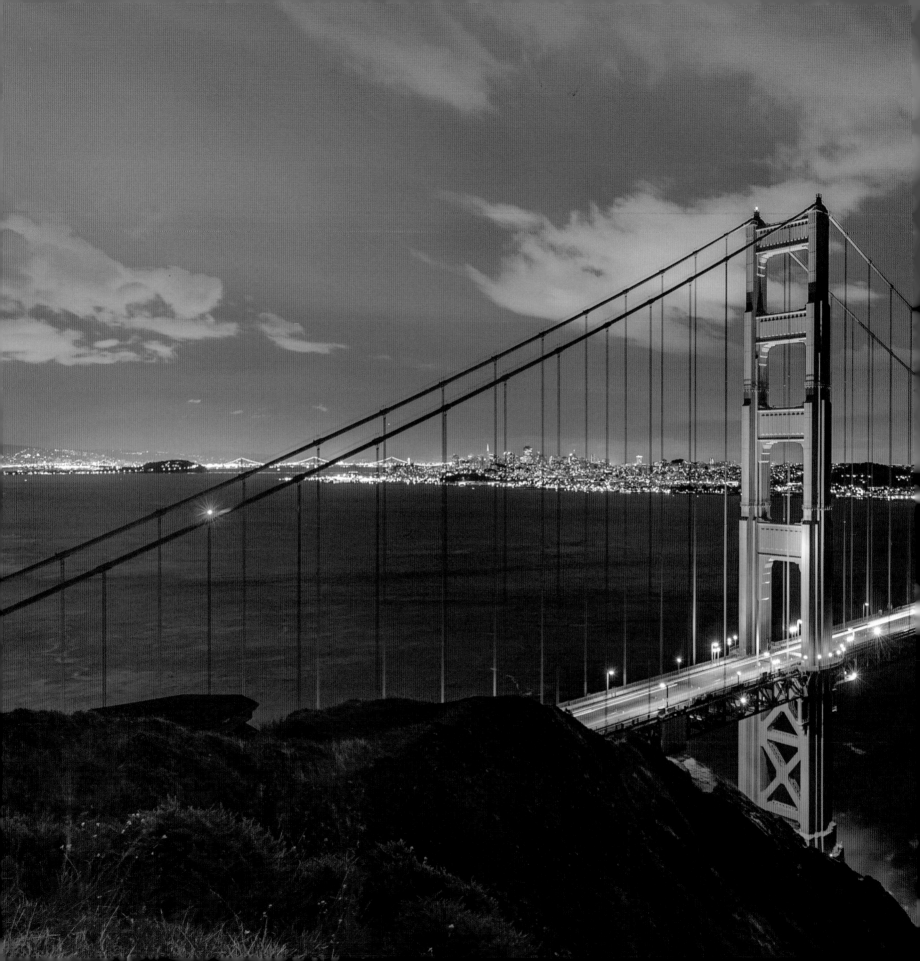

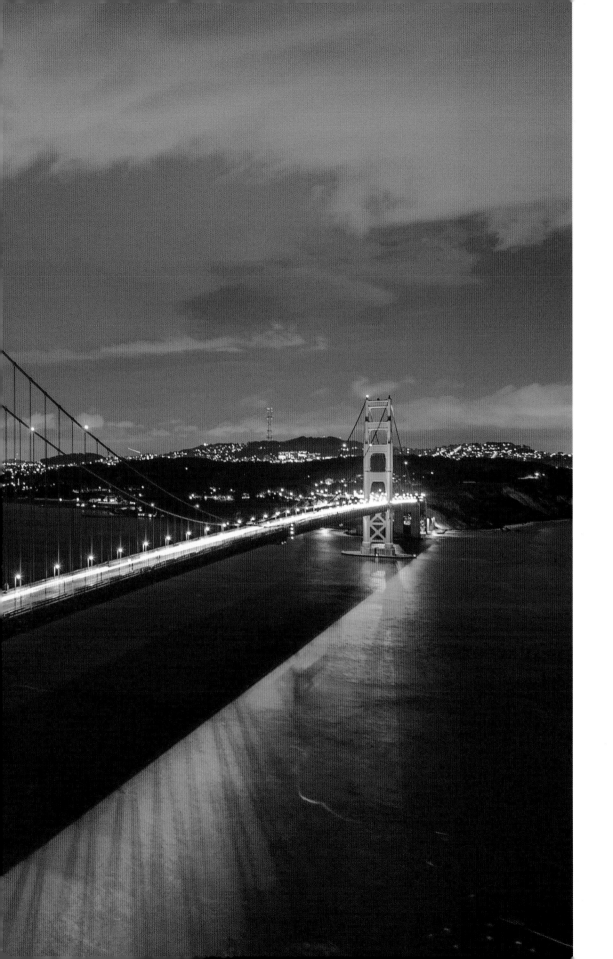

◈ Golden Gate Bridge, San Francisco

◈ Fisherman's Wharf, San Francisco
(left); Cupid's Span, Rincon Park,
San Francisco (right)

83

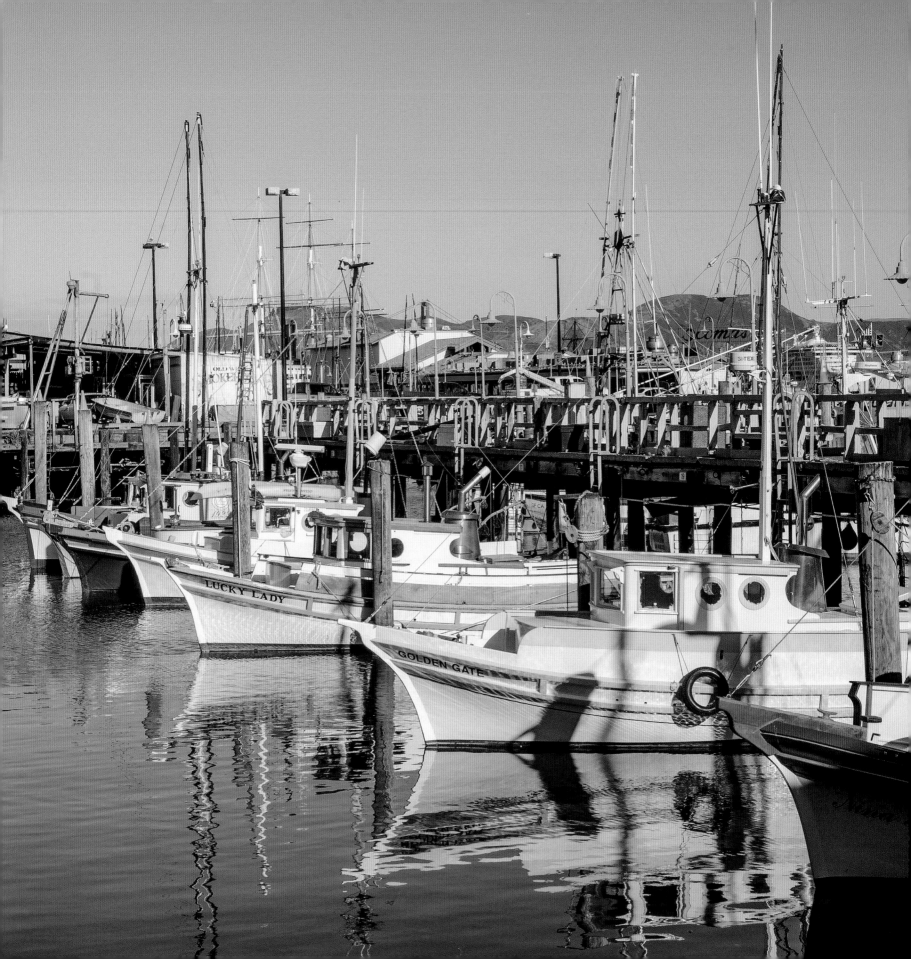

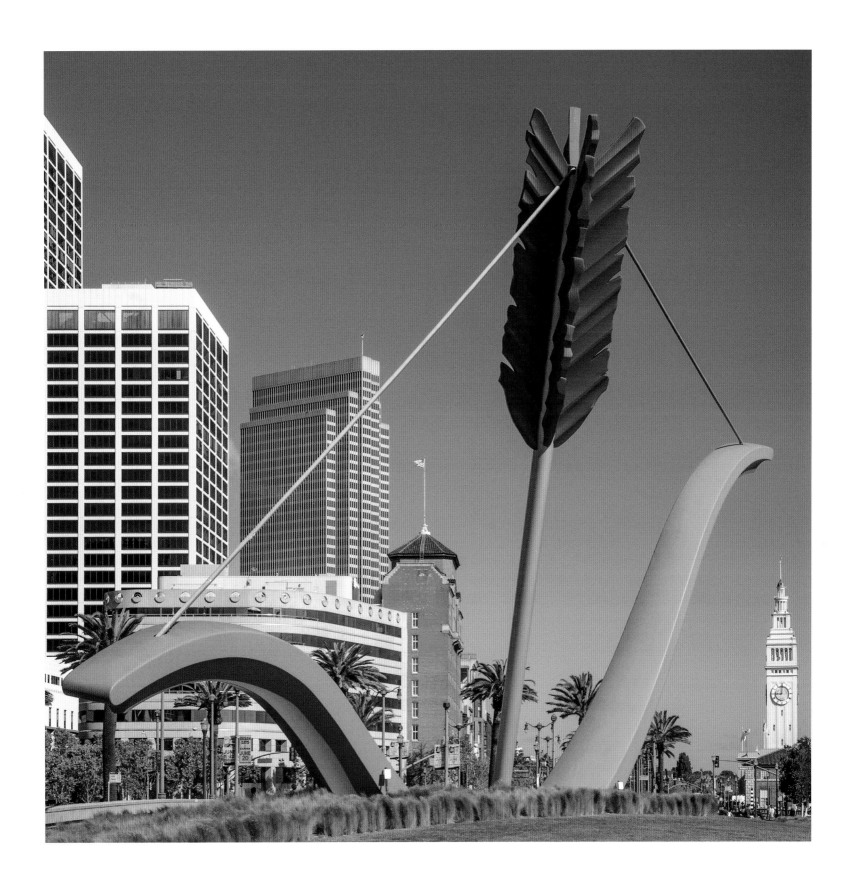

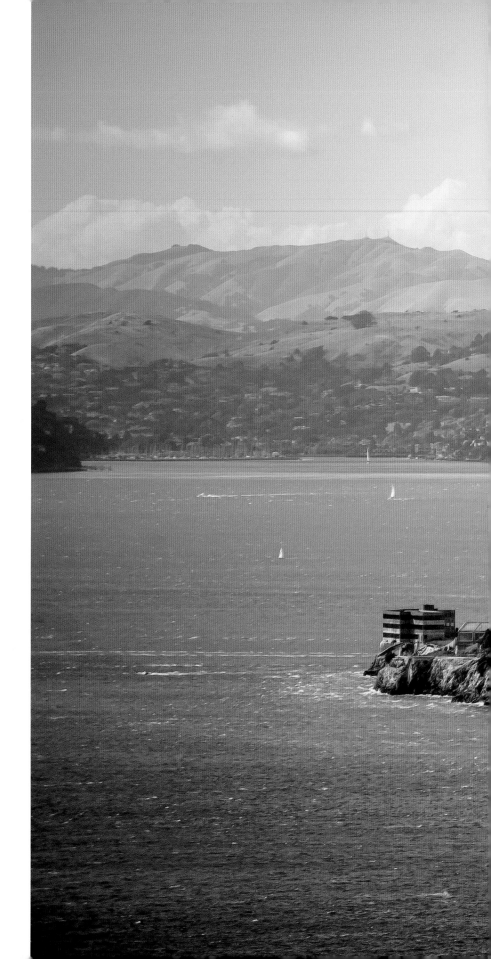

◈ Alcatraz Federal Penitentiary, San Francisco

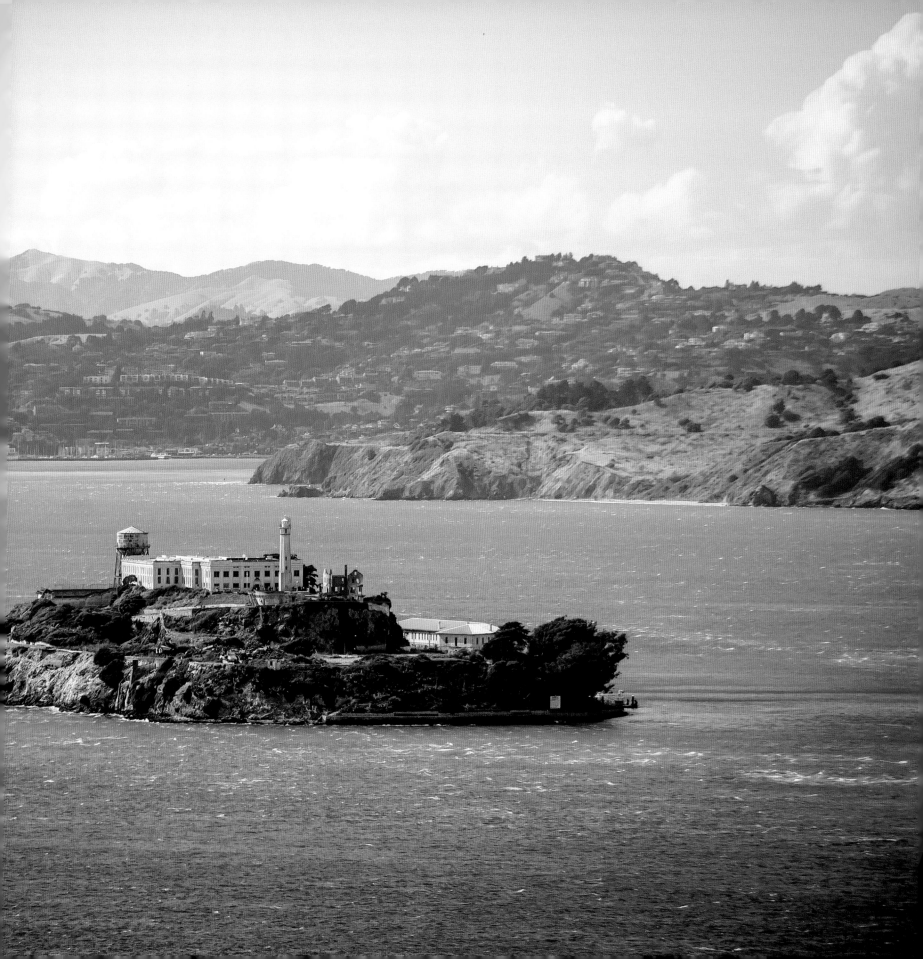

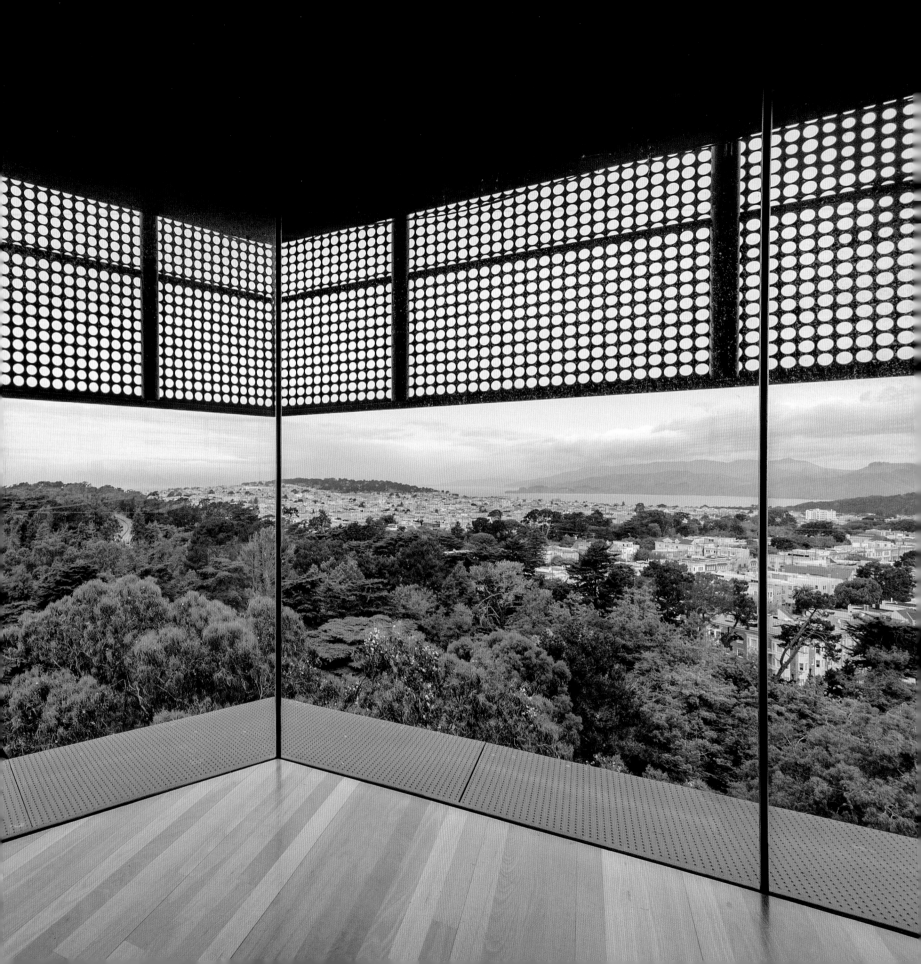

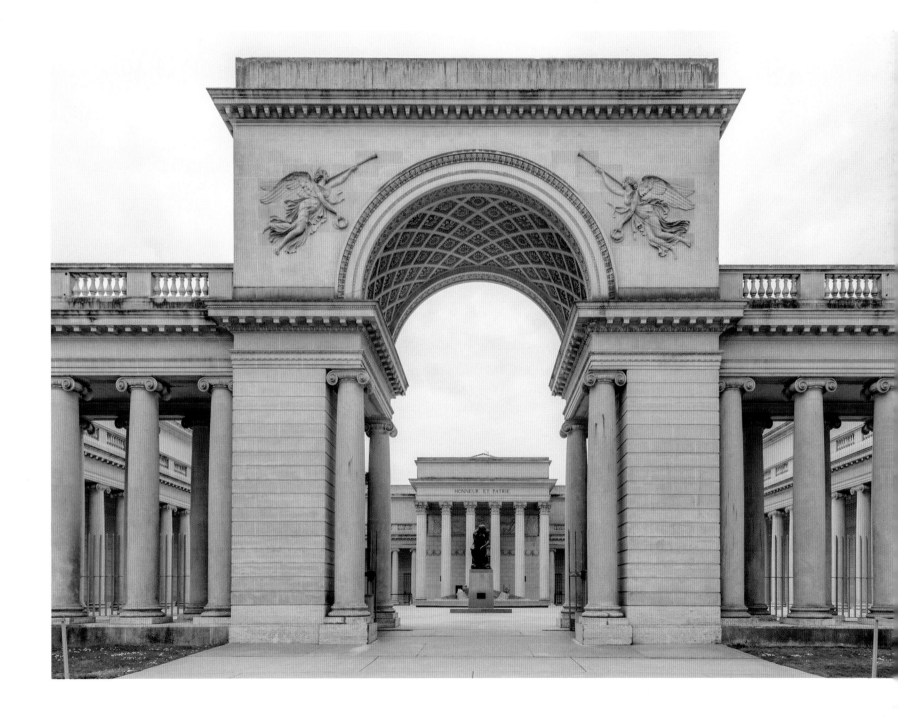

◈ De Young Museum, San Francisco ◈ Legion of Honor Museum, San Francisco ◈ Row of Victorian homes, San Francisco

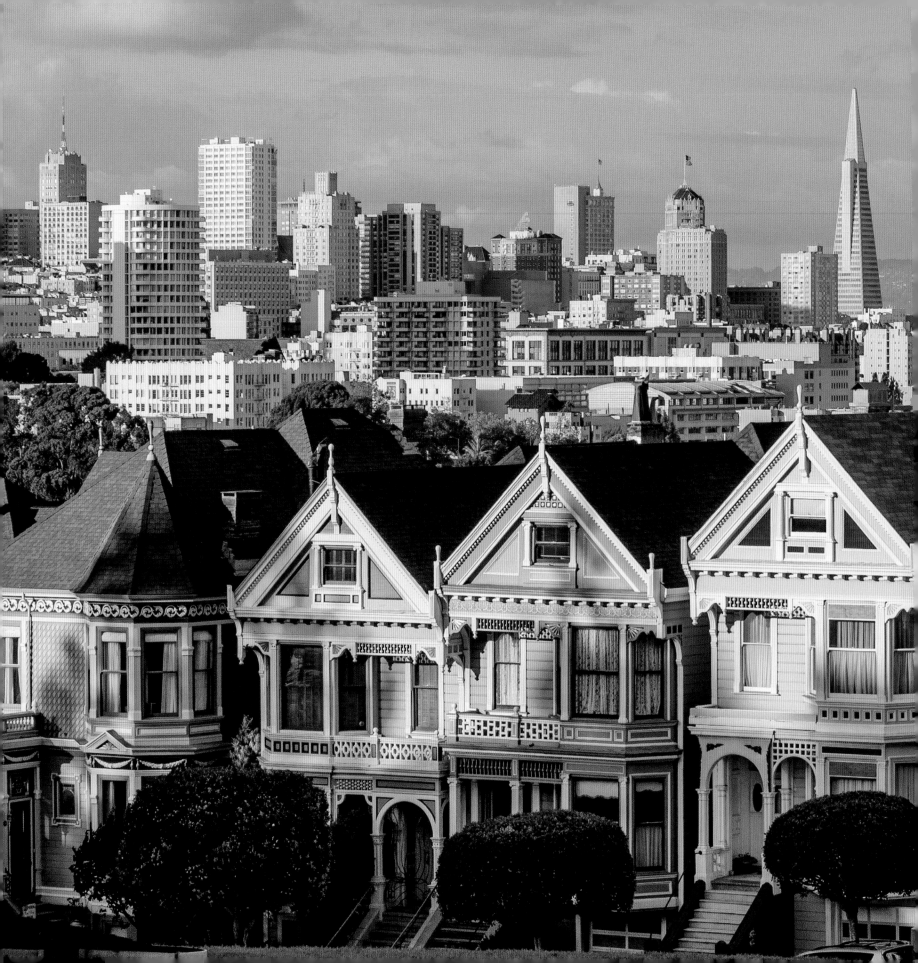

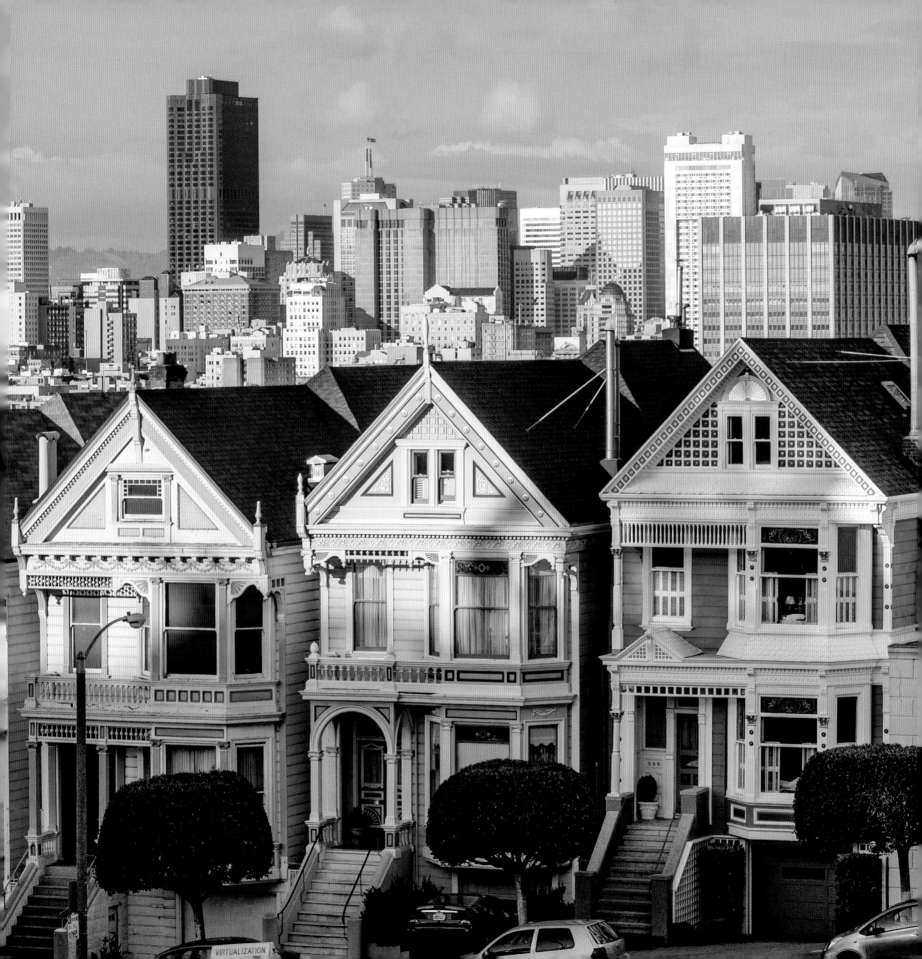

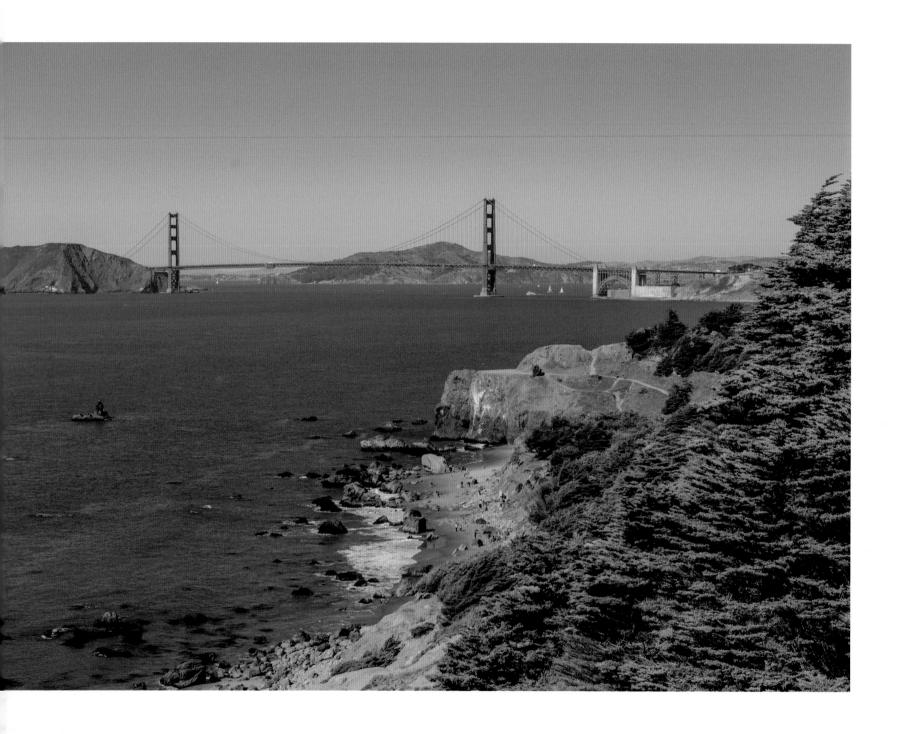

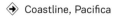 Lands End, Golden Gate National Recreation Area, San Francisco 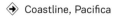 Coastline, Pacifica 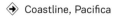 Half Moon Bay Golf Links, Half Moon Bay

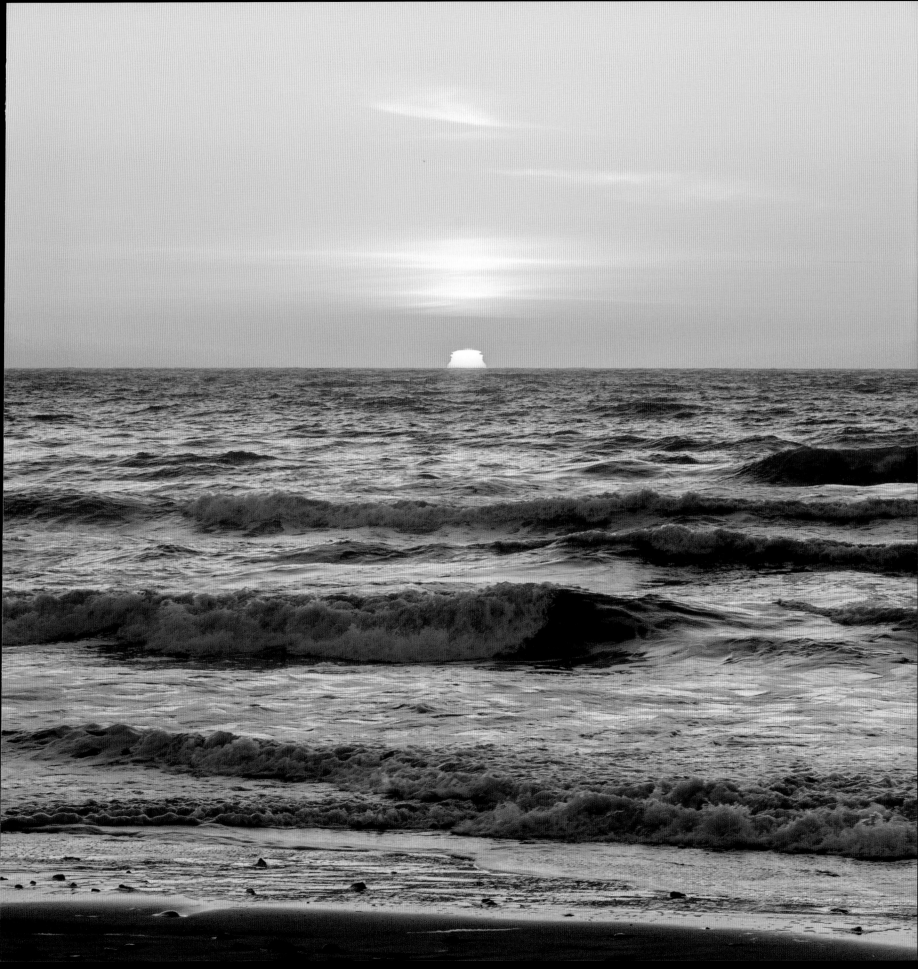

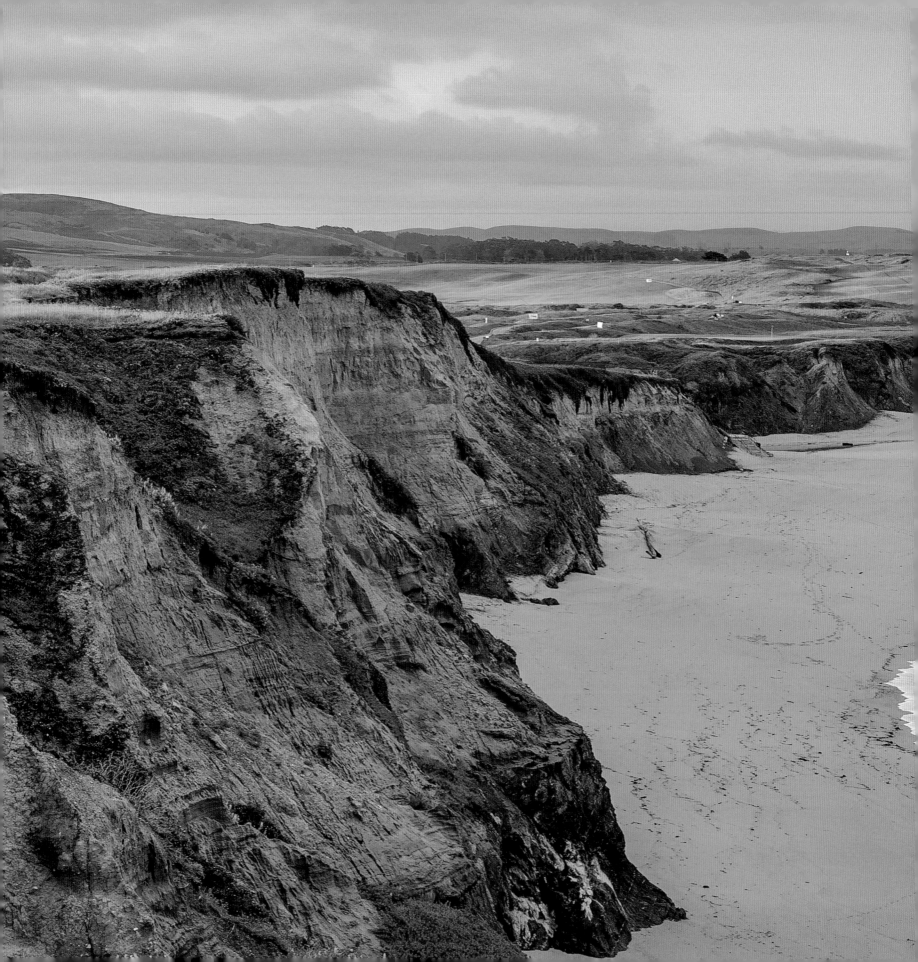

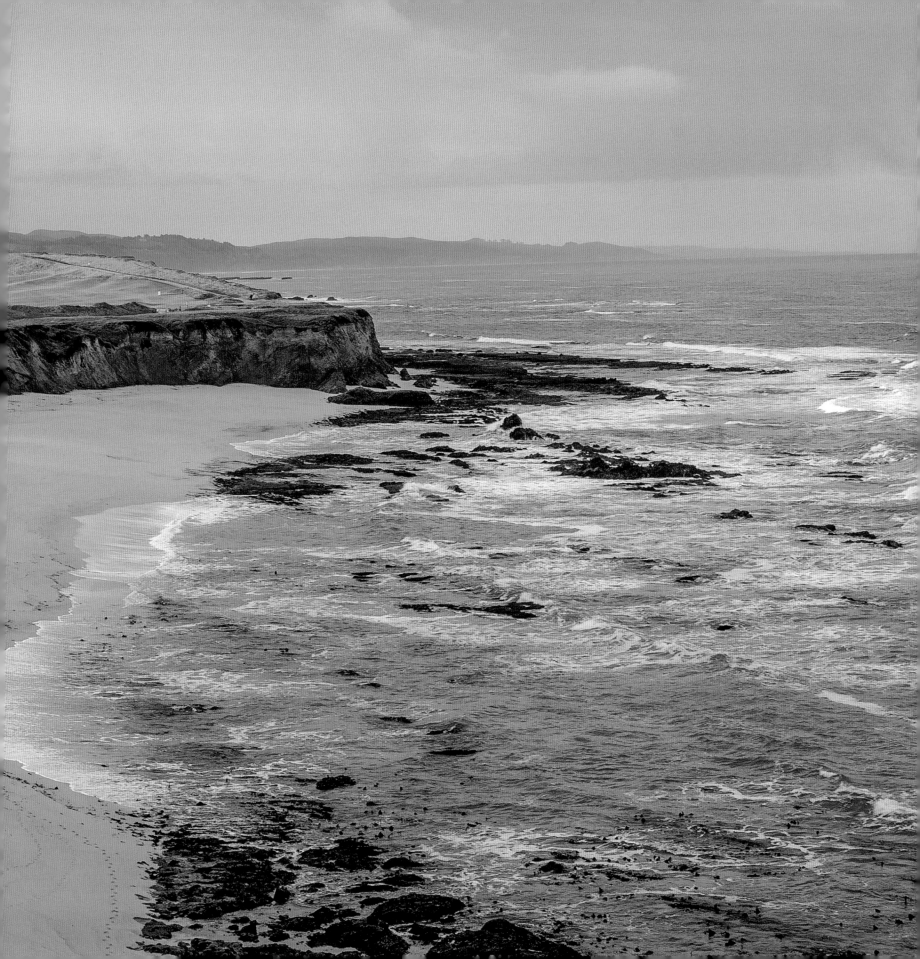

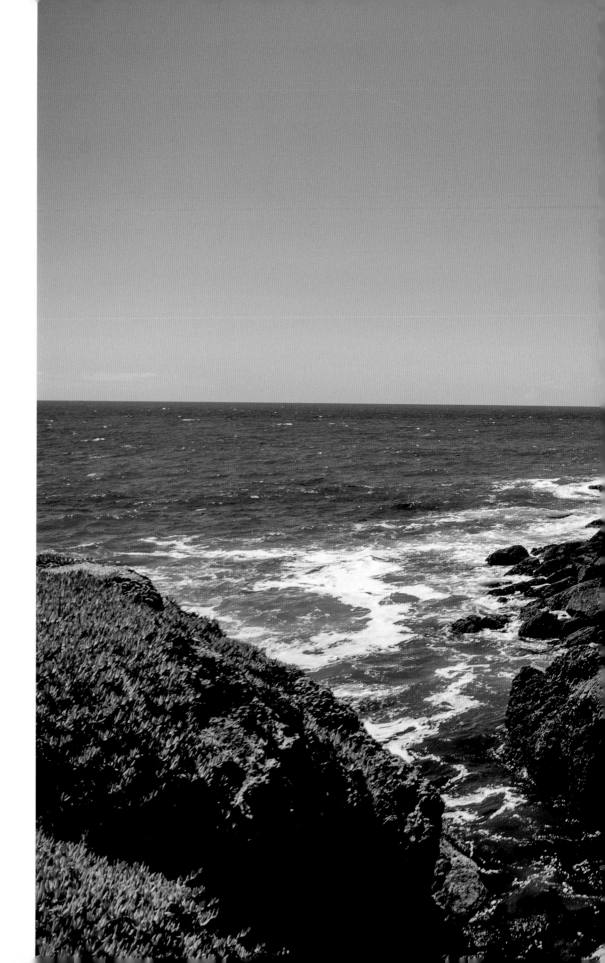

◈ Pigeon Point Lighthouse, Pescadero

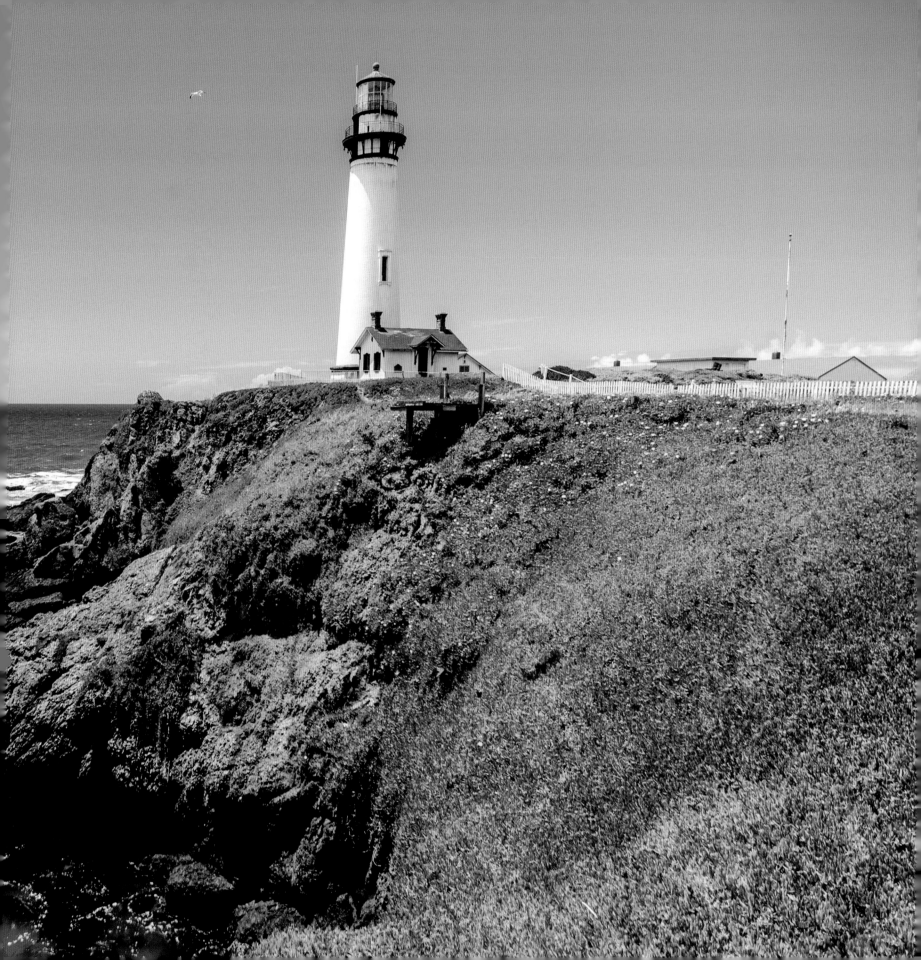

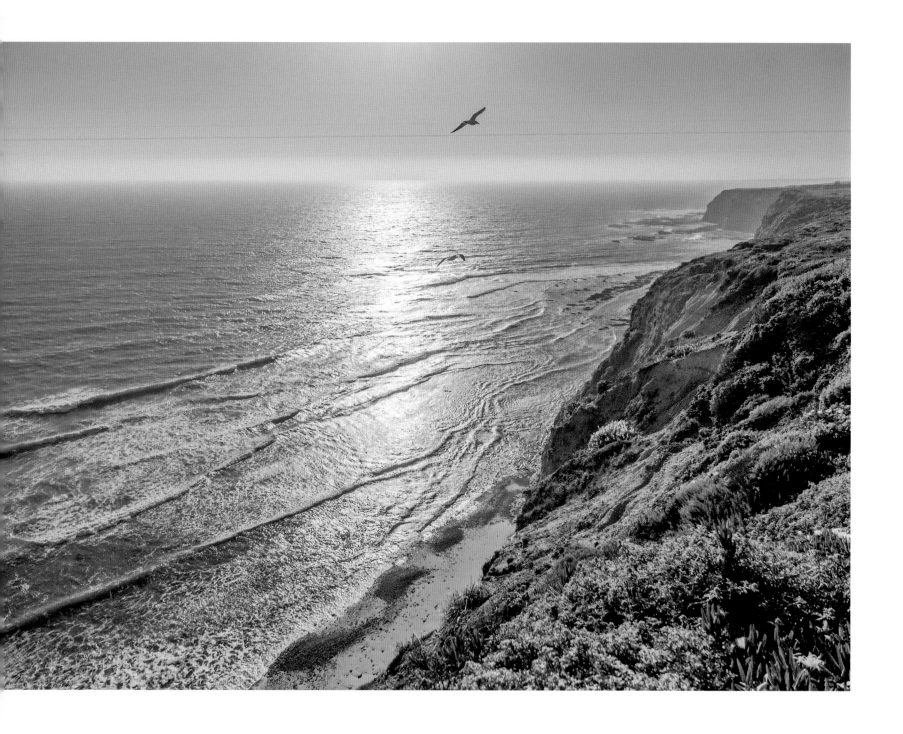

⬆ Coastline, Pescadero ⬌ Monterey ⬇ Santa Cruz

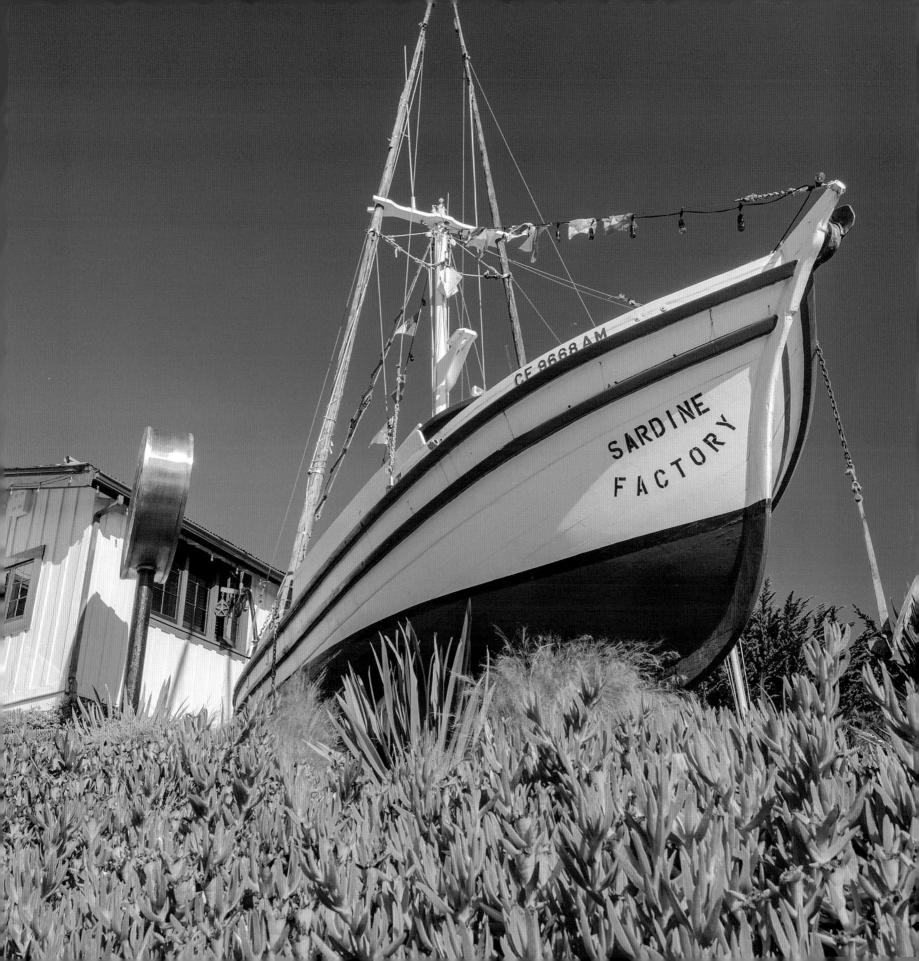

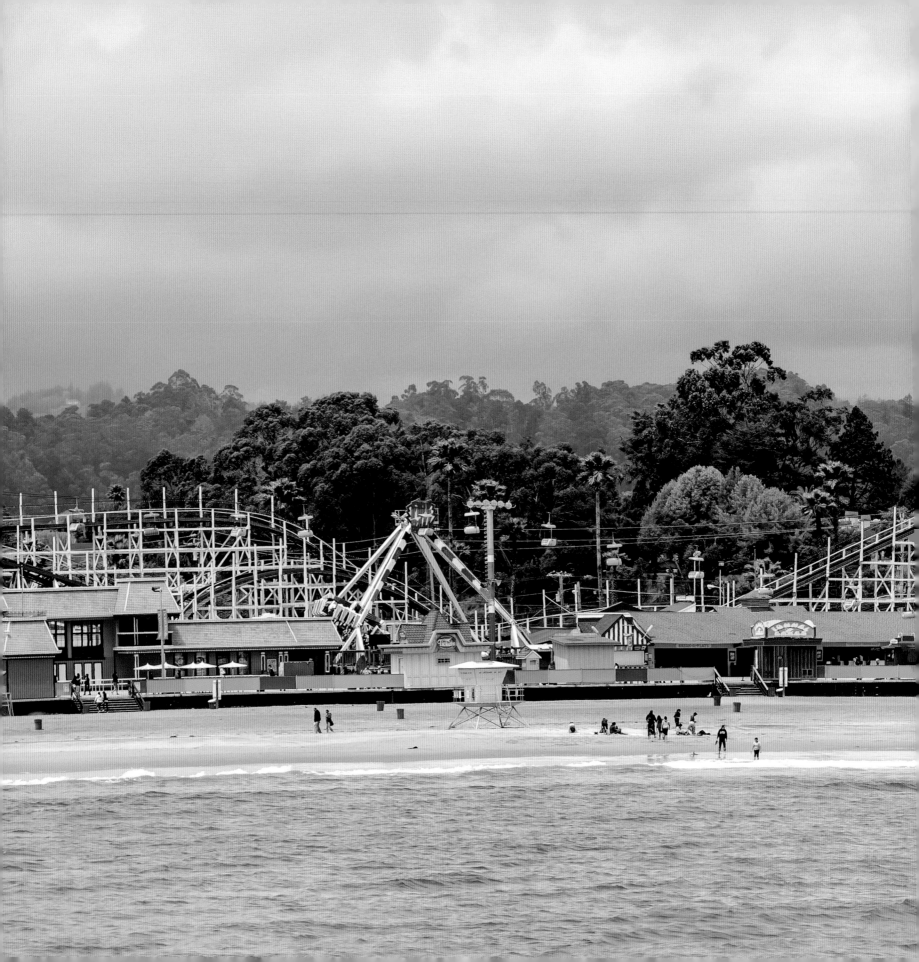

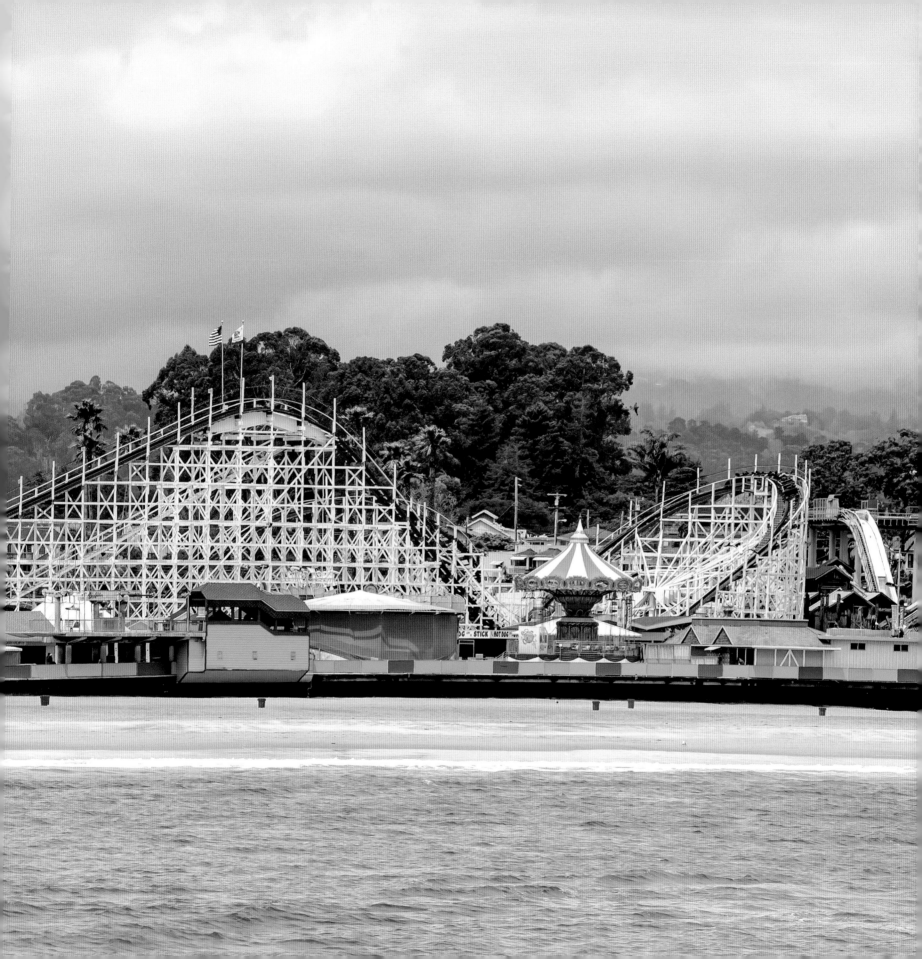

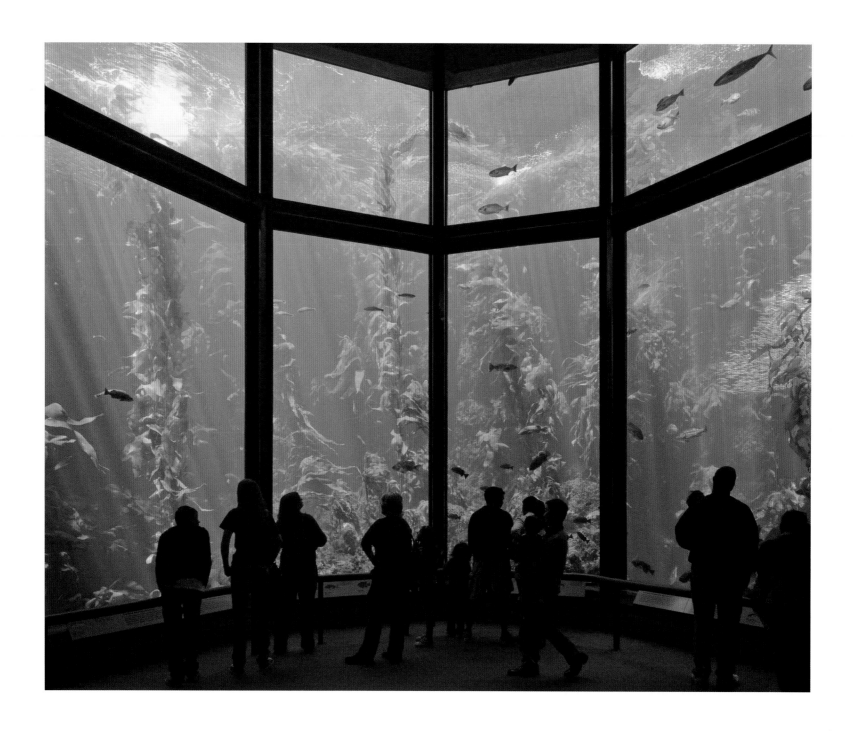

◈ ➔ Monterey Bay Aquarium, Monterey

⬇ Fishing boats, Monterey Bay, Monterey

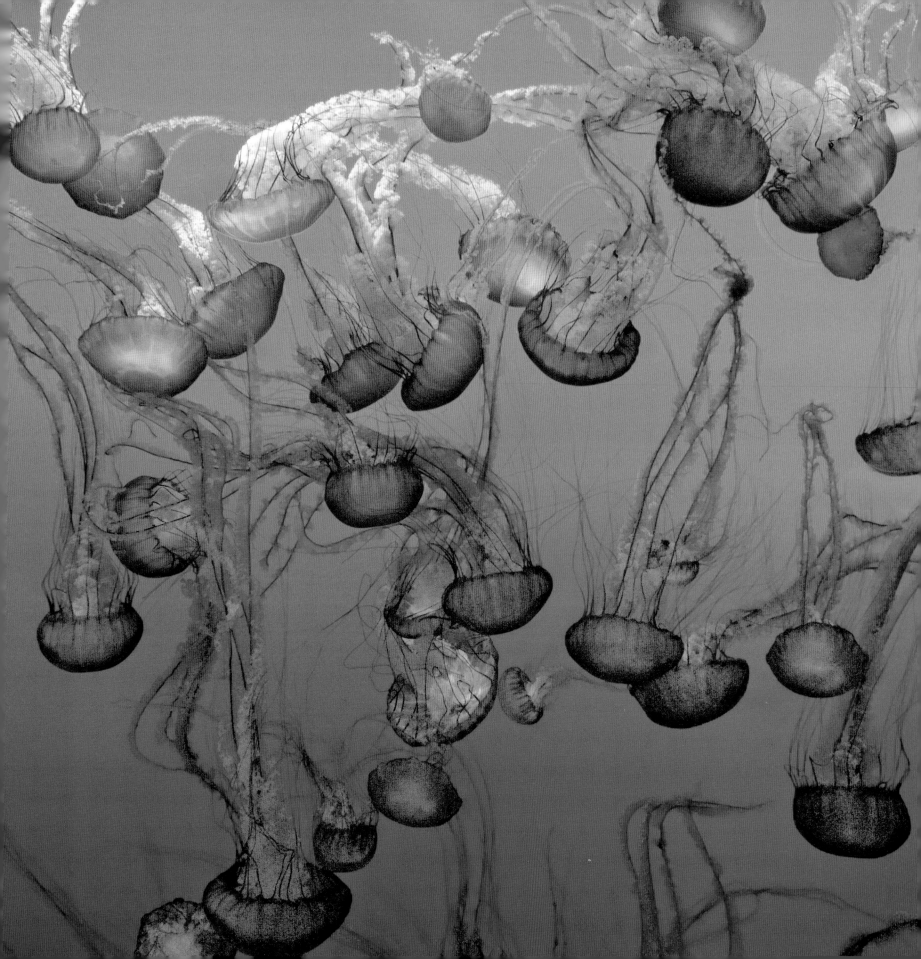

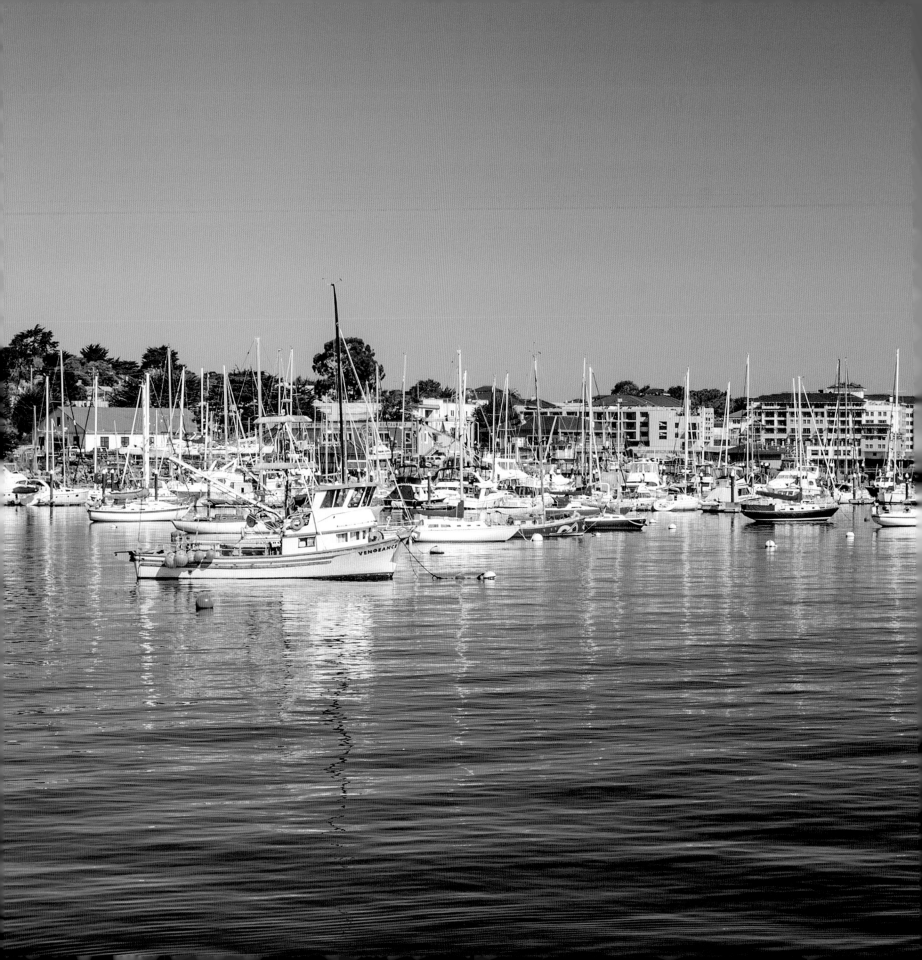

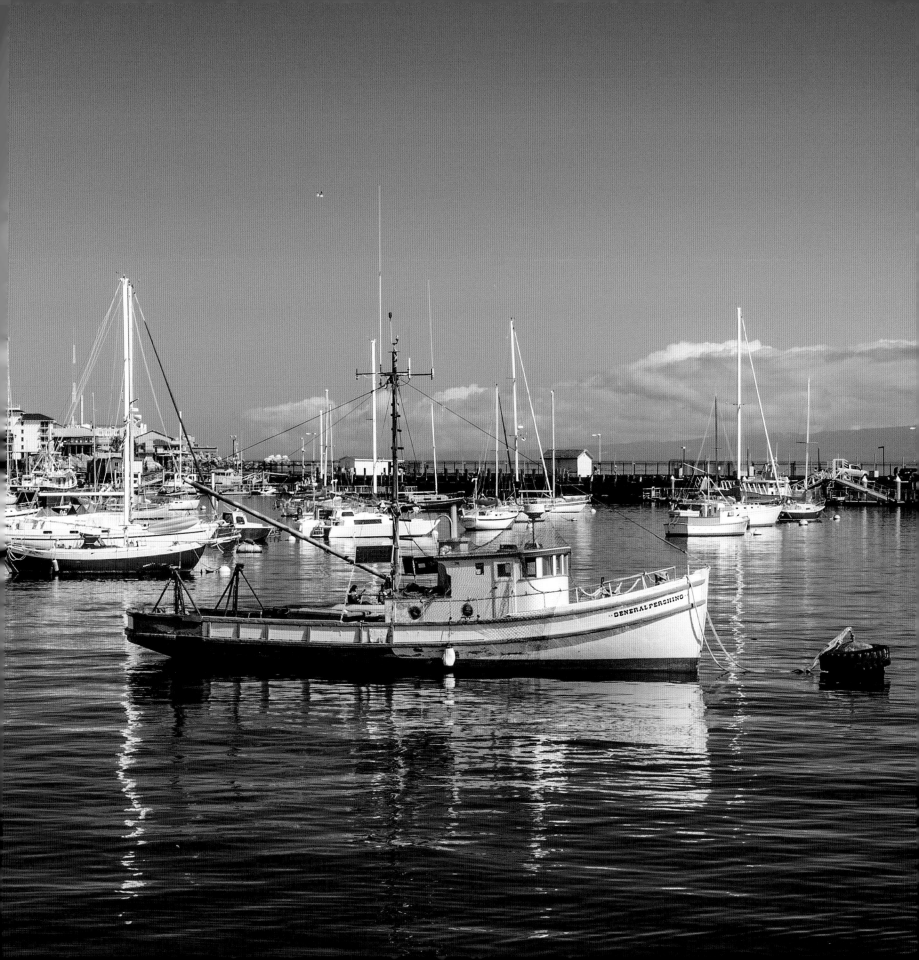

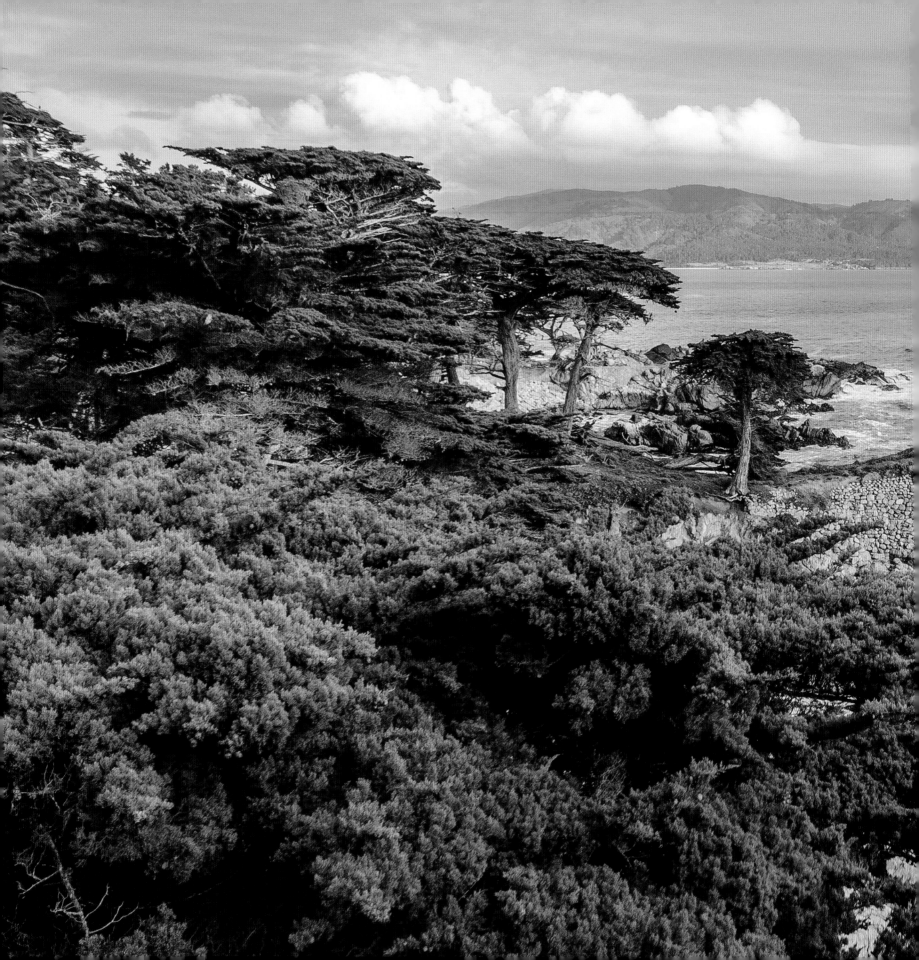

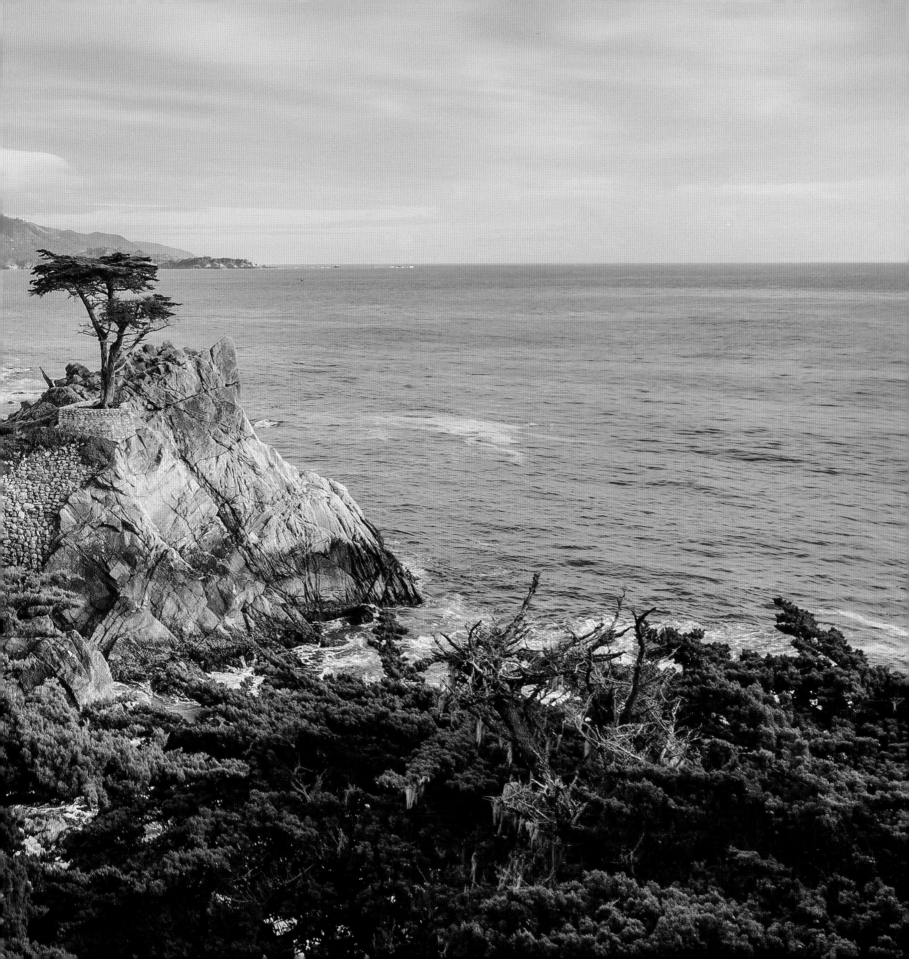

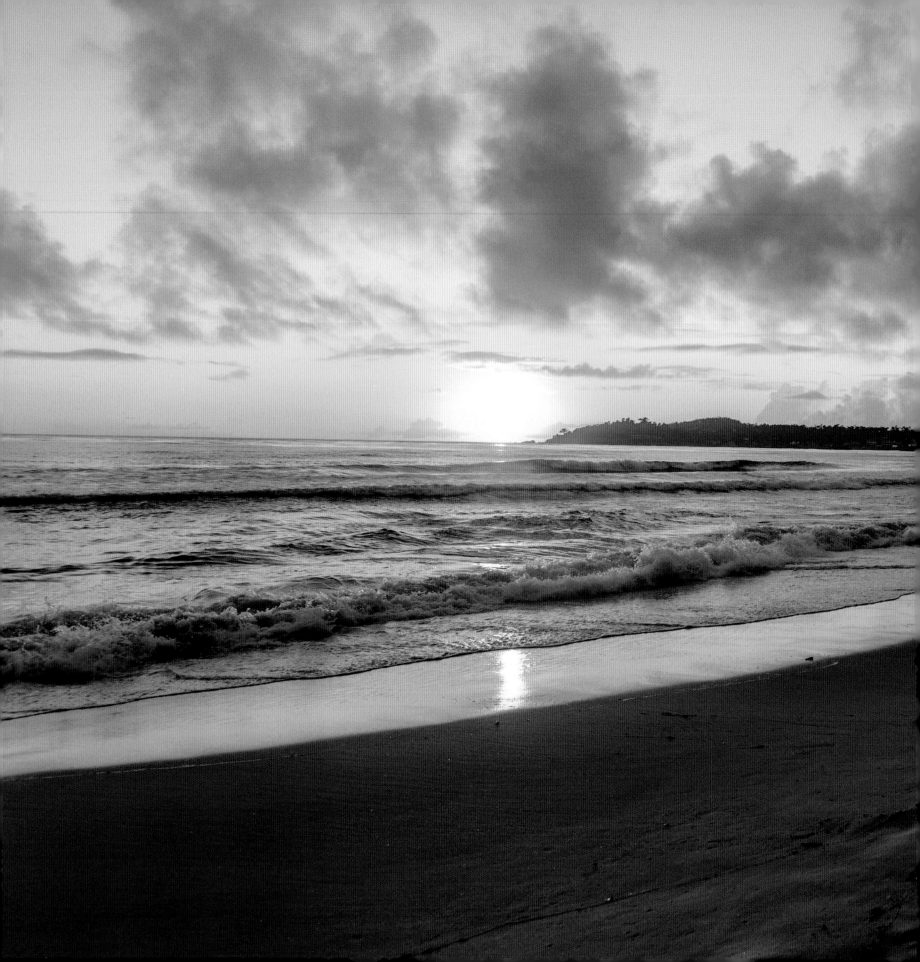

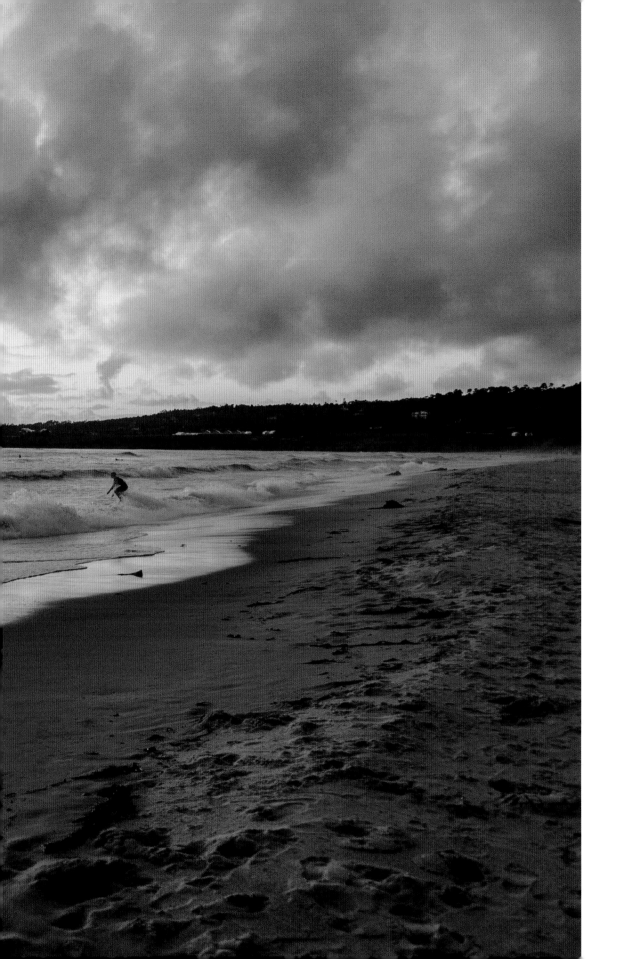

↑ The Lone Cypress, Carmel

← Carmel Beach City Park, Carmel

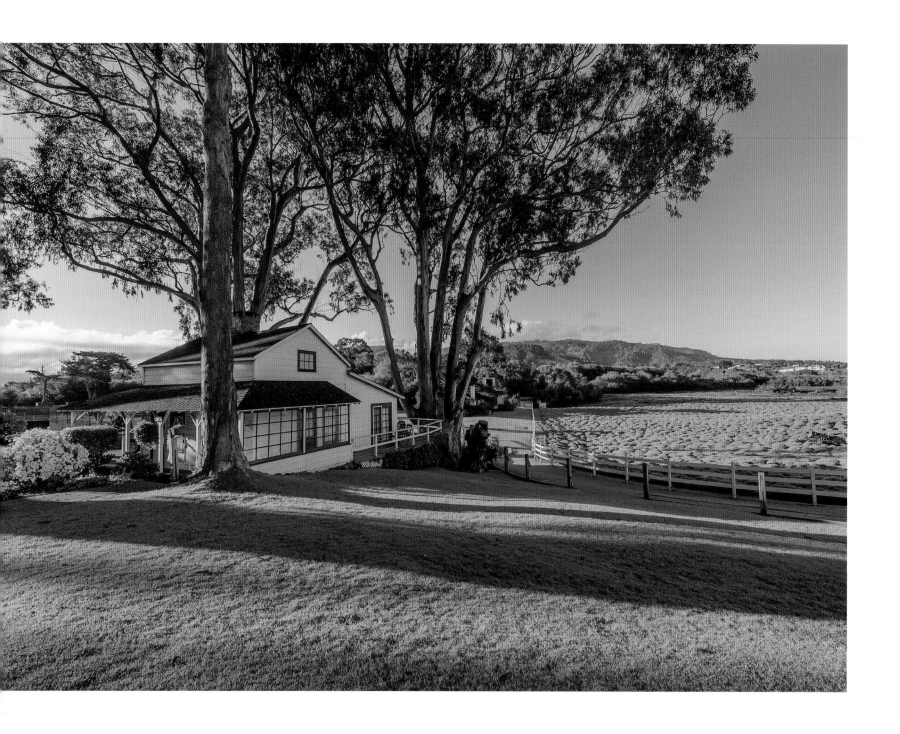

◈ Mission Ranch Hotel and Restaurant, Carmel ◈ Mission San Carlos Borromeo de Carmelo, Carmel ◈ Carmel Highlands, Carmel

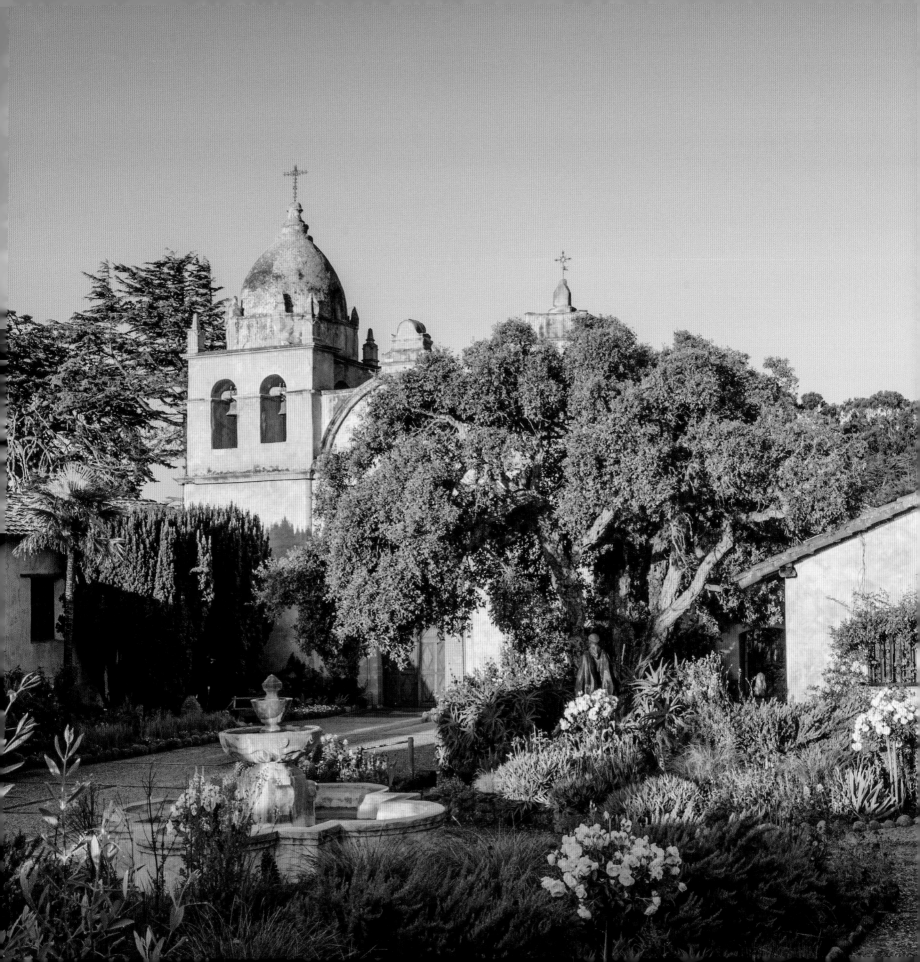

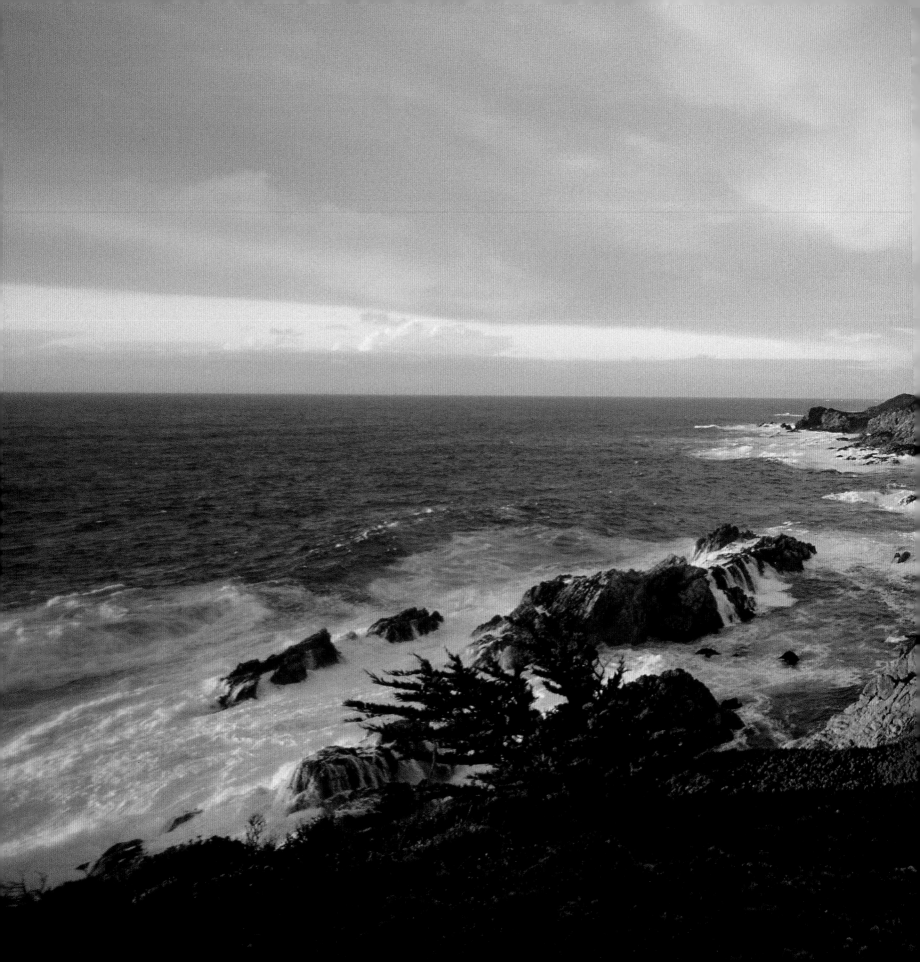

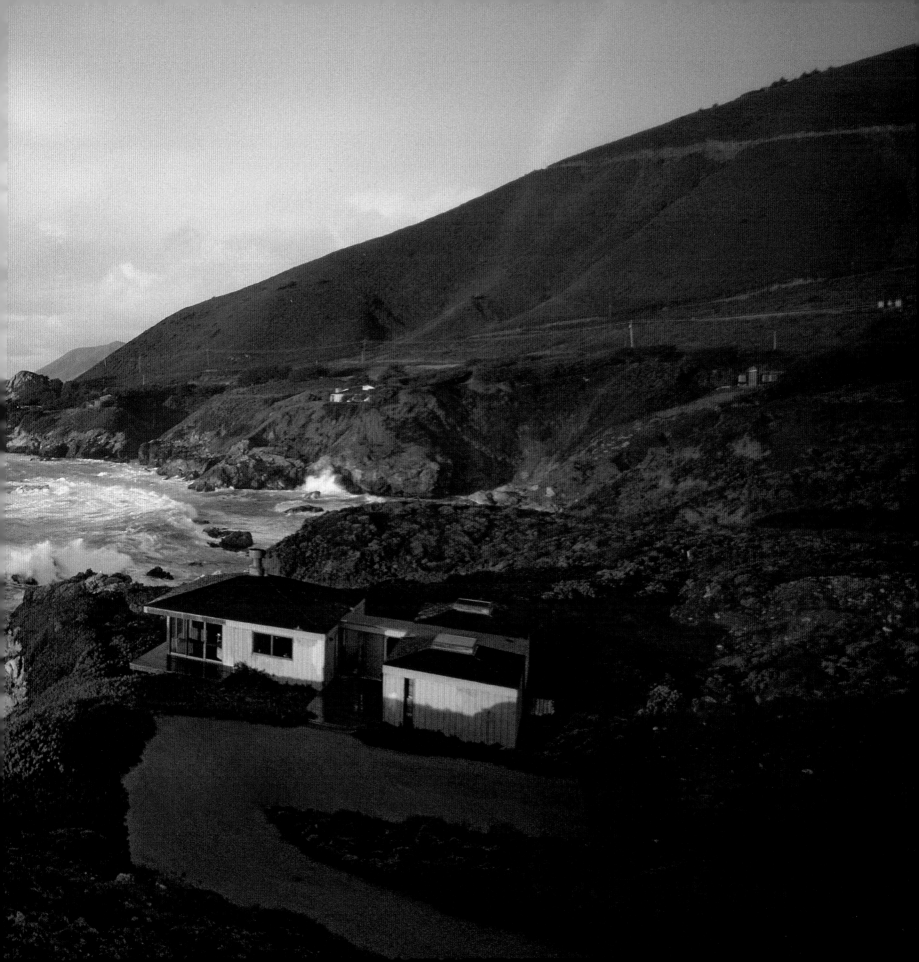

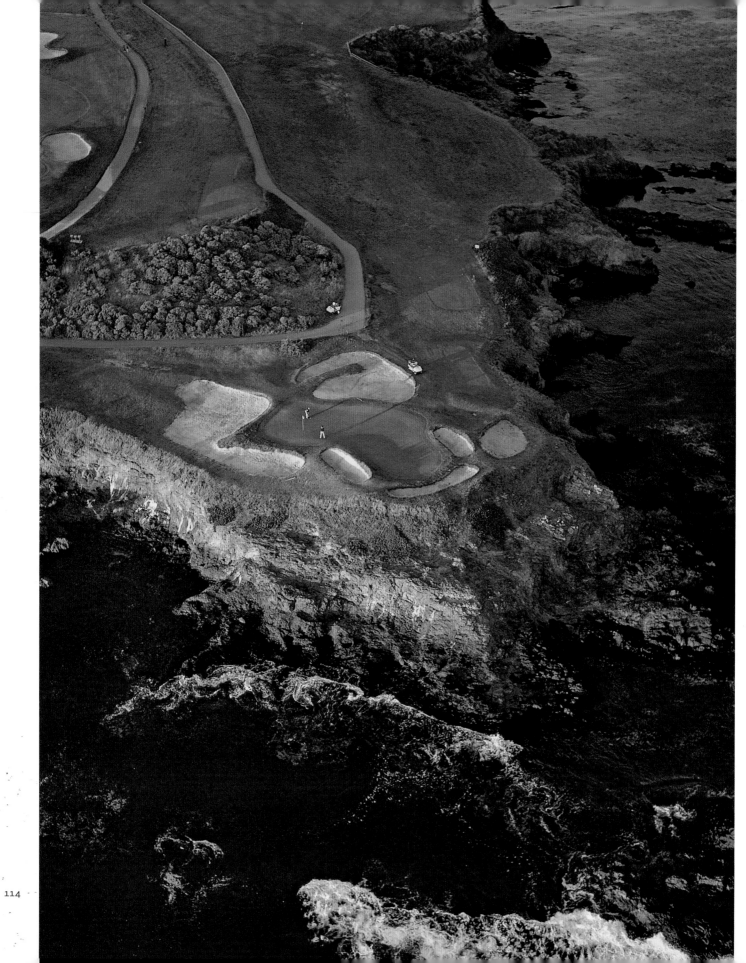

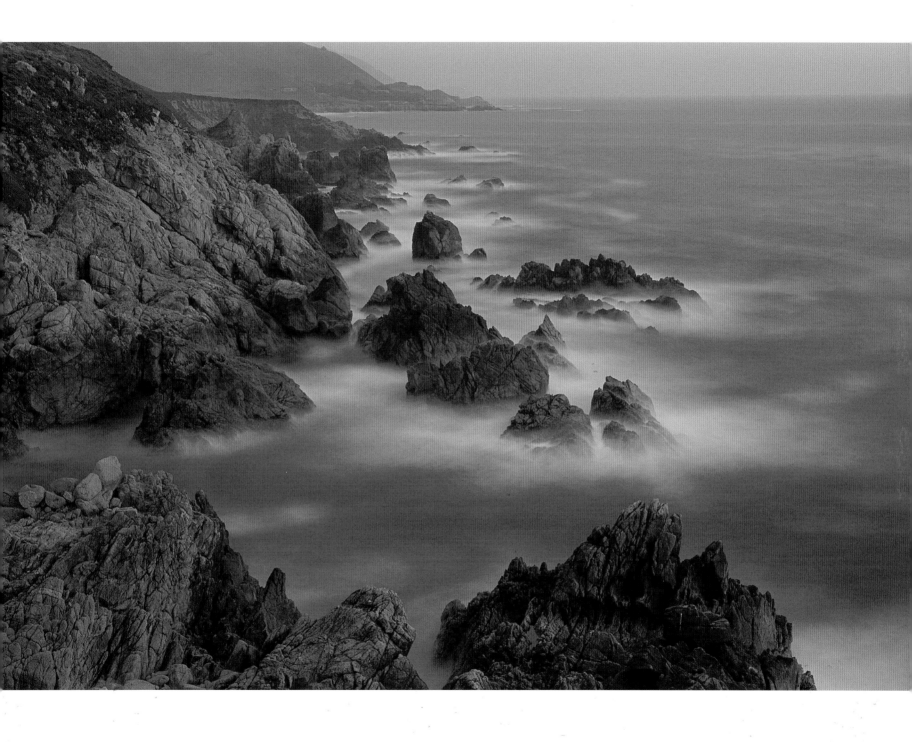

◈ Pebble Beach Golf Links, Pebble Beach ◈ Garrapata State Park, Carmel ◈ Point Lobos State Reserve, Carmel

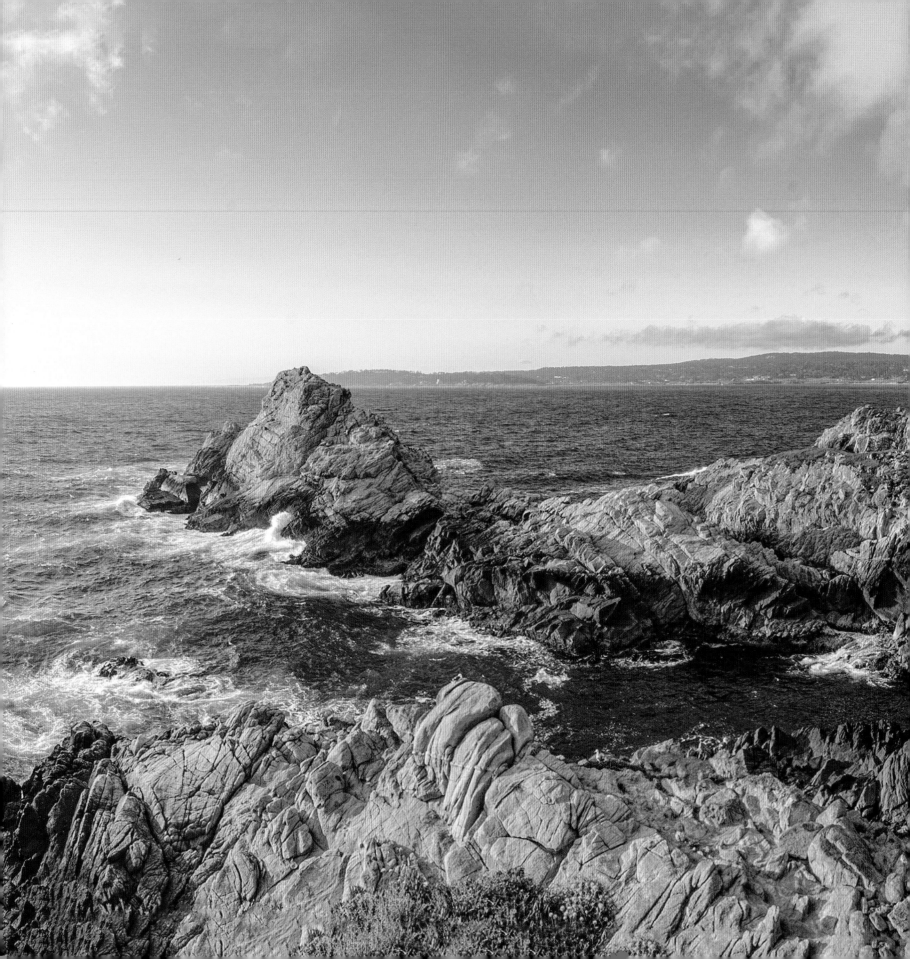

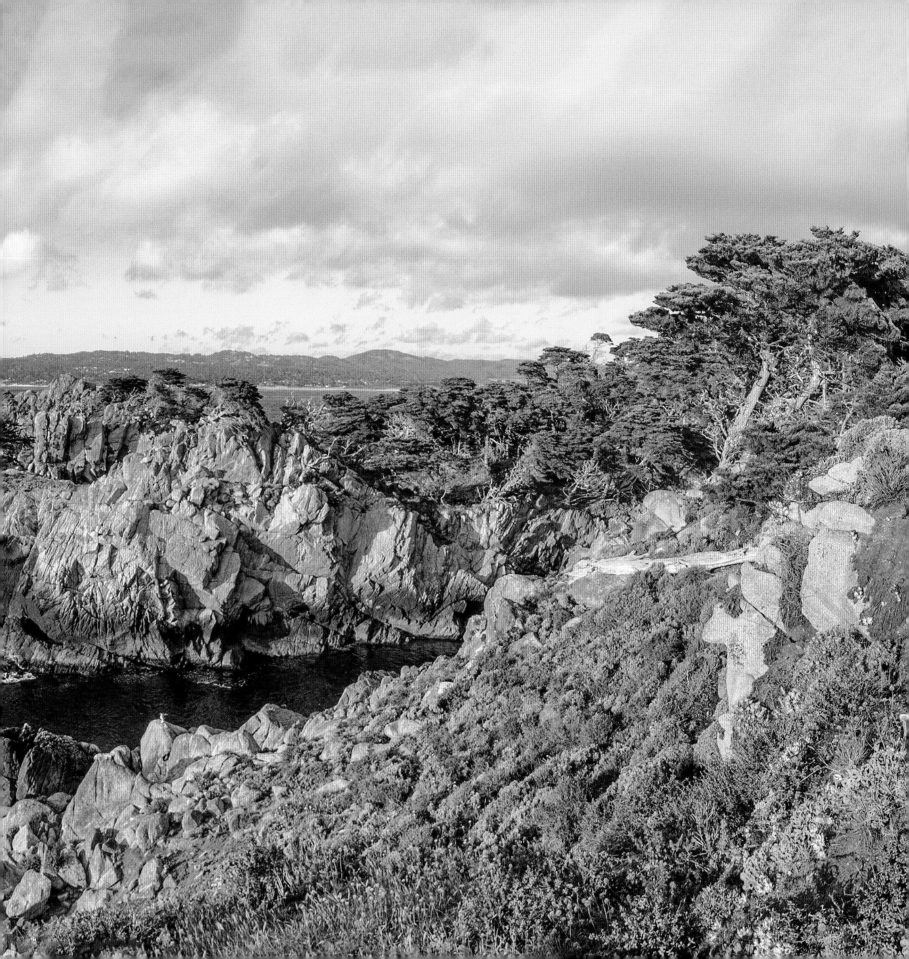

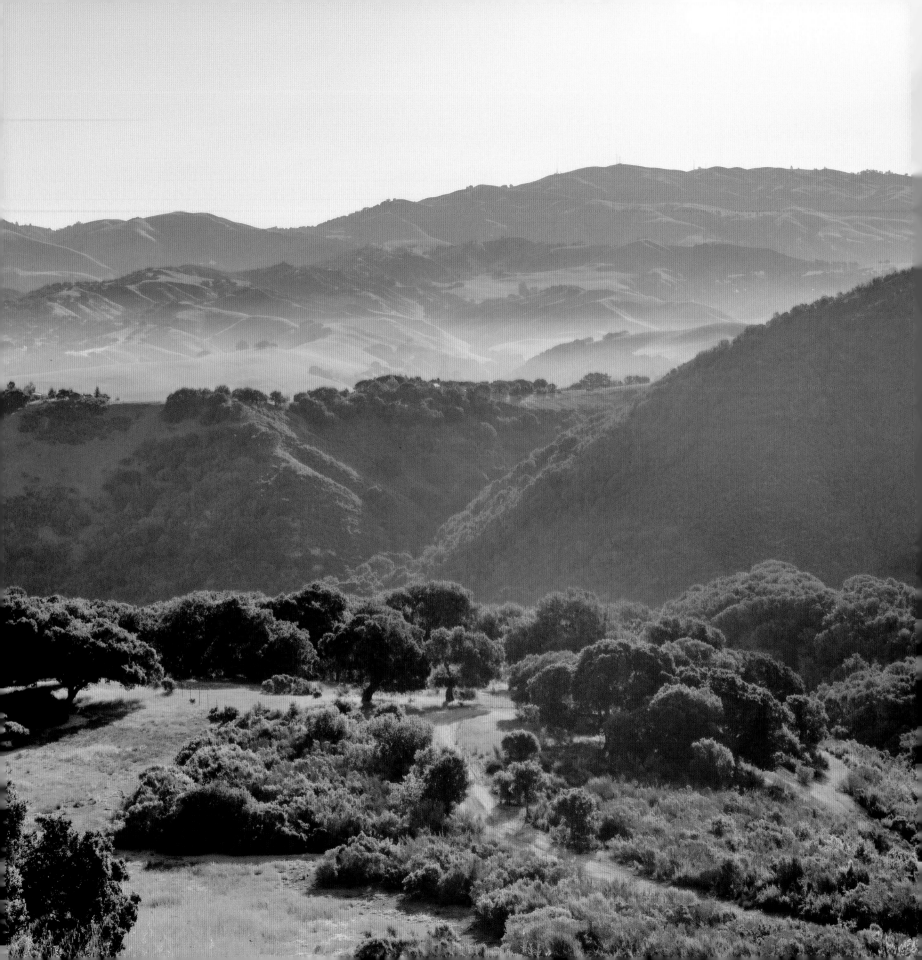

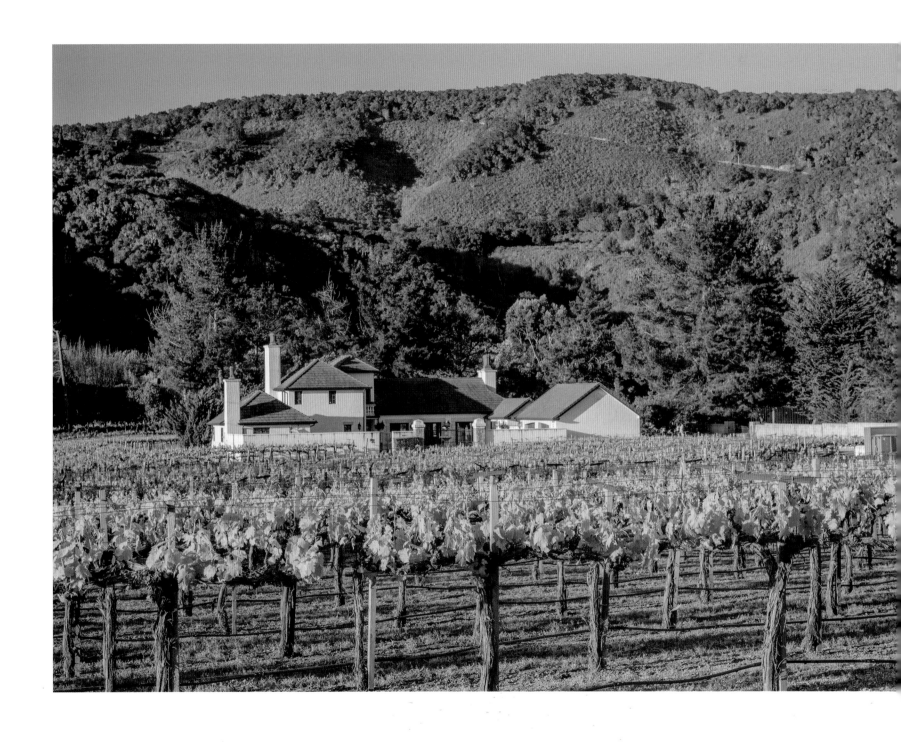

◈ ⬆ Rolling hills and vineyards, Carmel Valley

◈ Rocky Point, Carmel

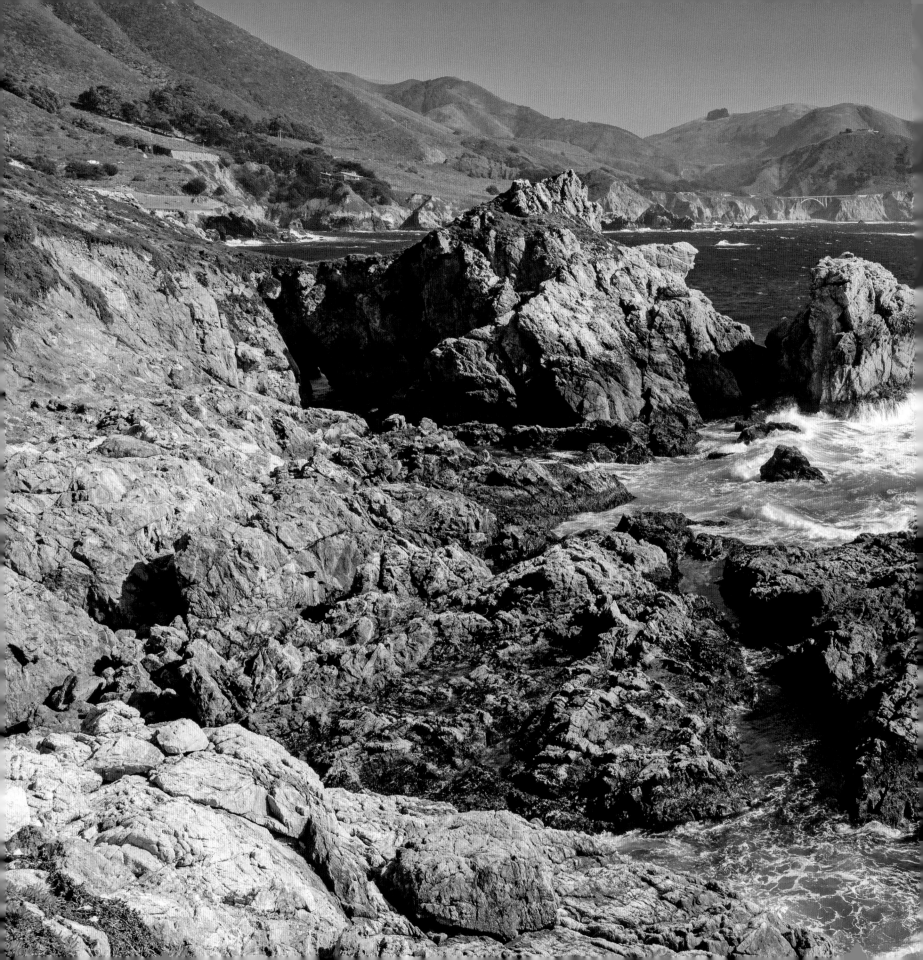

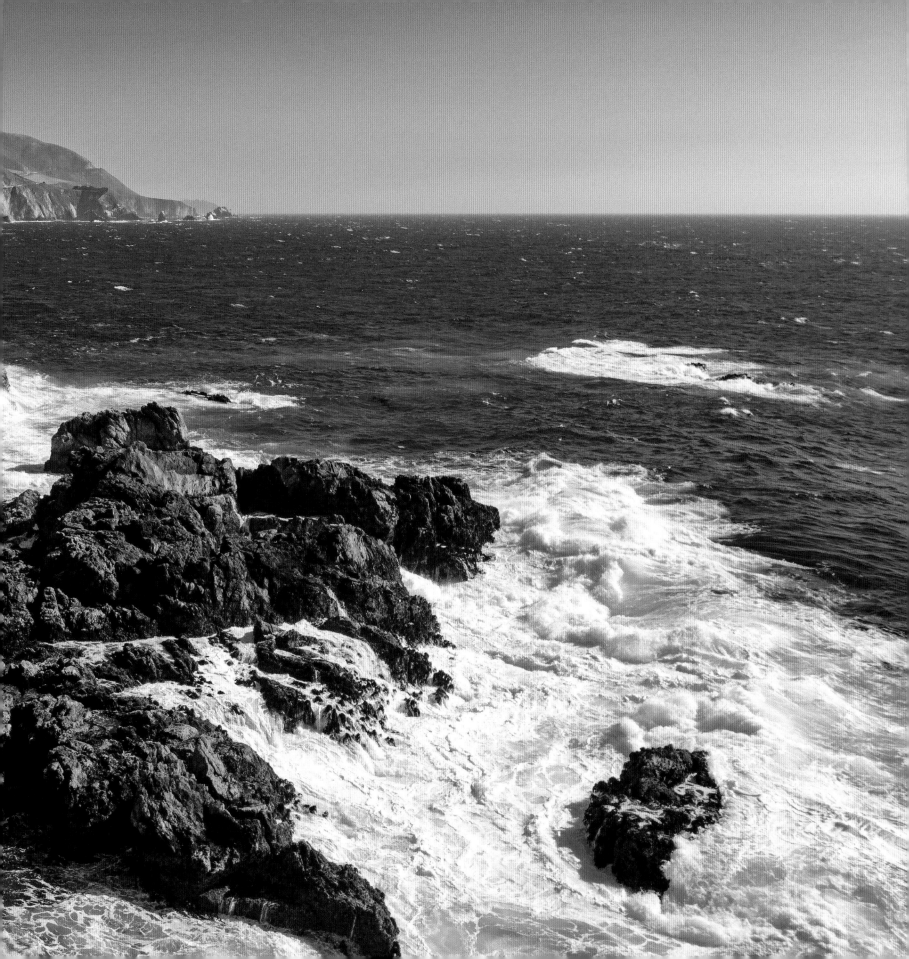

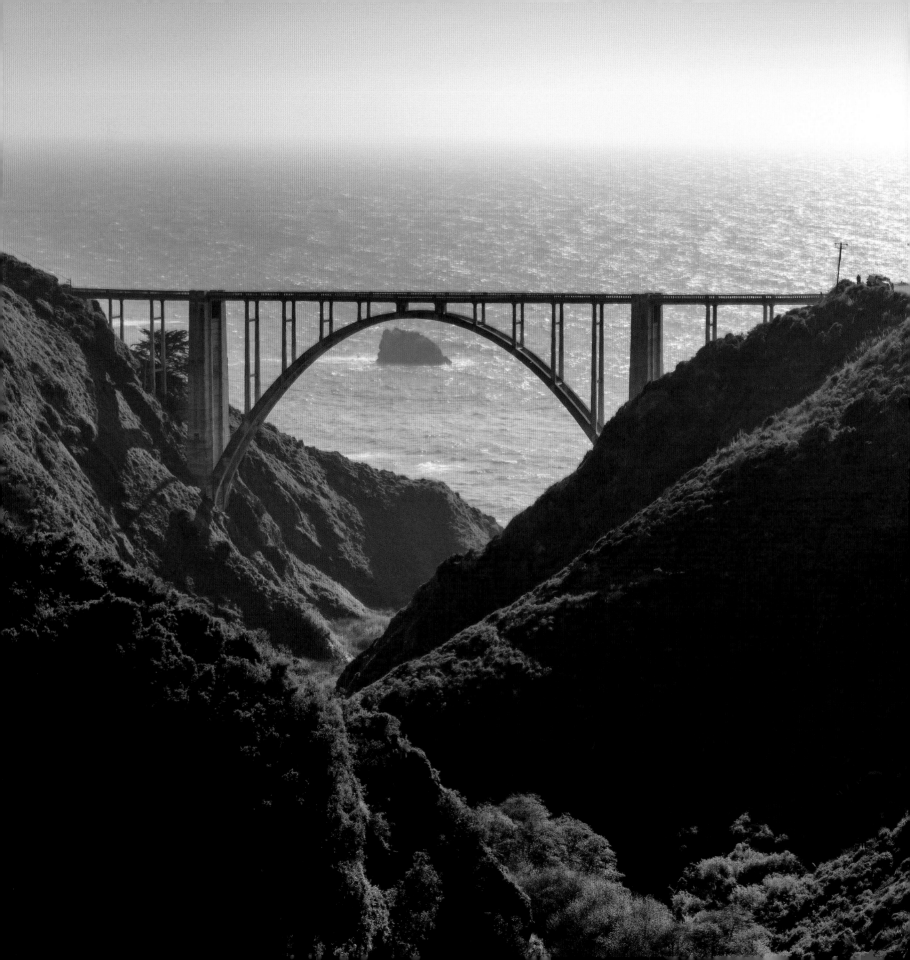

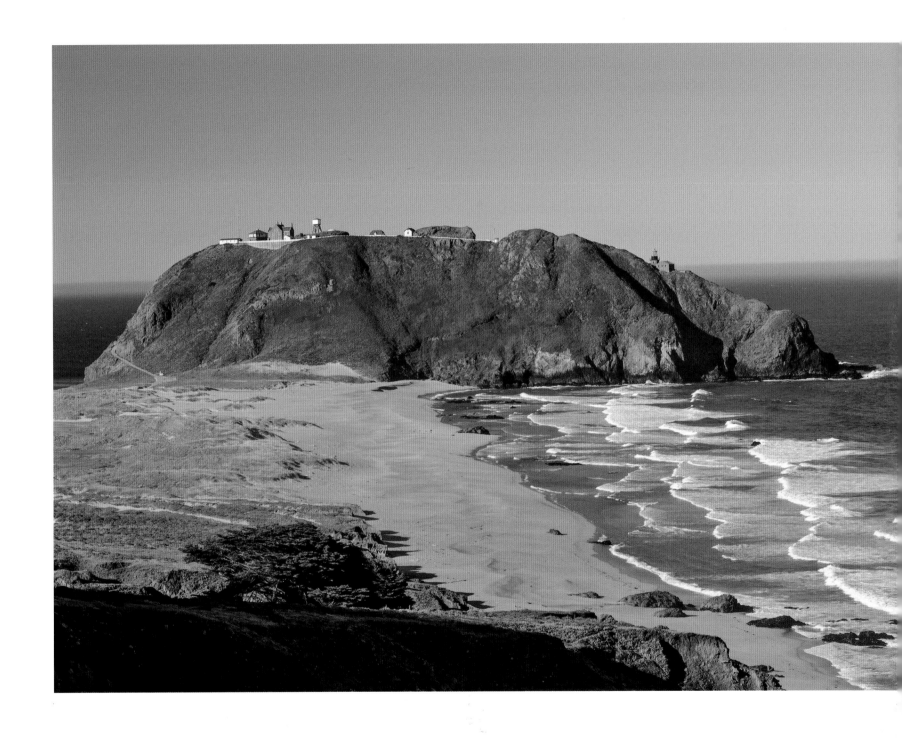

◈ Bixby Creek Bridge, Big Sur

◈ Point Sur Lighthouse, Big Sur

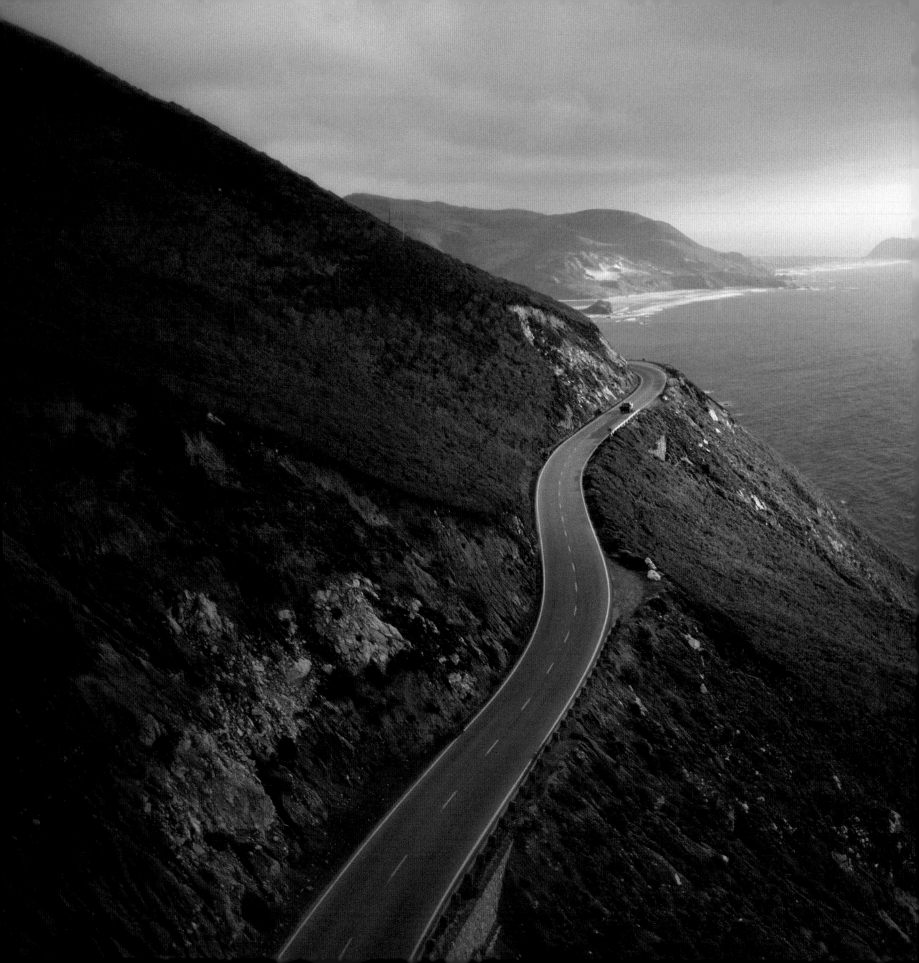

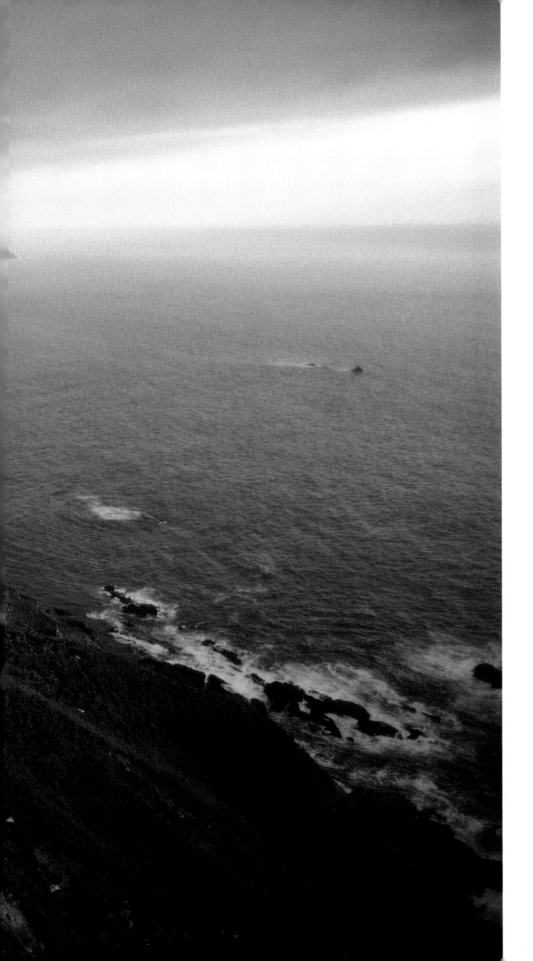

◆ California Route 1, Big Sur

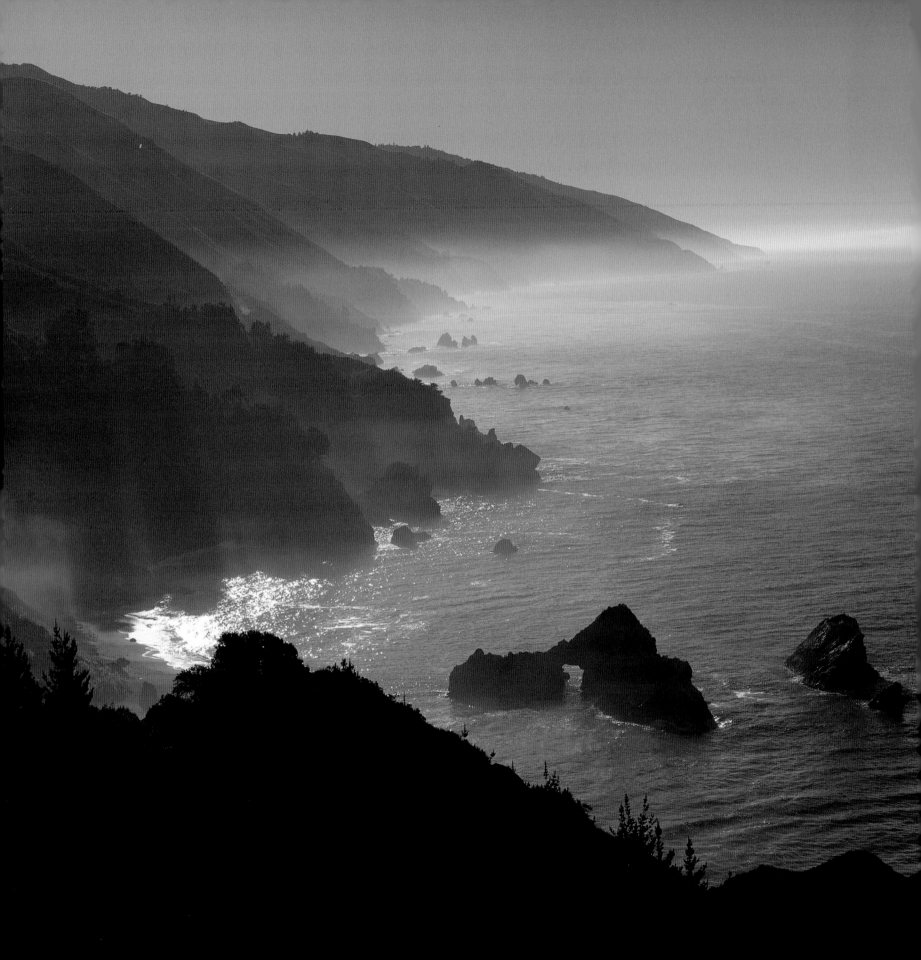

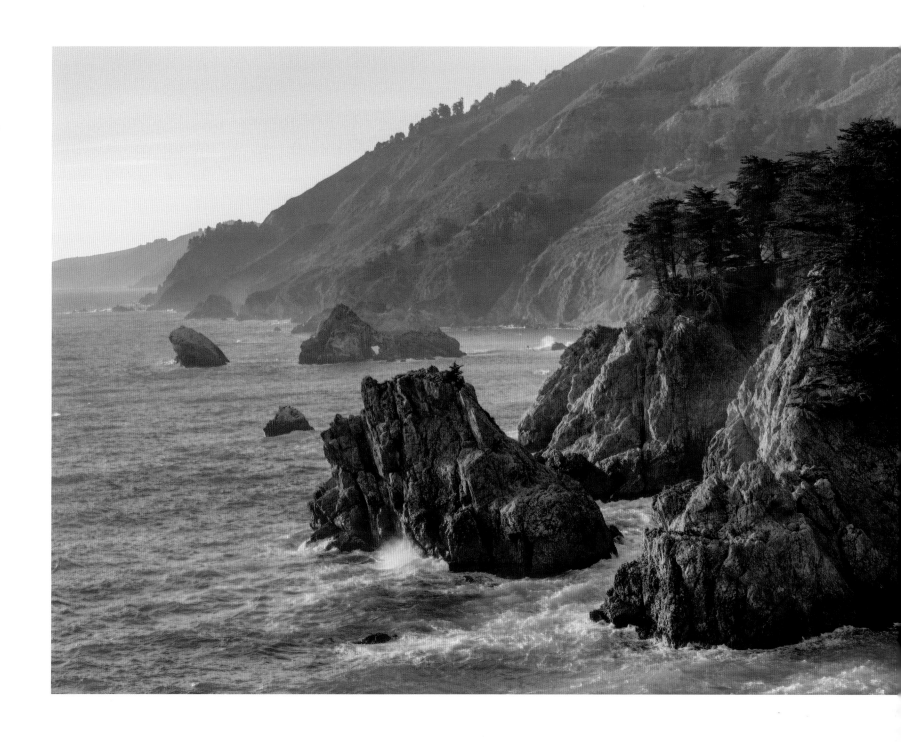

◆ Coastline, Big Sur

⬆ Julia Pfeiffer Burns State Park, Big Sur

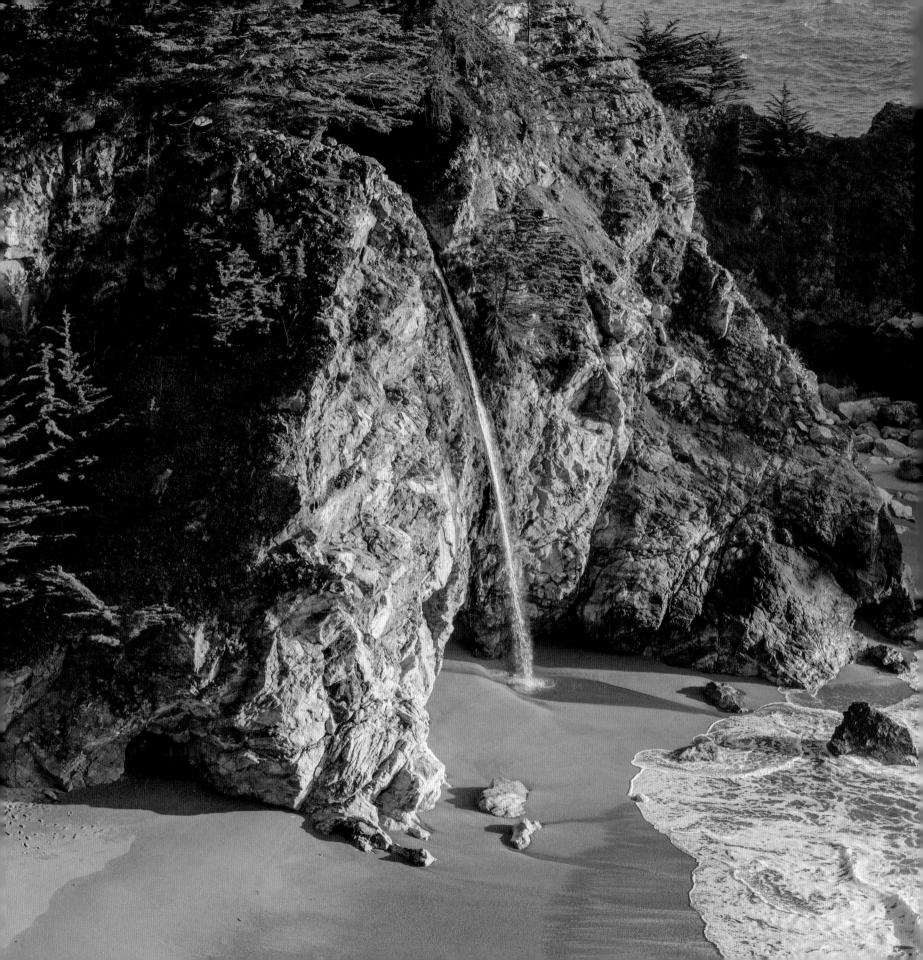

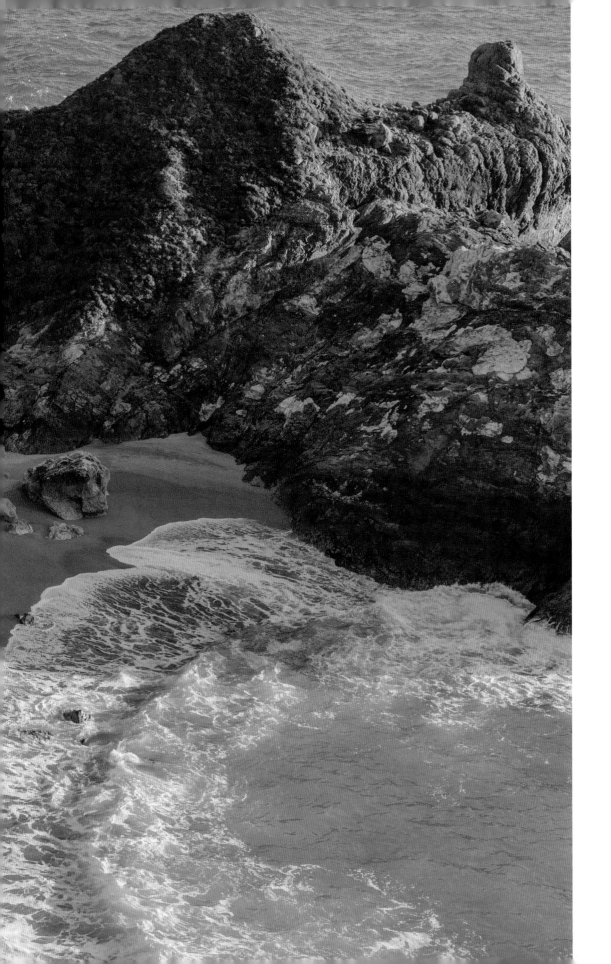

◈ McWay Cove and Falls, Julia
Pfeiffer Burns State Park, Big Sur

◈ Coast Gallery, Big Sur (top left);
Post Ranch Inn entrance, Big Sur
(bottom left); Los Padres National
Forest, Big Sur (right)

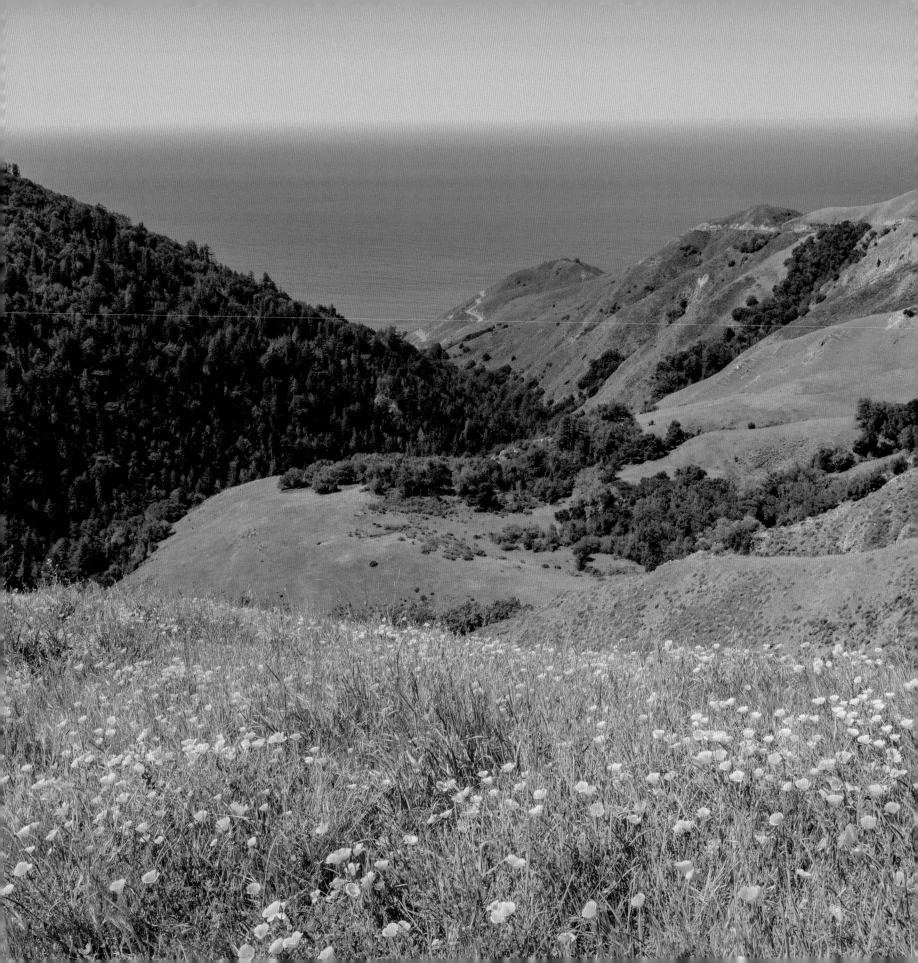

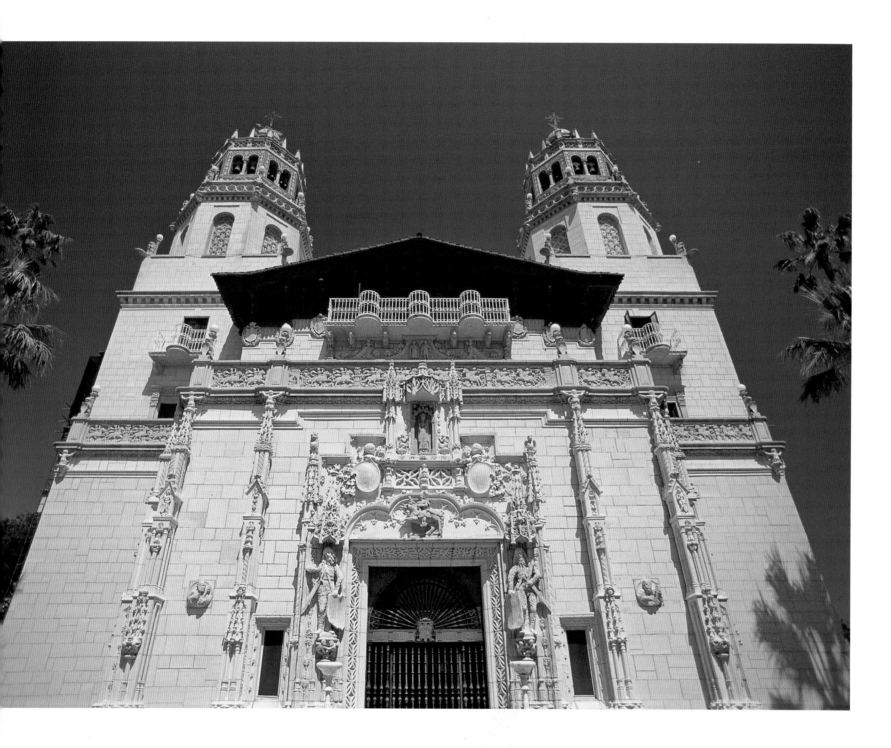

◈ ◈ ⬇ Hearst Castle, San Simeon

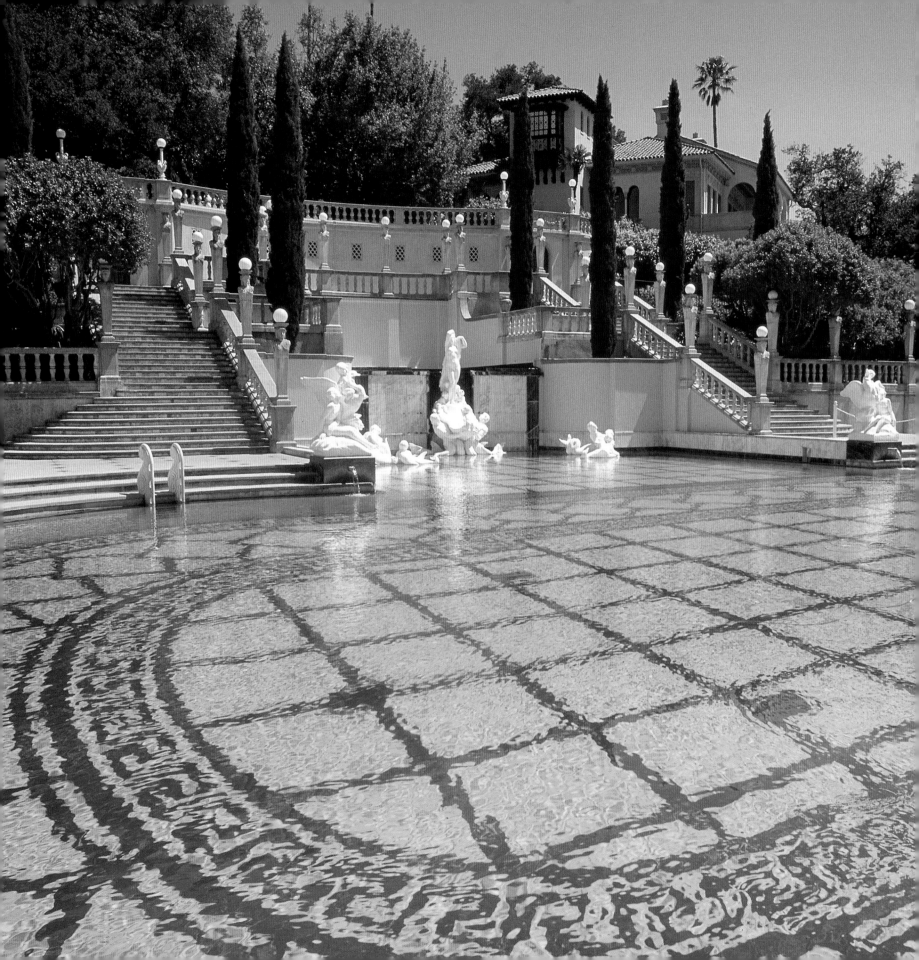

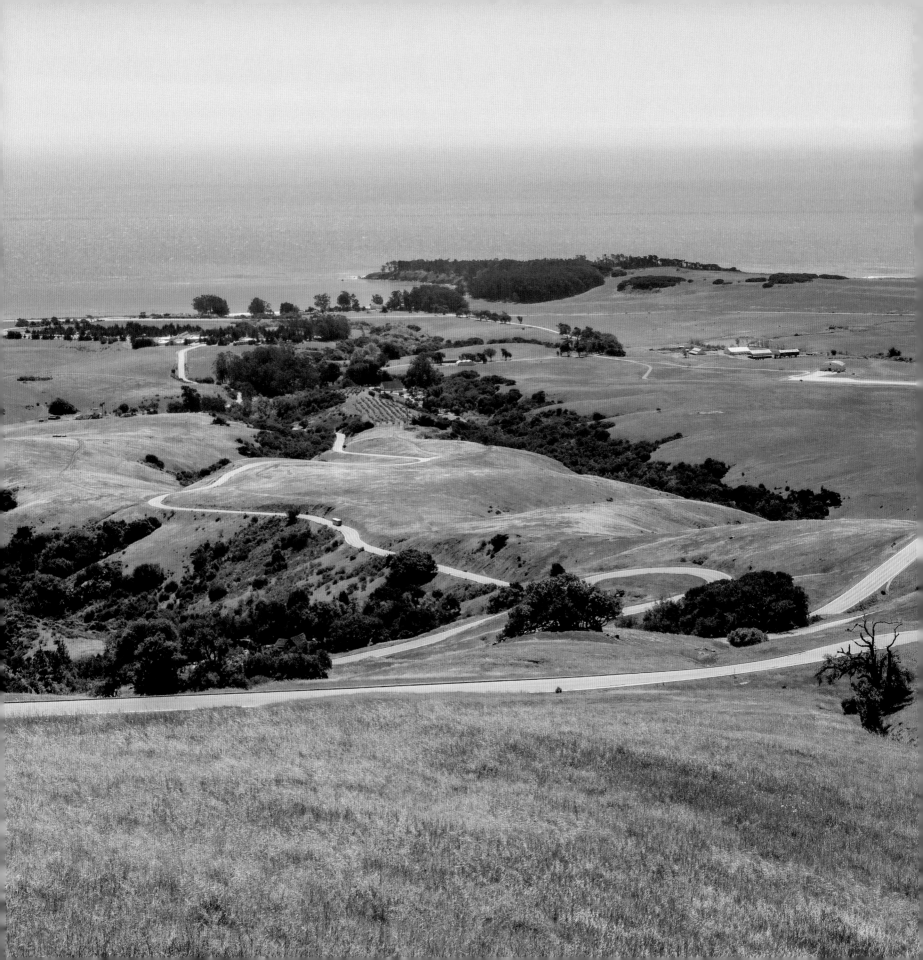

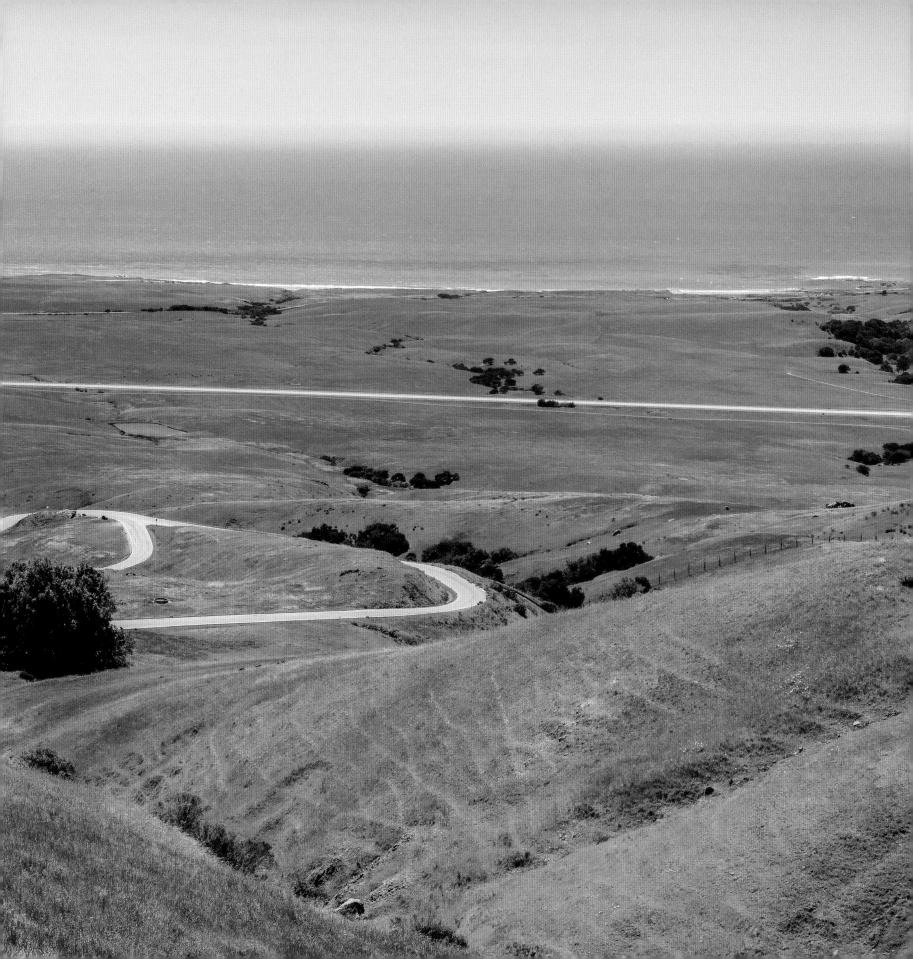

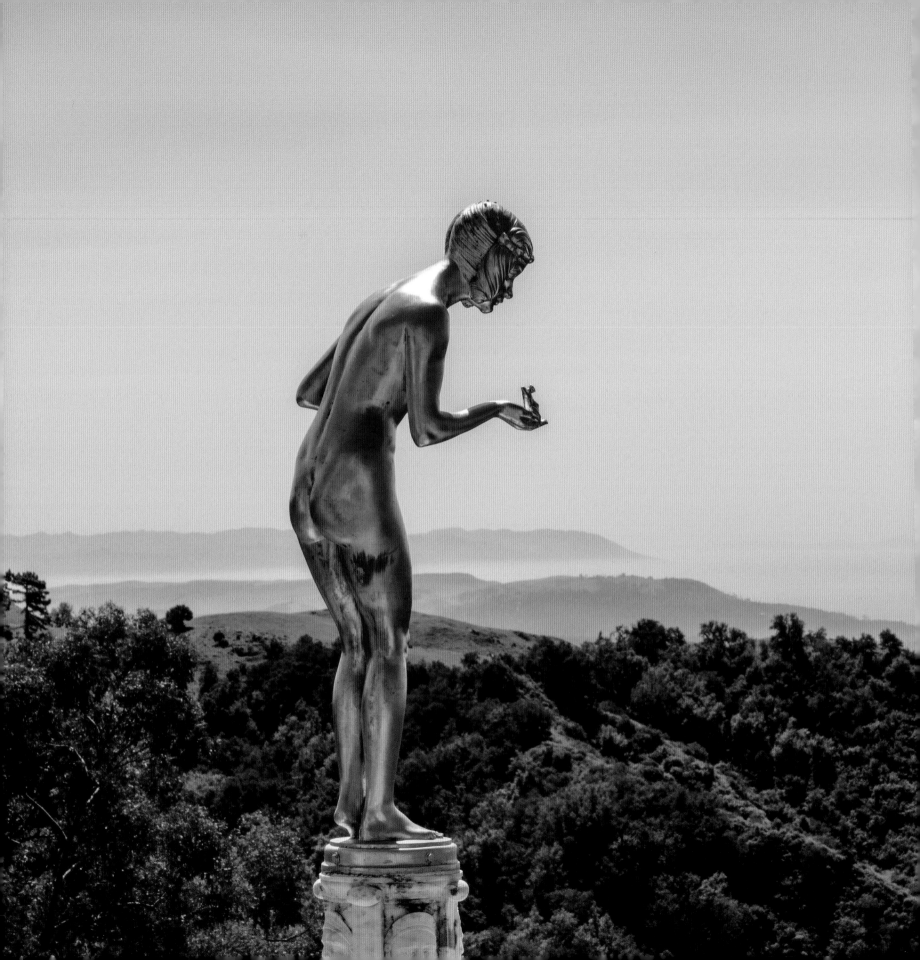

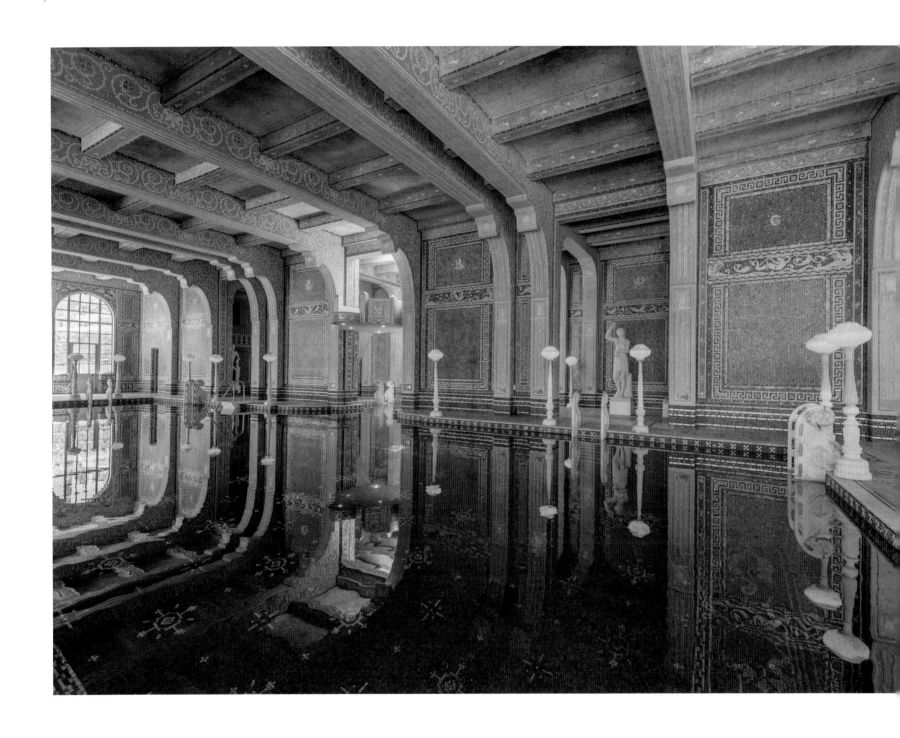

◆ ⬧ Hearst Castle, San Simeon

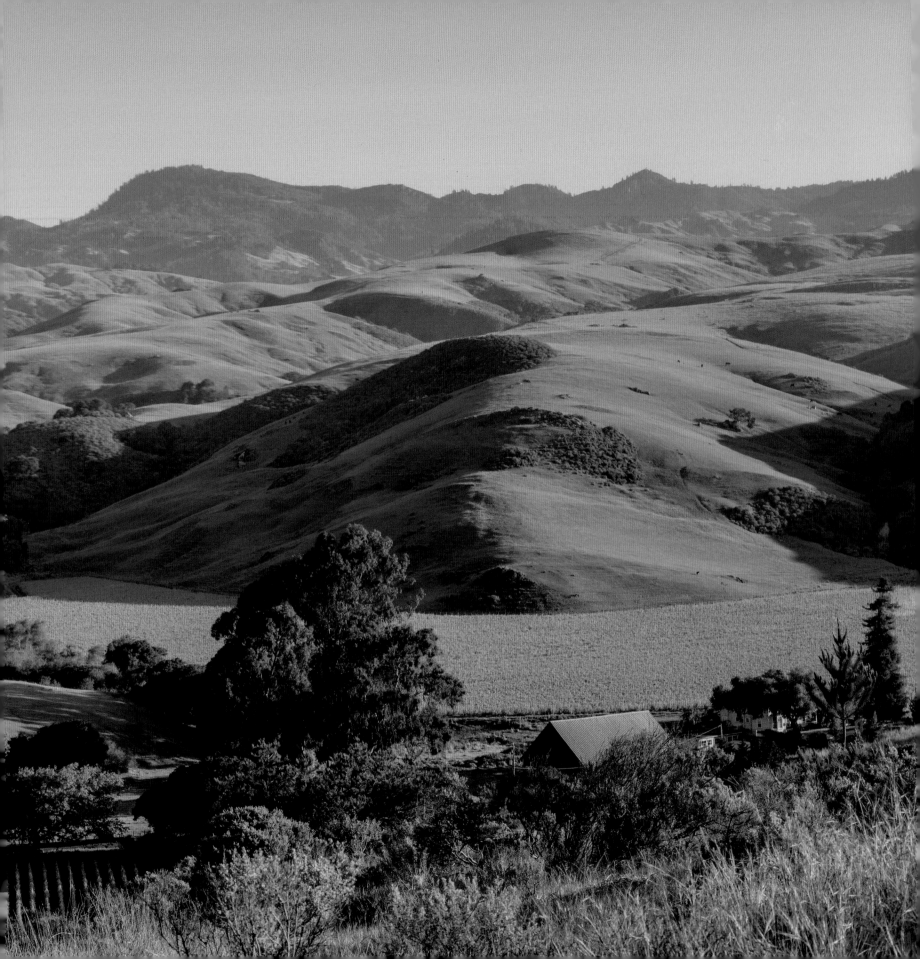

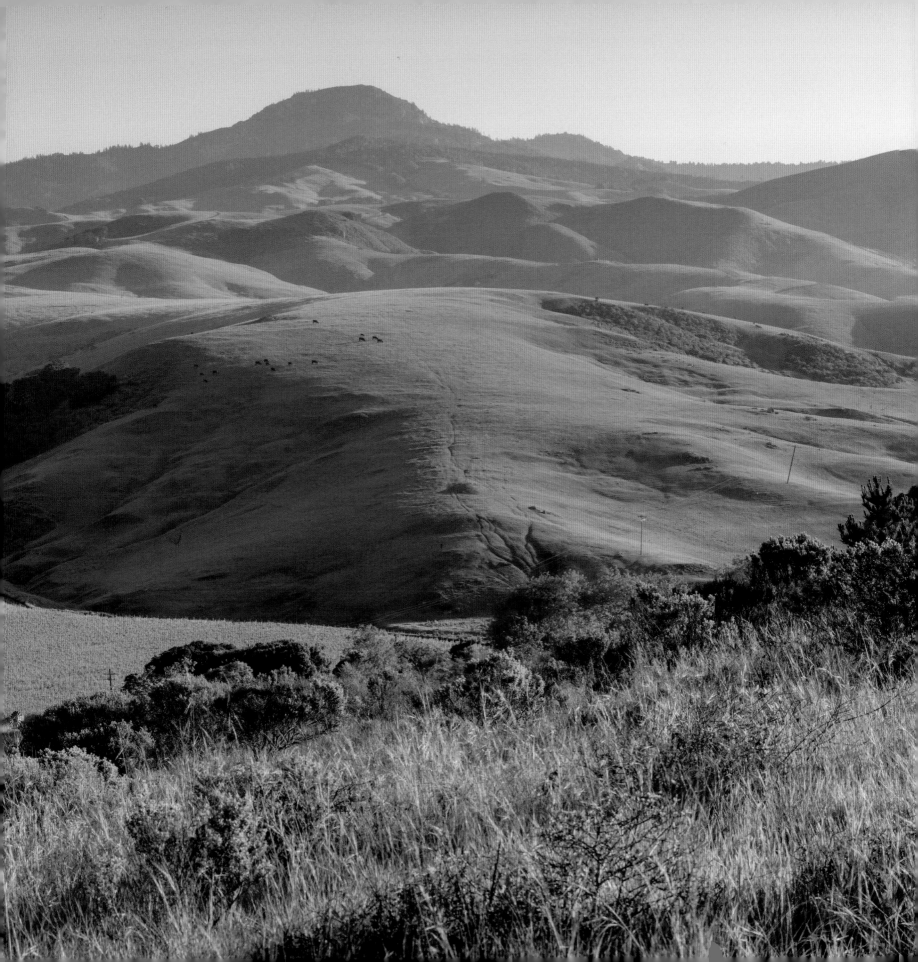

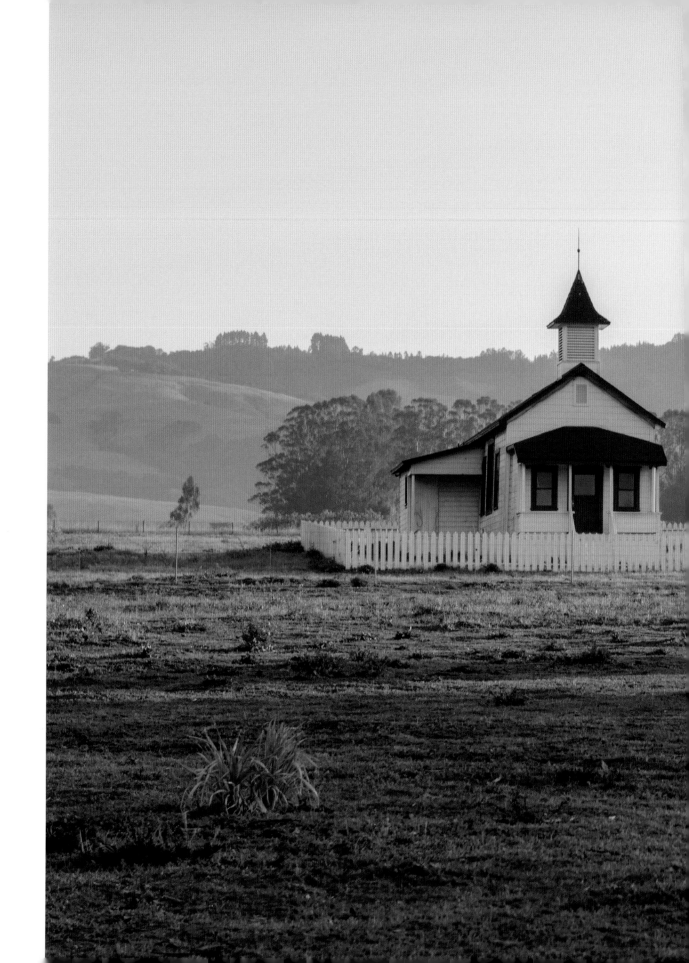

◈ ◈ San Simeon

◈ Morro Bay, San Luis
 Obispo County

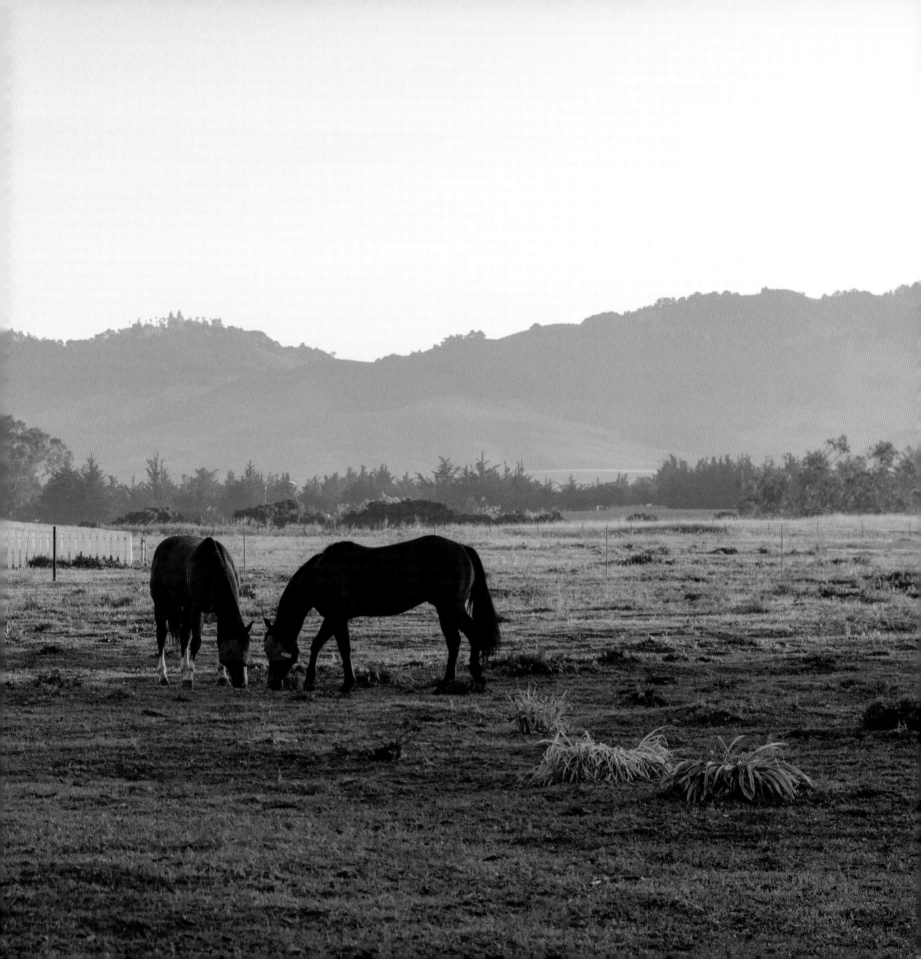

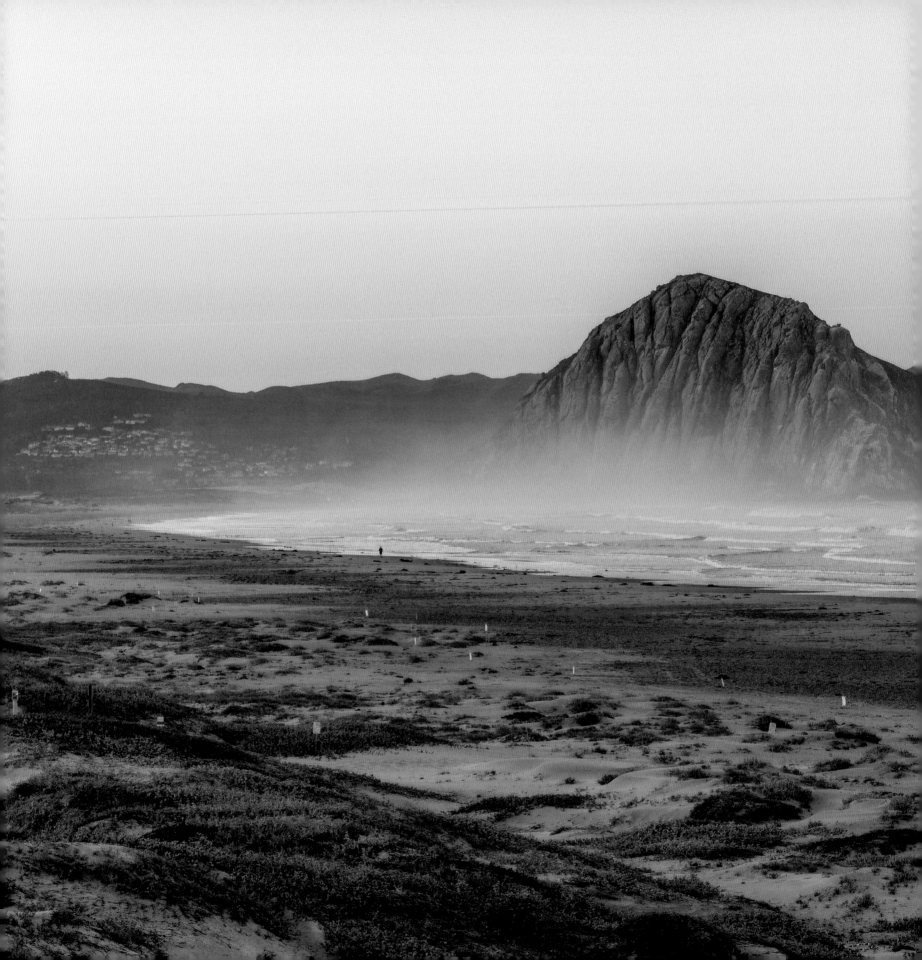

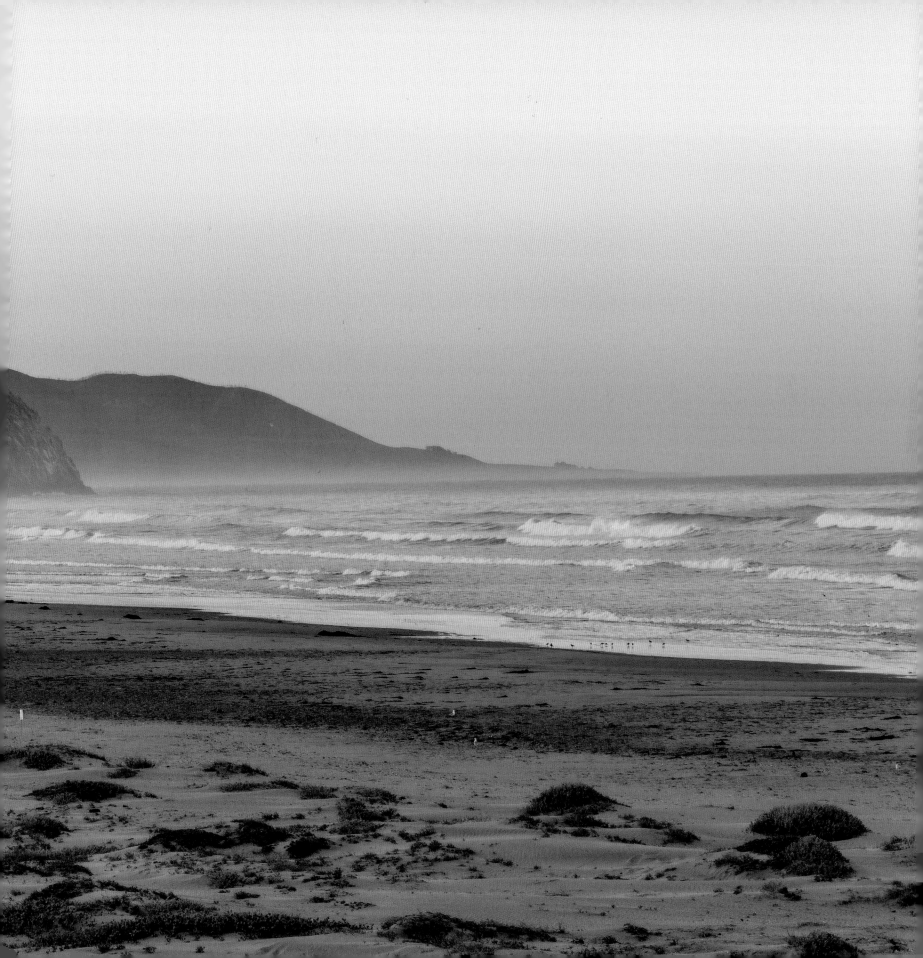

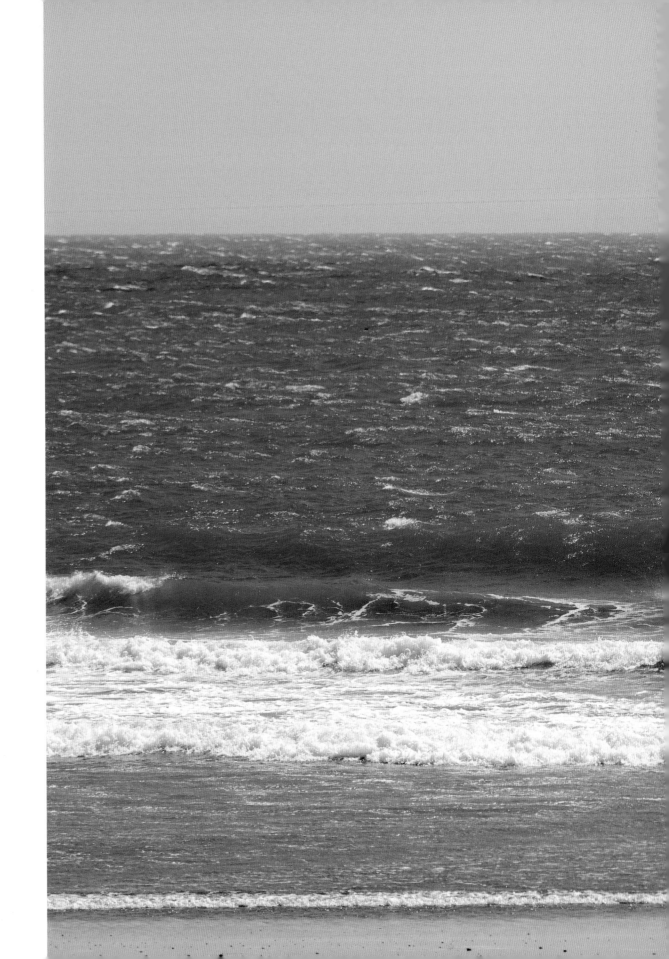

◈ Windsurfer, San Simeon

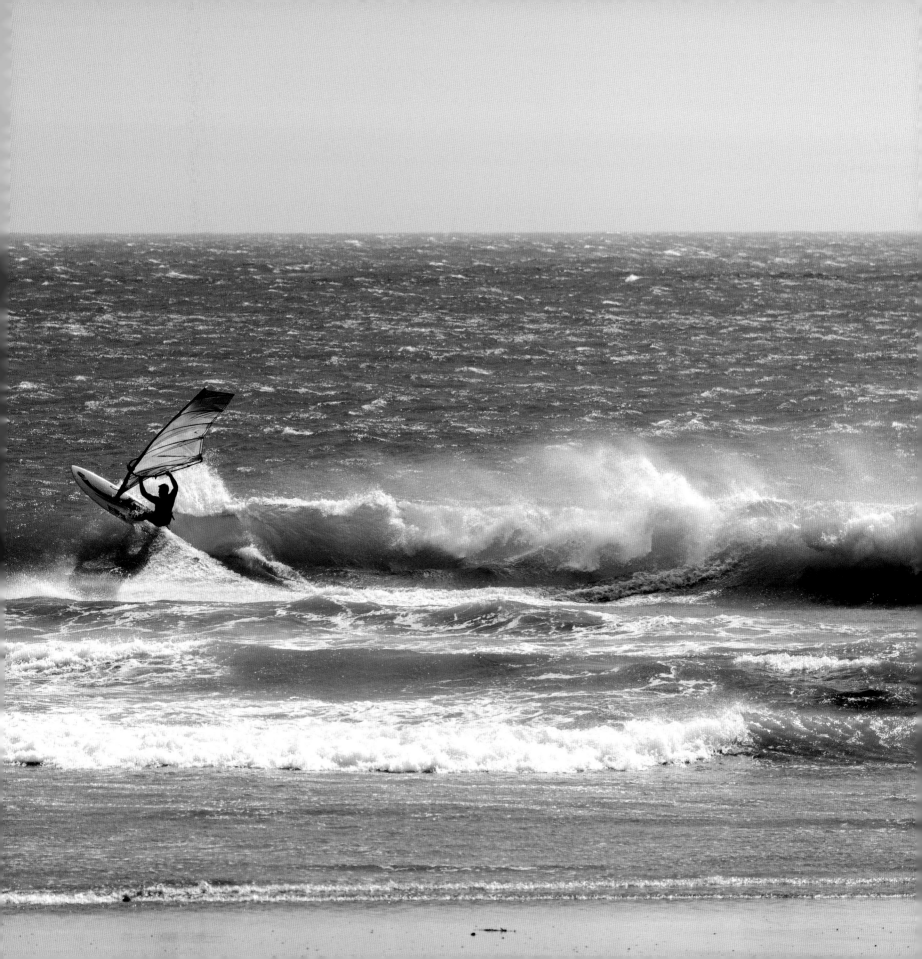

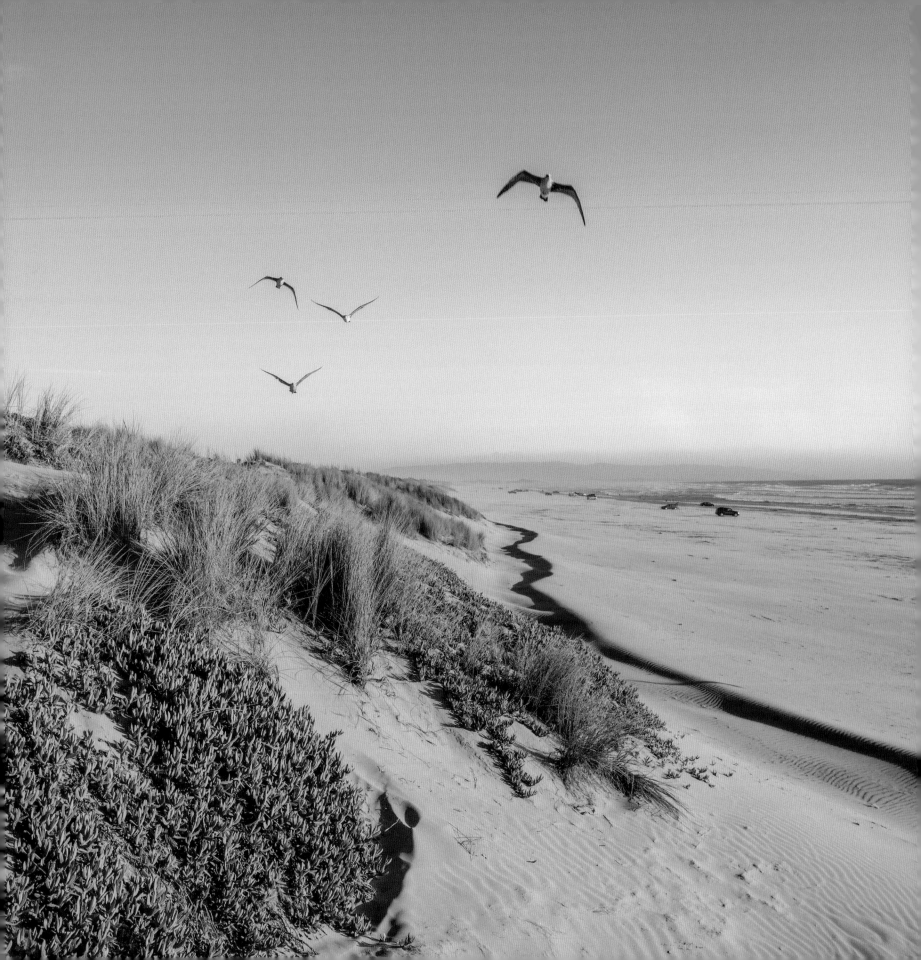

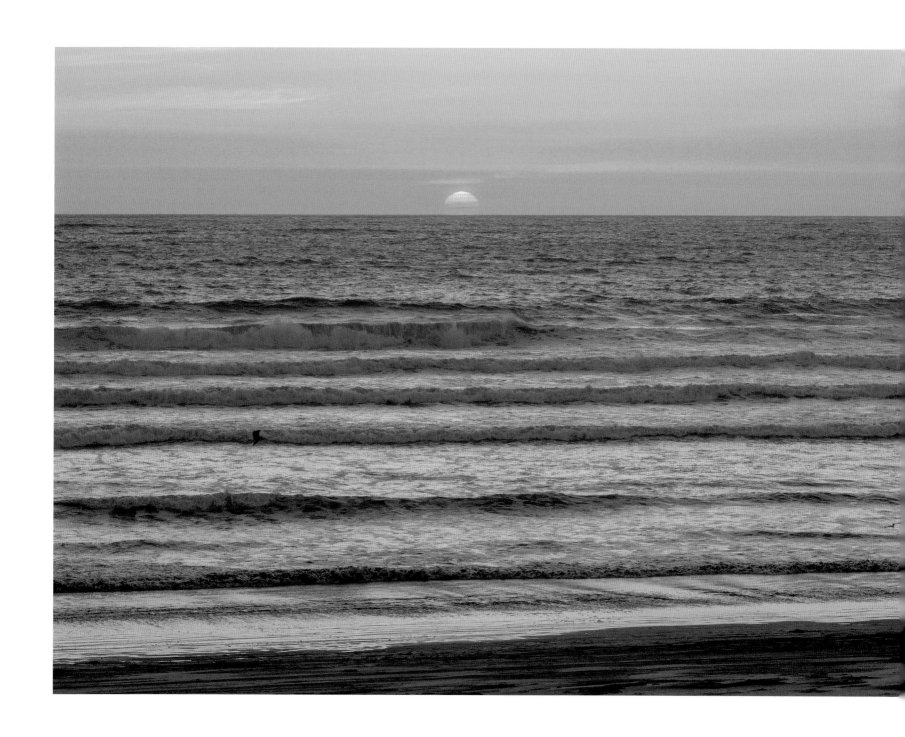

Oceano Dunes State Vehicular Recreation Area, Oceano

Moonstone Beach, Cambria

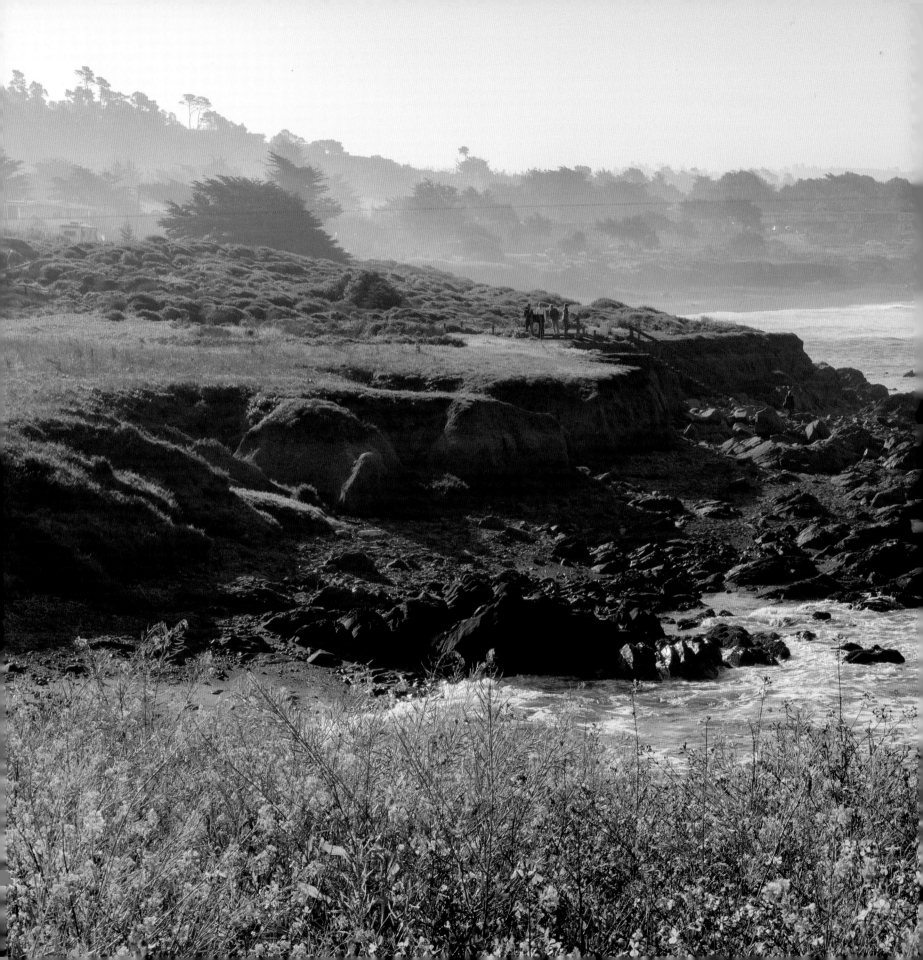

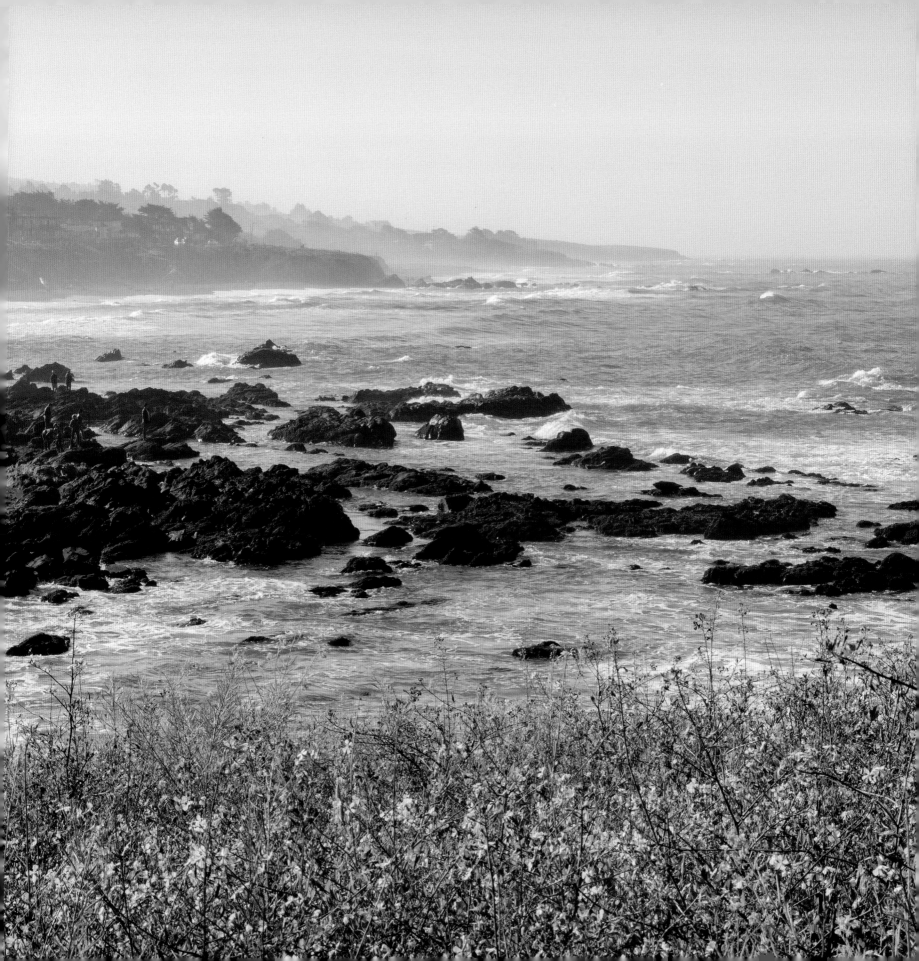

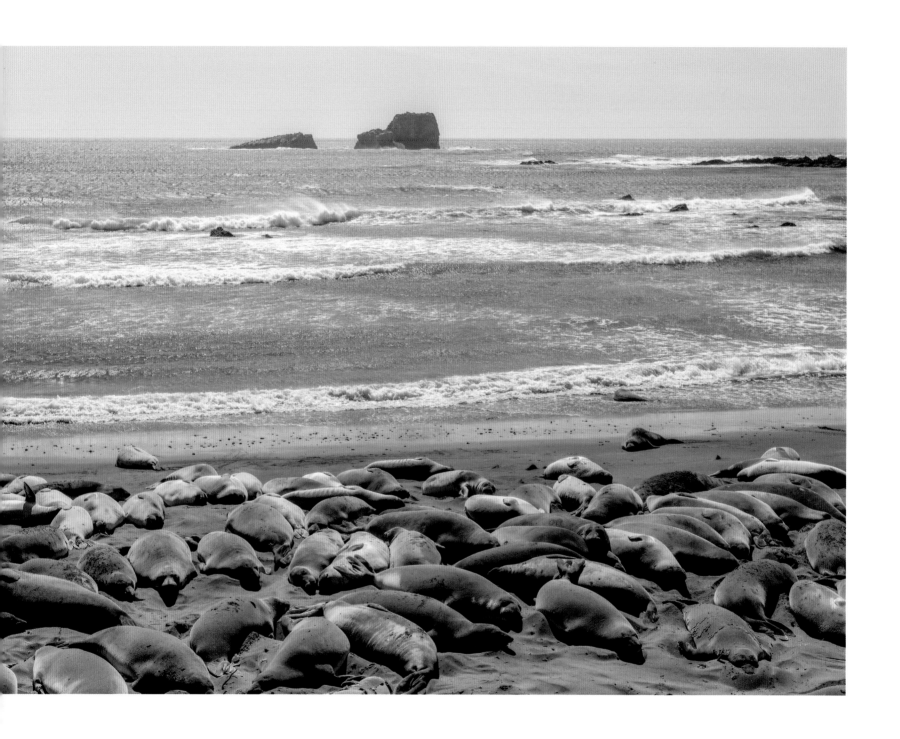

↑ → Piedras Blancas Elephant Seal Rookery, San Simeon

⬇ El Capitán State Beach, Santa Barbara

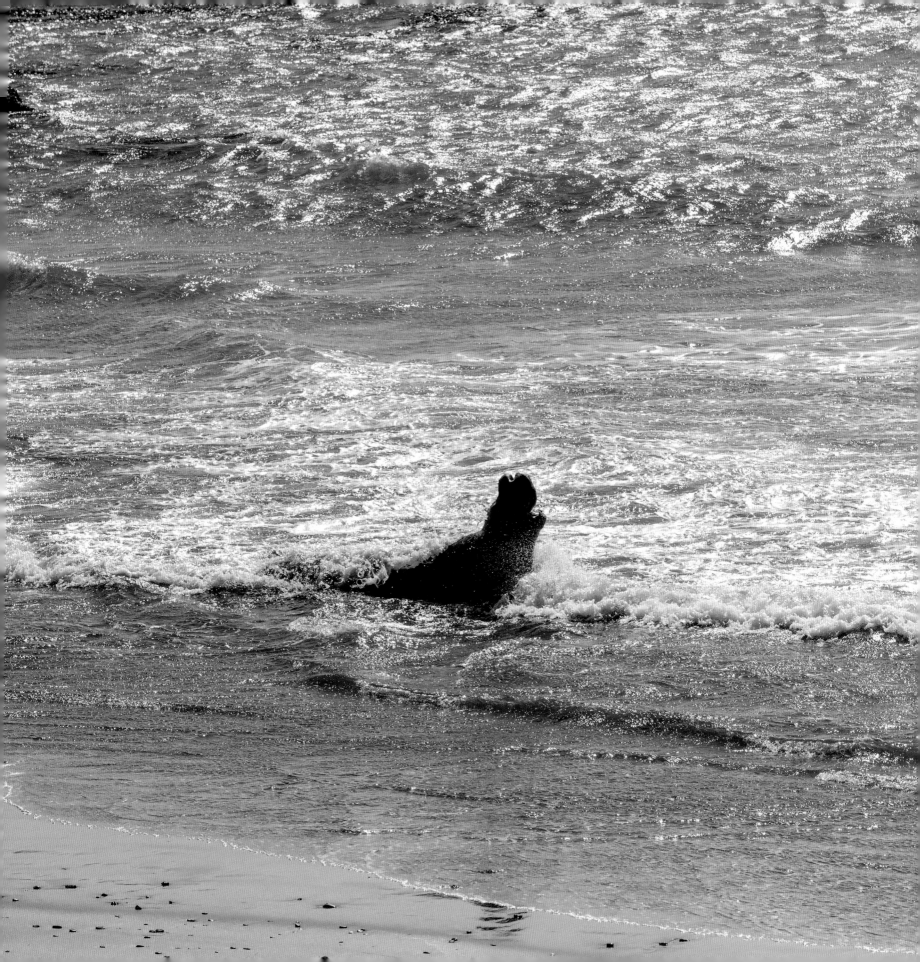

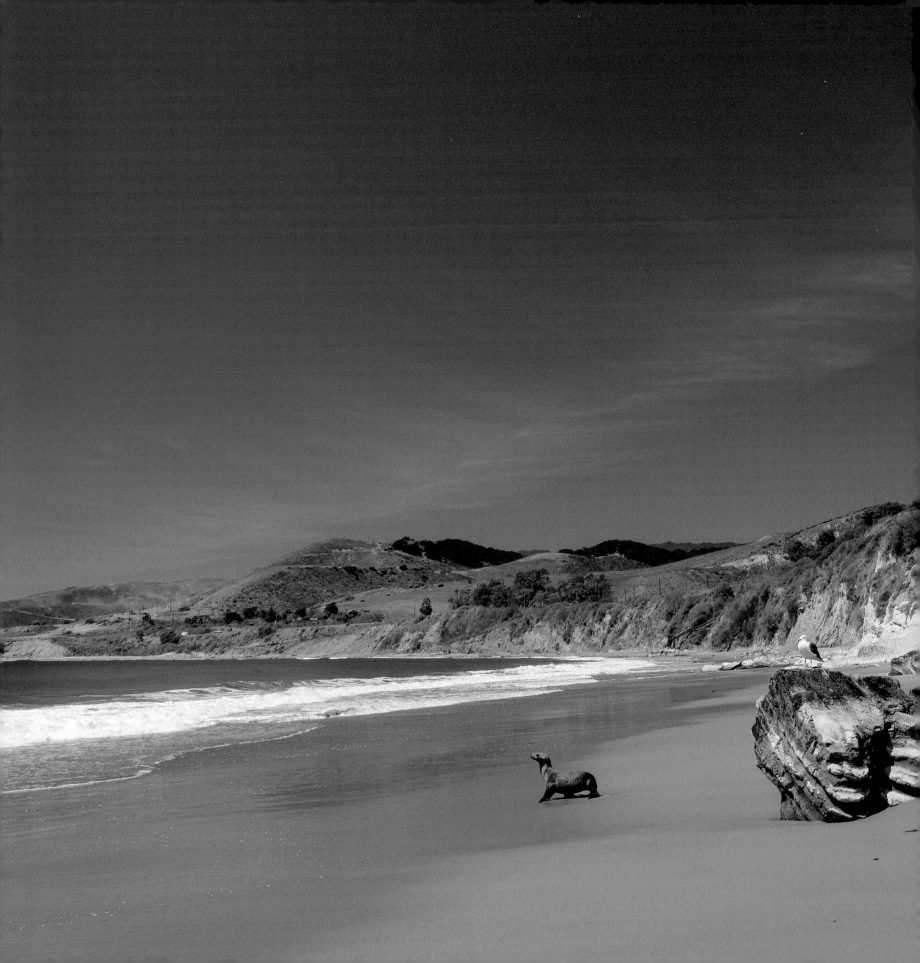

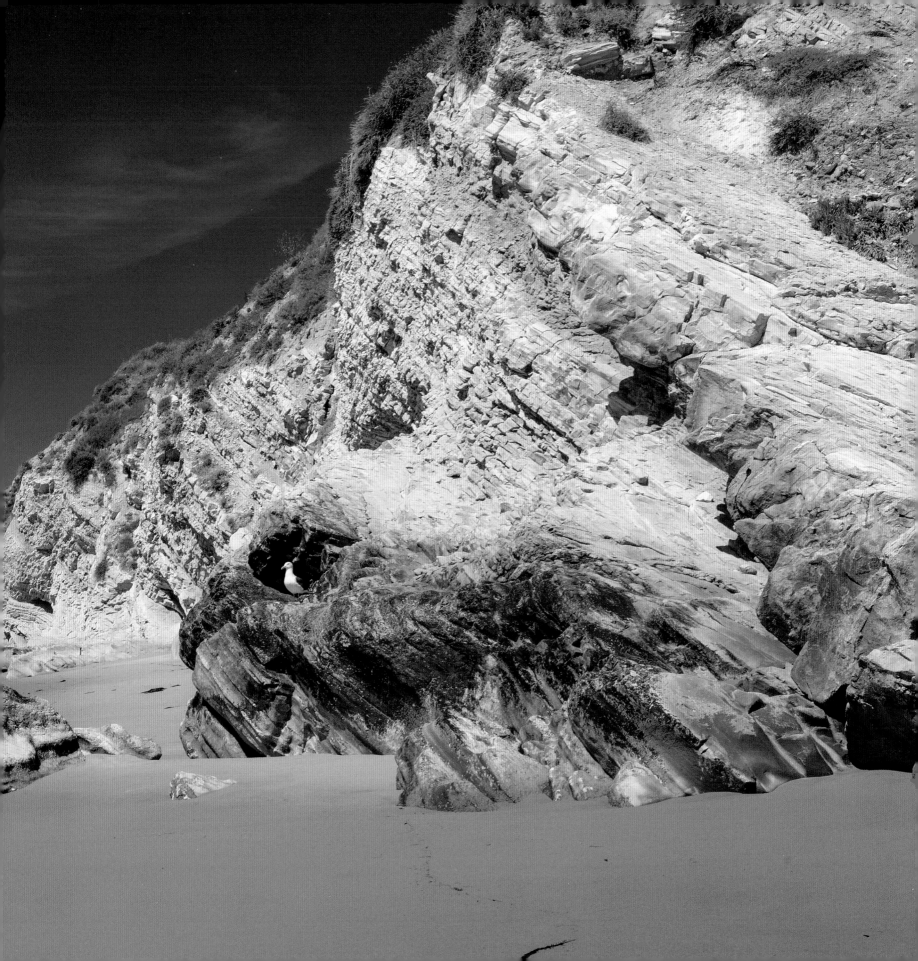

◈ El Capitán State Beach, Santa Barbara

◆ Santa Barbara

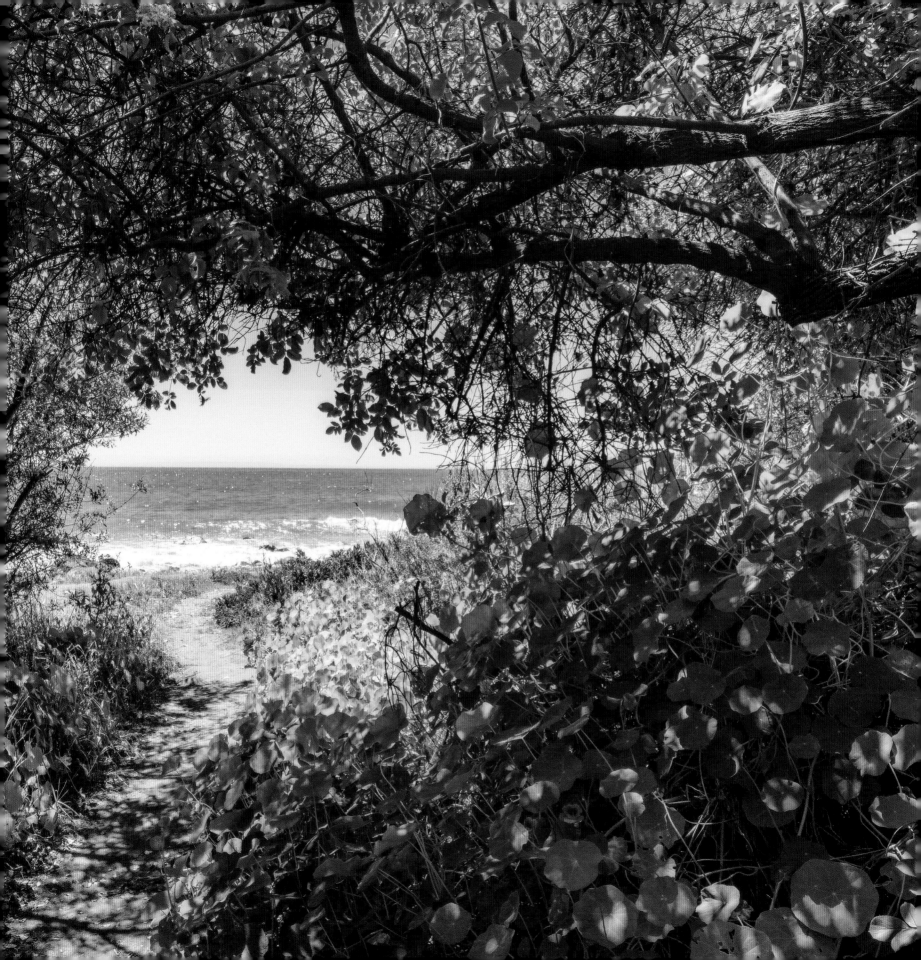

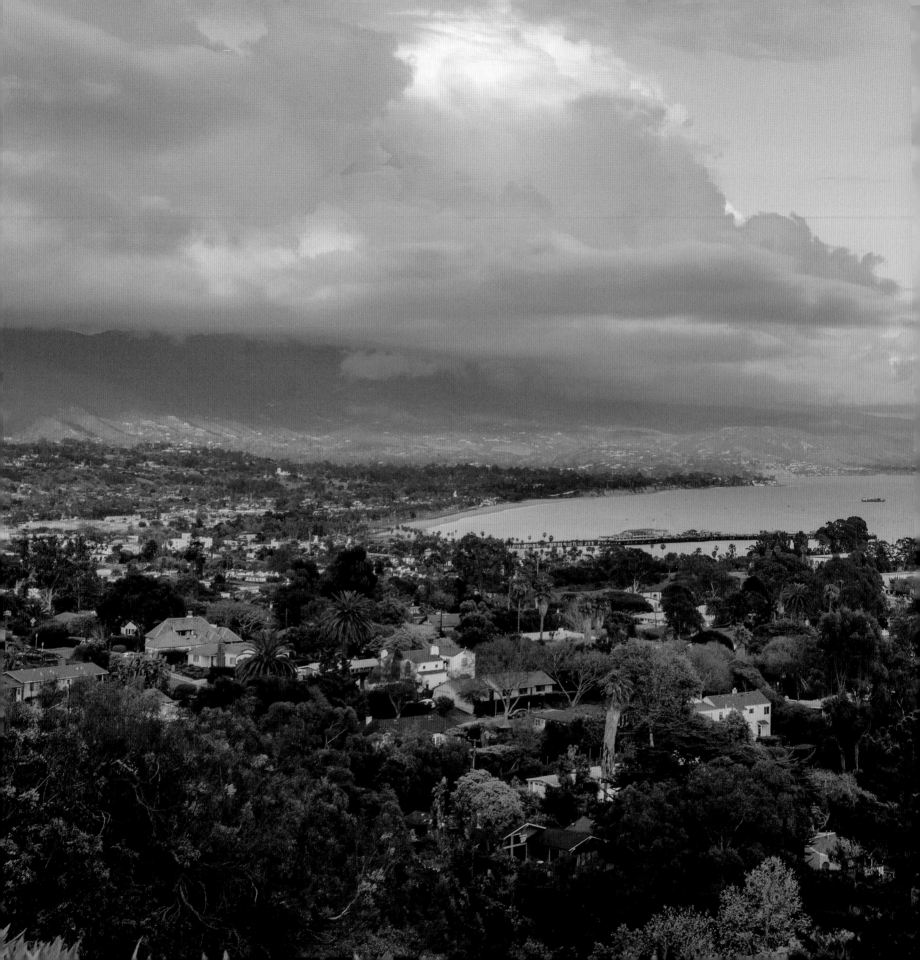

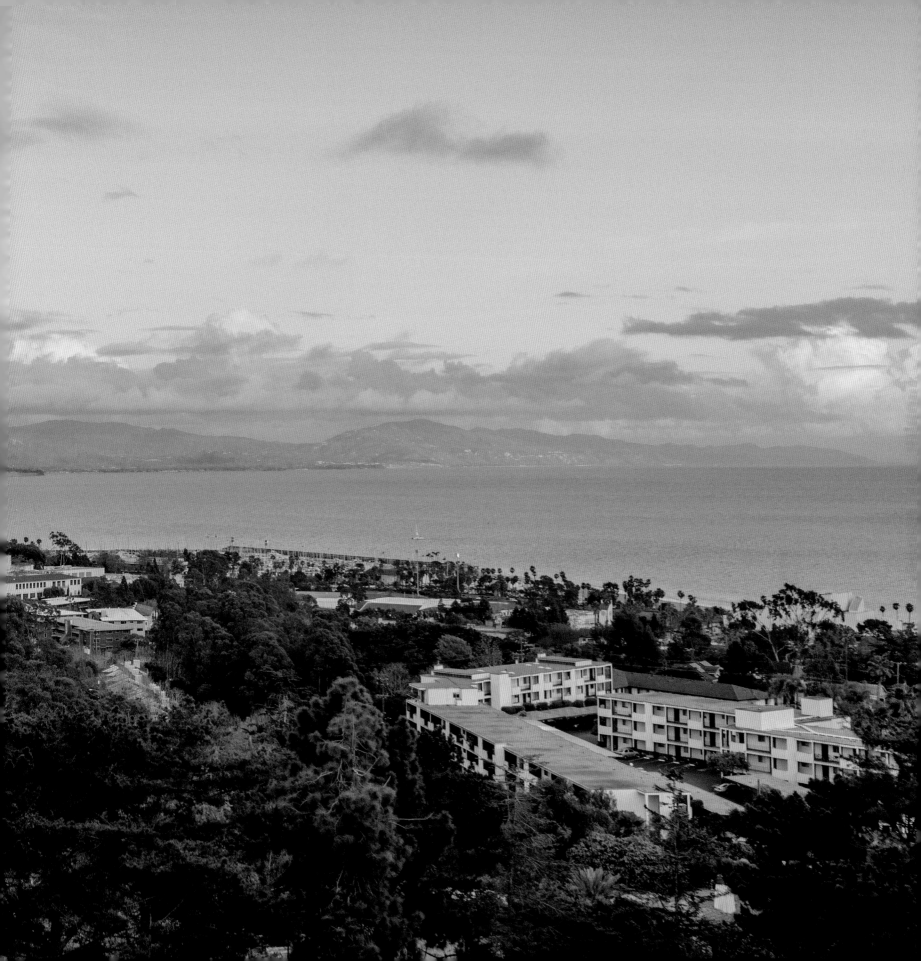

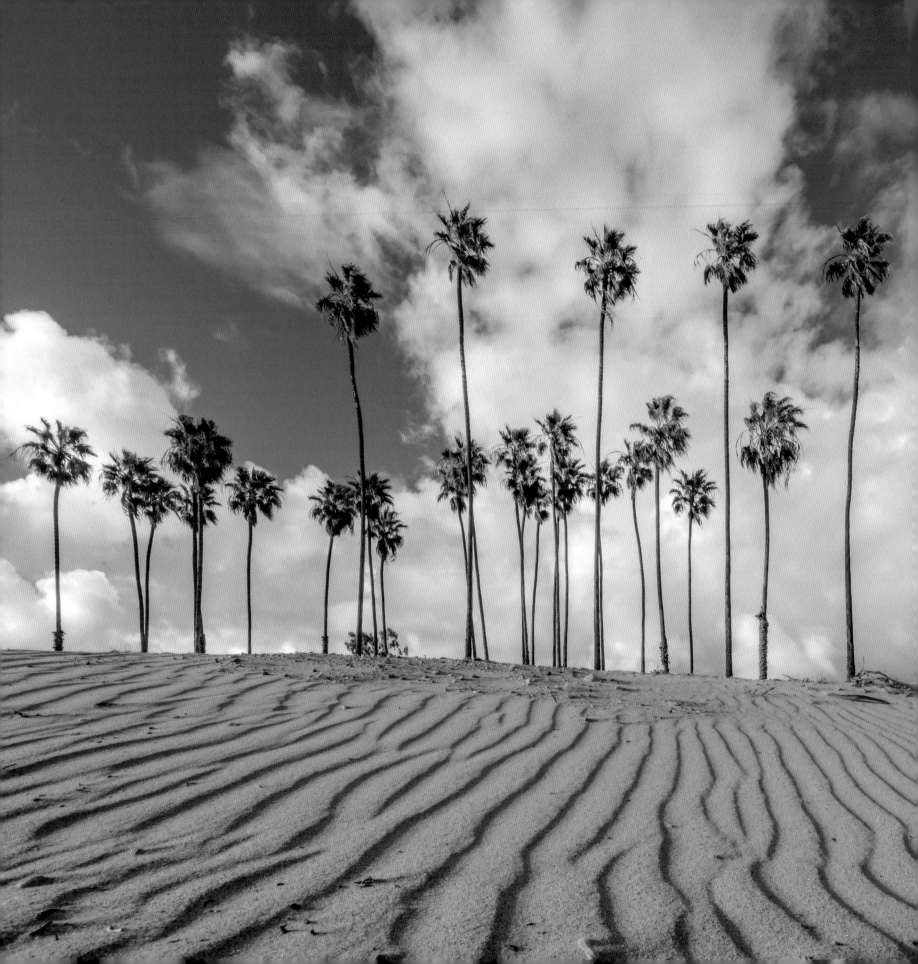

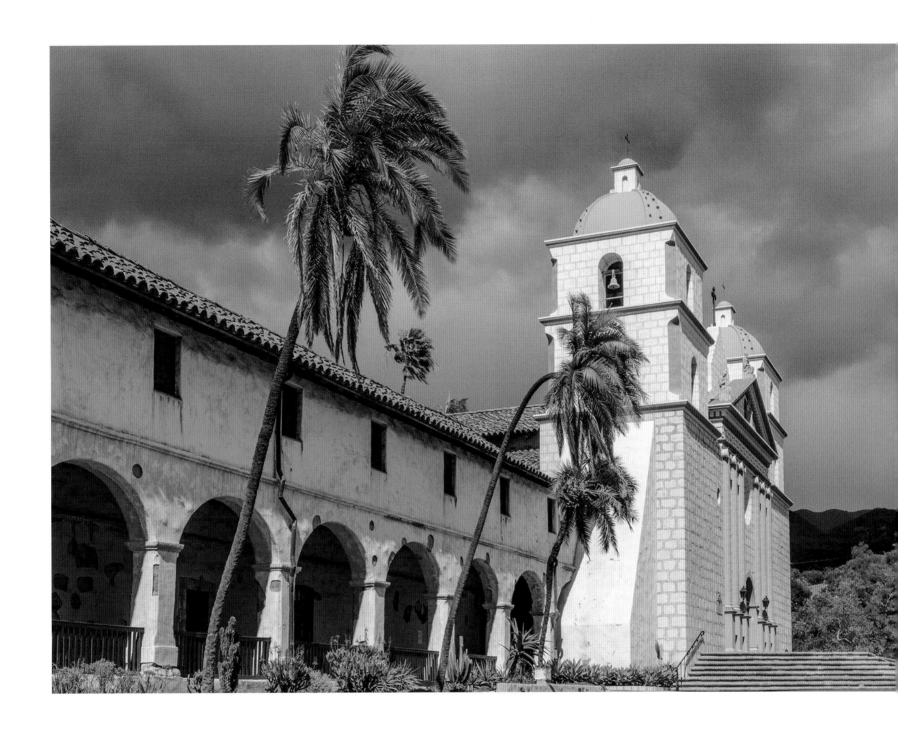

◆ Chase Palm Park, Santa Barbara

◆ Santa Barbara Mission, Santa Barbara

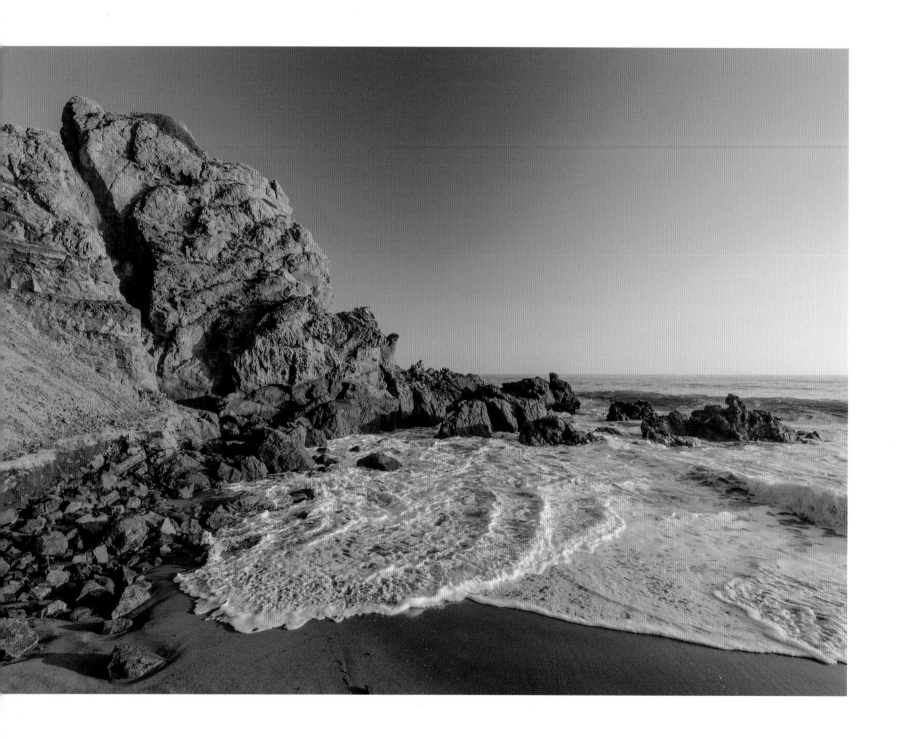

◈ Point Mugu State Park, Malibu

◈ El Matador State Beach, Malibu

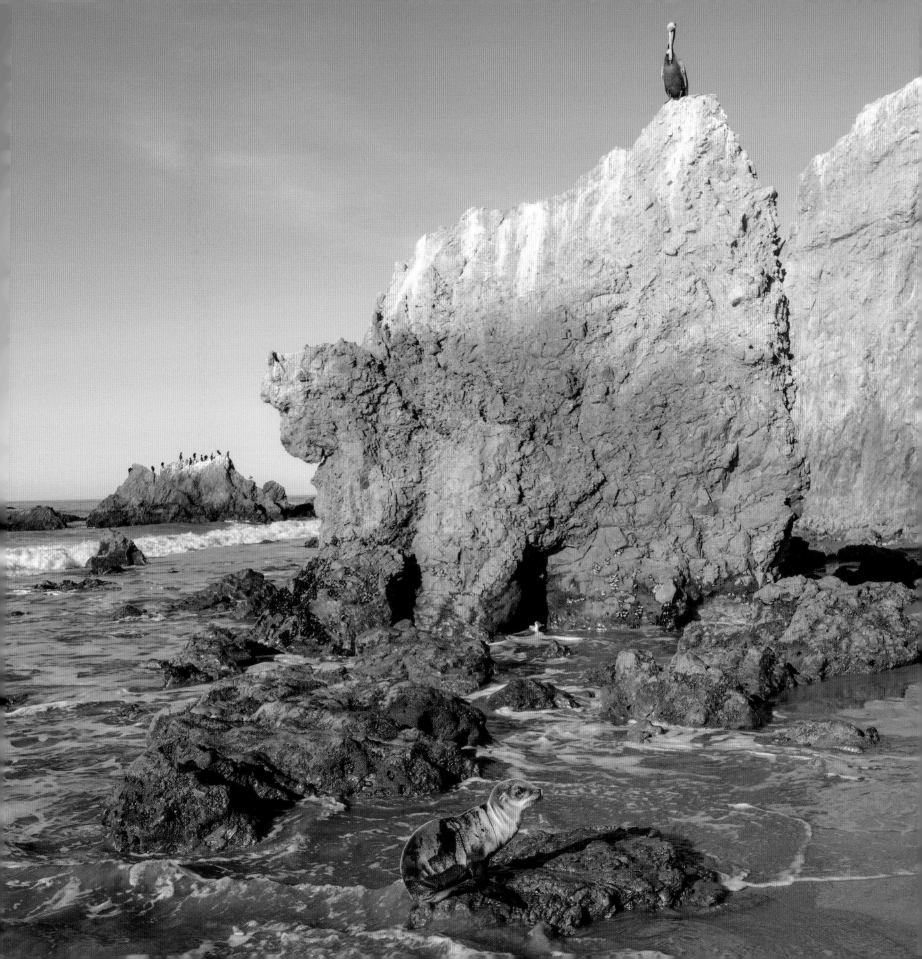

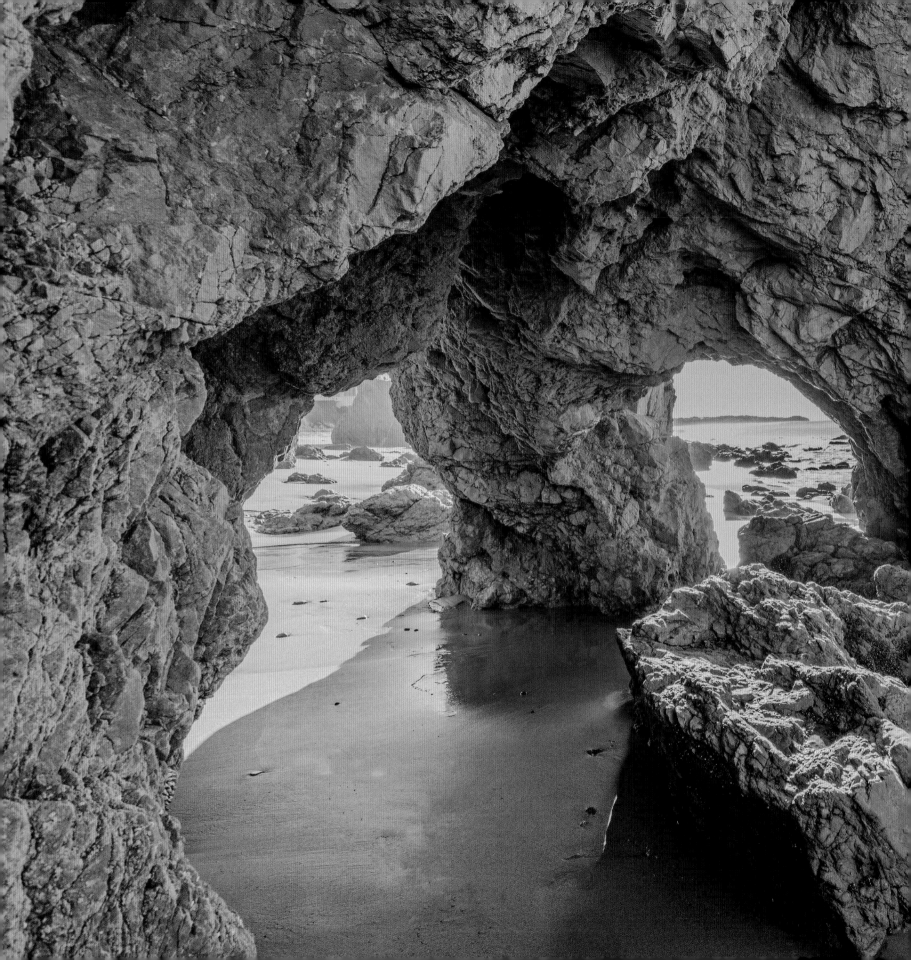

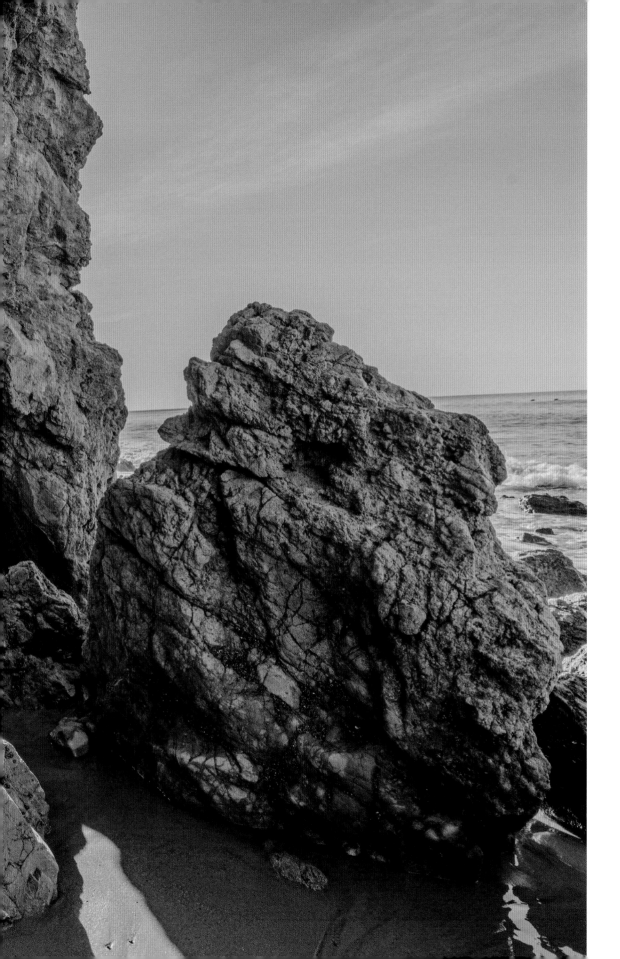

El Matador State Beach, Malibu

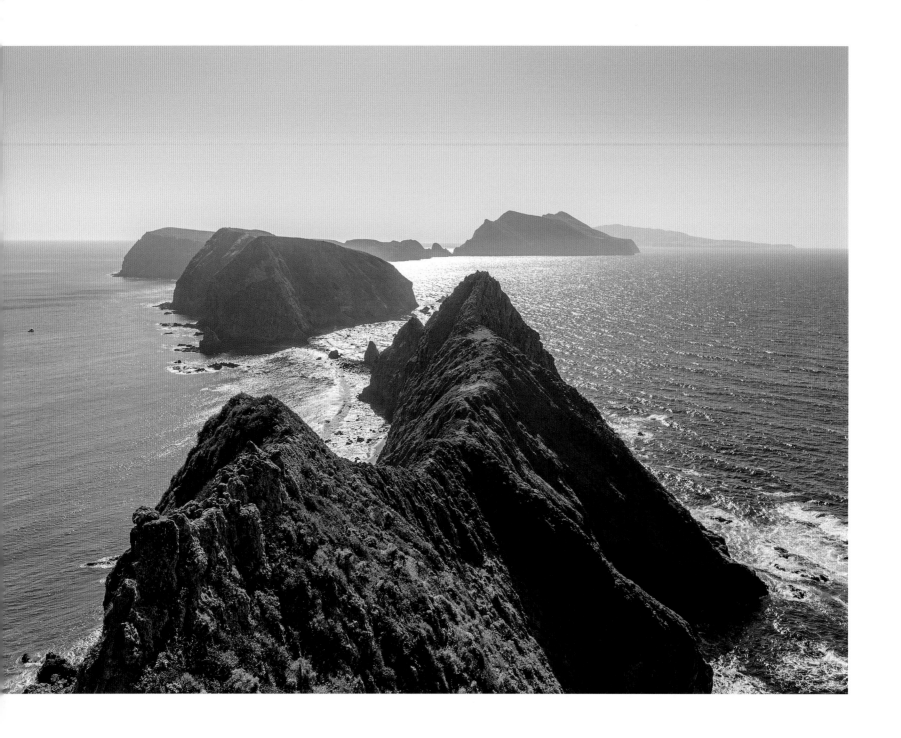

◈ ◈ ◈ Channel Islands National Park, Ventura County

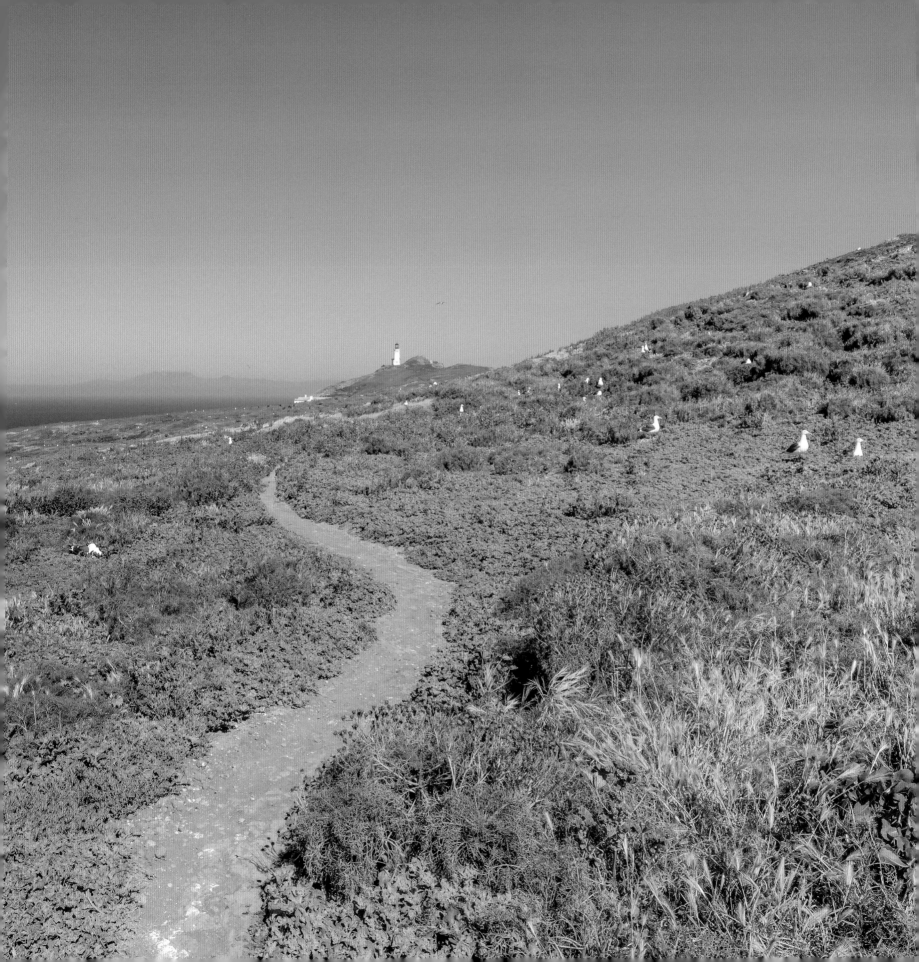

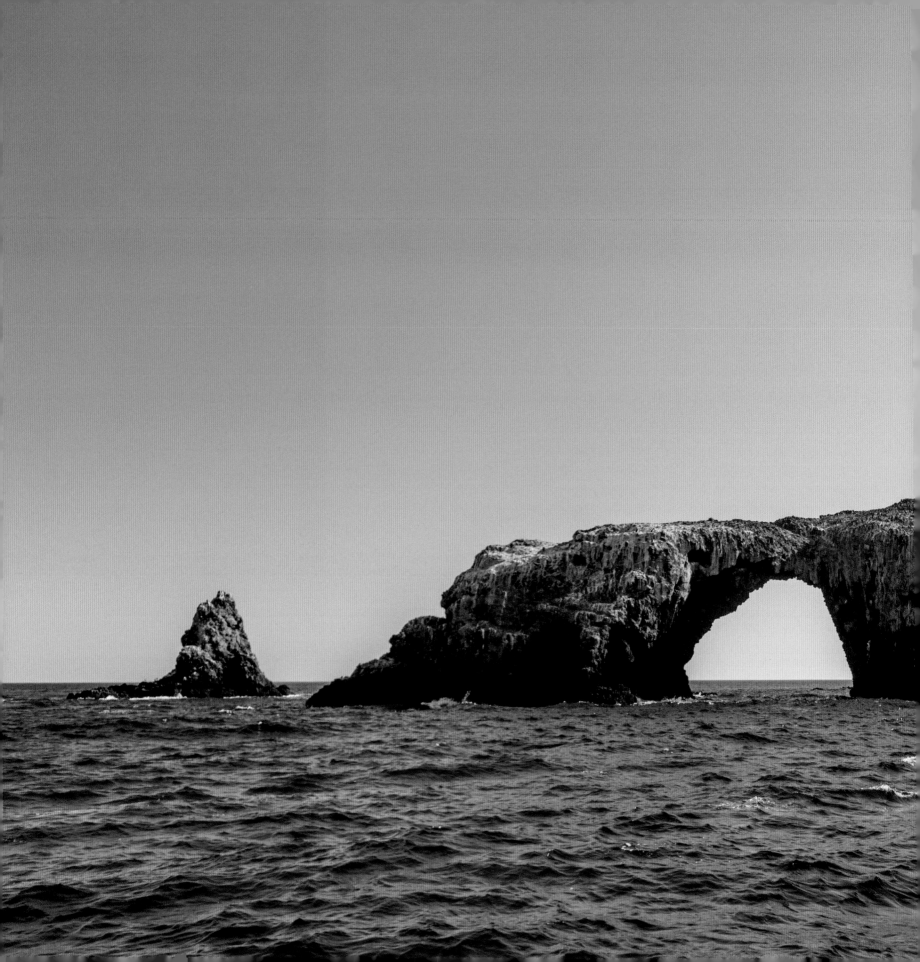

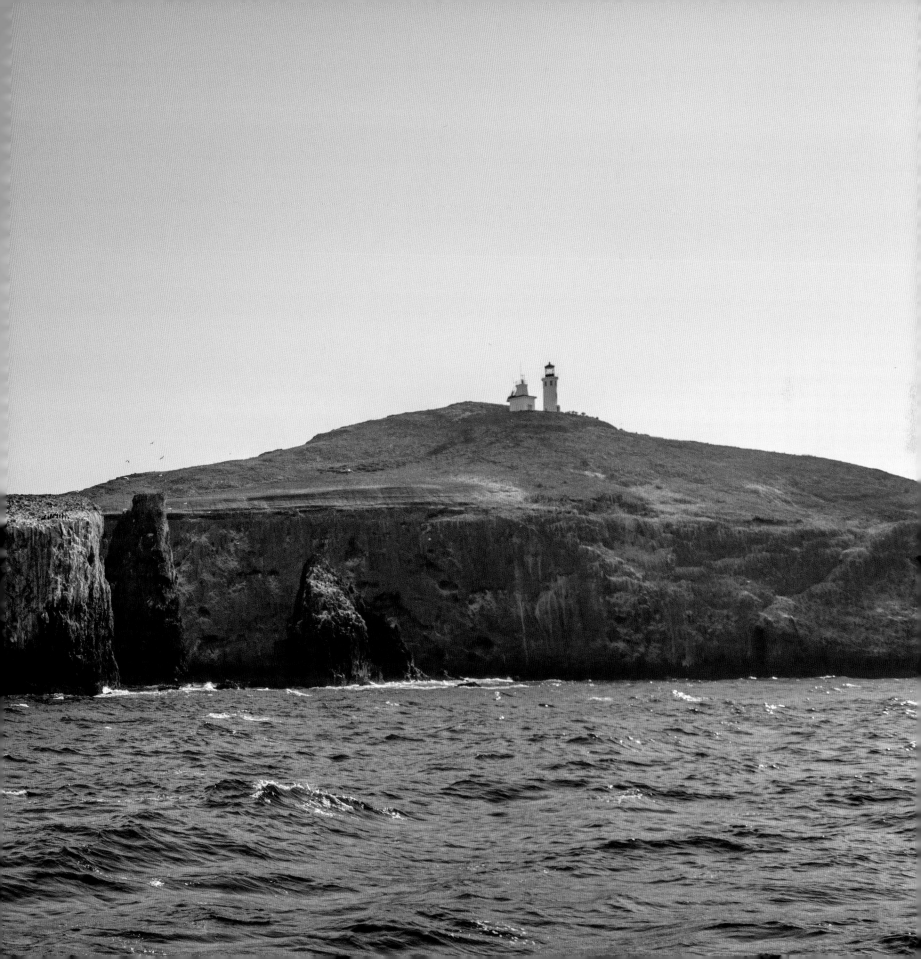

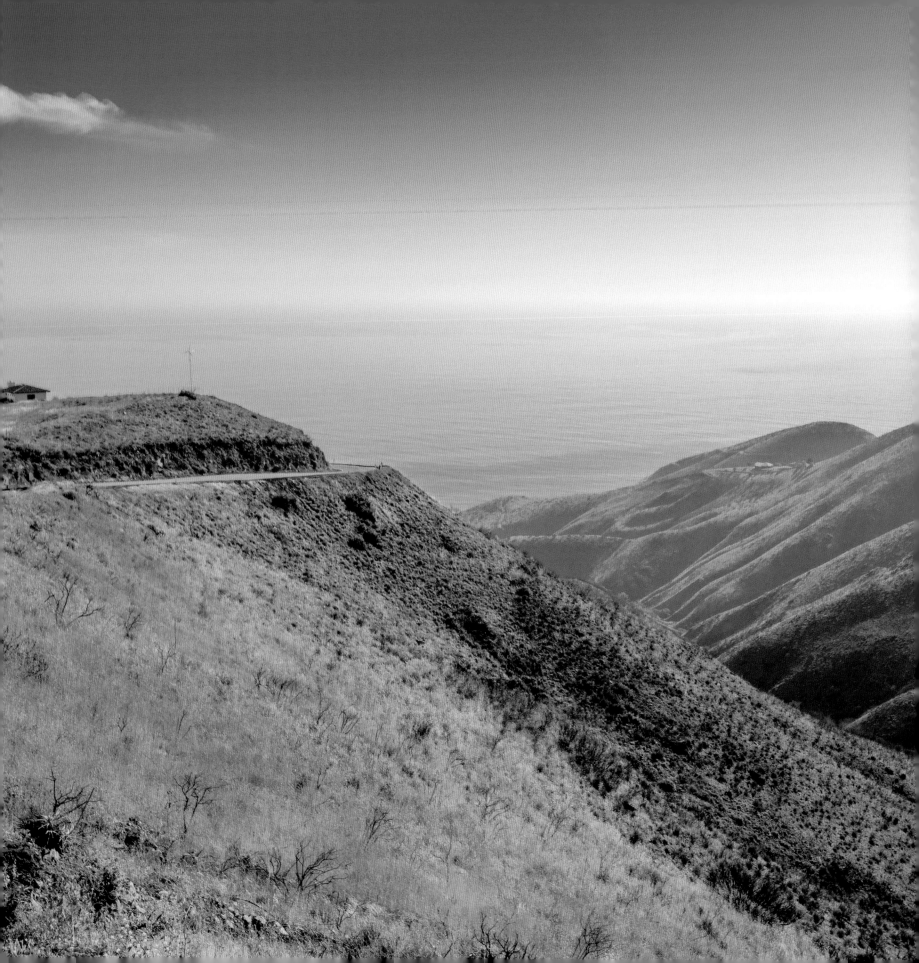

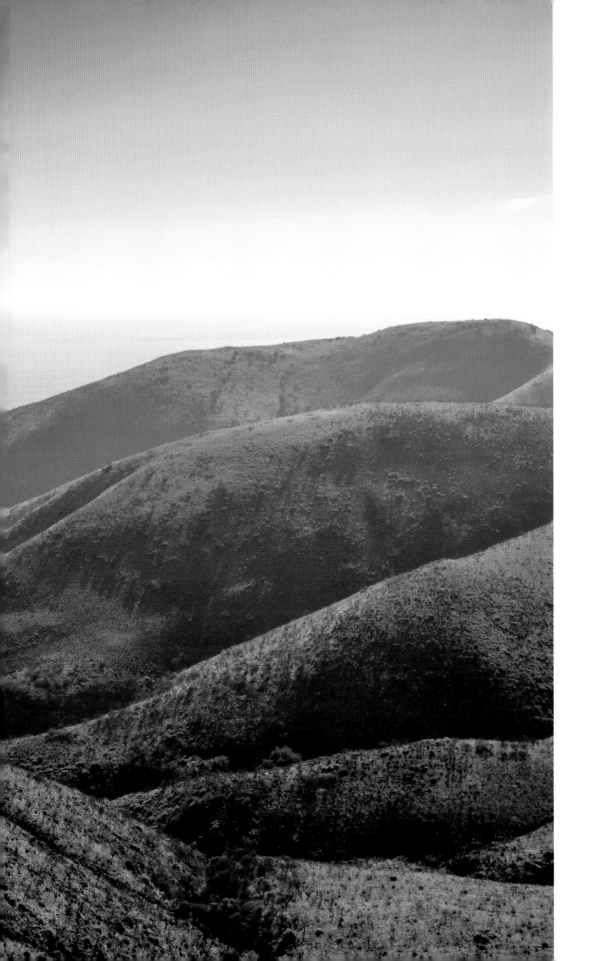

◆ Santa Monica Mountains National
 Recreation Area, Malibu

◈ Sailboat and dolphin, Ventura (left);
 Faria Beach Park, Ventura County (right)

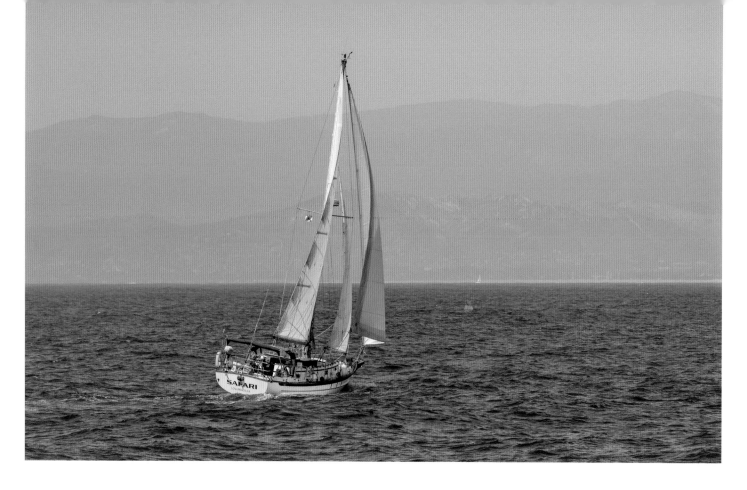

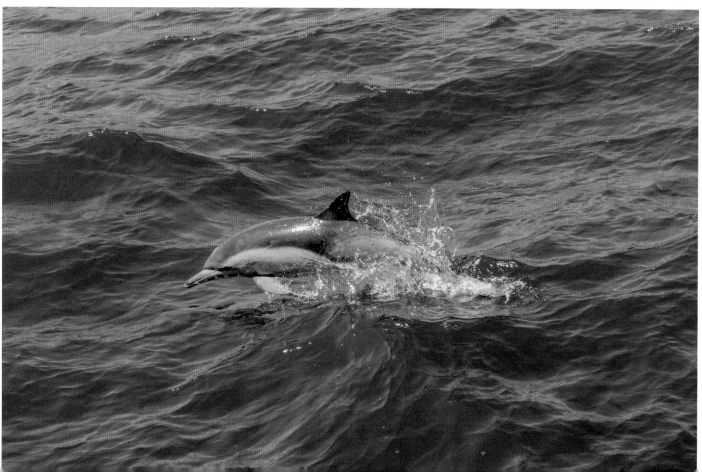

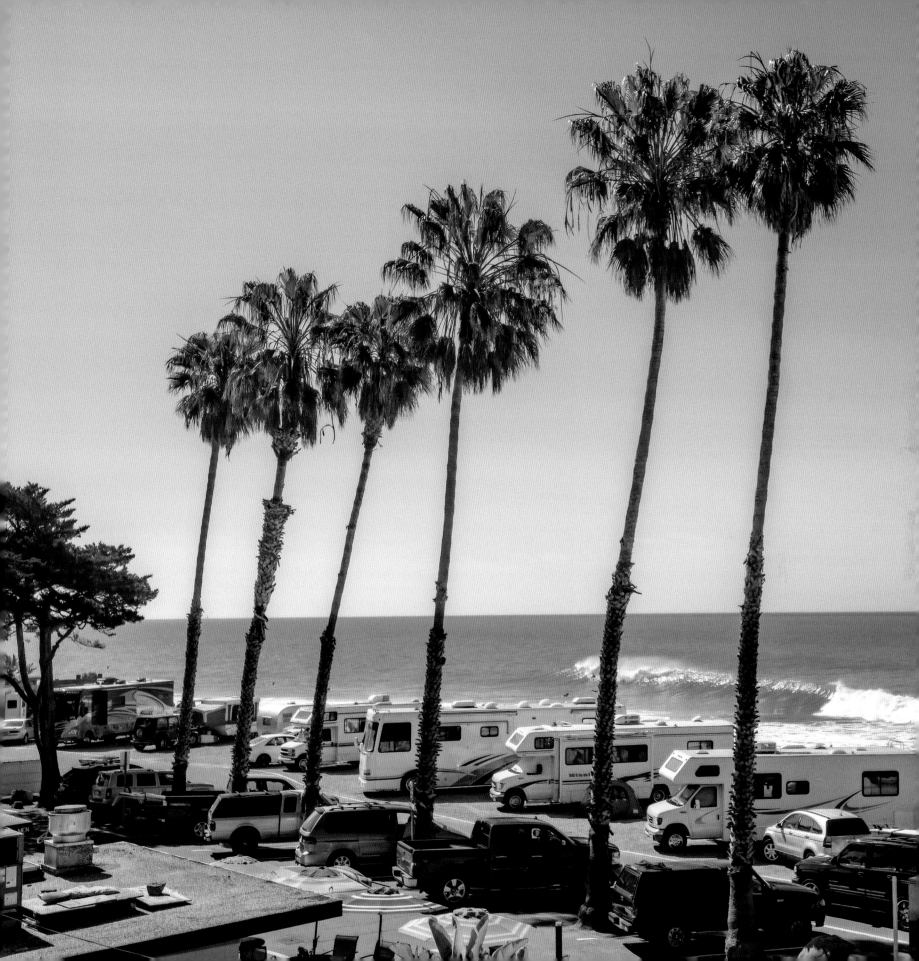

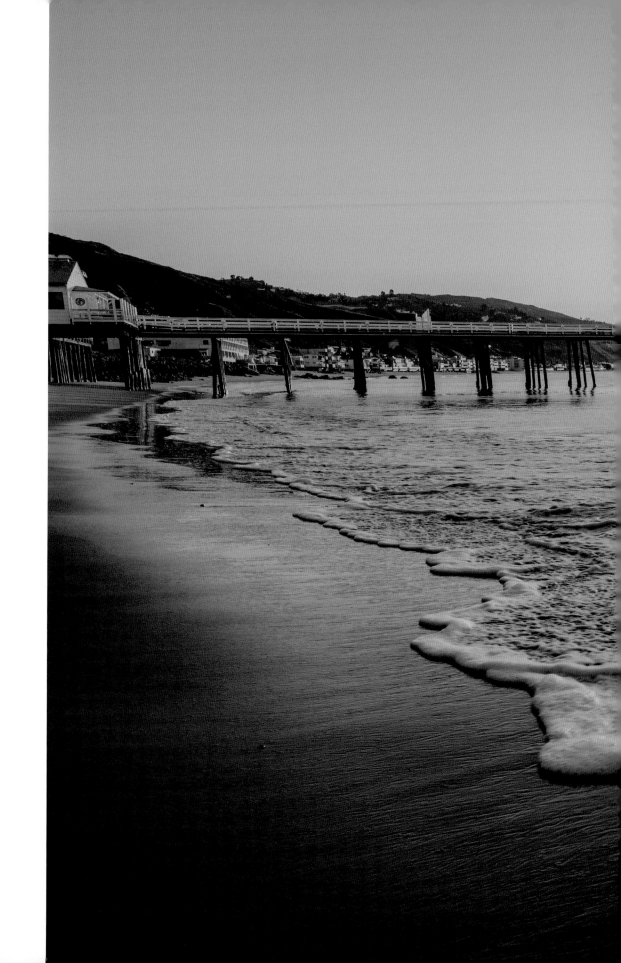

◈ Malibu Surfrider Beach Pier, Malibu

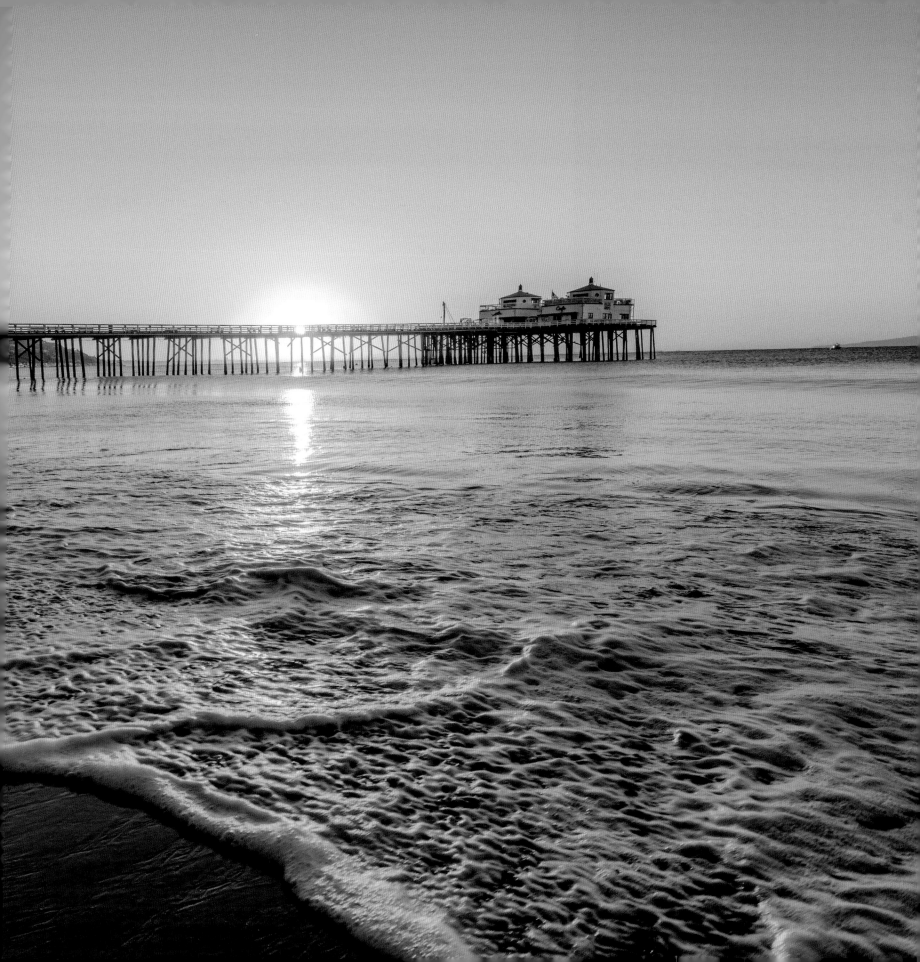

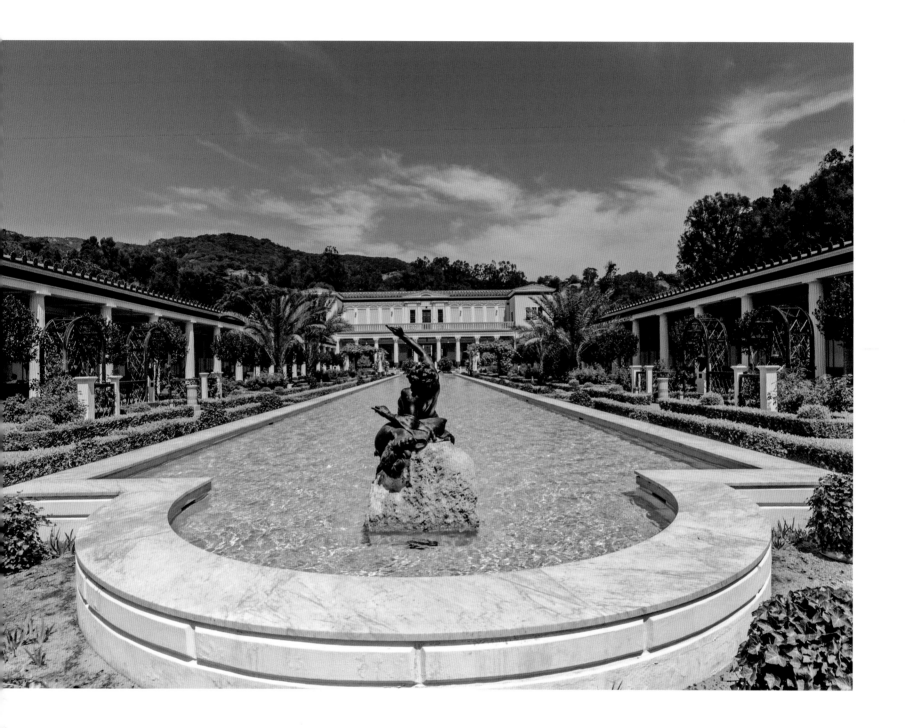

⬆ Getty Villa, Pacific Palisades ◆ Self-Realization Fellowship Lake Shrine, Pacific Palisades ⬇ Santa Monica

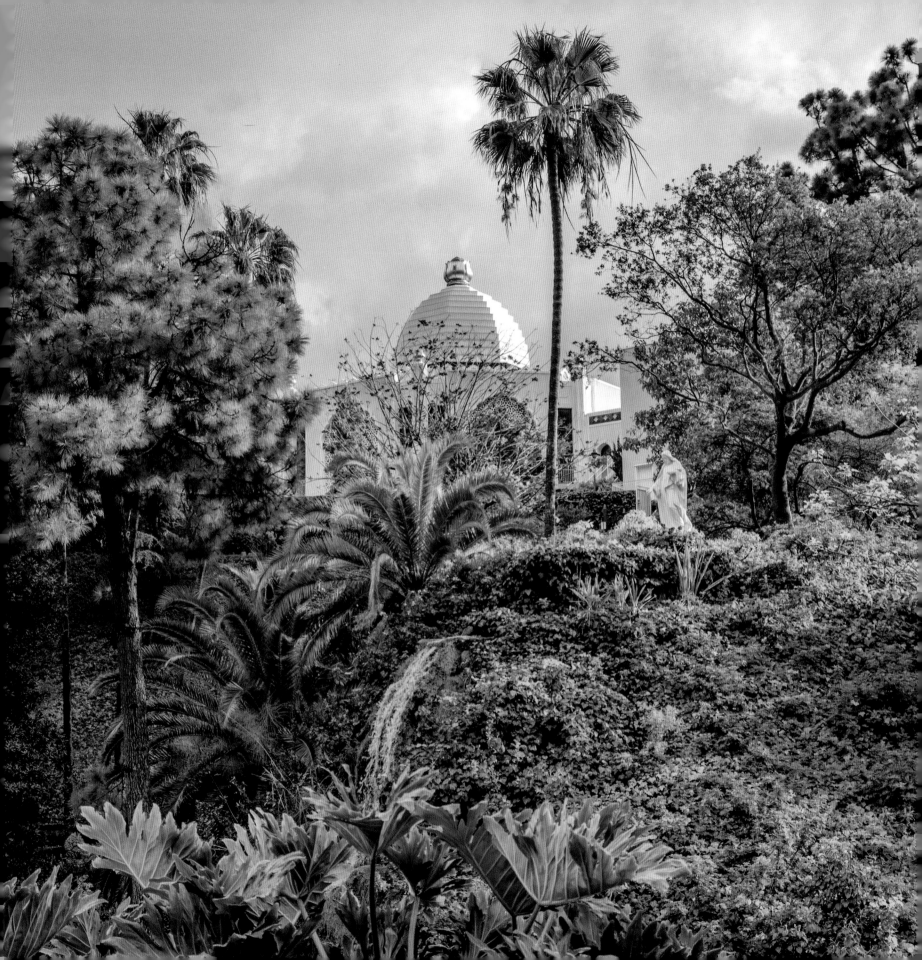

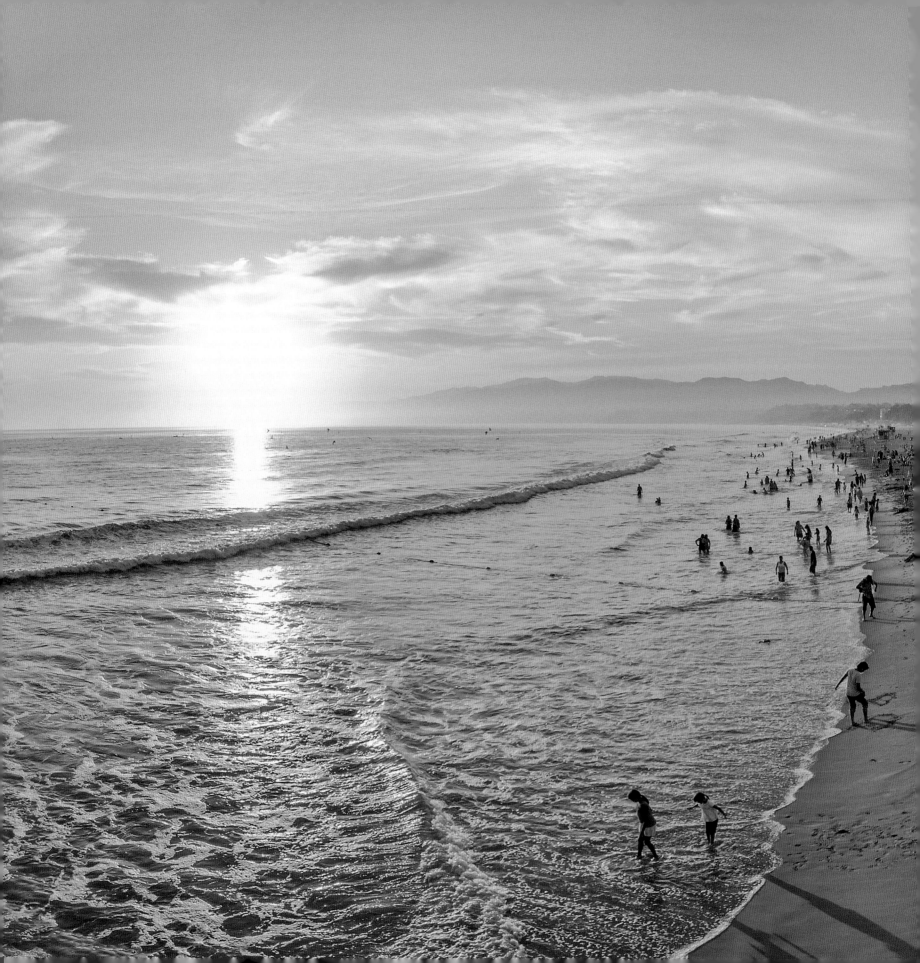

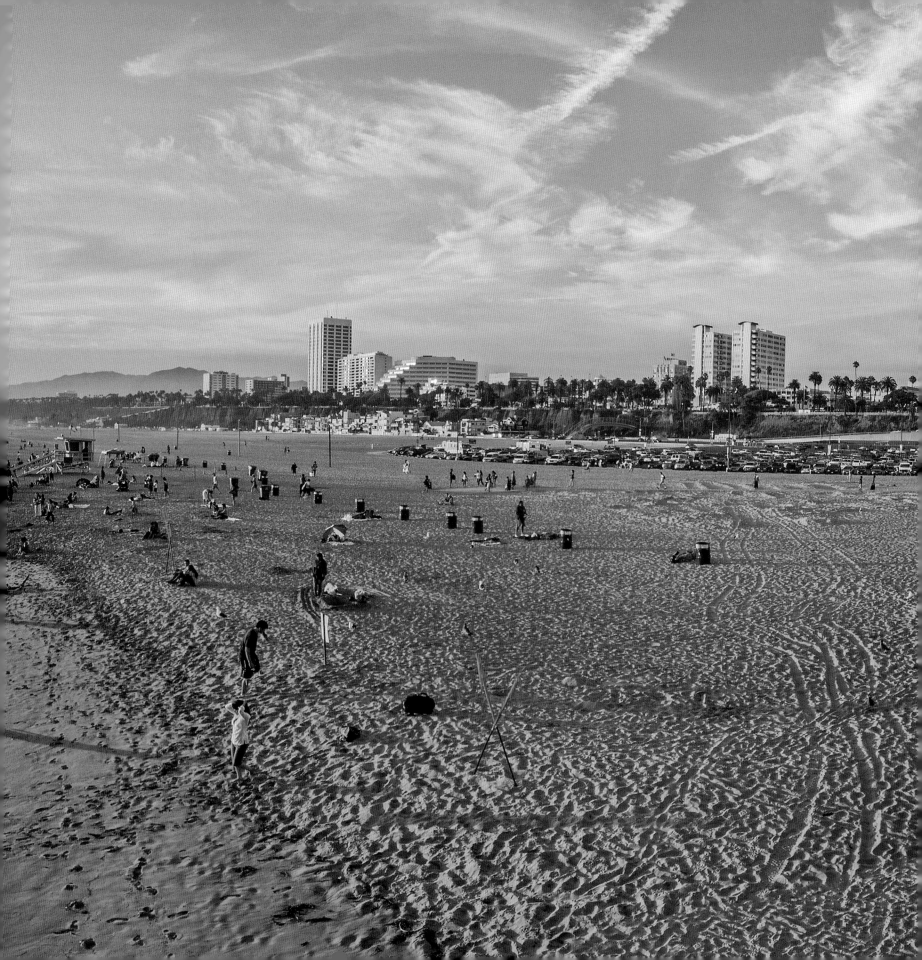

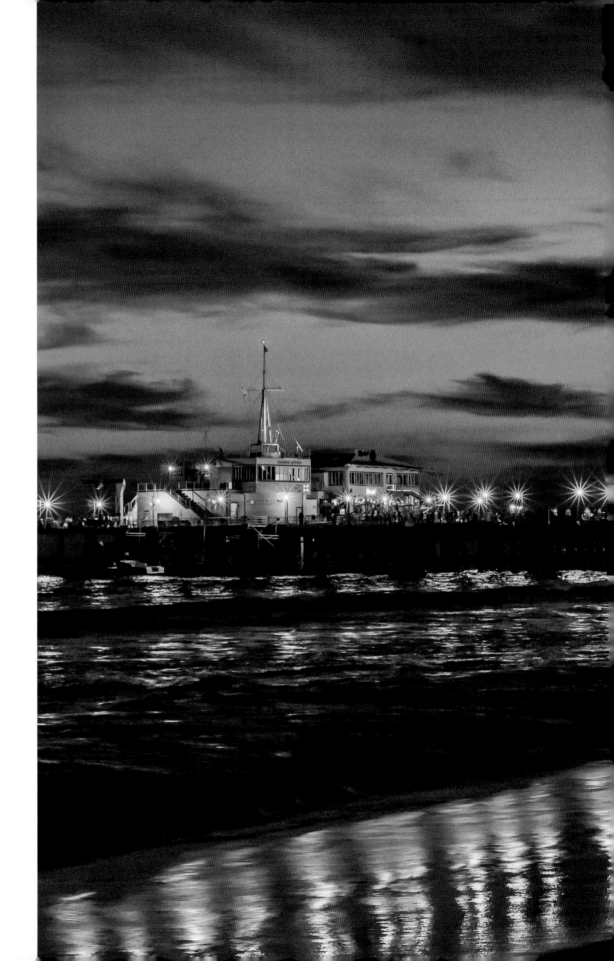

◈ Santa Monica Pier, Santa Monica

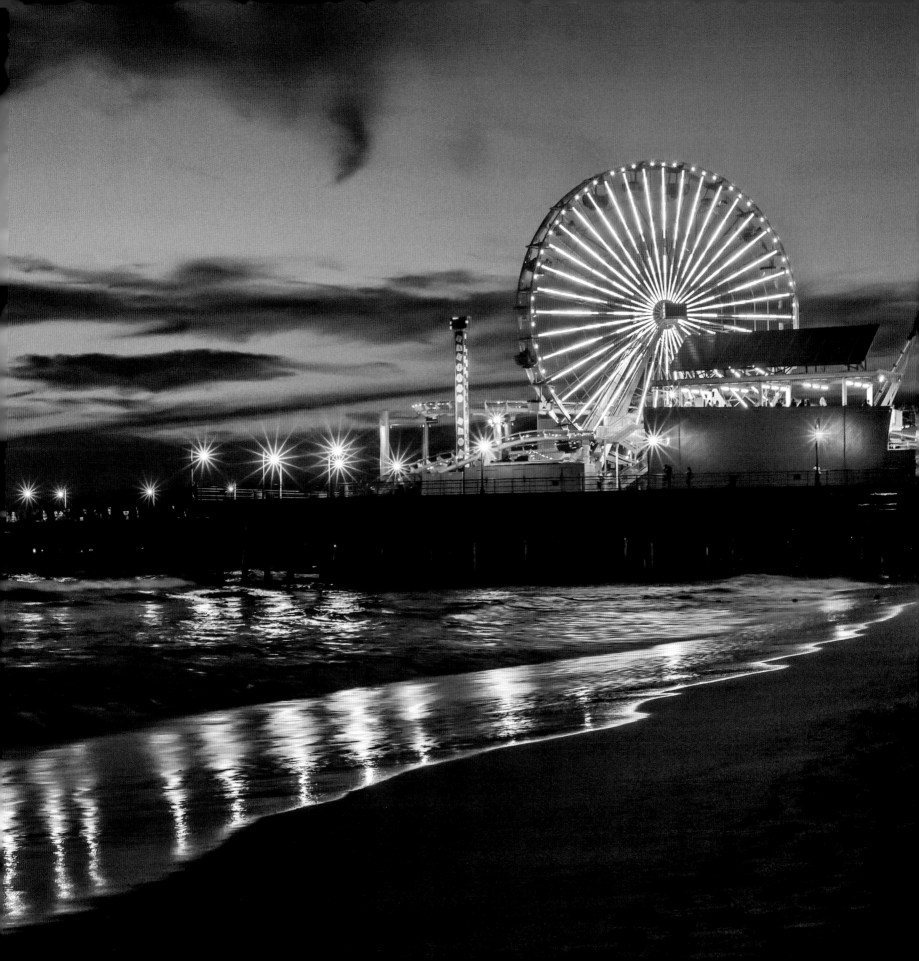

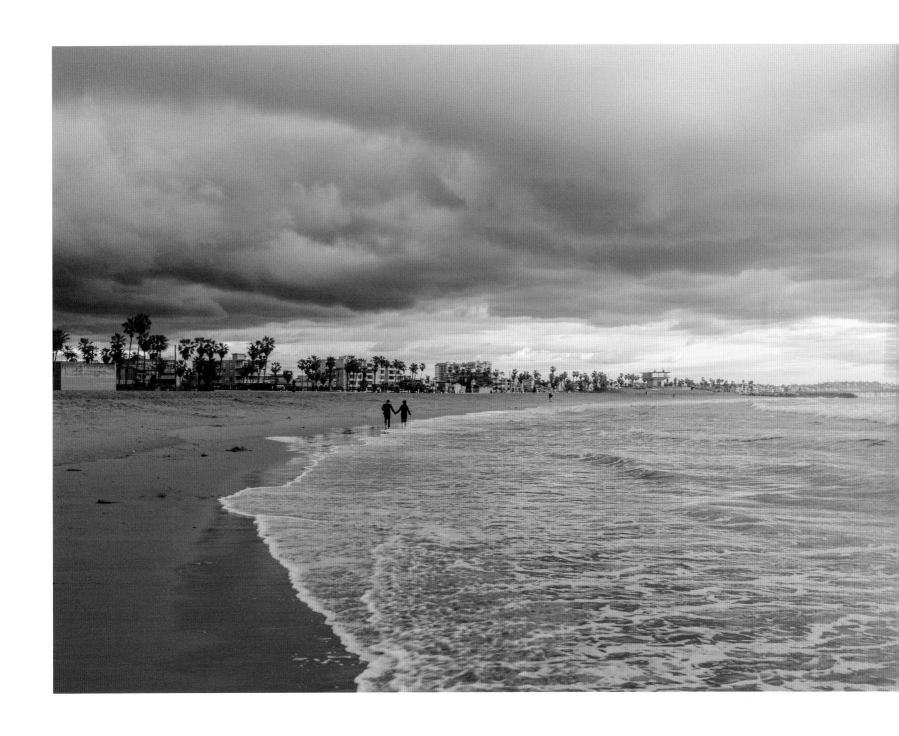

◈ ◈ Venice Beach

◈ Venice Canal, Venice

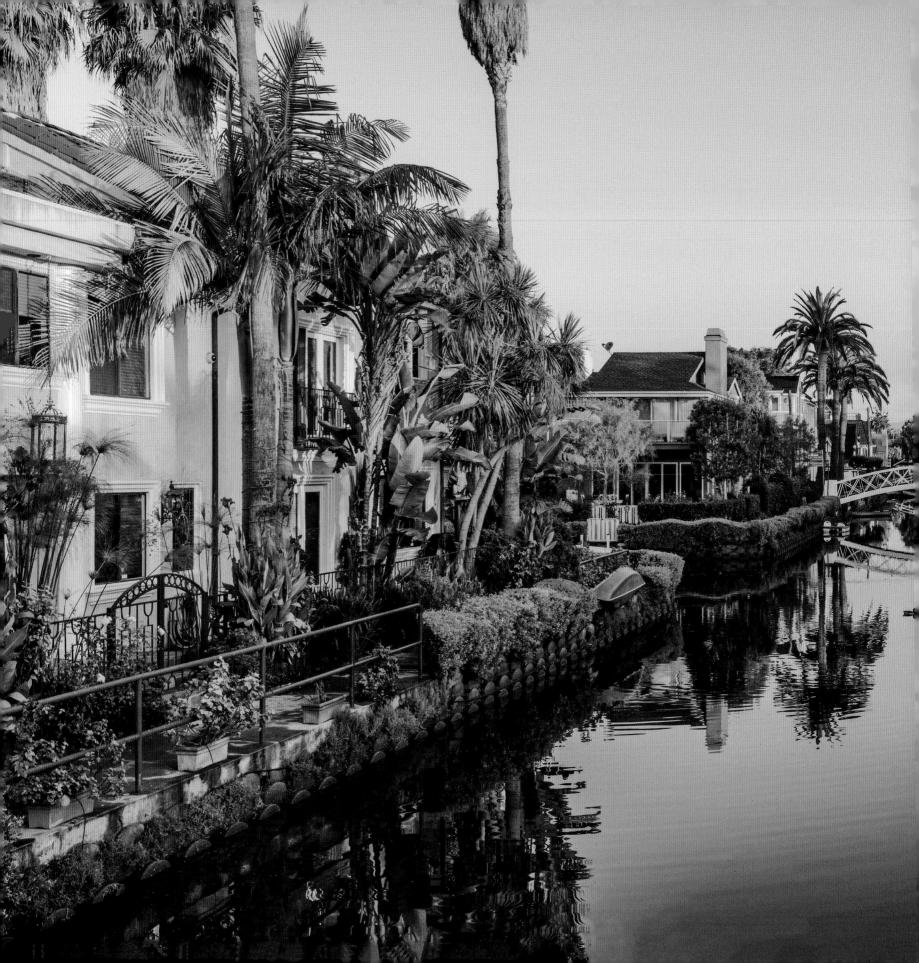

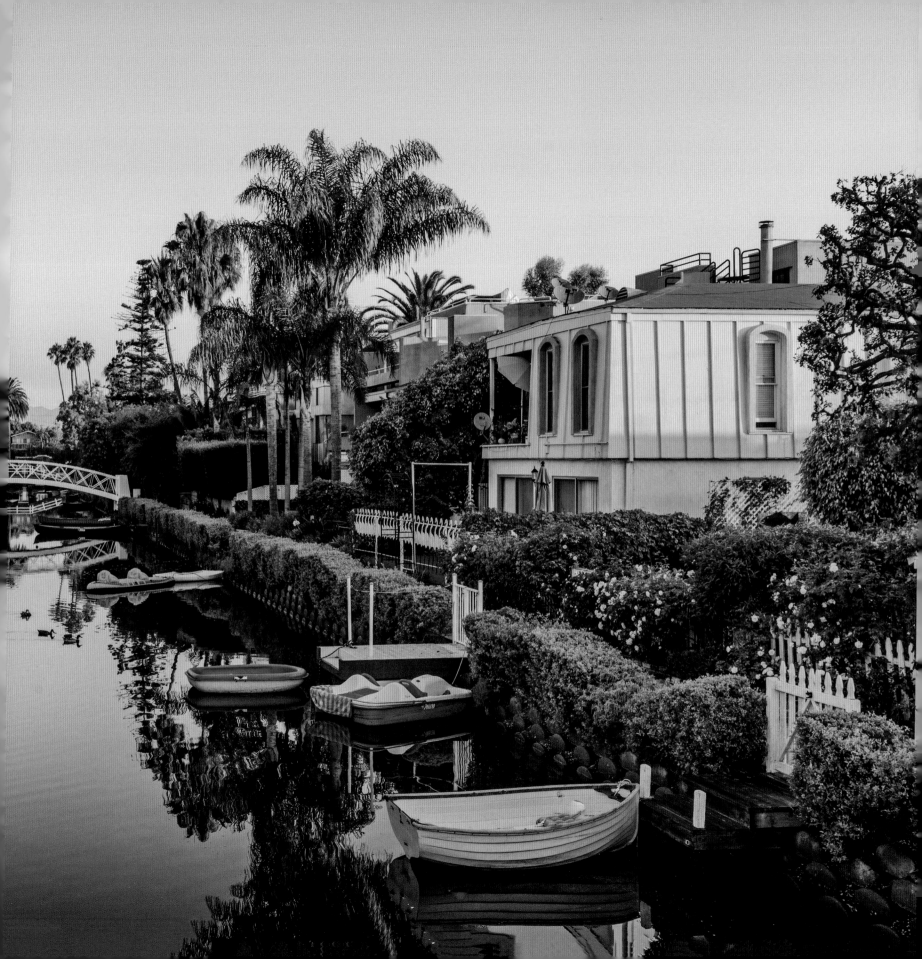

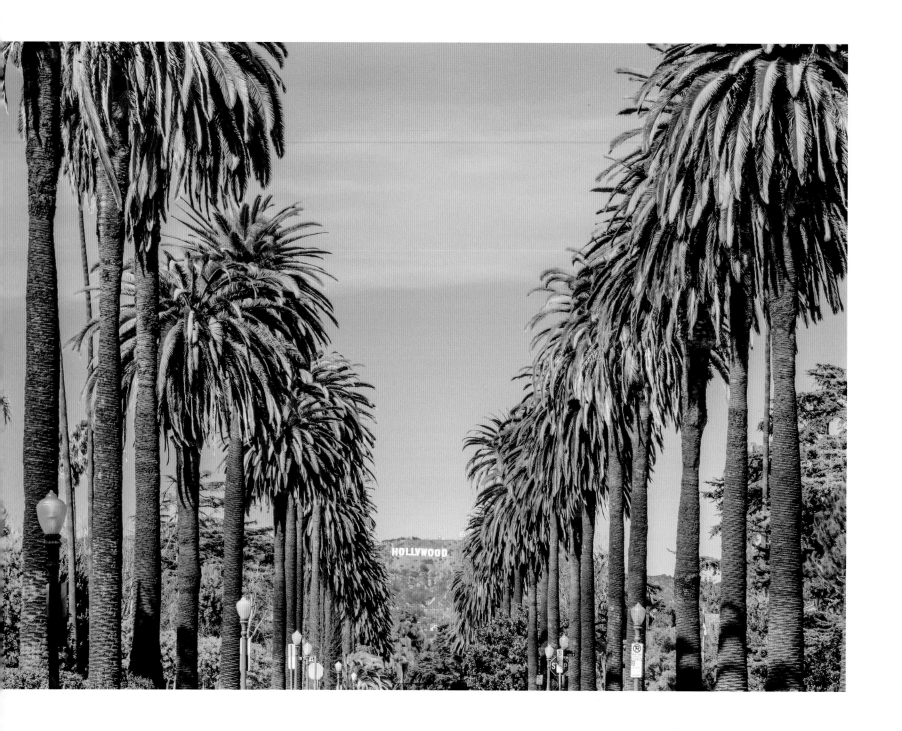

◈ Hollywood sign, Los Angeles

◈ Rodeo Drive, Beverly Hills, Los Angeles

184

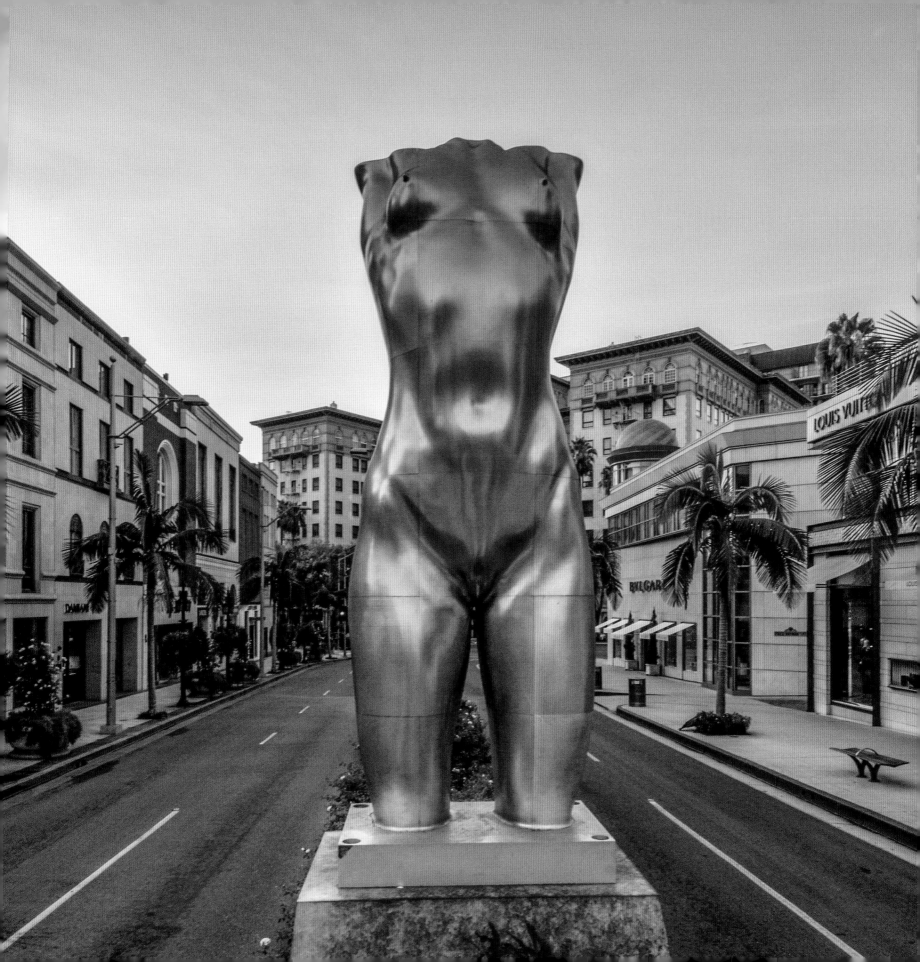

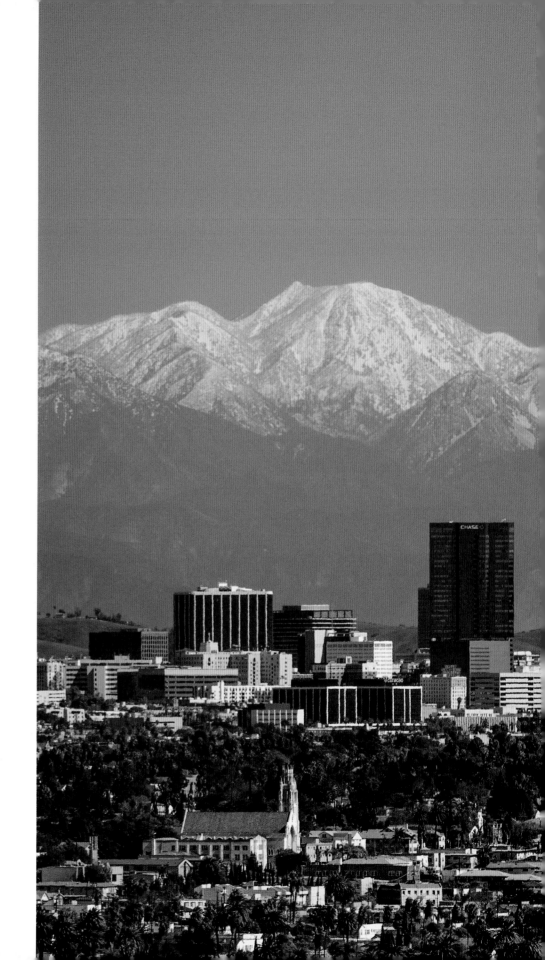

◈ Los Angeles

◈ Griffith Observatory, Los Angeles (top left);
Los Angeles County Museum of Art, Los Angeles
(bottom left); Greystone Mansion, Beverly Hills,
Los Angeles (right)

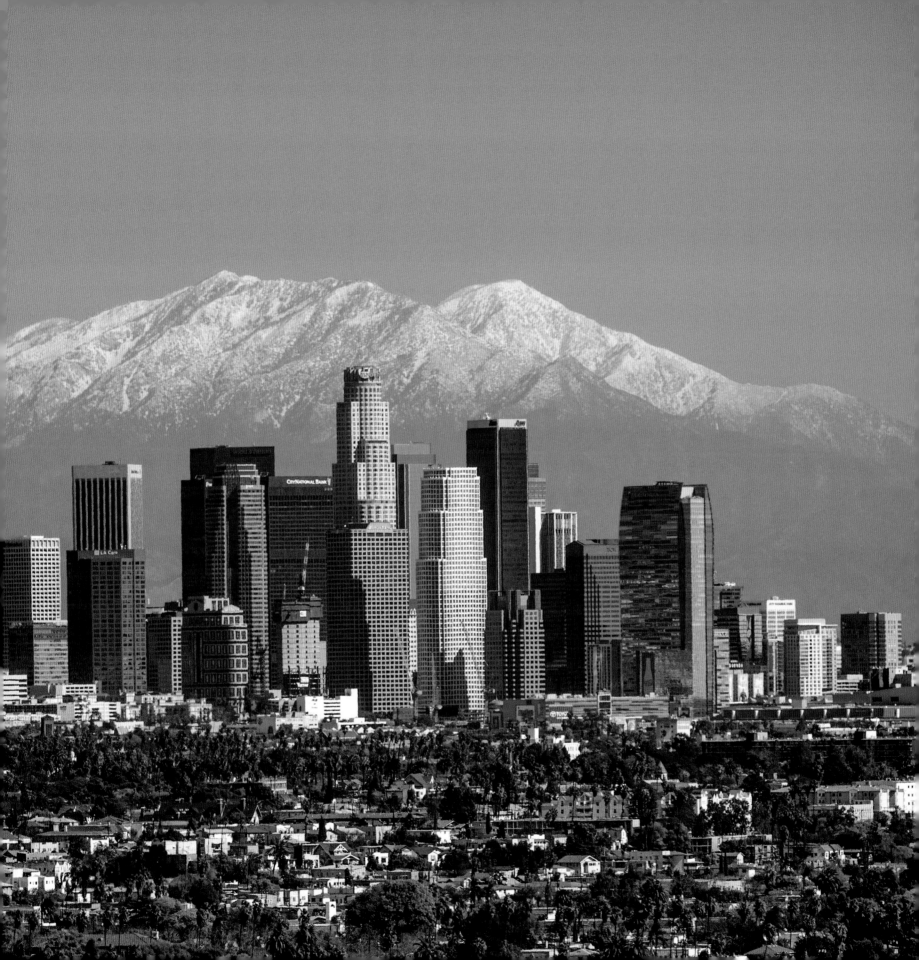

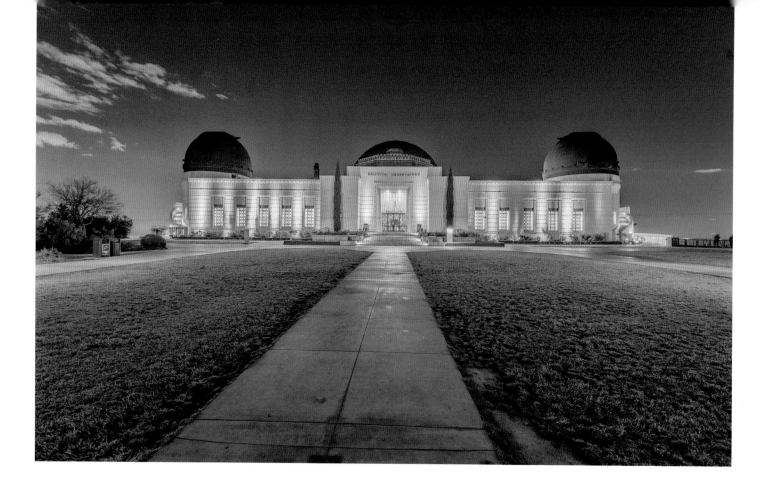

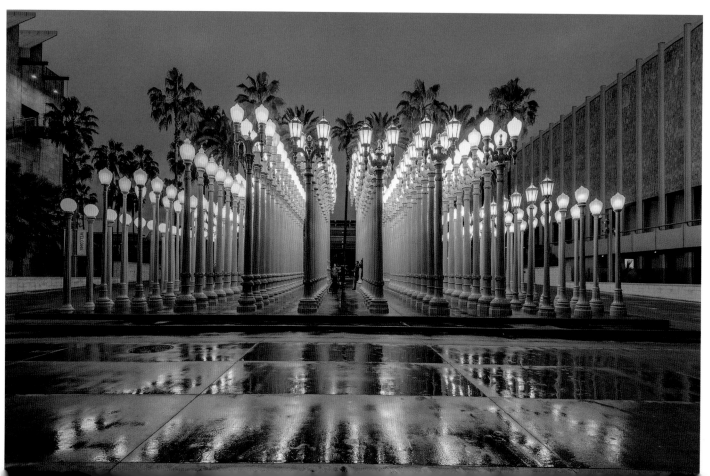

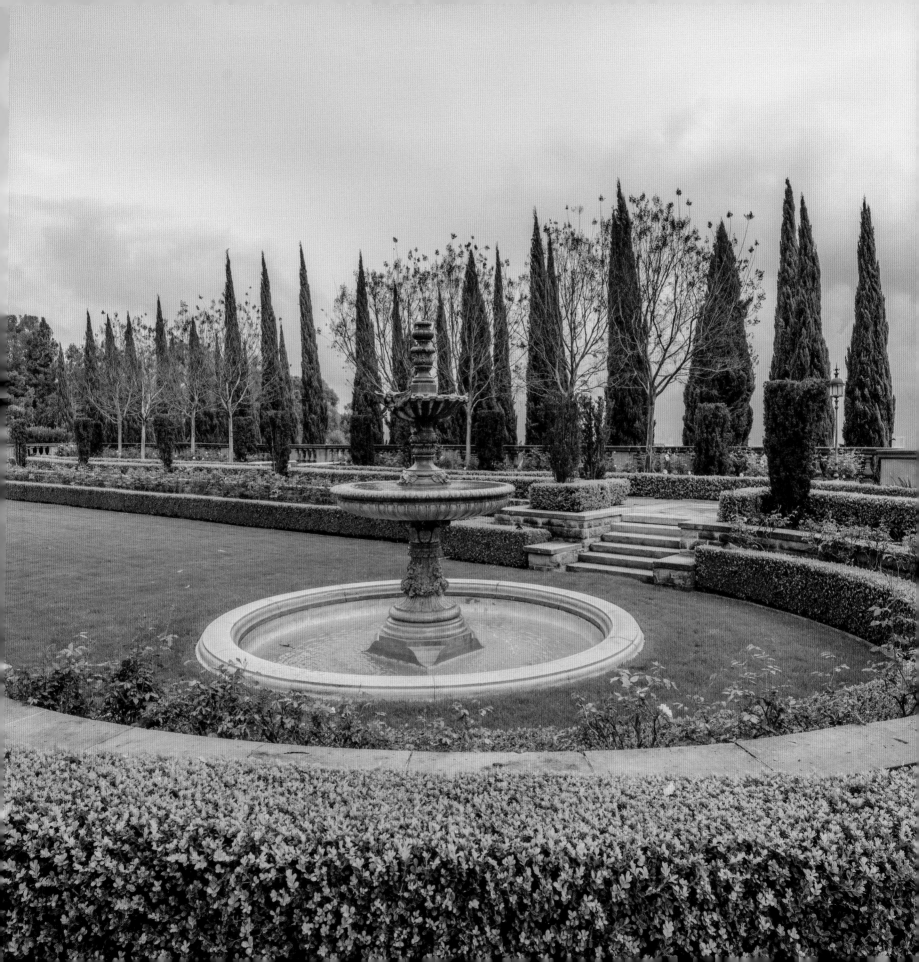

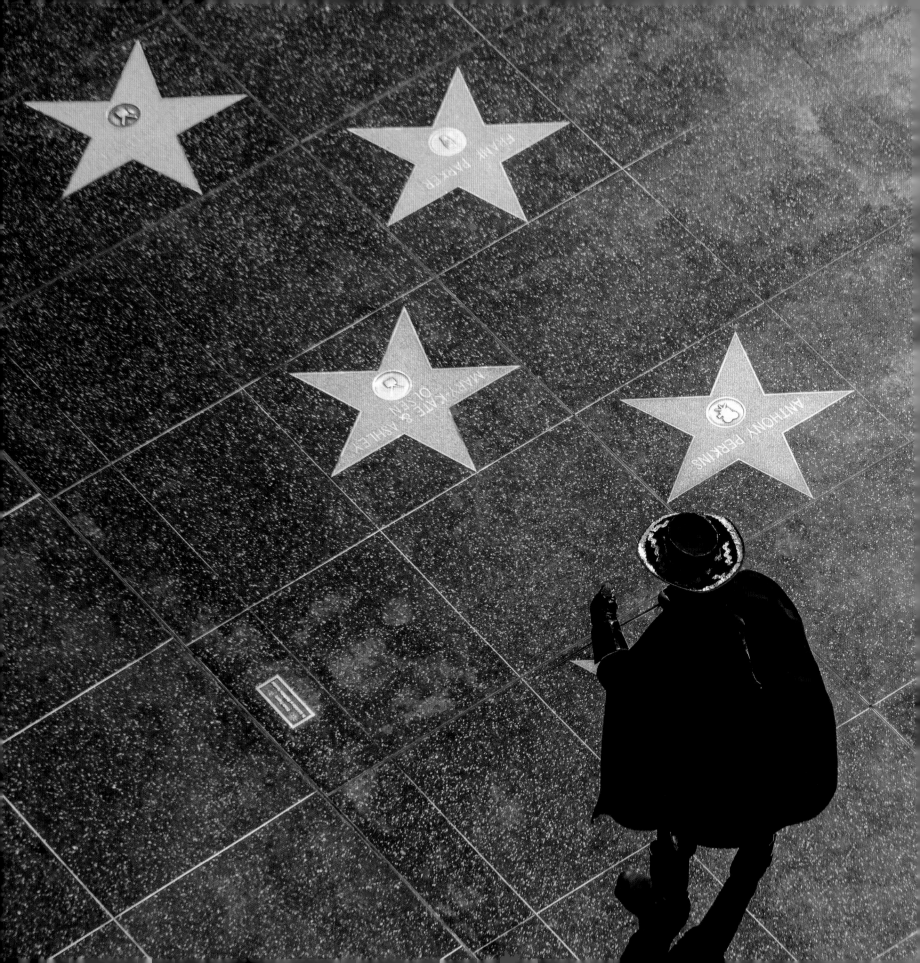

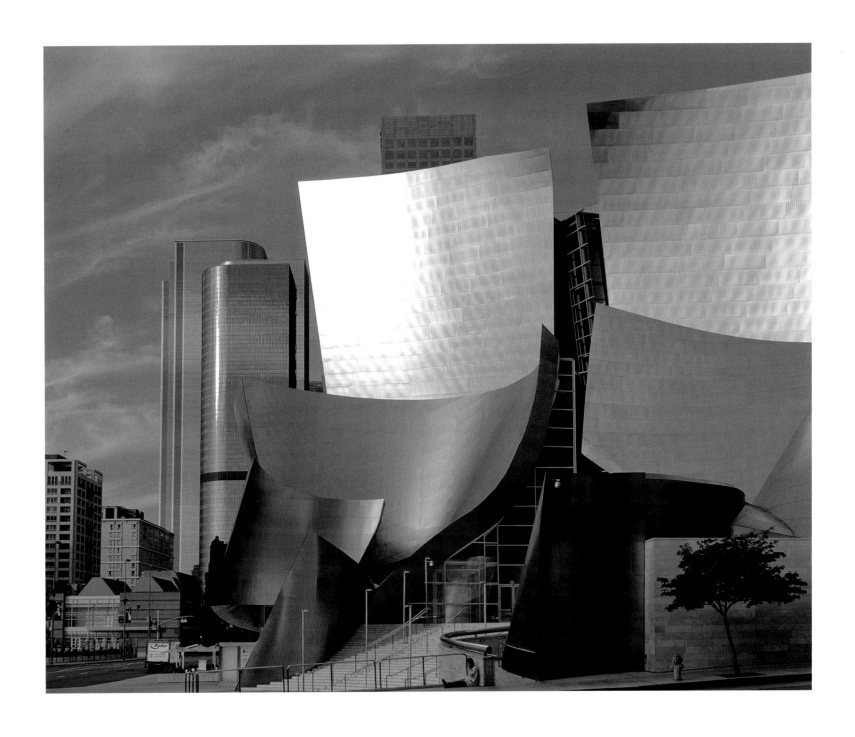

◈ Hollywood Walk of Fame, Los Angeles ◈ Walt Disney Concert Hall, Los Angeles ◈ J. Paul Getty Museum, Brentwood, Los Angeles

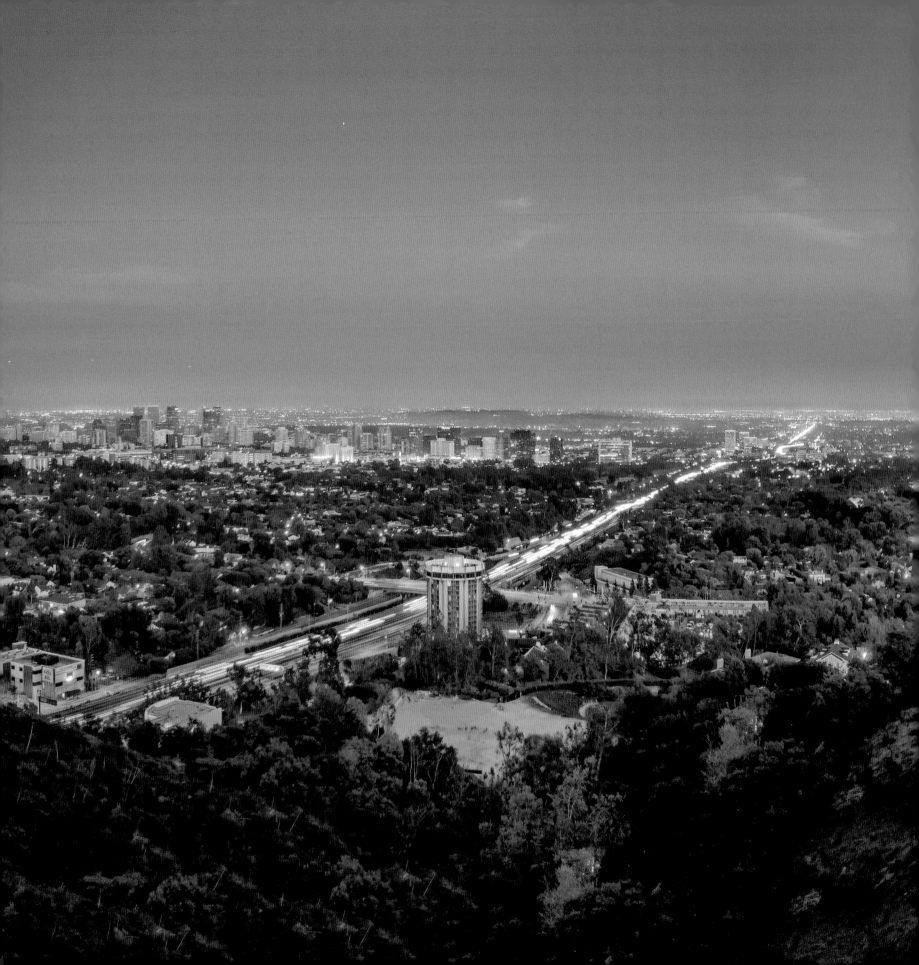

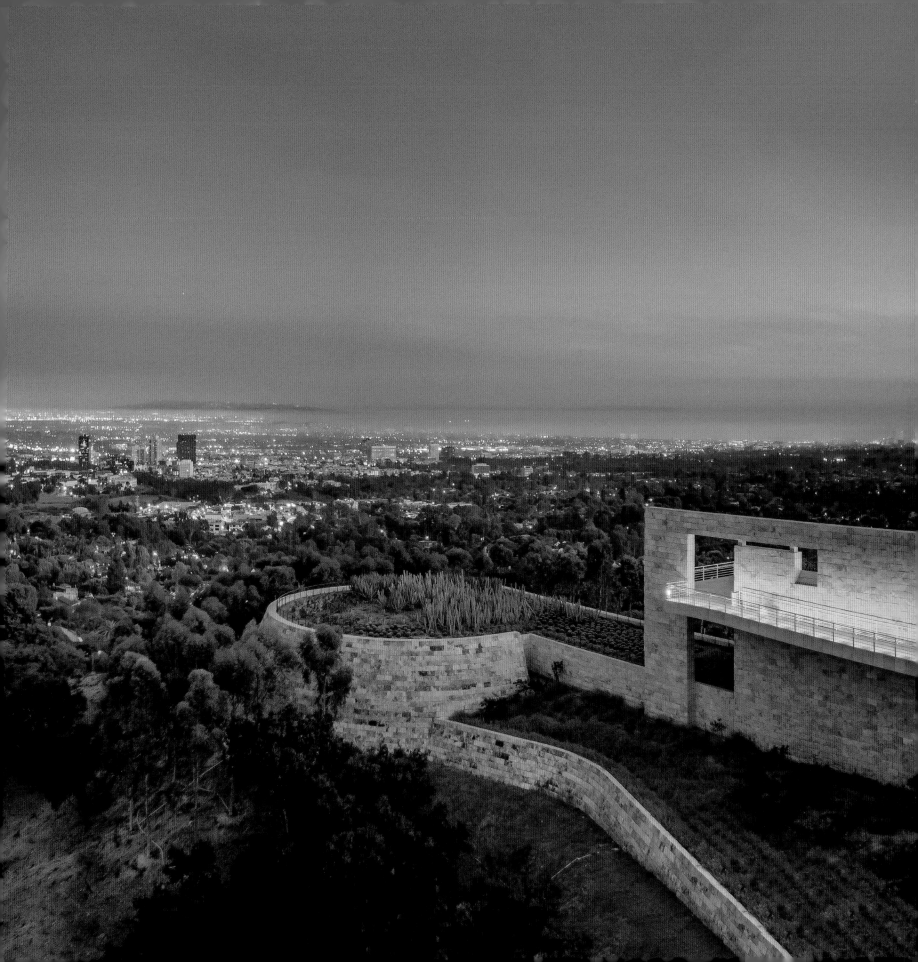

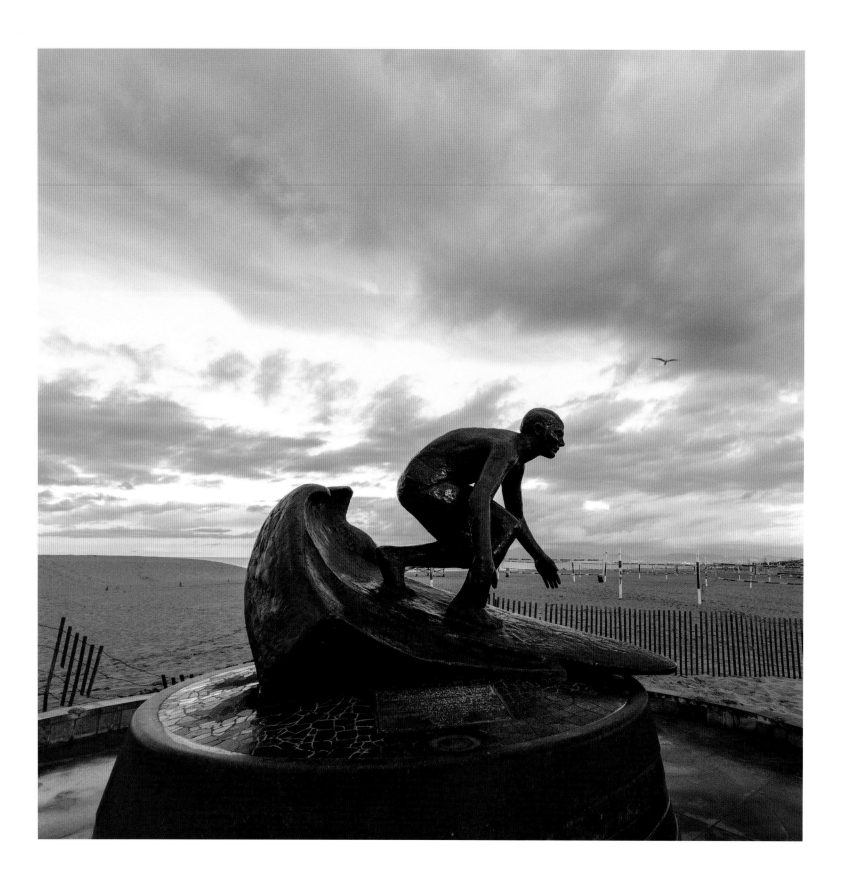

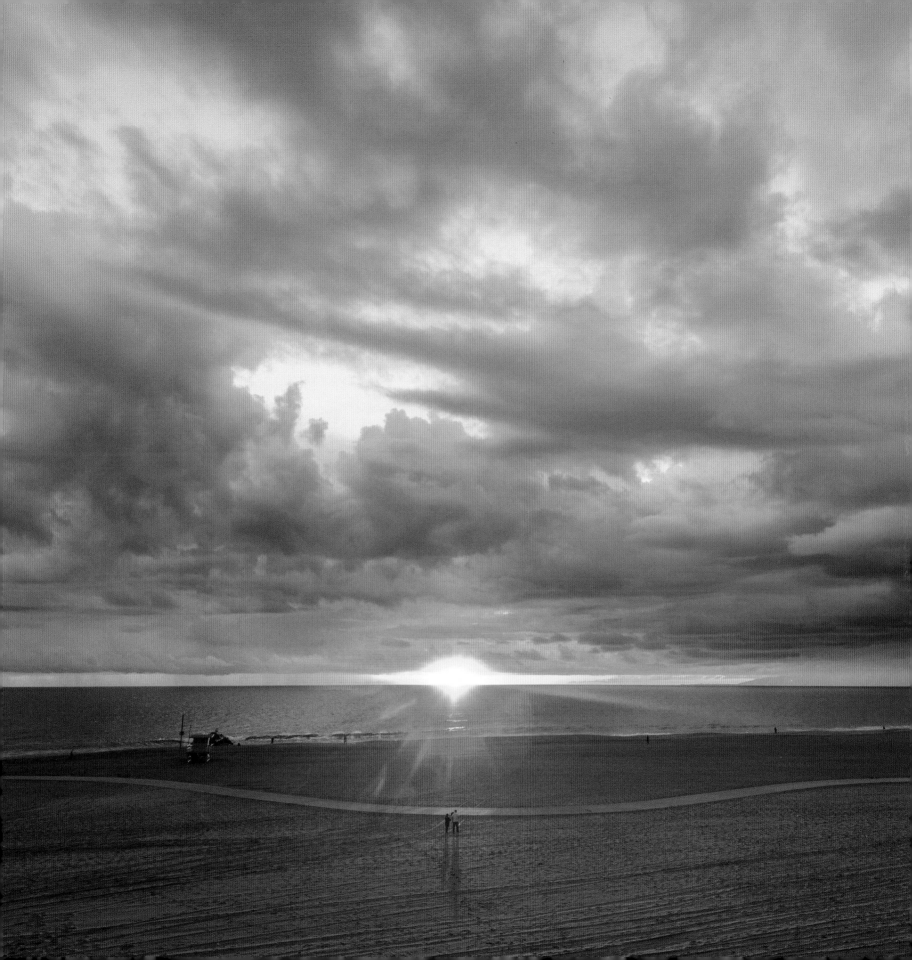

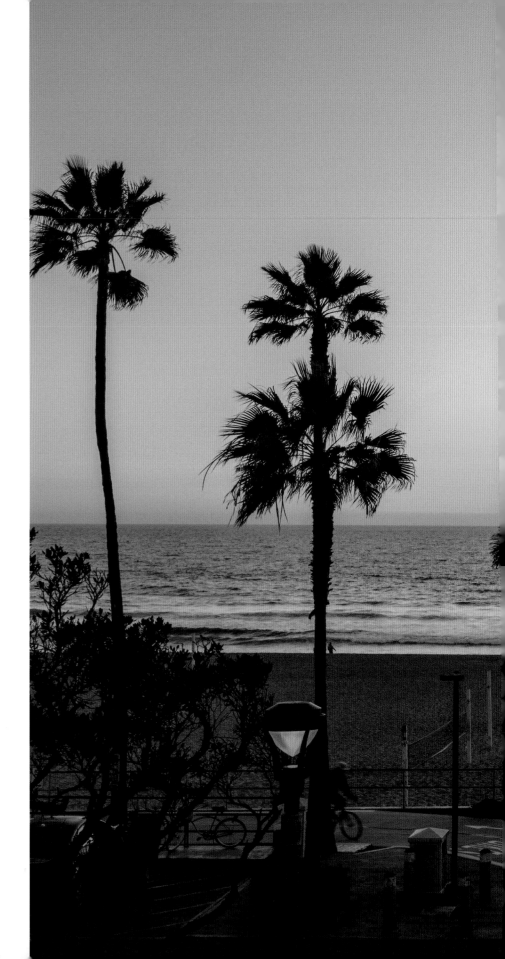

◈ Hermosa Beach (left); Playa del Rey (right)

◈ Manhattan Beach

◈ Corona Del Mar, Newport Beach

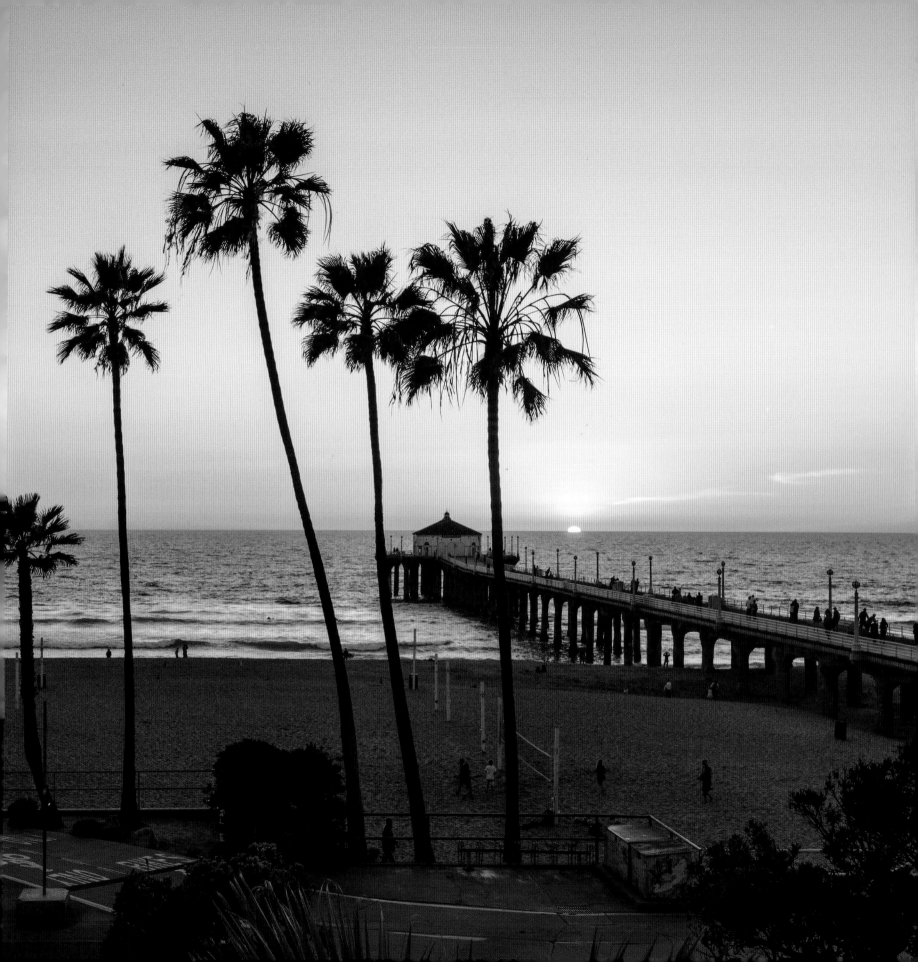

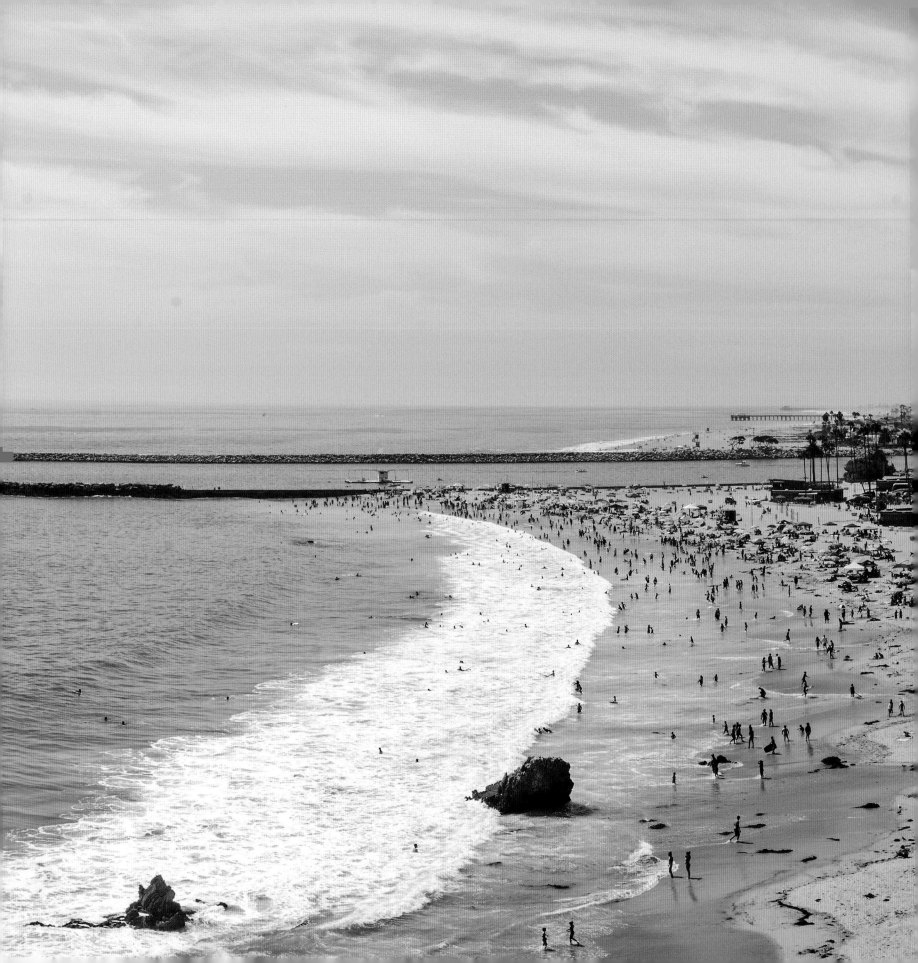

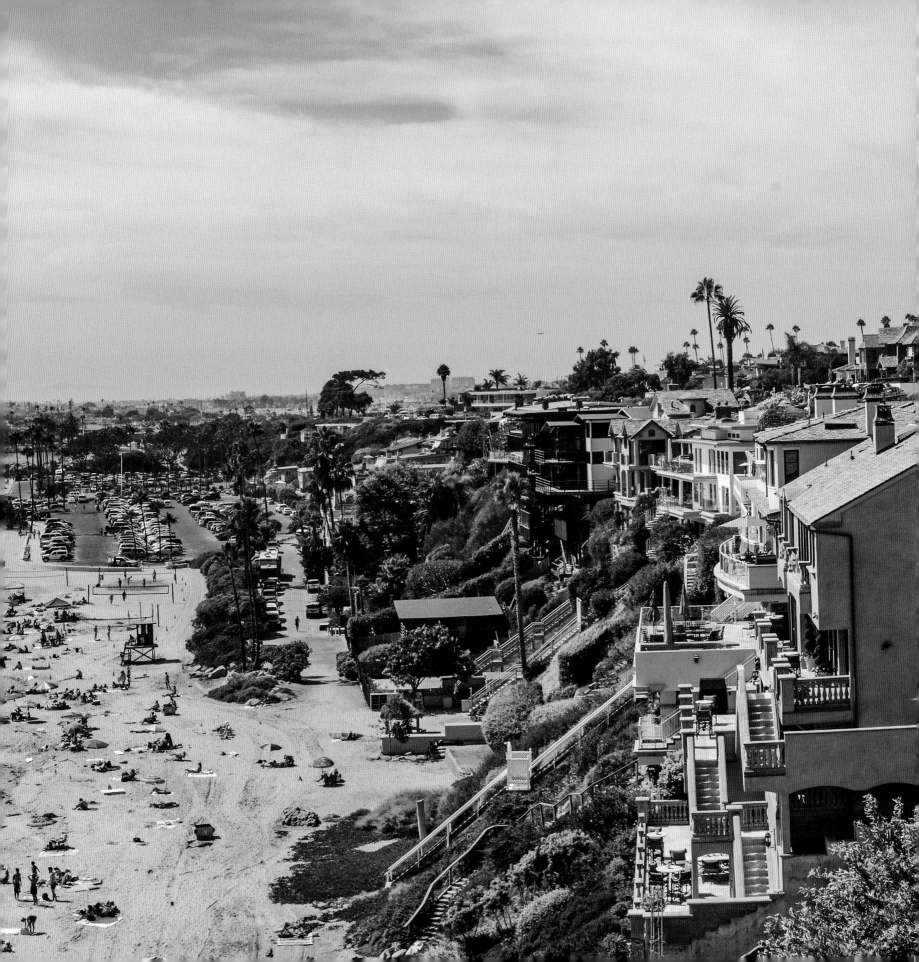

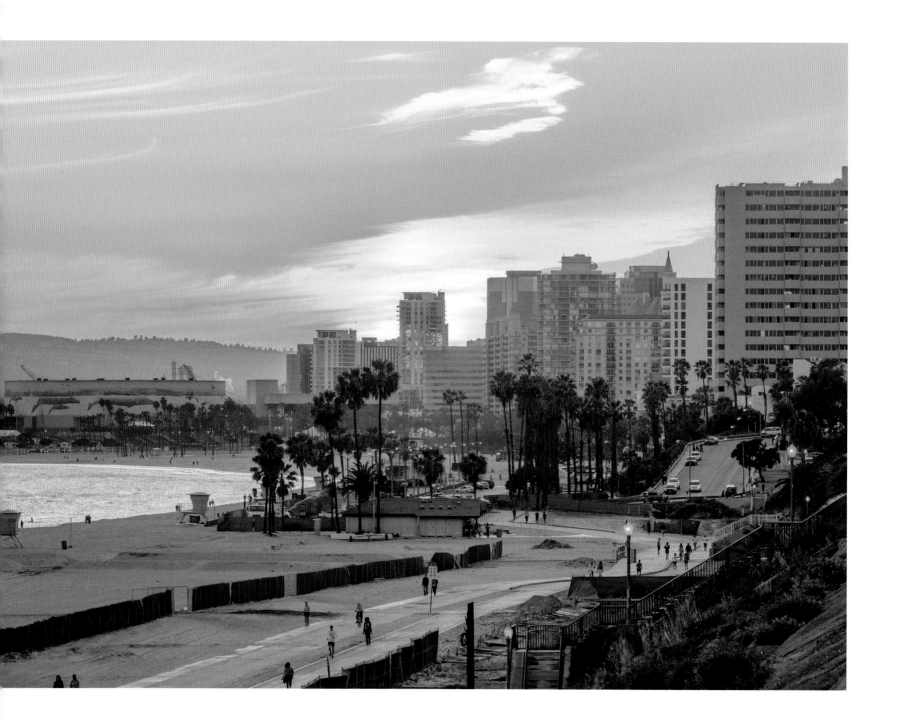

✧ ✧ Long Beach

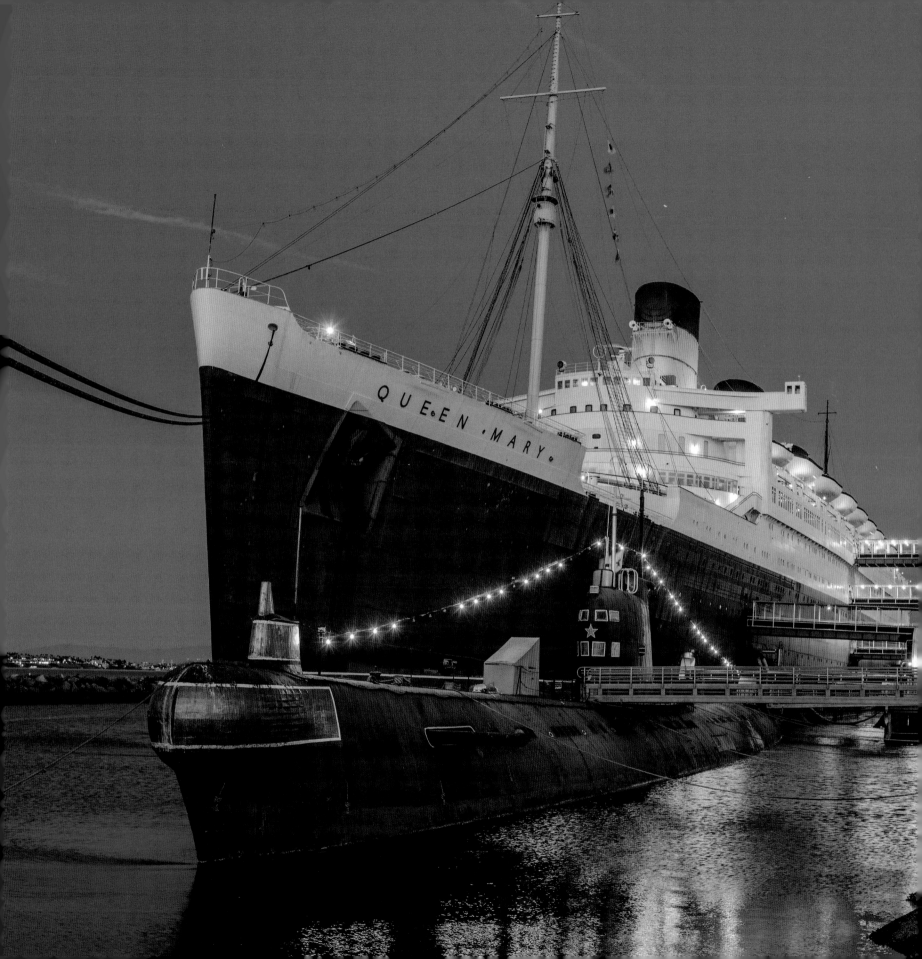

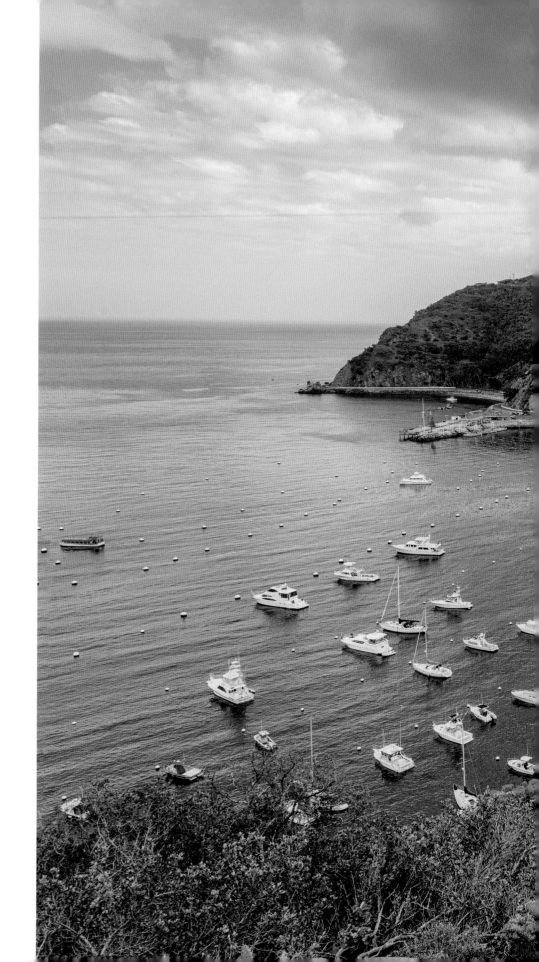

➡ Avalon, Santa Catalina Island

⬦ Buffalo on Santa Catalina Island

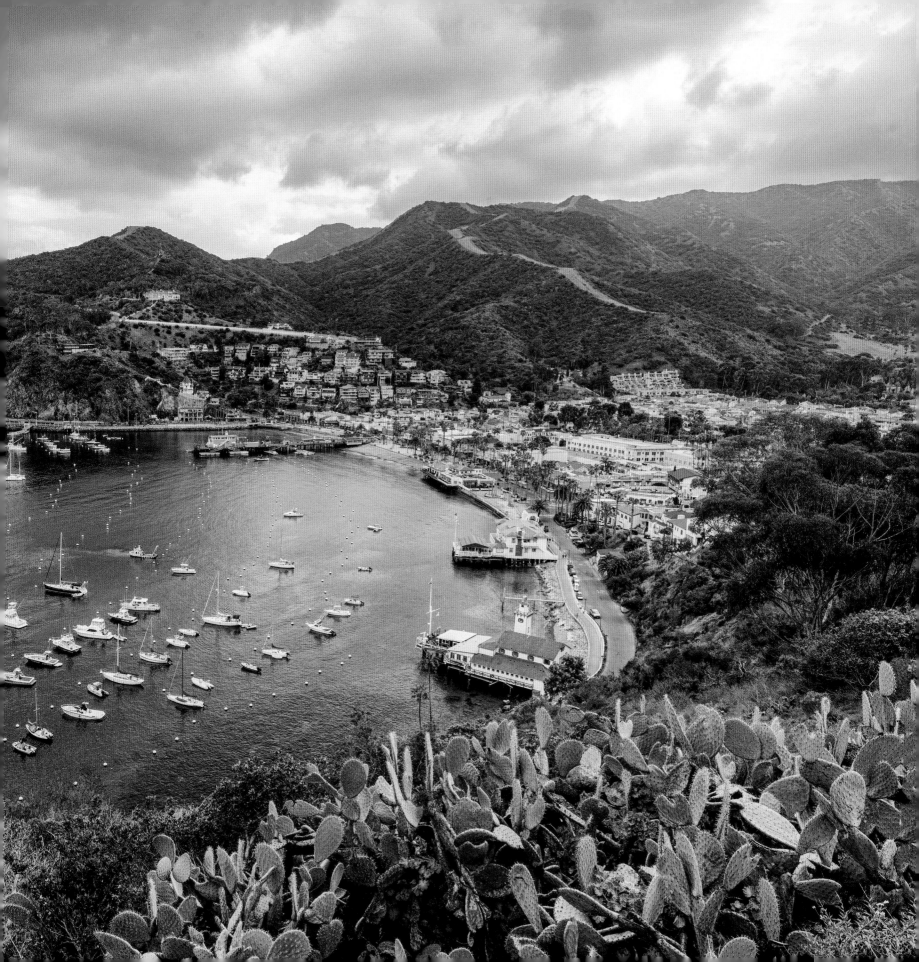

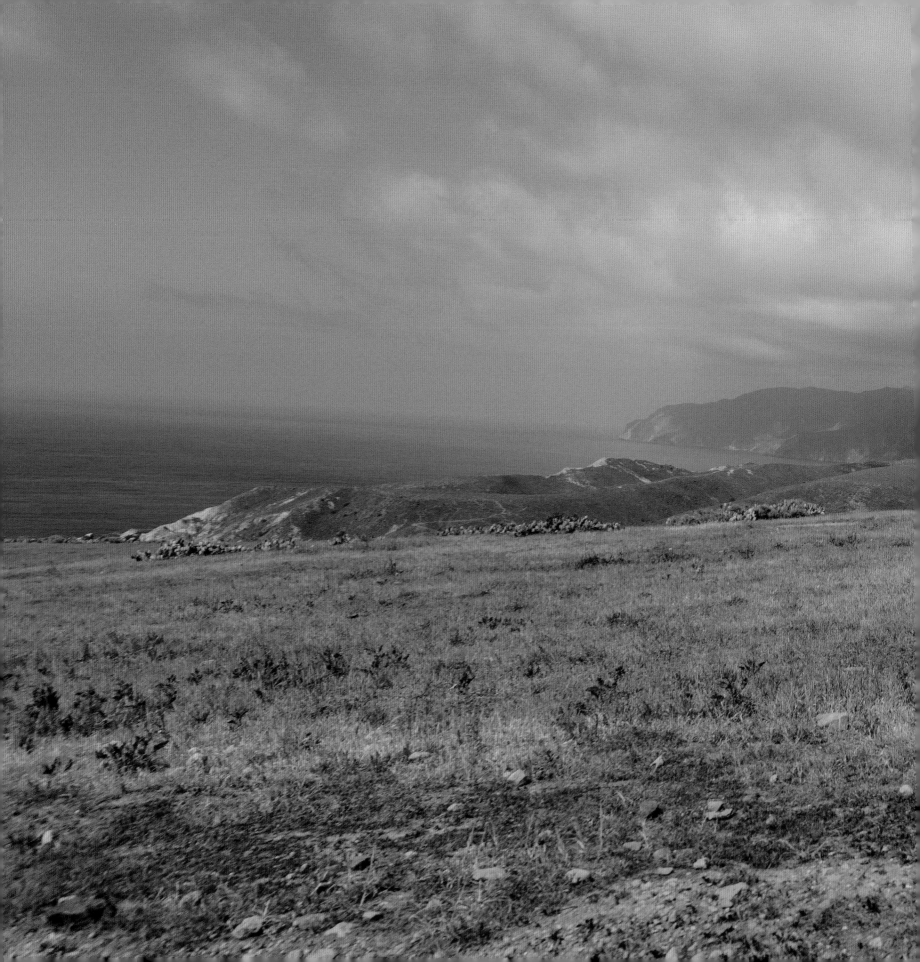

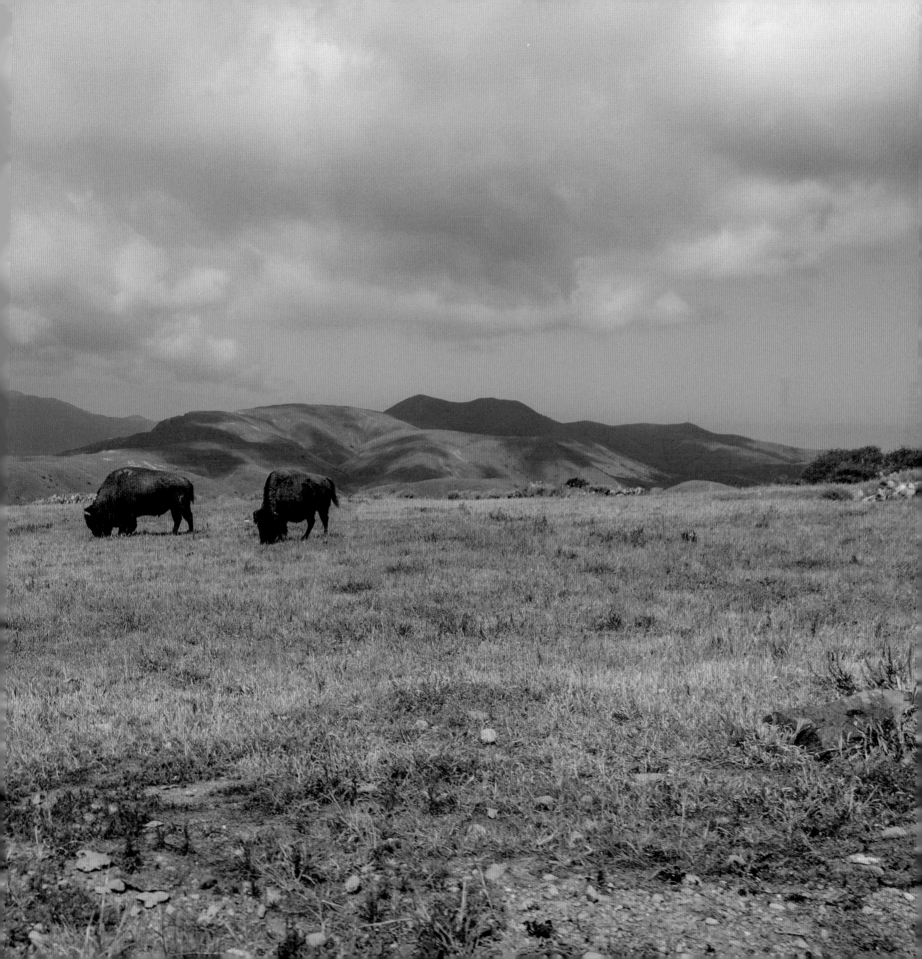

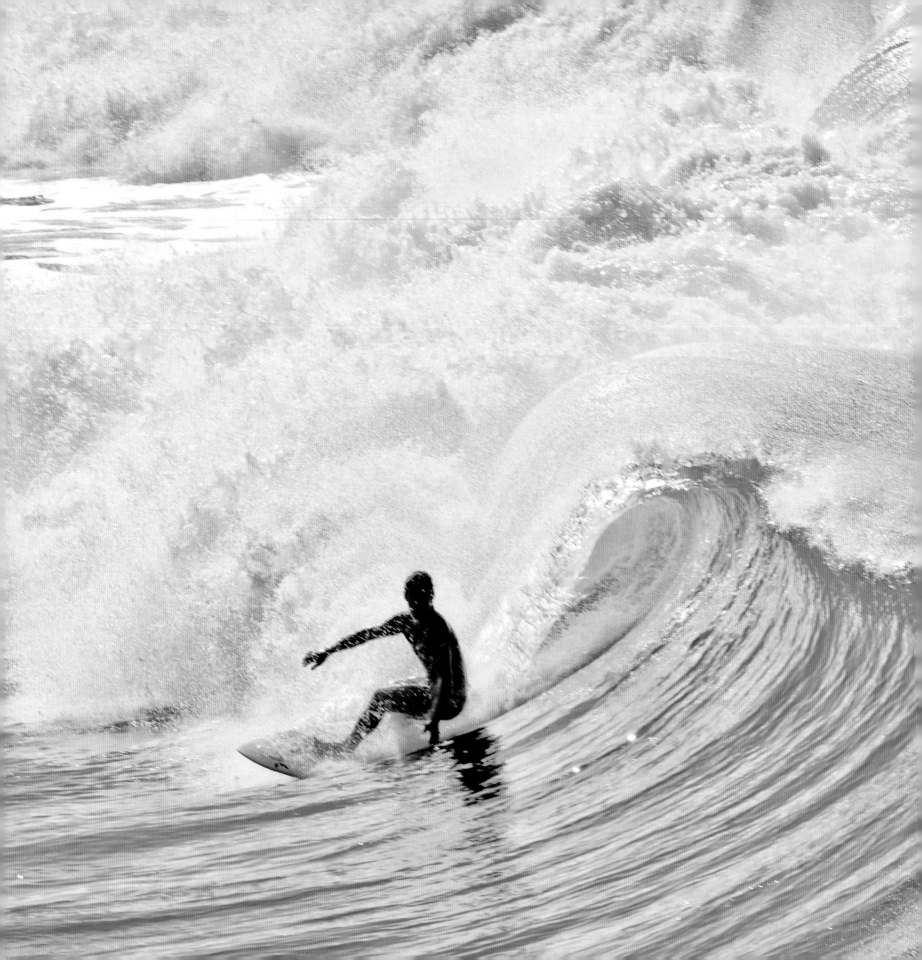

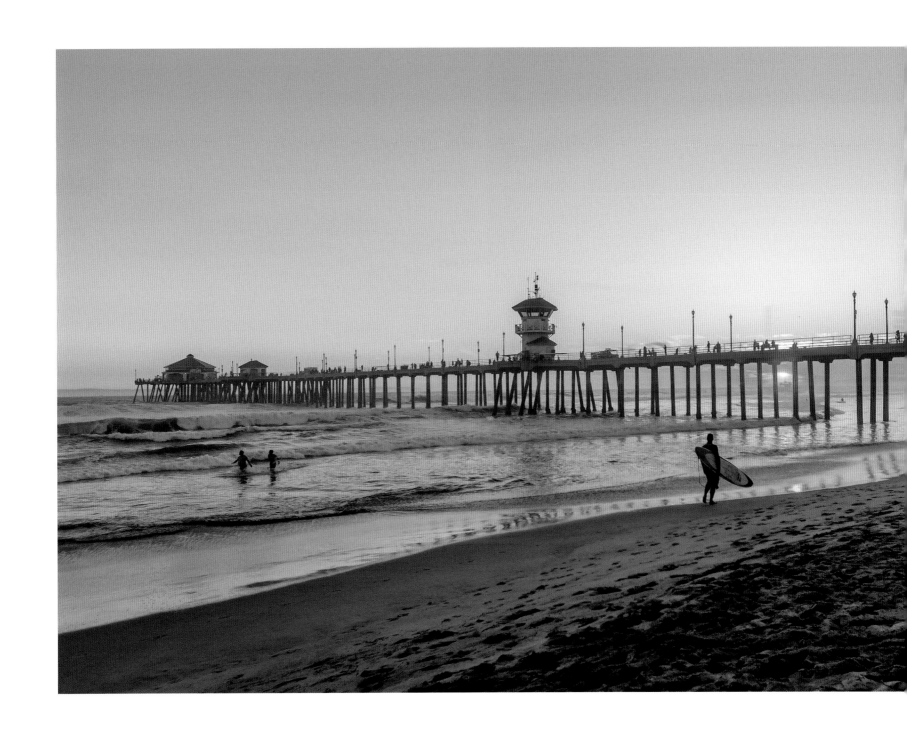

◆ ⬥ Huntington Beach

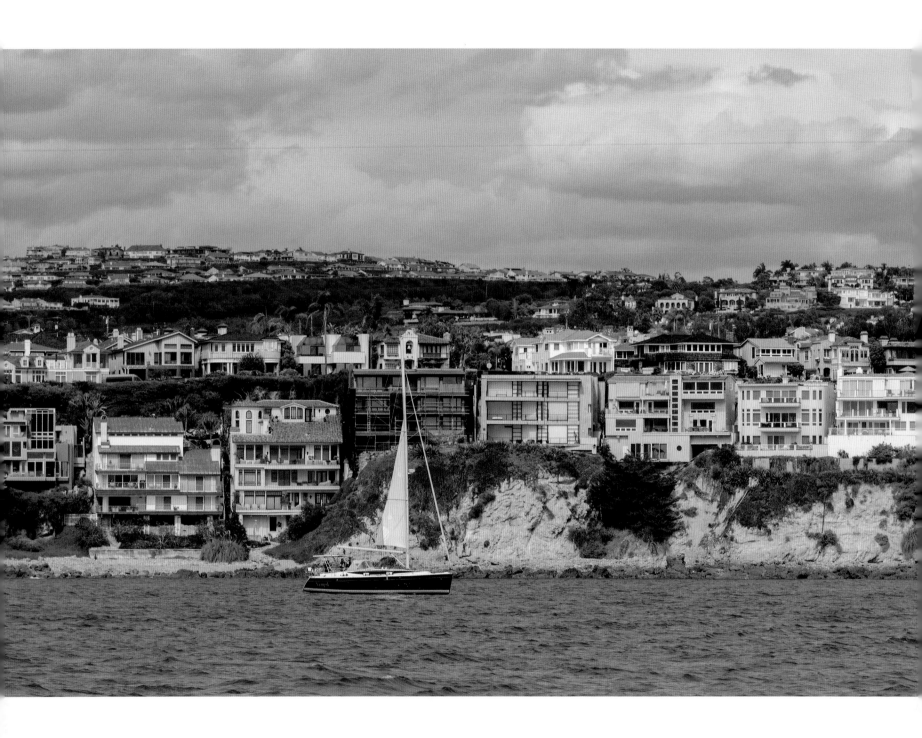

⬆ ◈ ⬇ Newport Beach

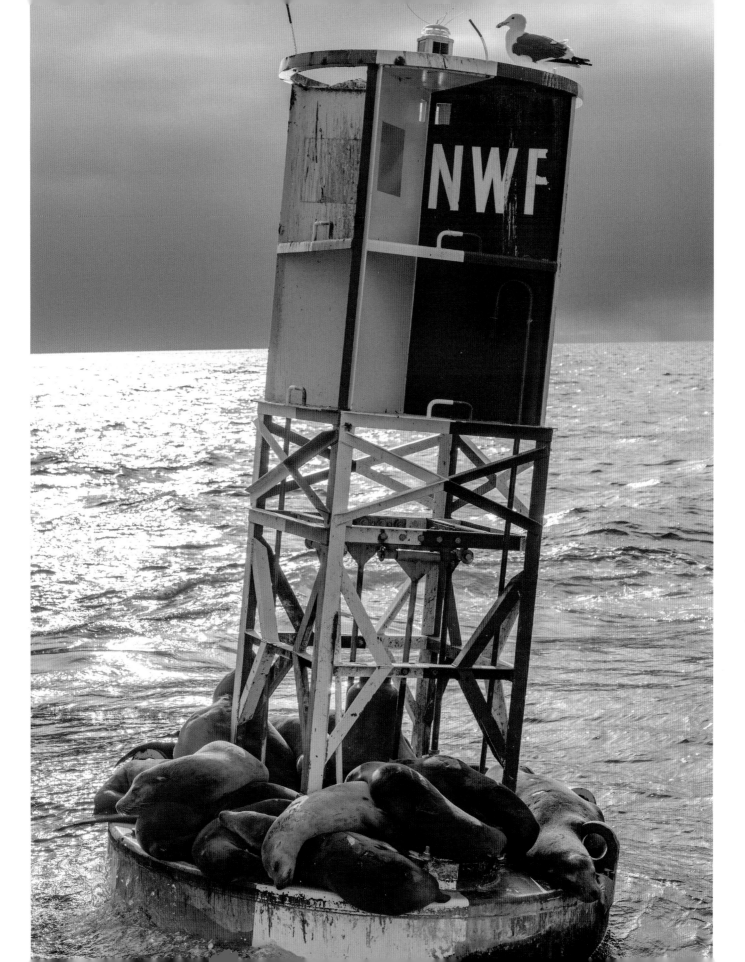

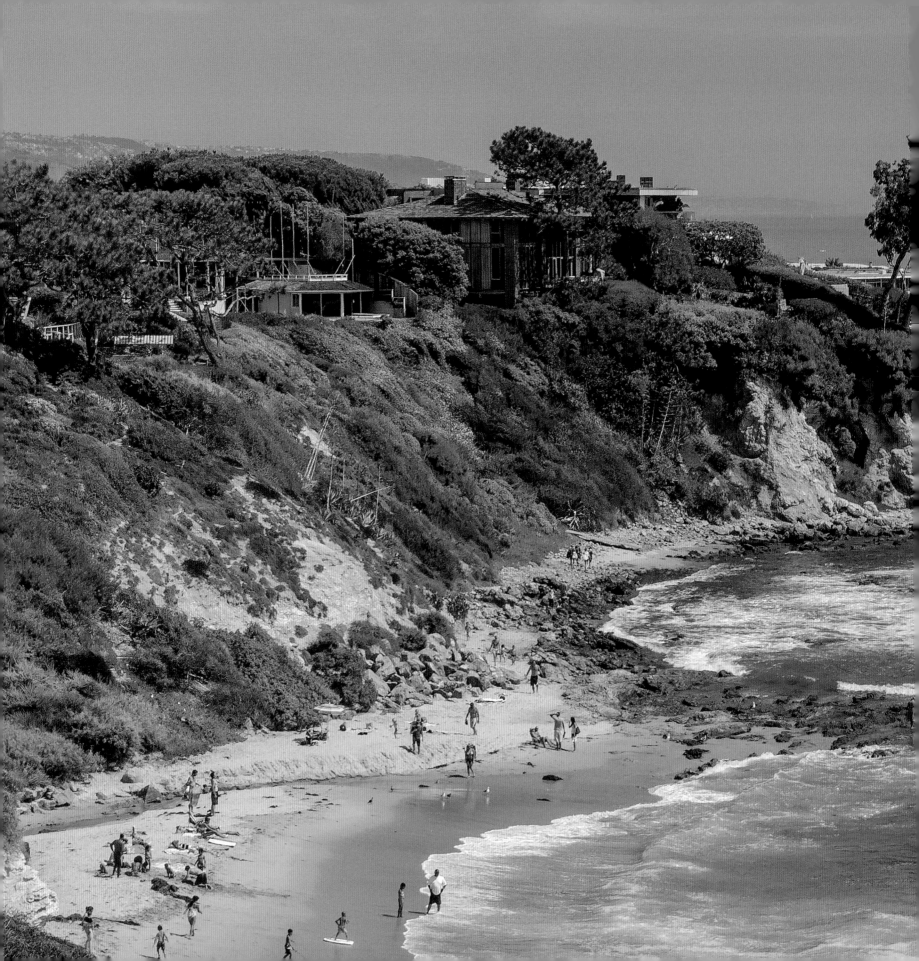

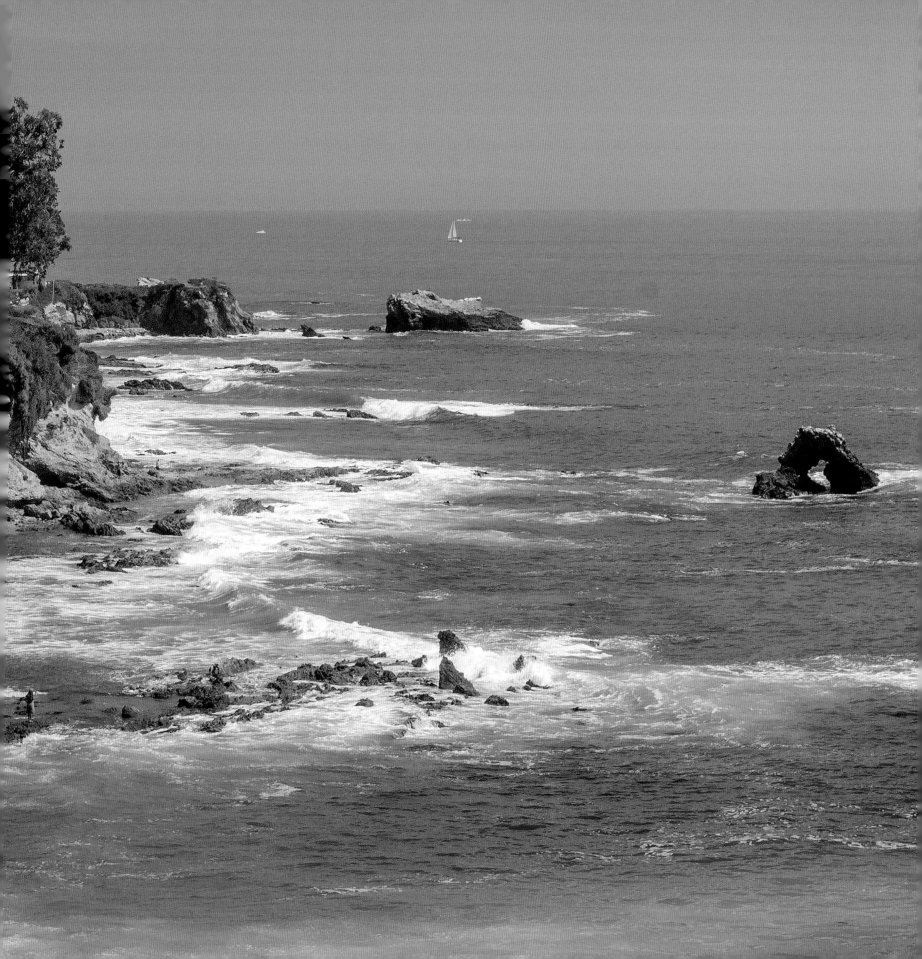

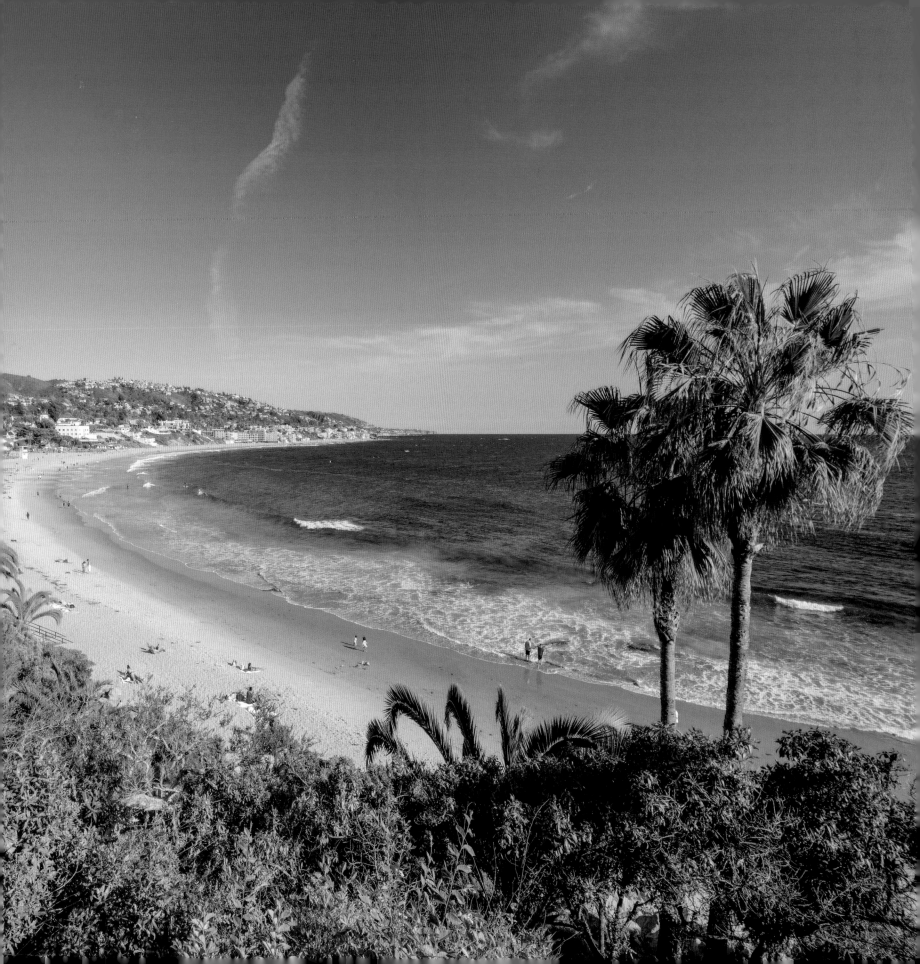

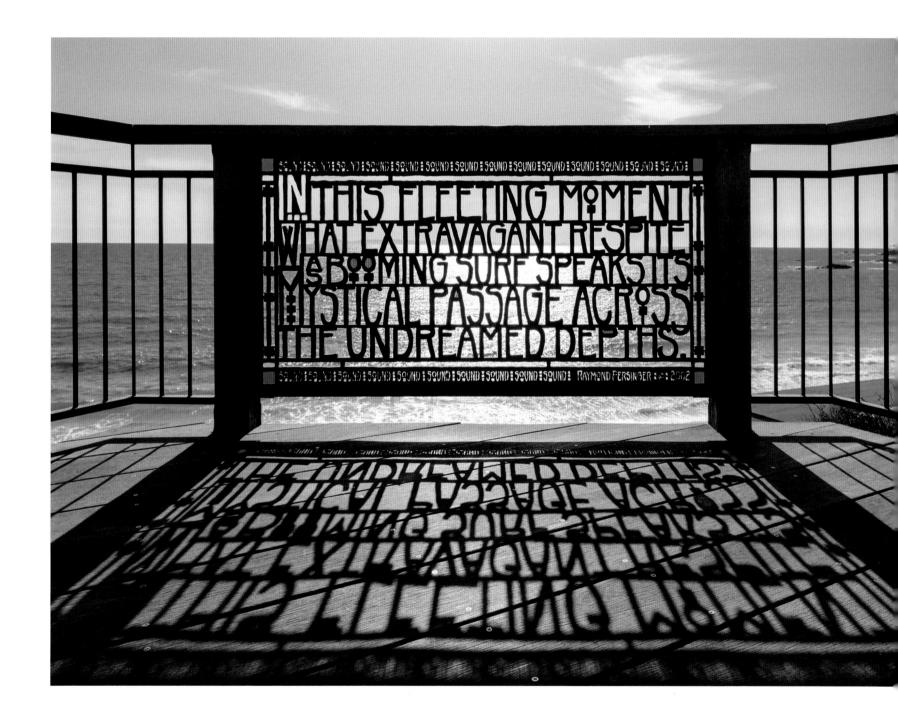

The sculpture/railing text reads:

SOUND SOUND SOUND SOUND SOUND SOUND SOUND SOUND SOUND SOUND SOUND SOUND SOUND SOUND SOUND

IN THIS FLEETING MOMENT
WHAT EXTRAVAGANT RESPITE
& BOOMING SURF SPEAKS ITS
MYSTICAL PASSAGE ACROSS
THE UNDREAMED DEPTHS.

SOUND SOUND SOUND SOUND SOUND SOUND SOUND SOUND SOUND SOUND RAYMOND PERSINGER 2002

← Laguna Beach ⬥ Brown's Park, Laguna Beach ⬥ Dana Point

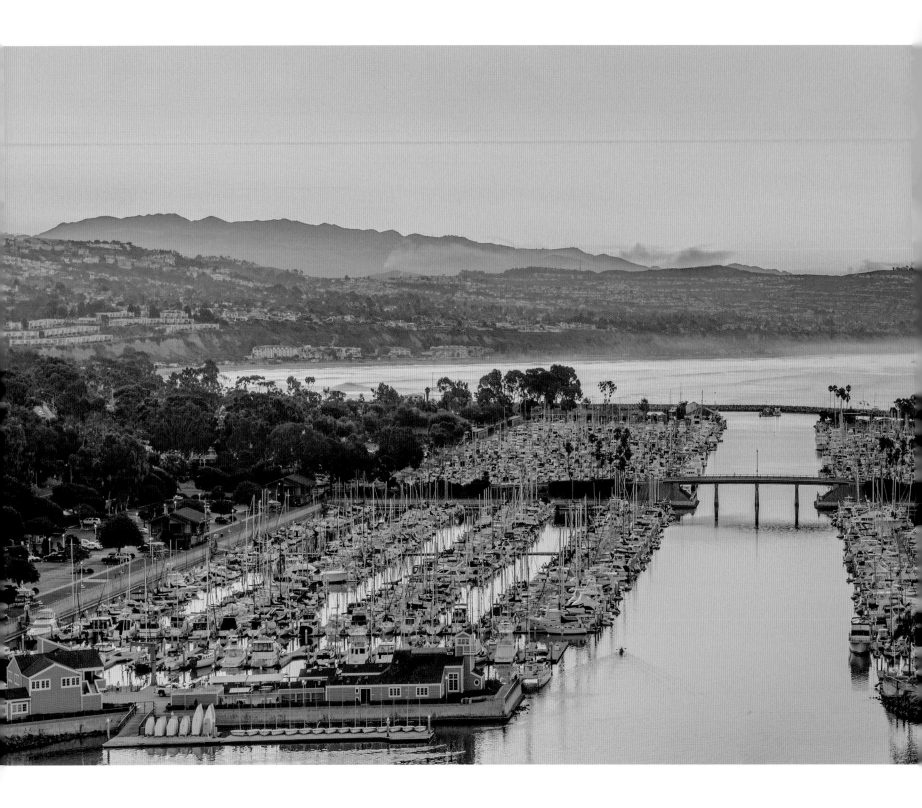

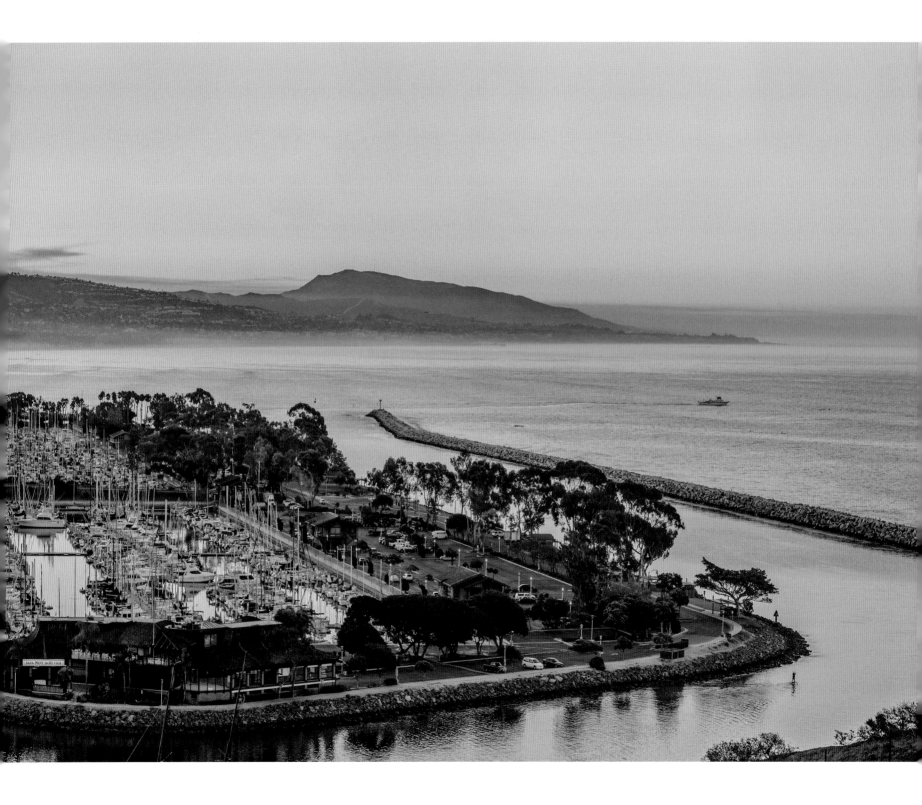

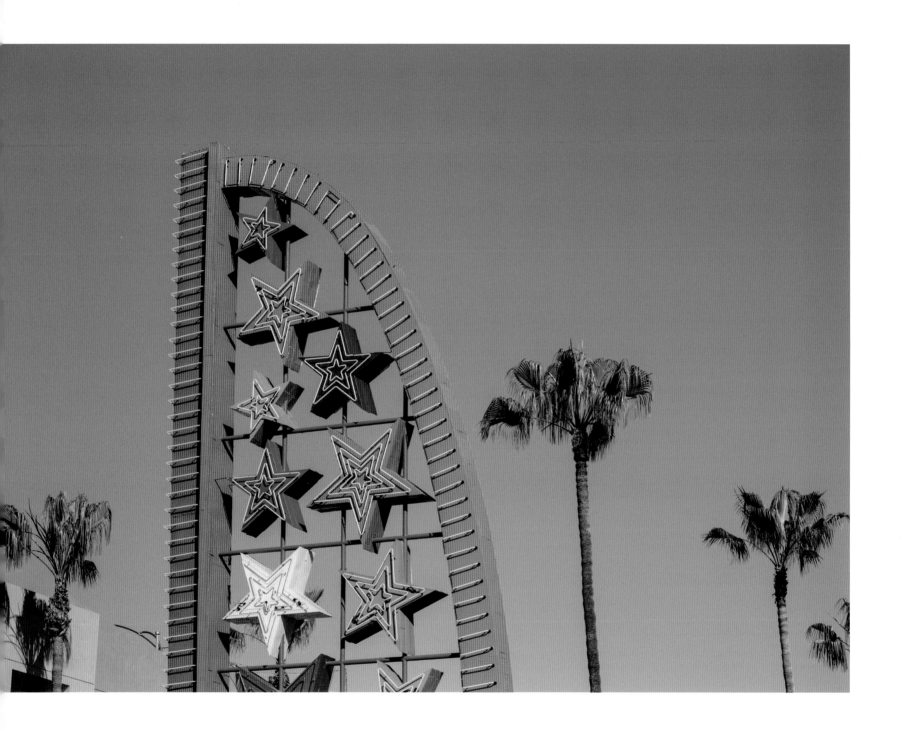

◈ Star Theatre, Oceanside ◈ Old Mission San Luis Rey de Francia, Oceanside ◈ Oceanside

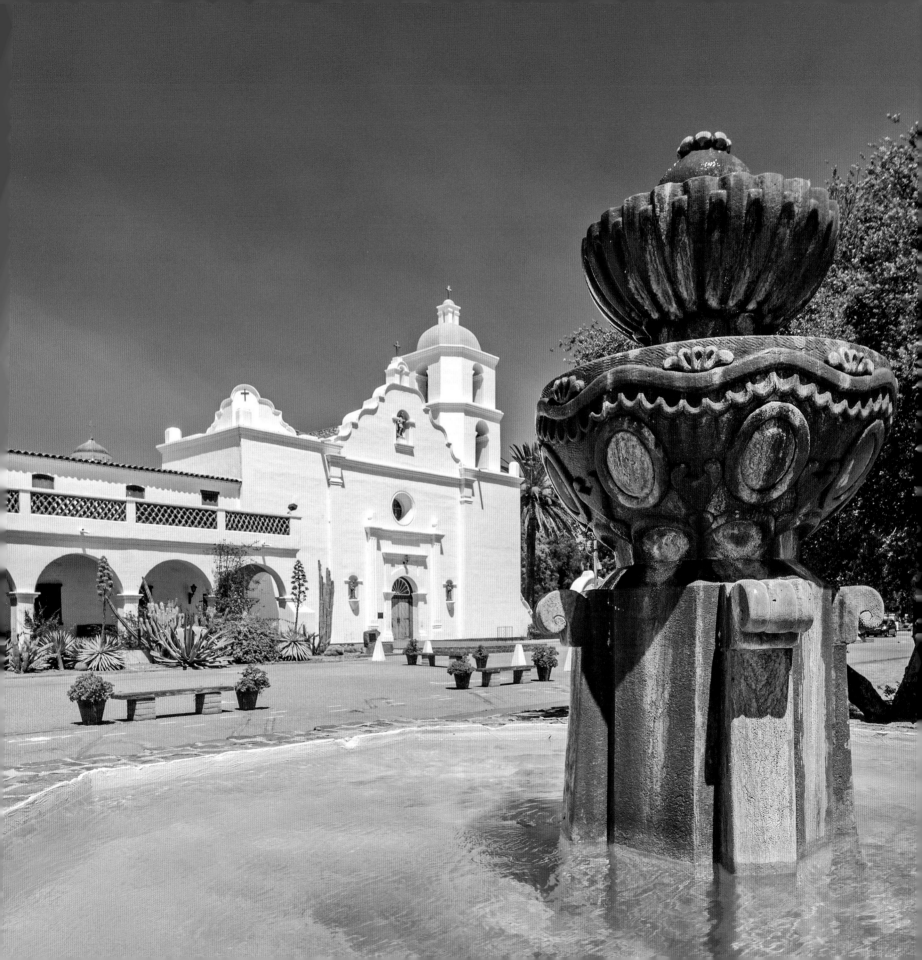

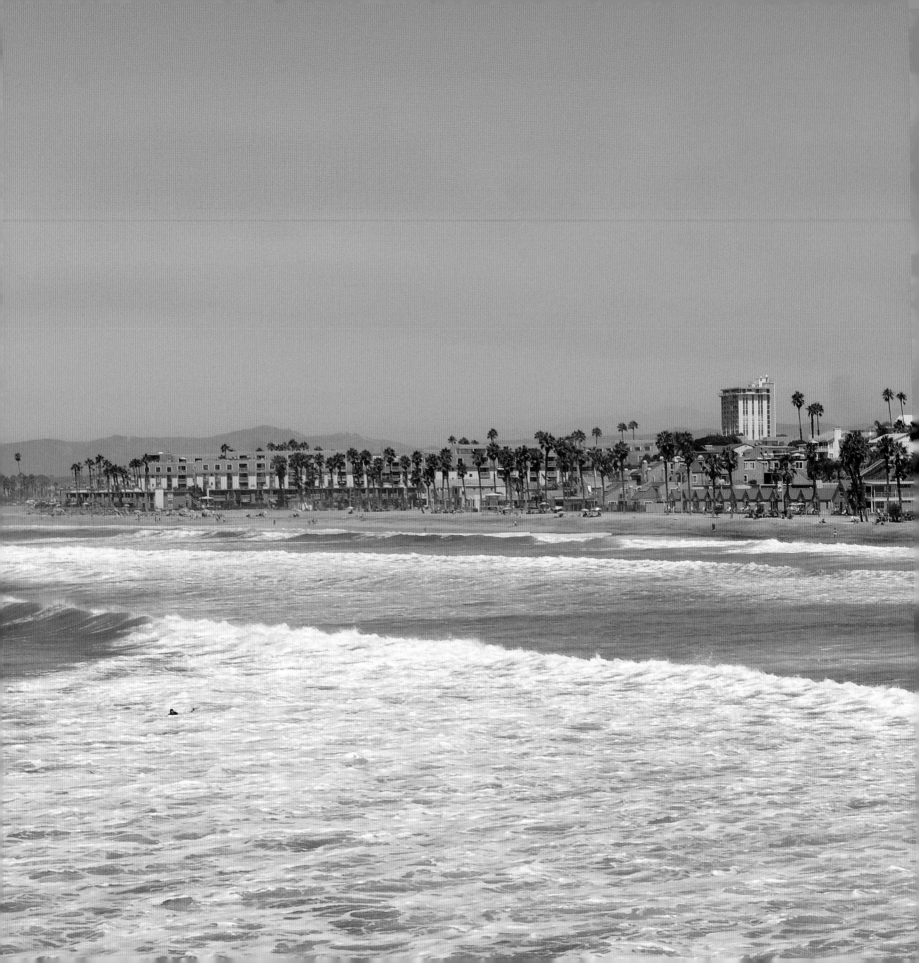

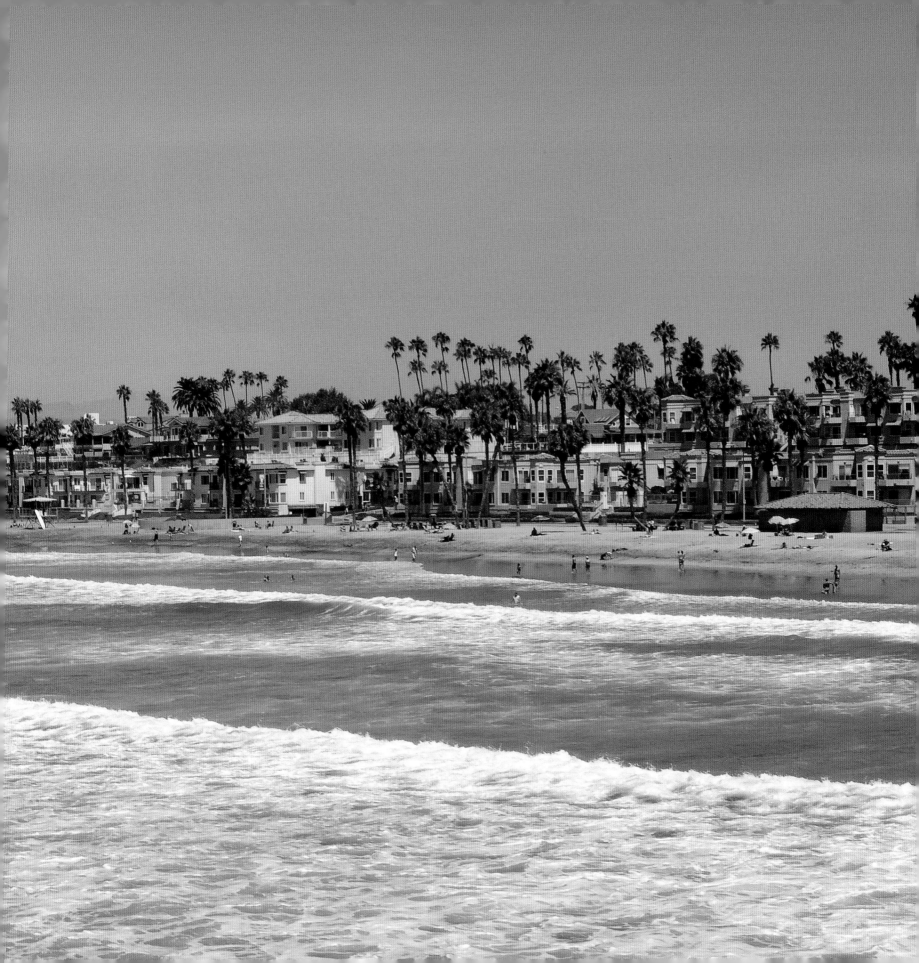

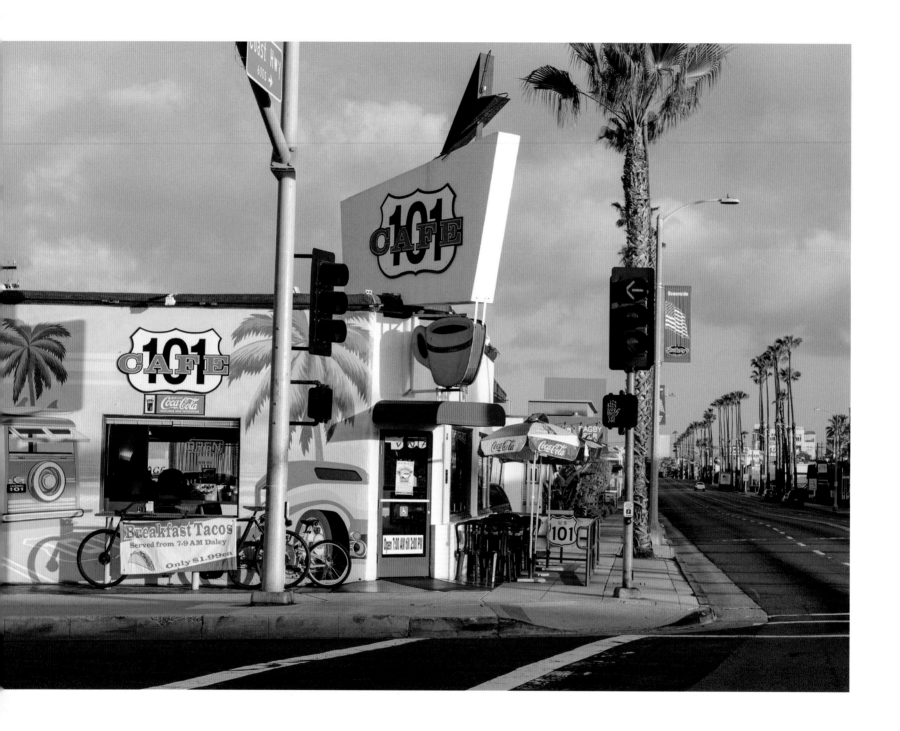

◈ 101 Cafe, Oceanside ➡ Flower fields, Carlsbad ◈ Torrey Pines State Natural Reserve, San Diego

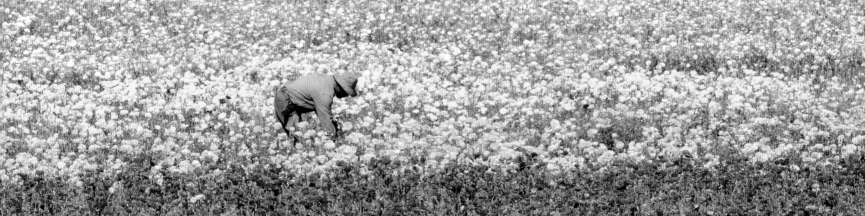

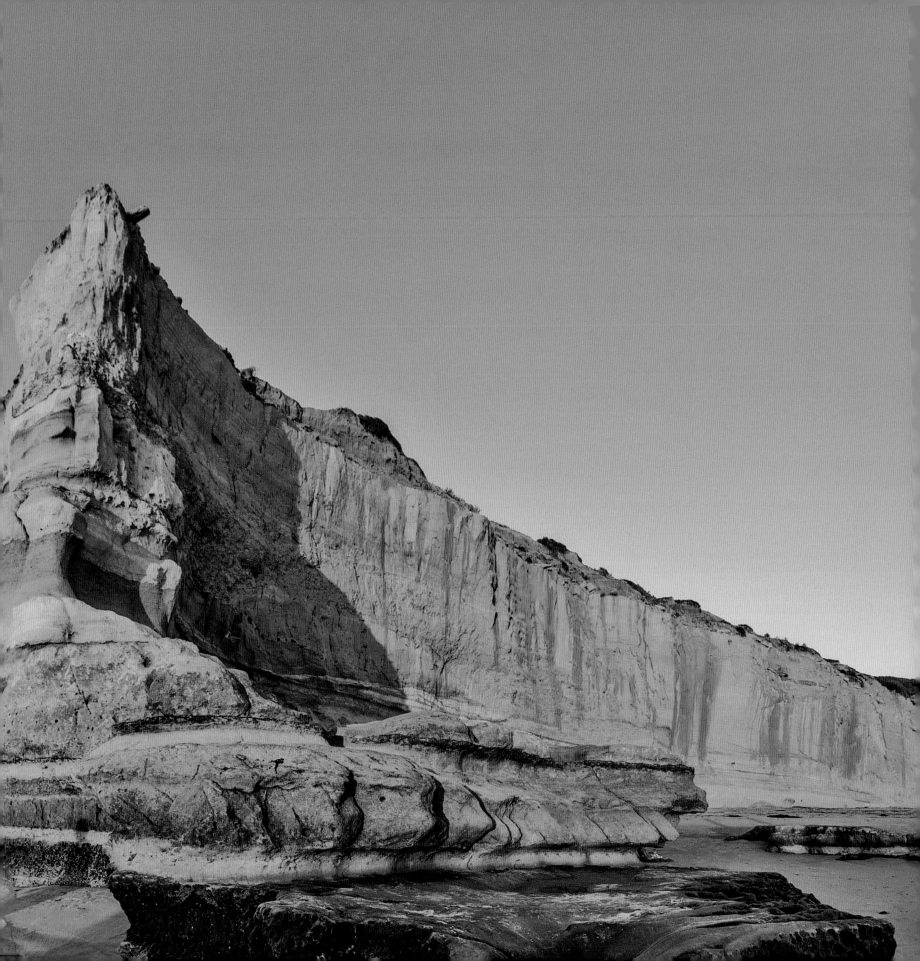

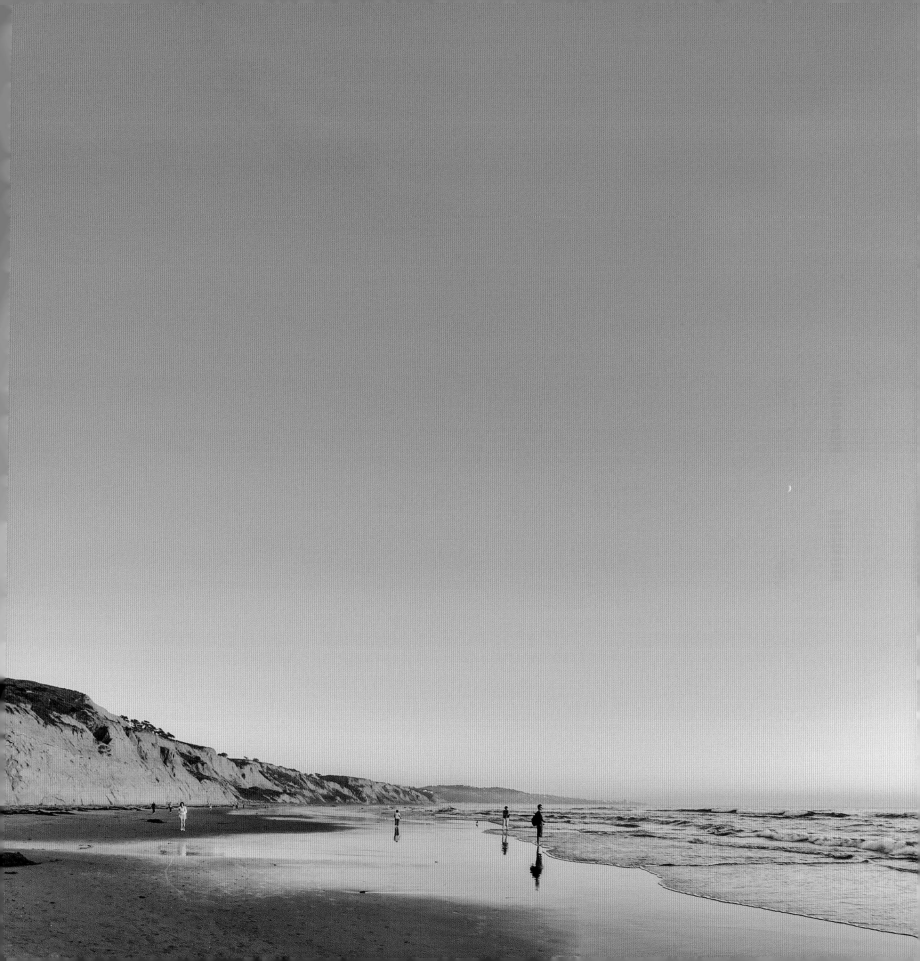

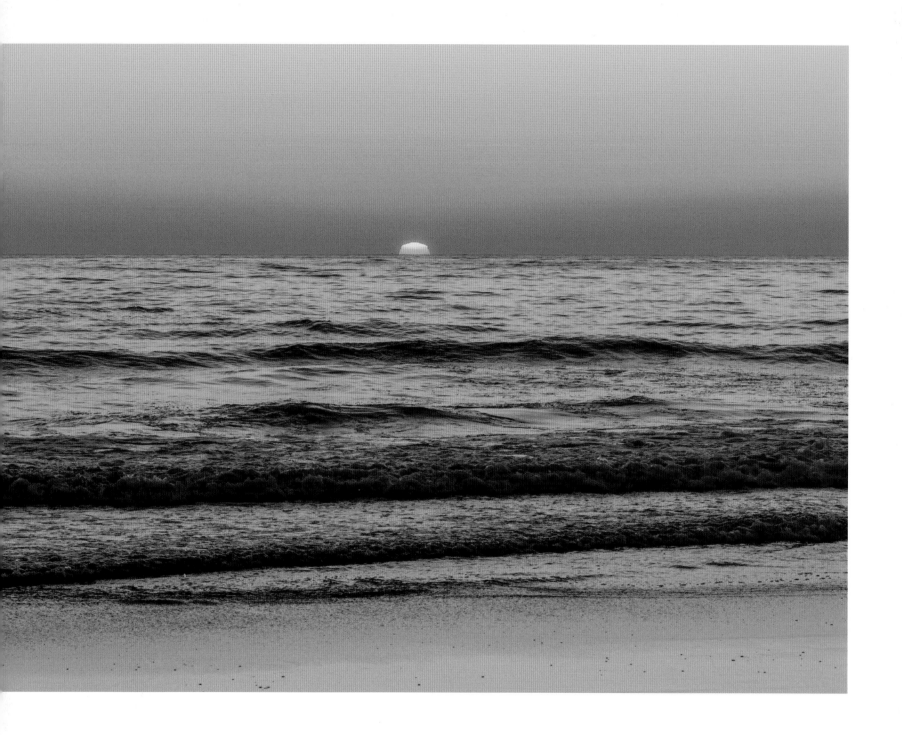

◈ Torrey Pines State Natural Reserve, San Diego ◈ Museum of Contemporary Art San Diego, La Jolla ◈ Coastline, San Diego

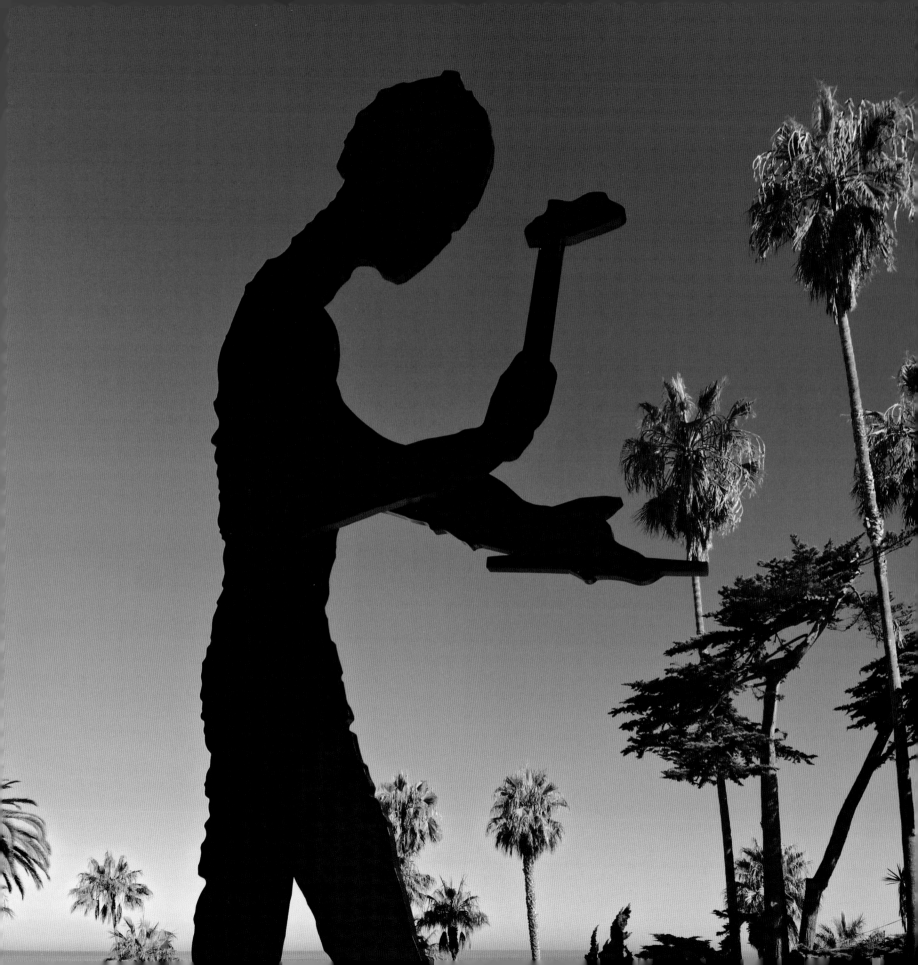

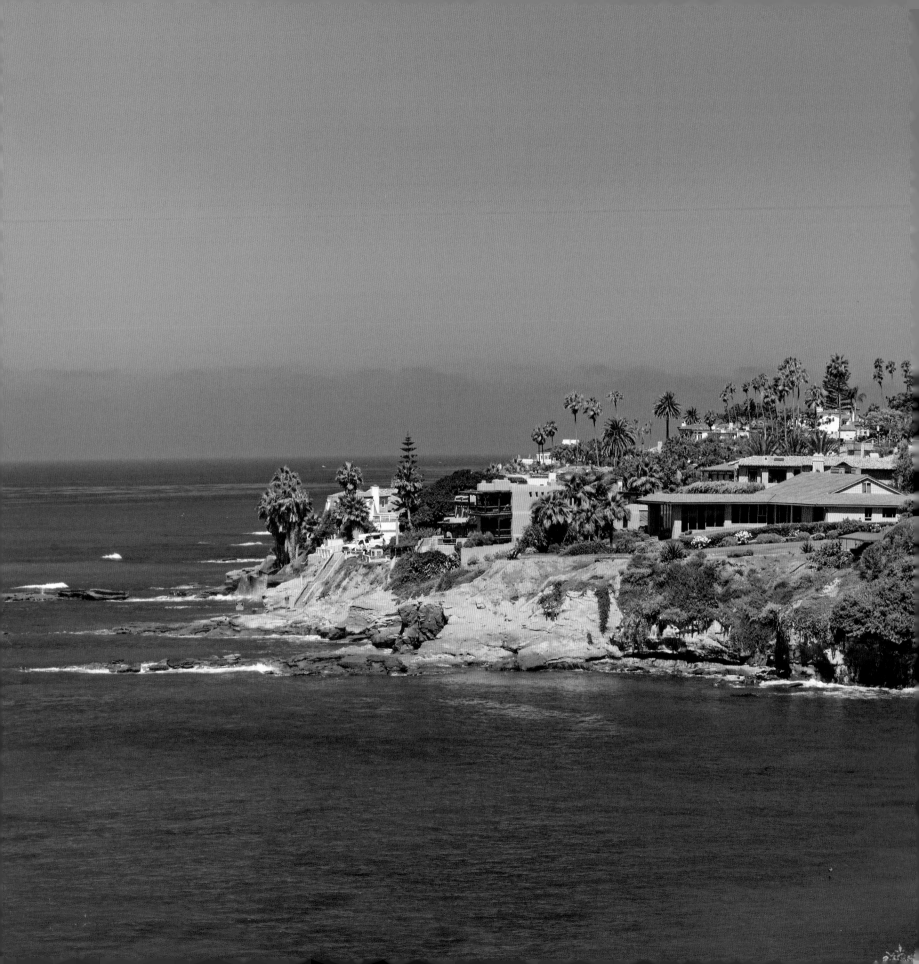

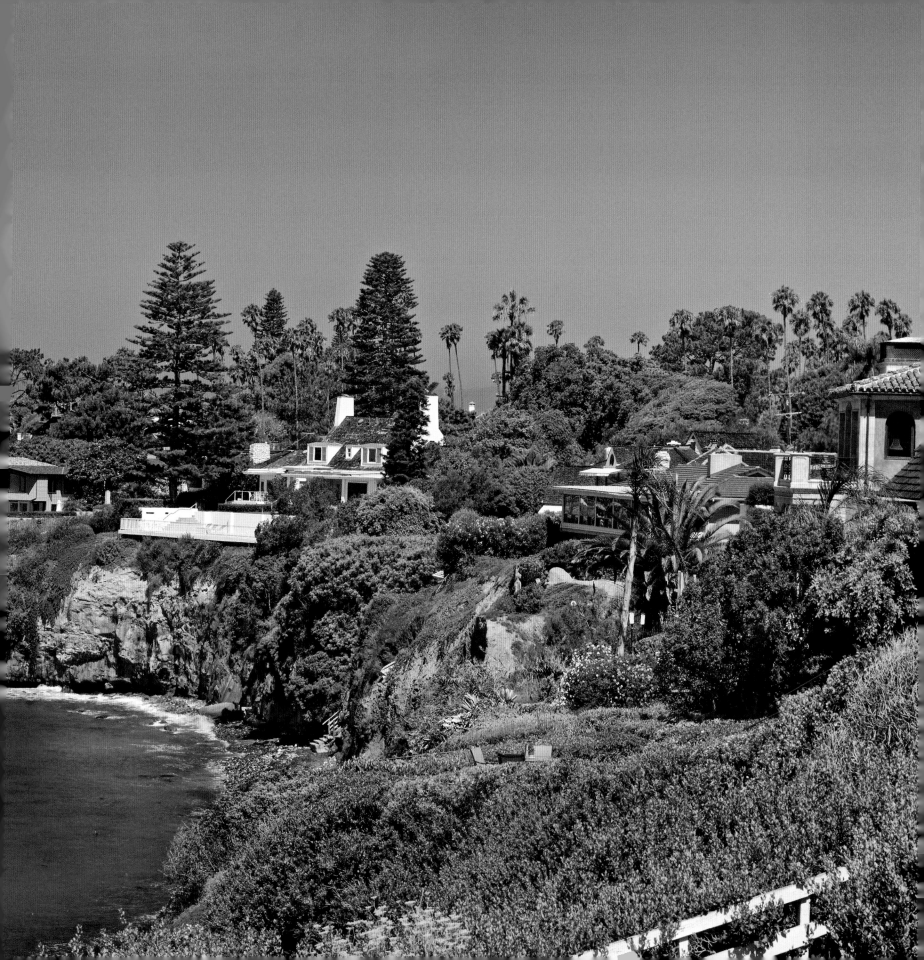

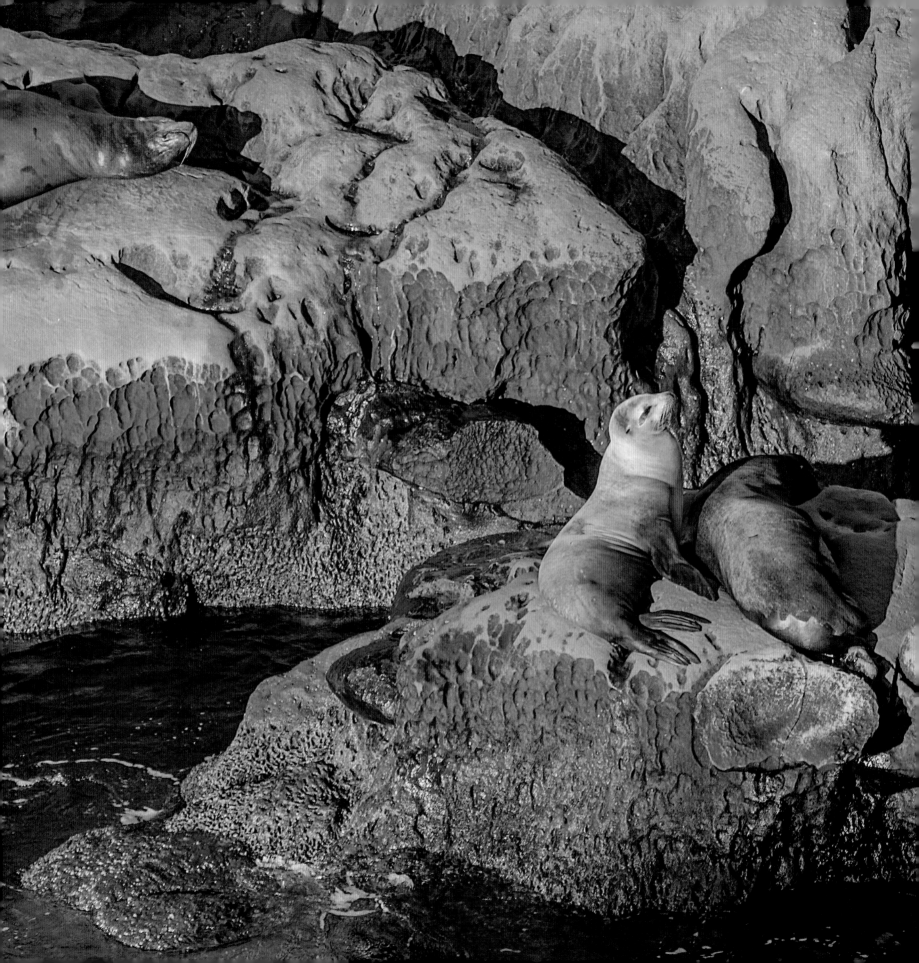

La Jolla, San Diego

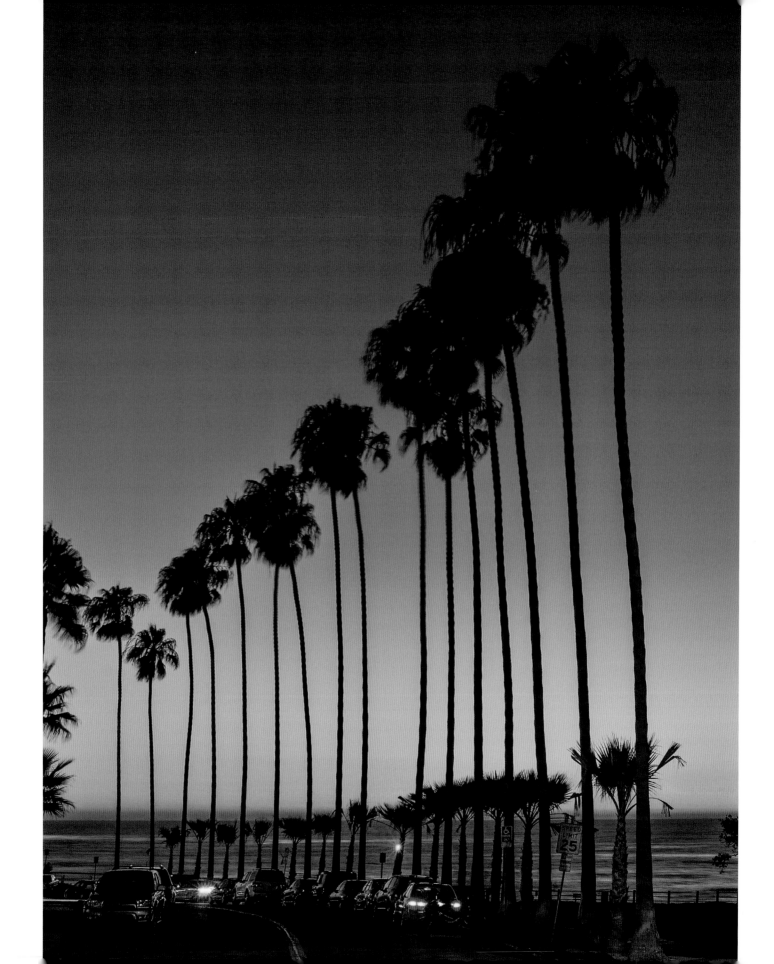

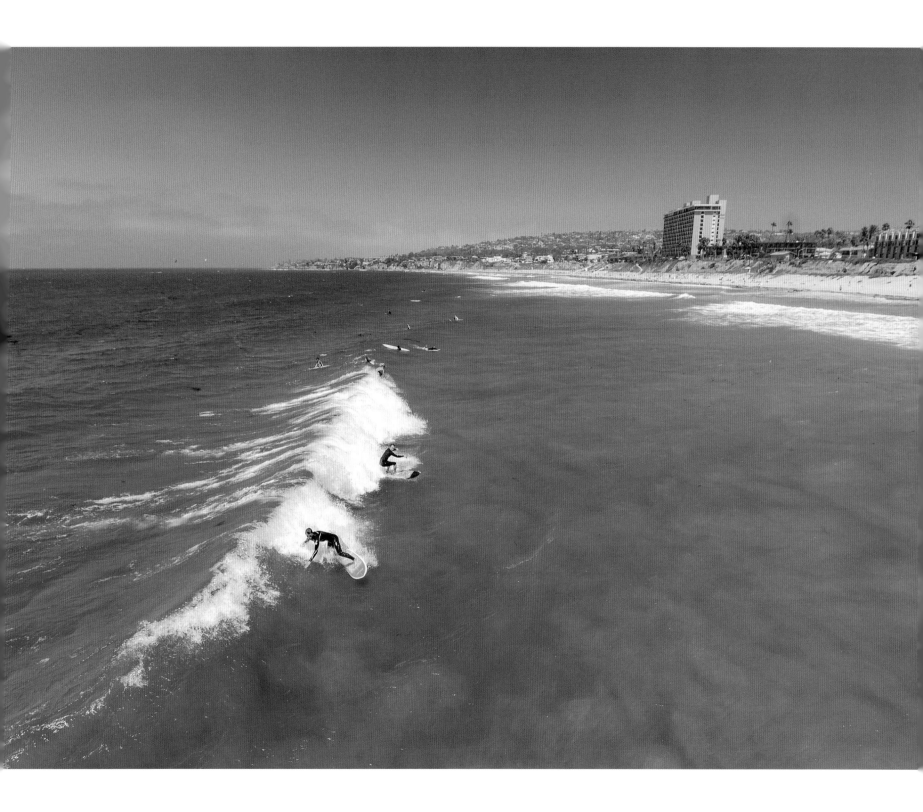

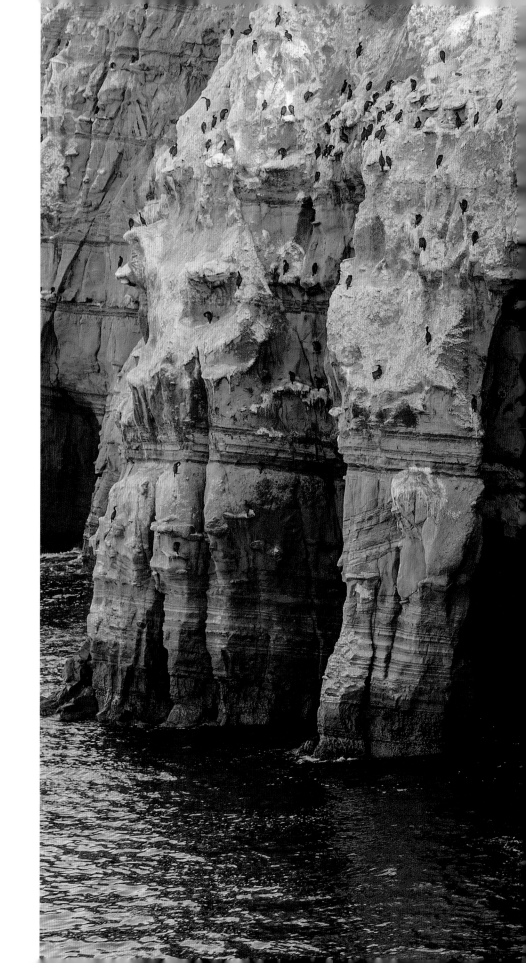

La Jolla, San Diego

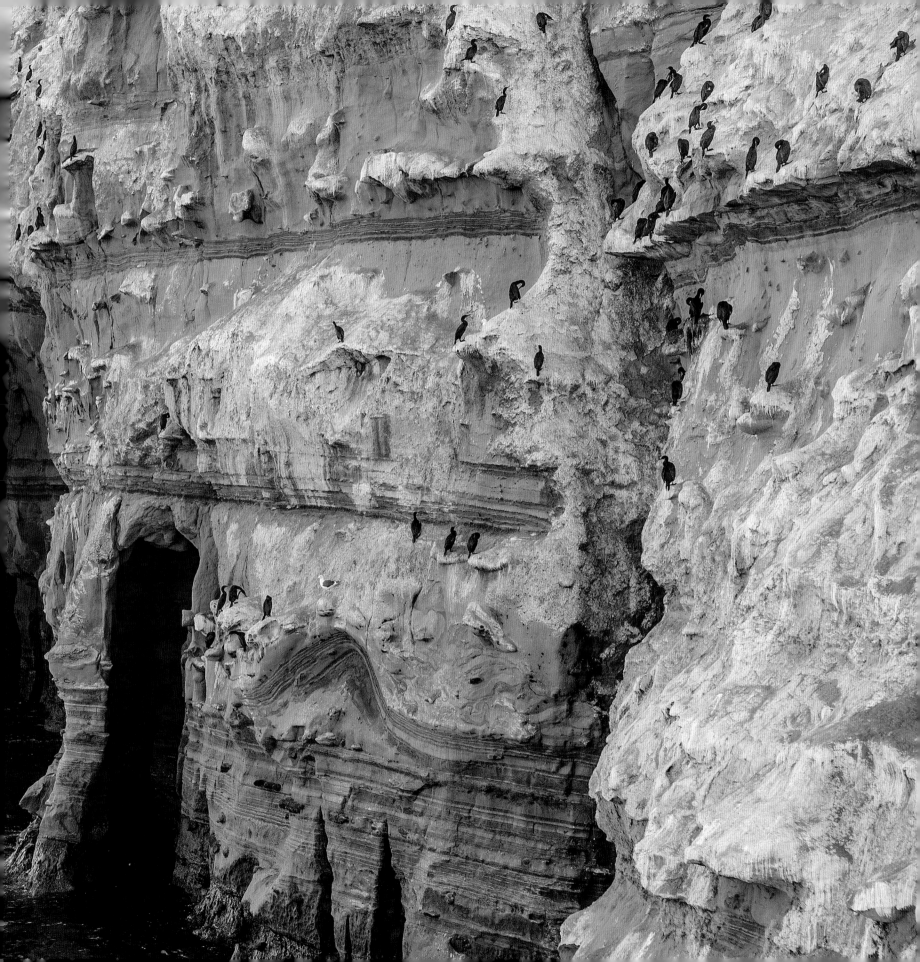

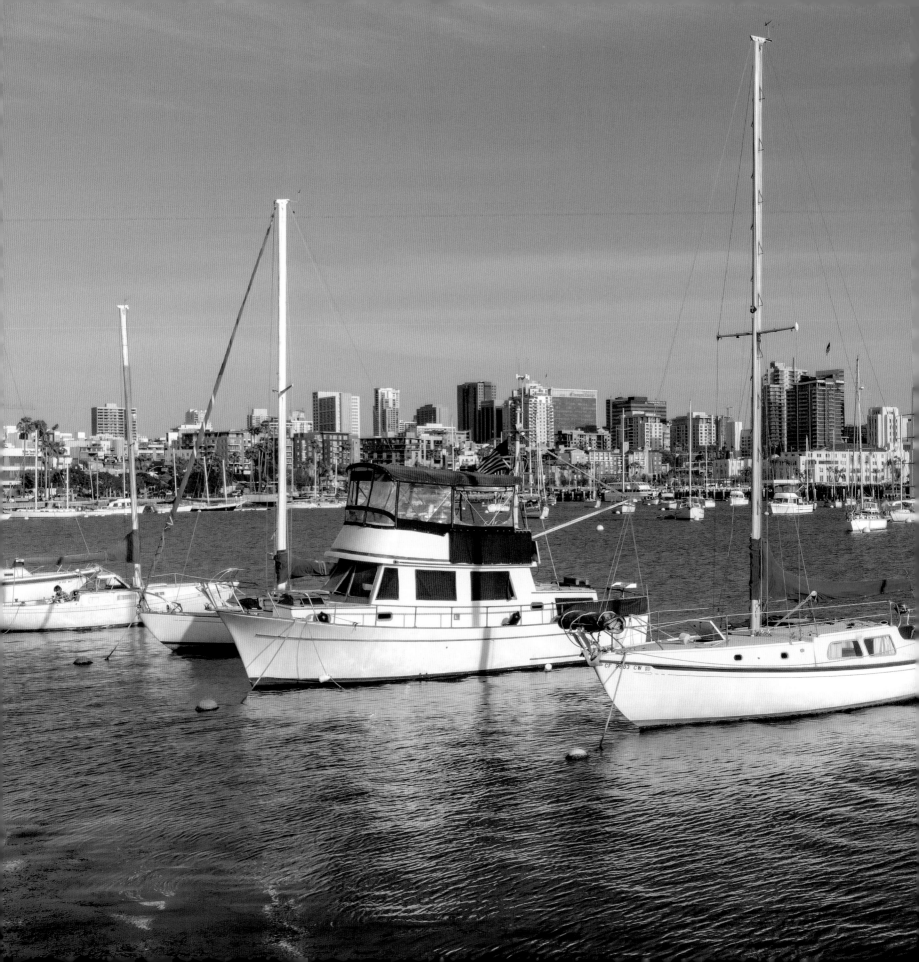

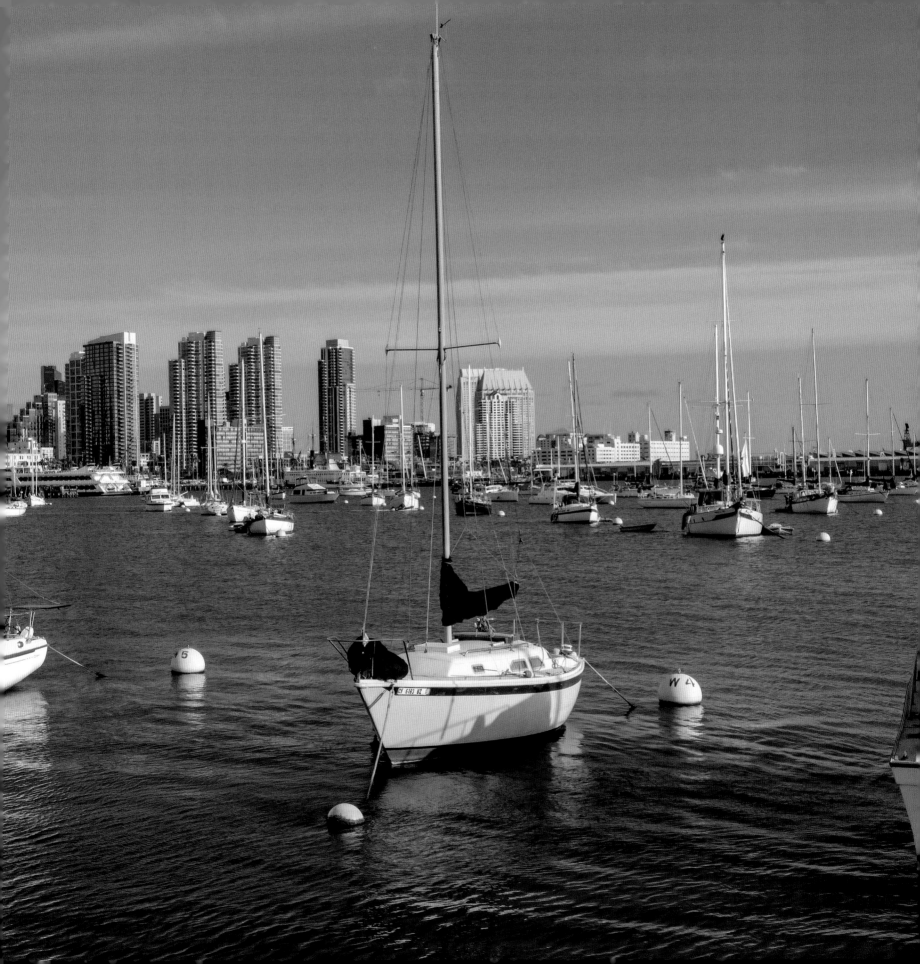

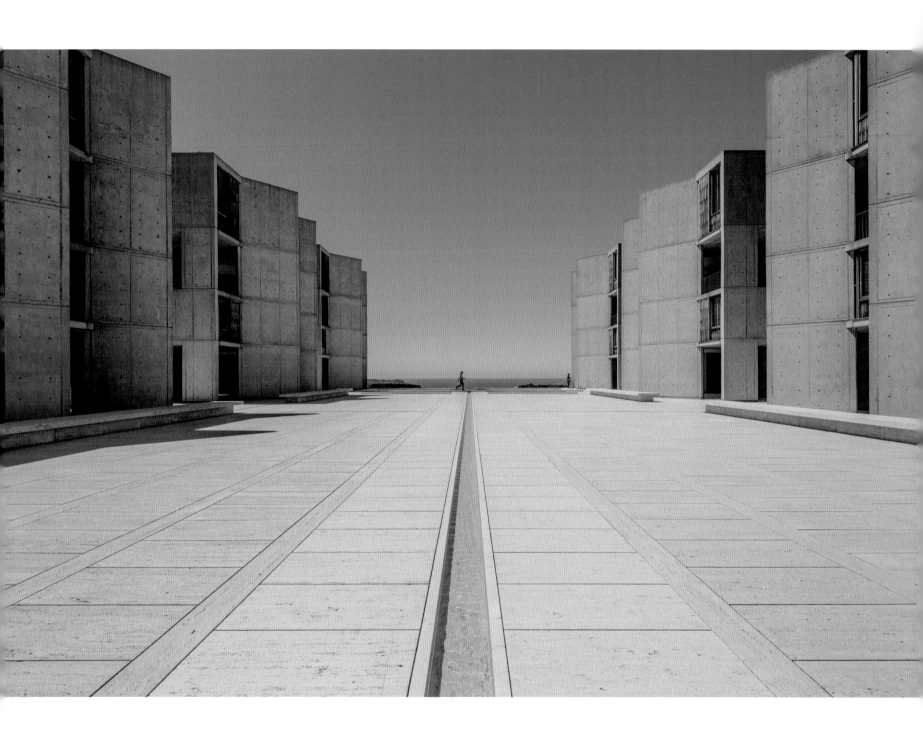

◈ Salk Institute for Biological Studies, La Jolla ◈ Mission Basilica San Diego de Alcalá, San Diego ◈ Balboa Park, San Diego

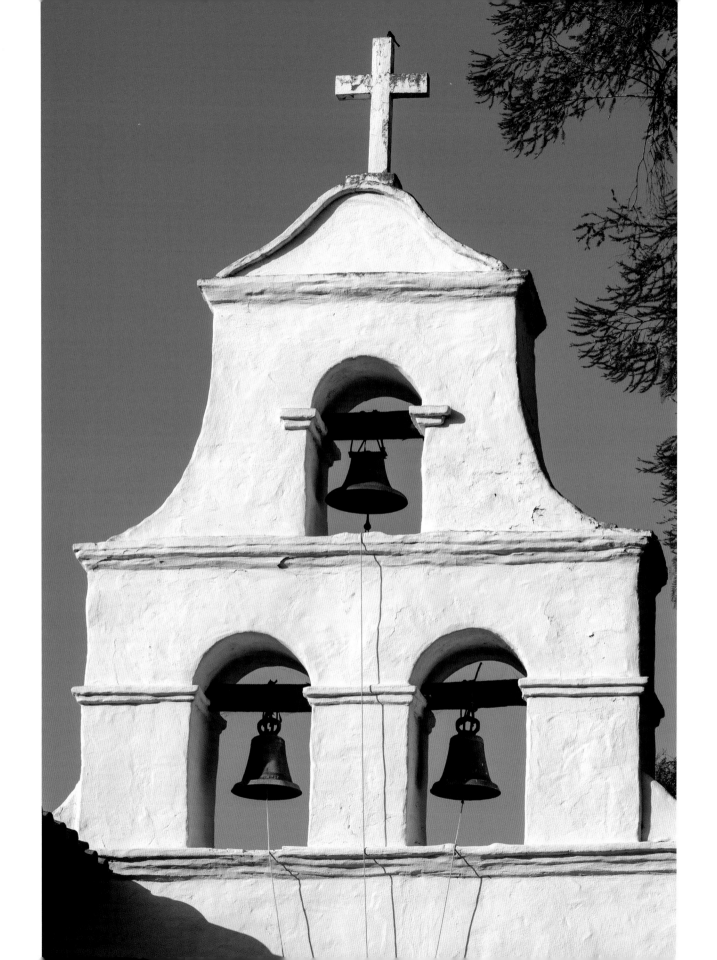

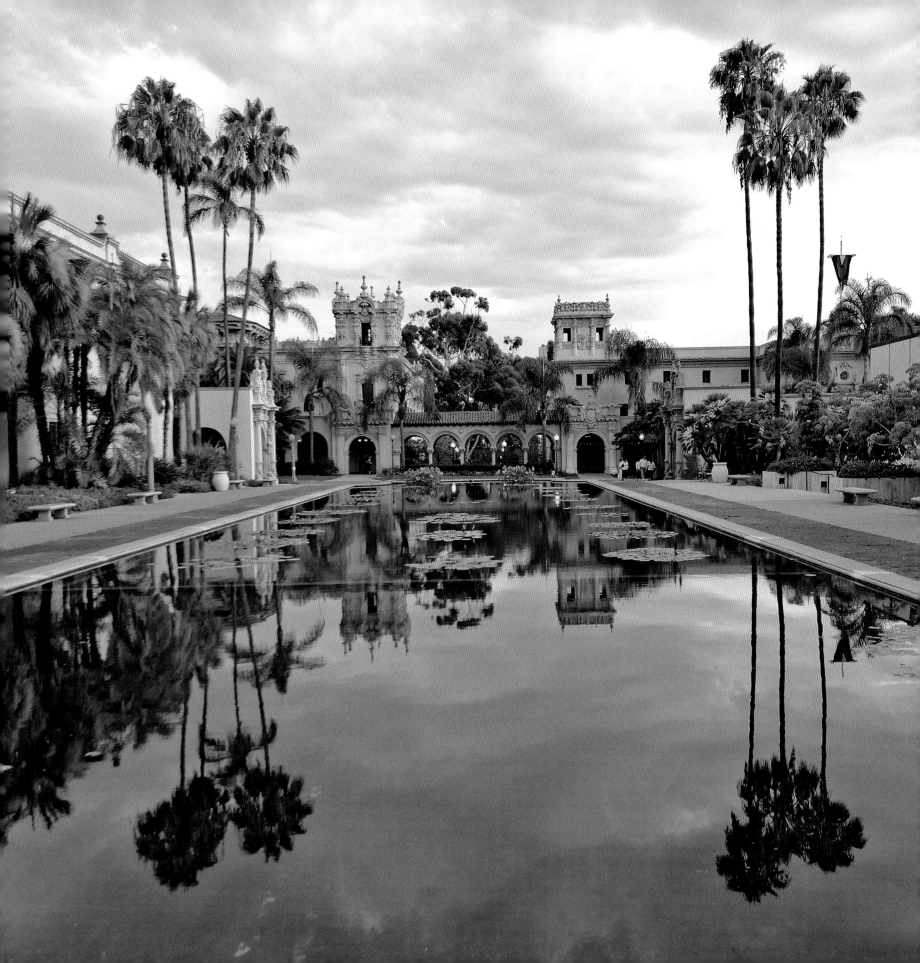

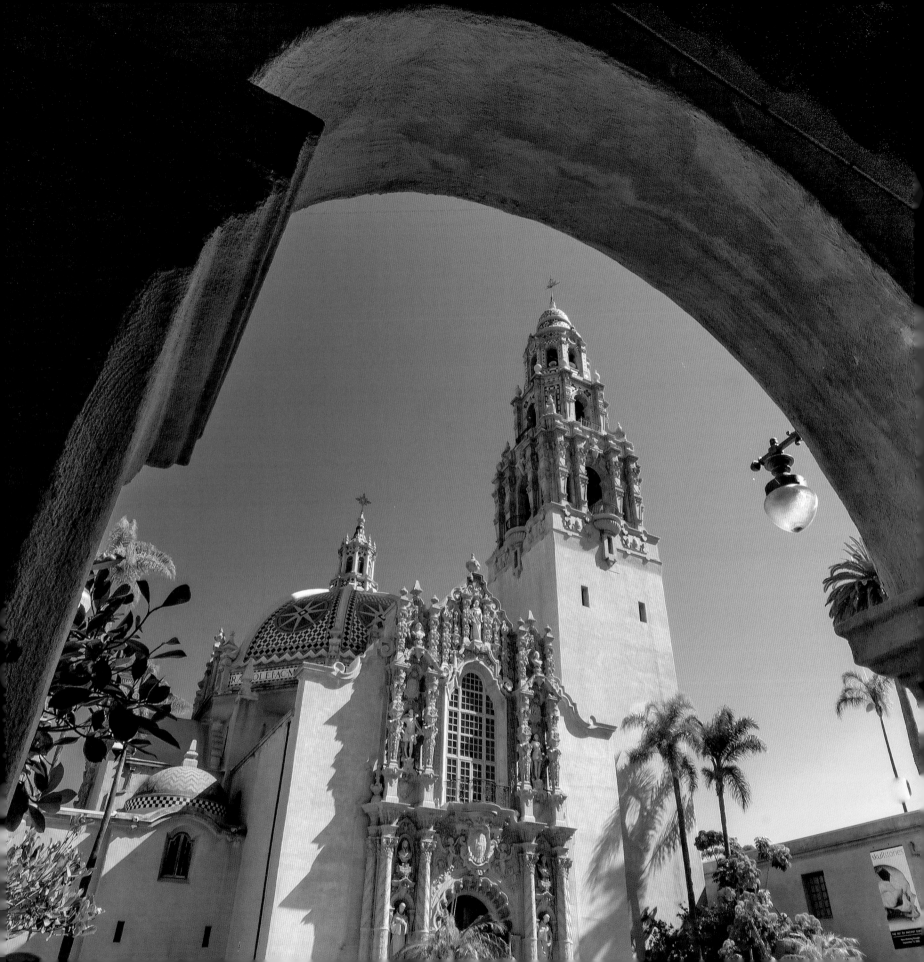

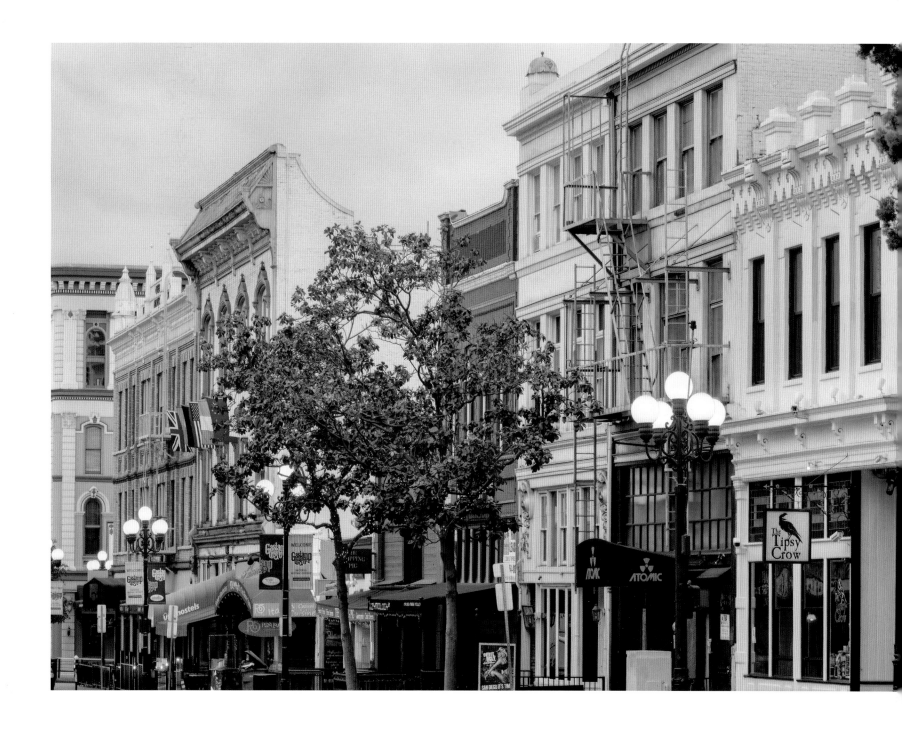

◈ Balboa Park, San Diego ◈ Gaslamp Quarter, San Diego

◈ La Jolla, San Diego

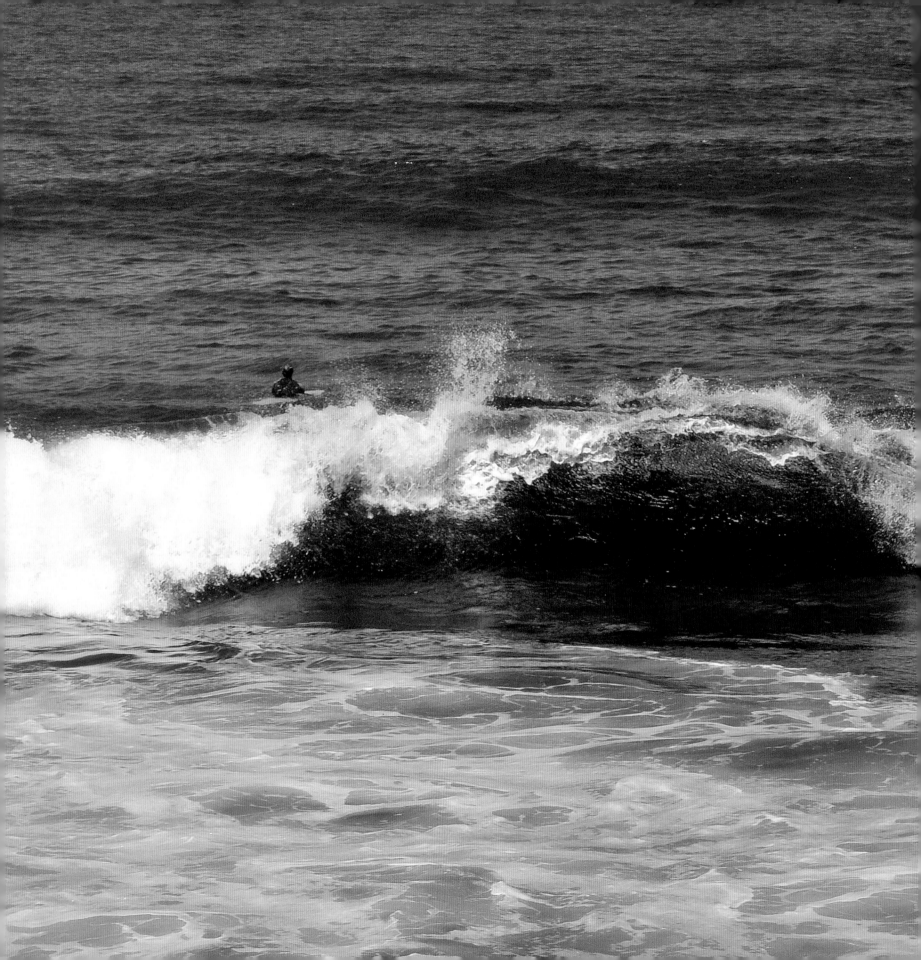

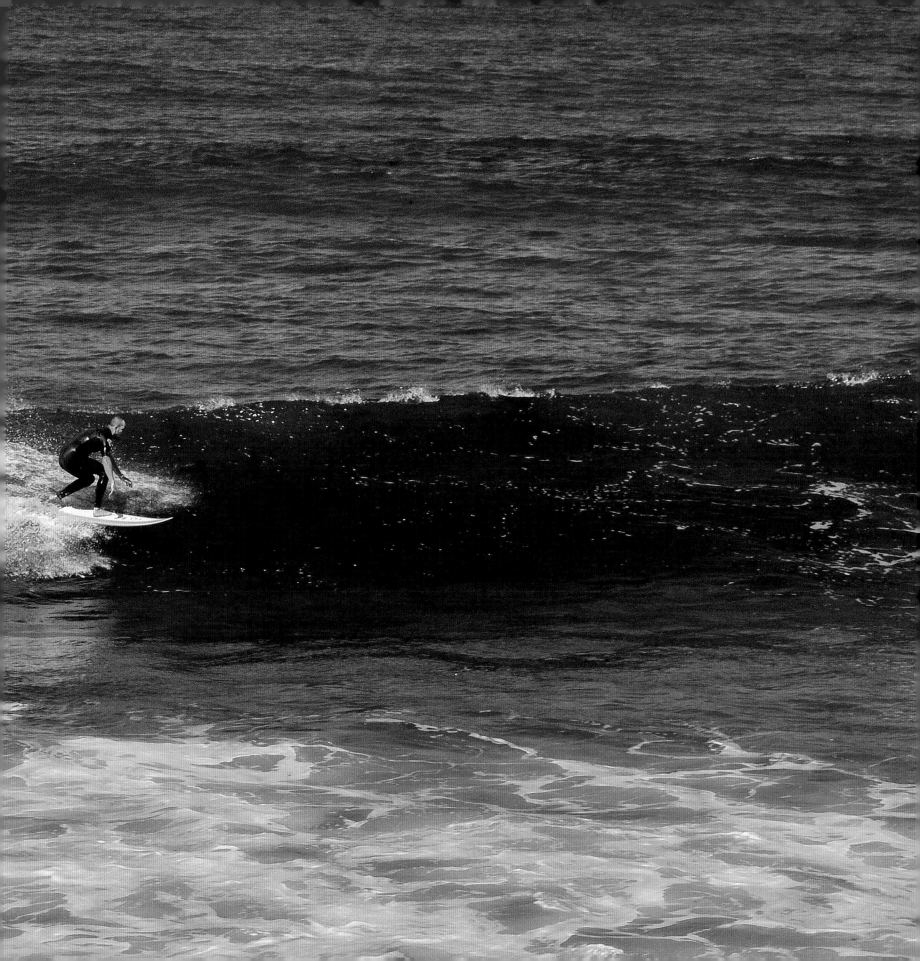

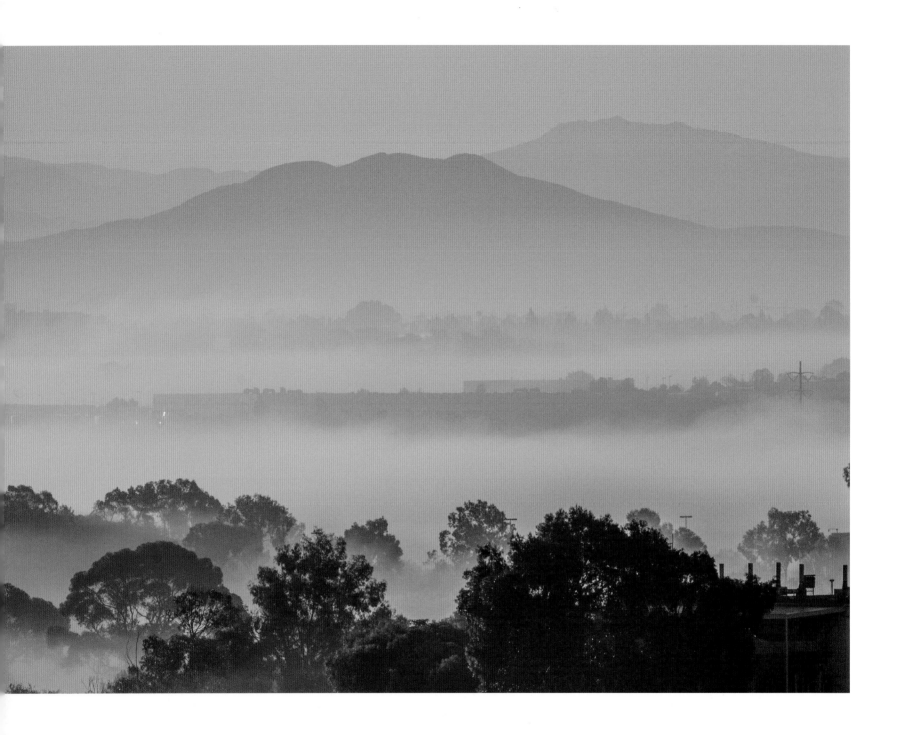

◈ Fog over valleys, San Diego ◈ Dog Beach, Ocean Beach, San Diego ◈ Torrey Pines Gliderport, La Jolla, San Diego

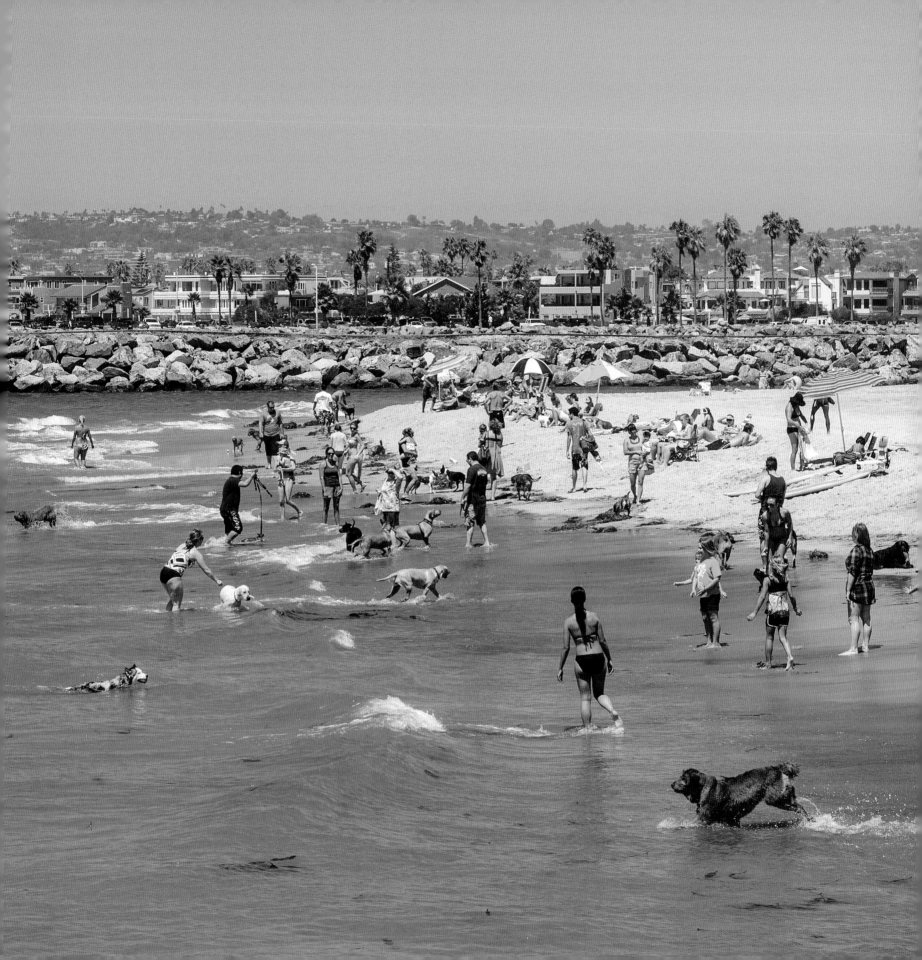

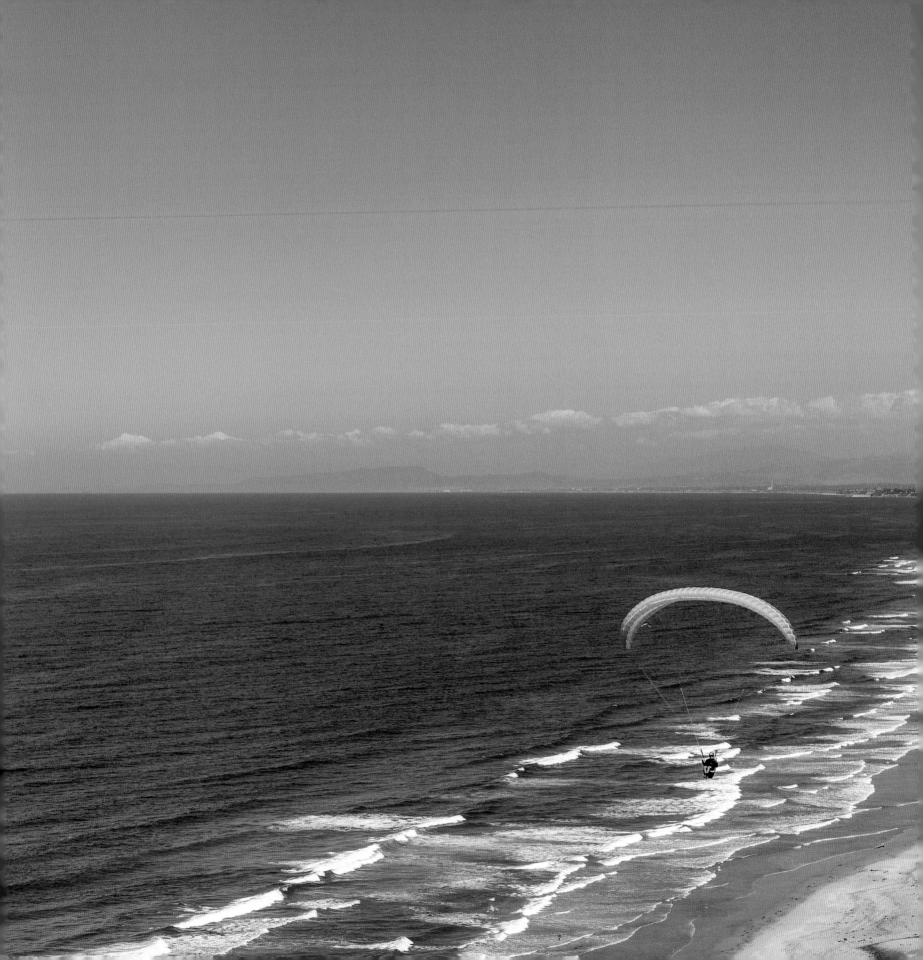

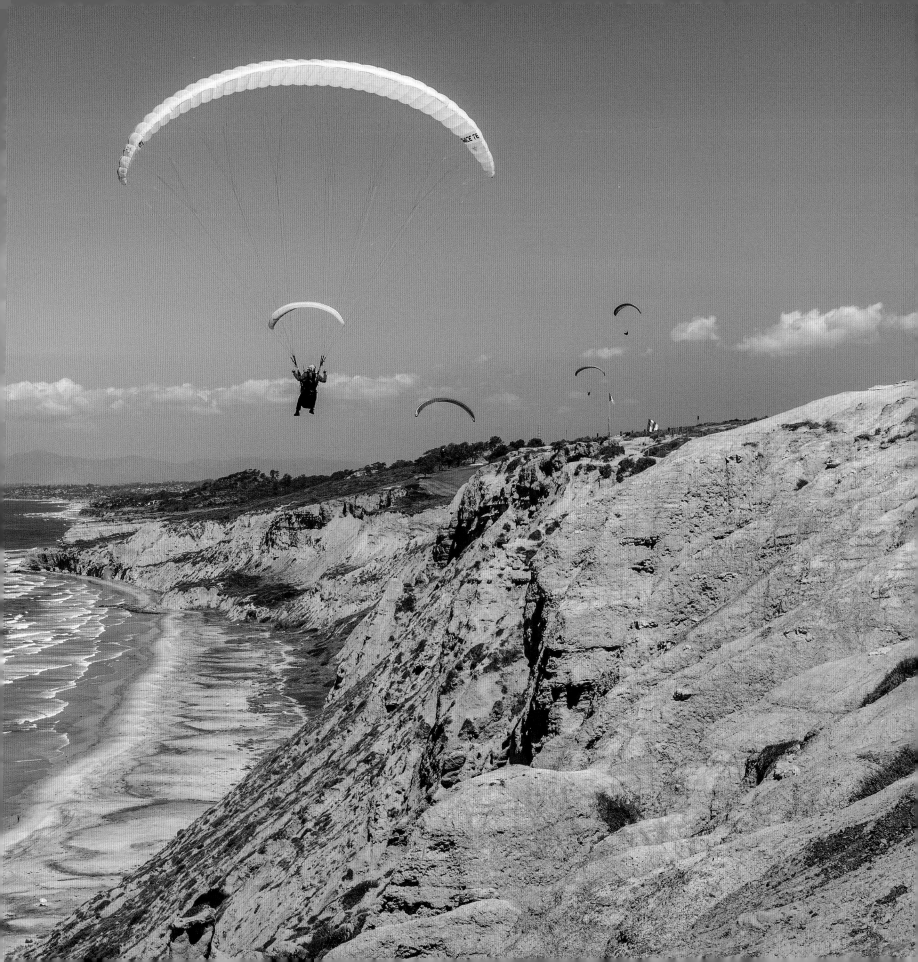

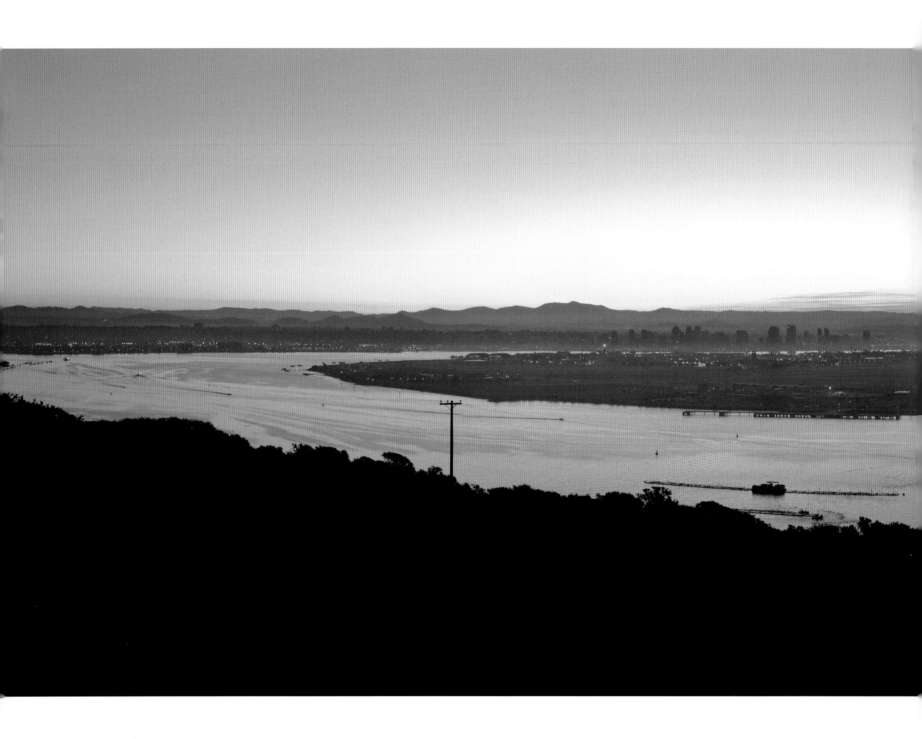

◈ San Diego Harbor, San Diego

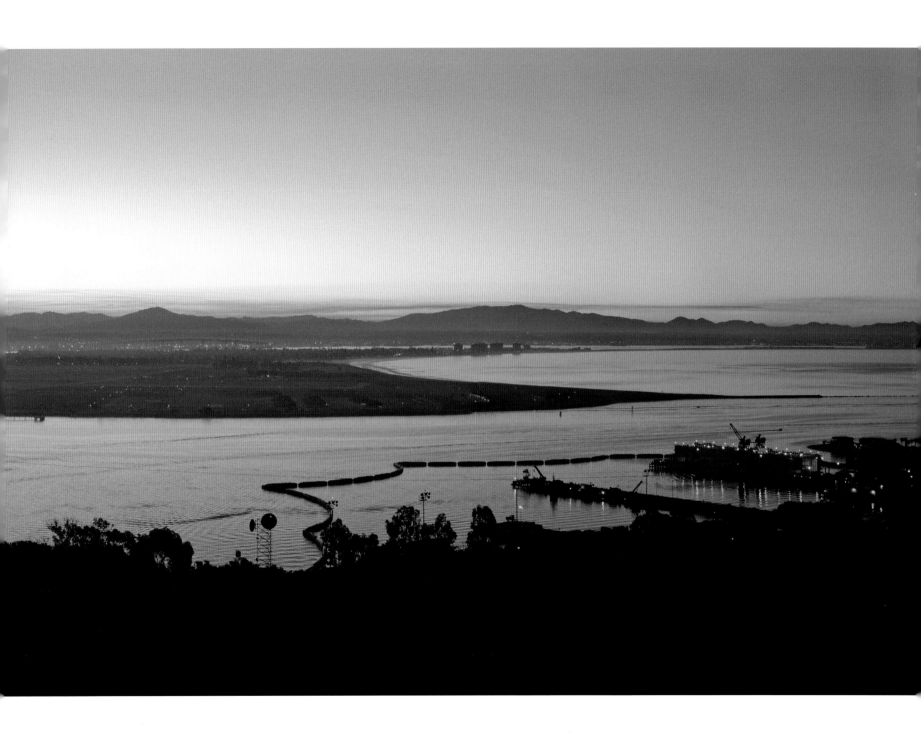

San Diego

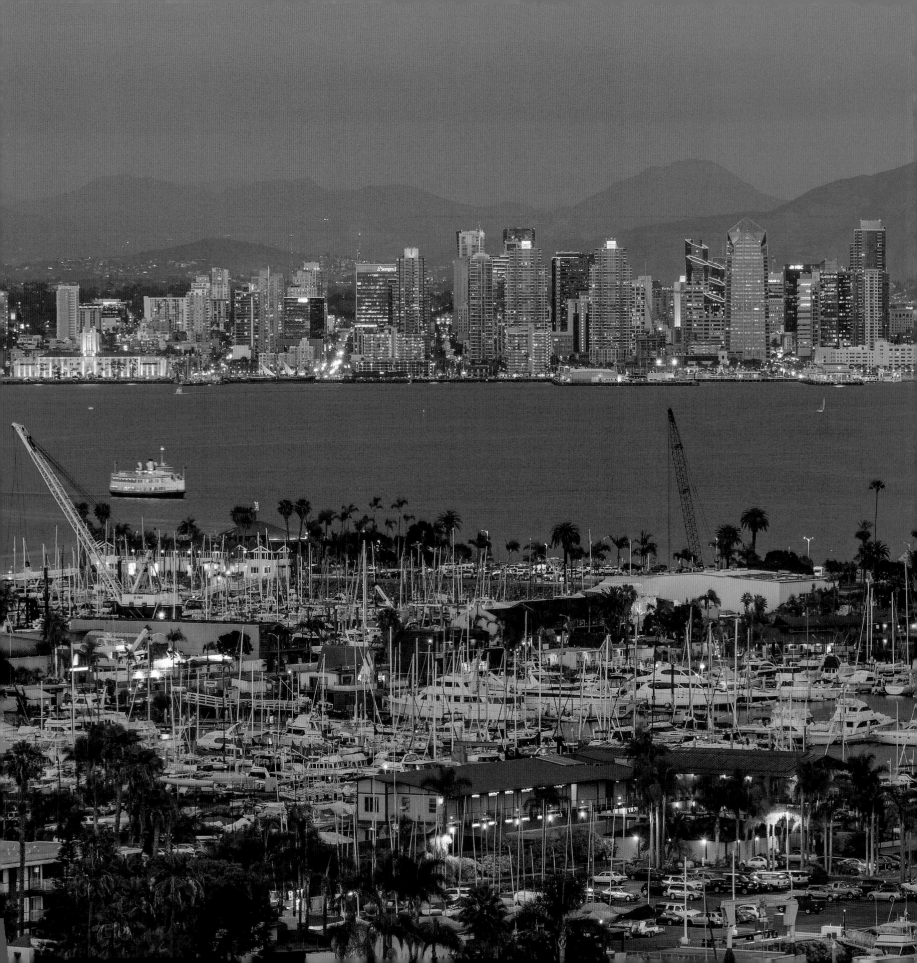

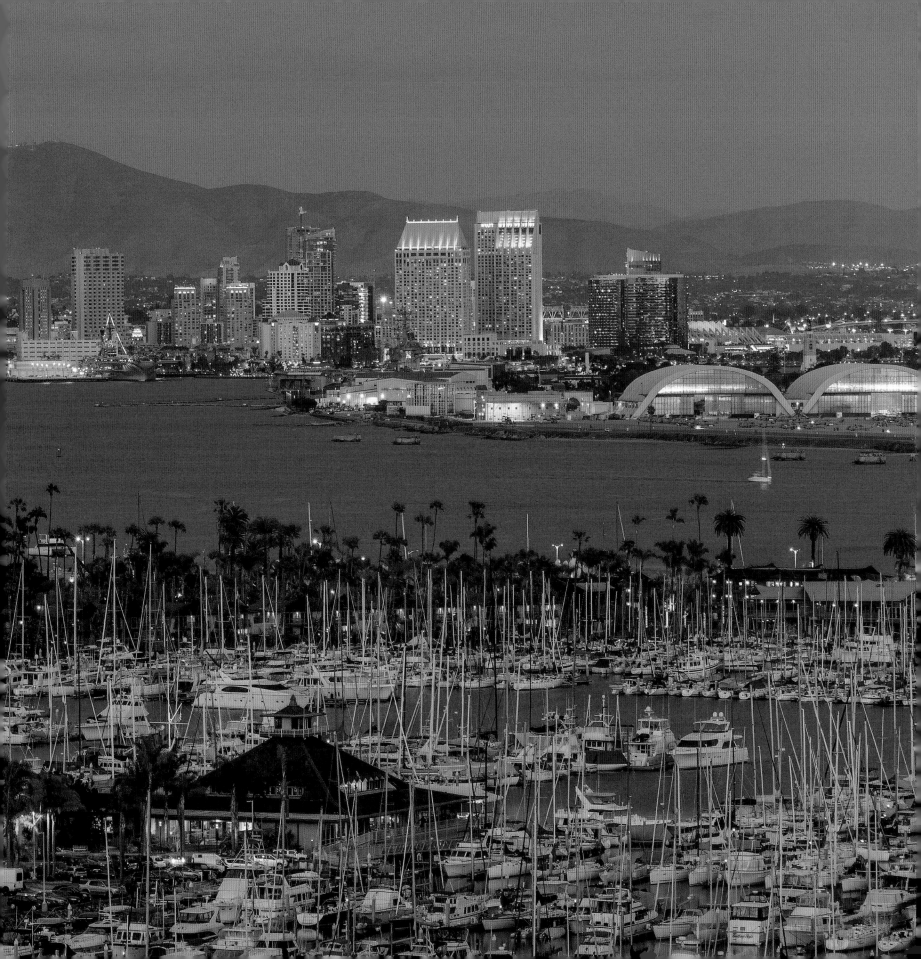

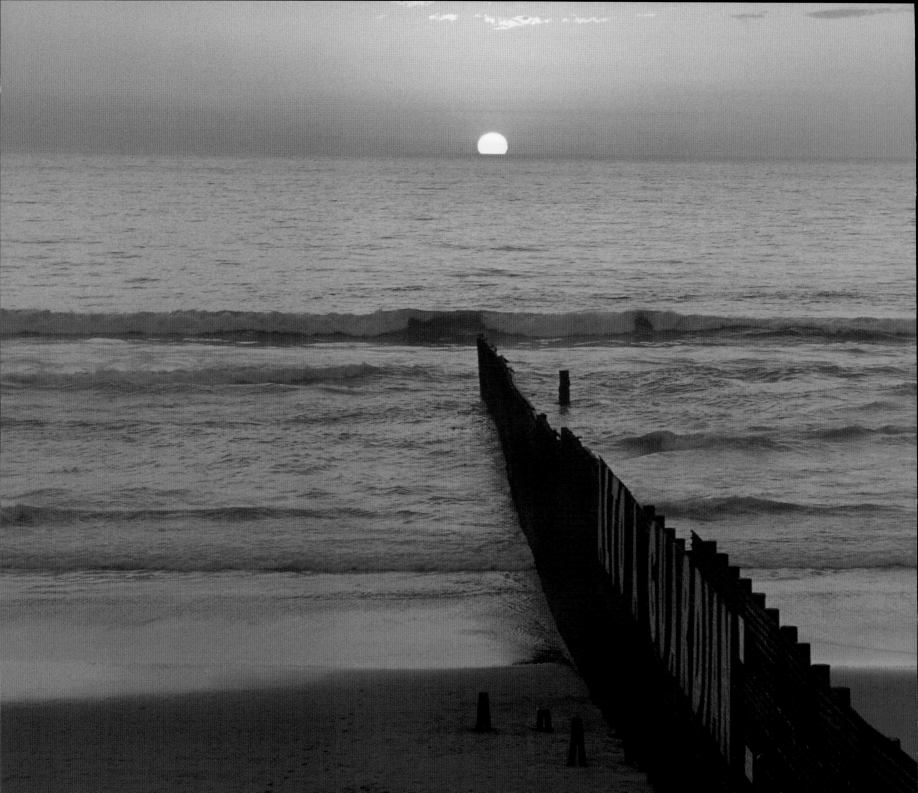

◆ United States-Mexico border wall

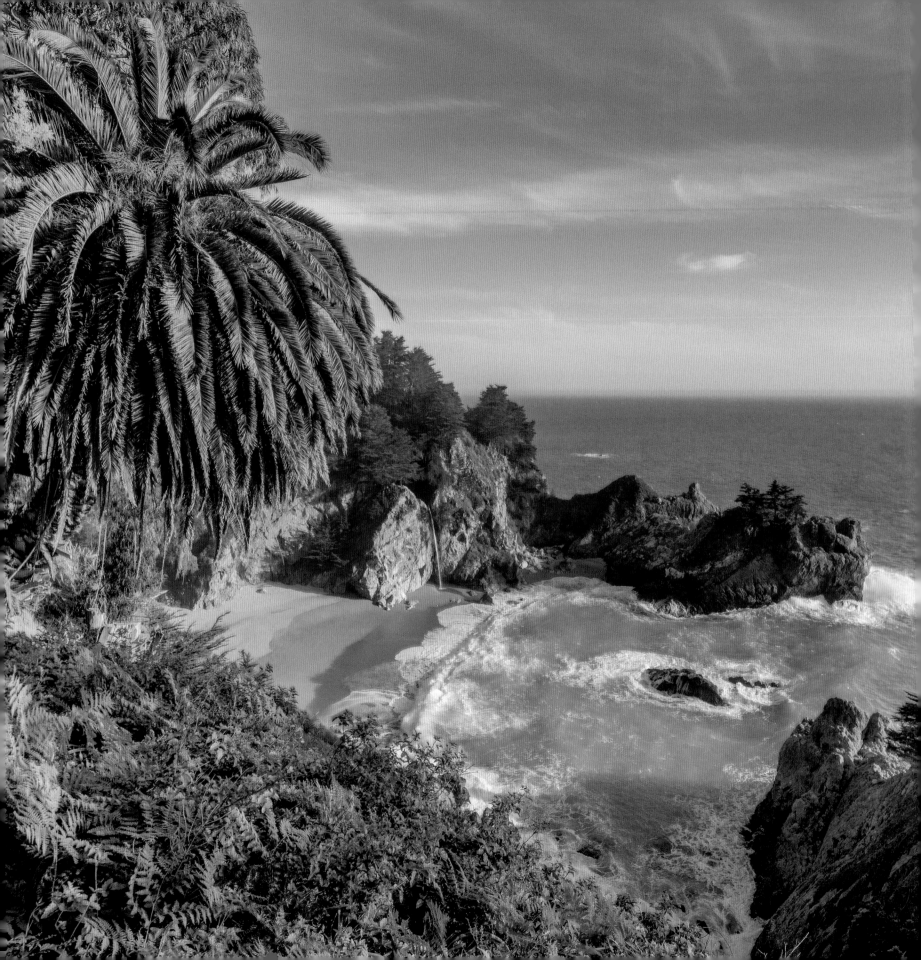

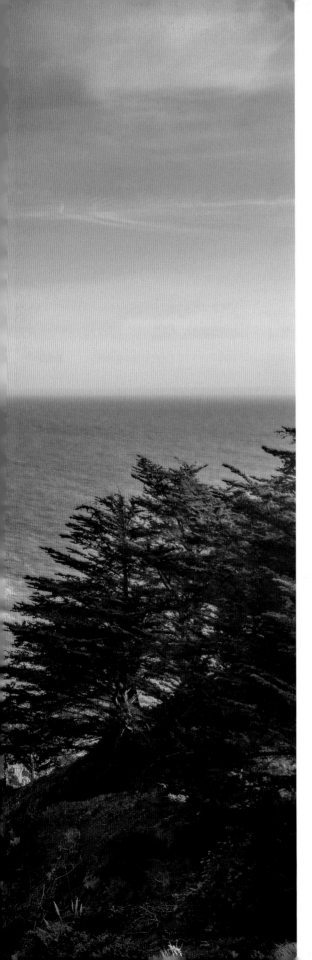

ACKNOWLEDGMENTS

I would like to thank the following people for their kindness and assistance in helping to make this book possible:

Jerry Brown	James O. Muschett
Phyllis Decker	Susi Oberhelman
Joe DeCarlo	Sean, Jack, and Grace O'Donnell
Steve Dailey	Isaac and Patty Bell Palmer
Candice Fehrman	Grant Parrish
Jessica Fuller	Sara and Greg Rosalsky
Mike Goldstein	Jules Solo
Alexandra Hobson	Mary Steinbacker
Nancy Kanter	Fran and Tim Wagner
Adam Kaufman	My daughters, Chloe and Olivia Rajs
Sandi Kaufman	In memory of JJ Jackson and Sam Rosalsky
Charles Miers	All the museums, state parks, and national parks

All photographs in this book are available as fine art prints at www.jakerajs.com

◆ McWay Cove, Julia Pfeiffer Burns State Park, Big Sur

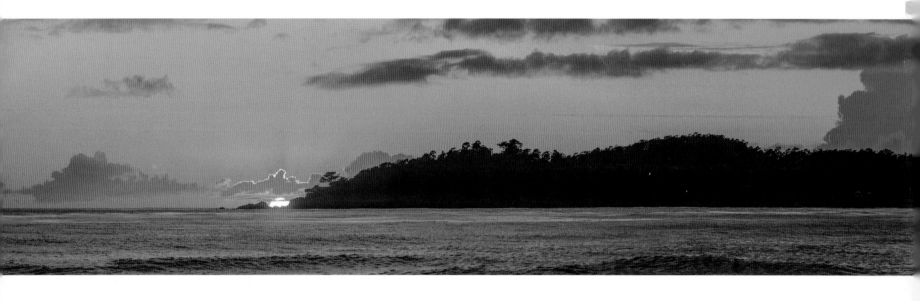

DEDICATED TO
FRAN, MICHAEL, AND SANDI
ALL-WEATHER FRIENDS

First published in the United States of America in 2017
Rizzoli International Publications, Inc. • 300 Park Avenue South • New York, NY 10010 • www.rizzoliusa.com

© 2017 Jake Rajs • Foreword © 2017 Governor Edmund G. Brown Jr.

Book Design: Susi Oberhelman • Project Editor: Candice Fehrman

2023 2024 2025 2026 / 10 9 8 7

Printed in Hong Kong

ISBN-13: 978-0-8478-6109-5

Library of Congress Catalog Control Number: 2017937207

PAGE 1: Aliso Beach, Laguna Beach; PAGES 2–3: Coastline, Elk; PAGES 4–5: Torrey Pines State Natural Reserve, San Diego; ABOVE: Carmel Beach City Park, Carmel